D1226338

HENRY MOORE
SCULPTURE

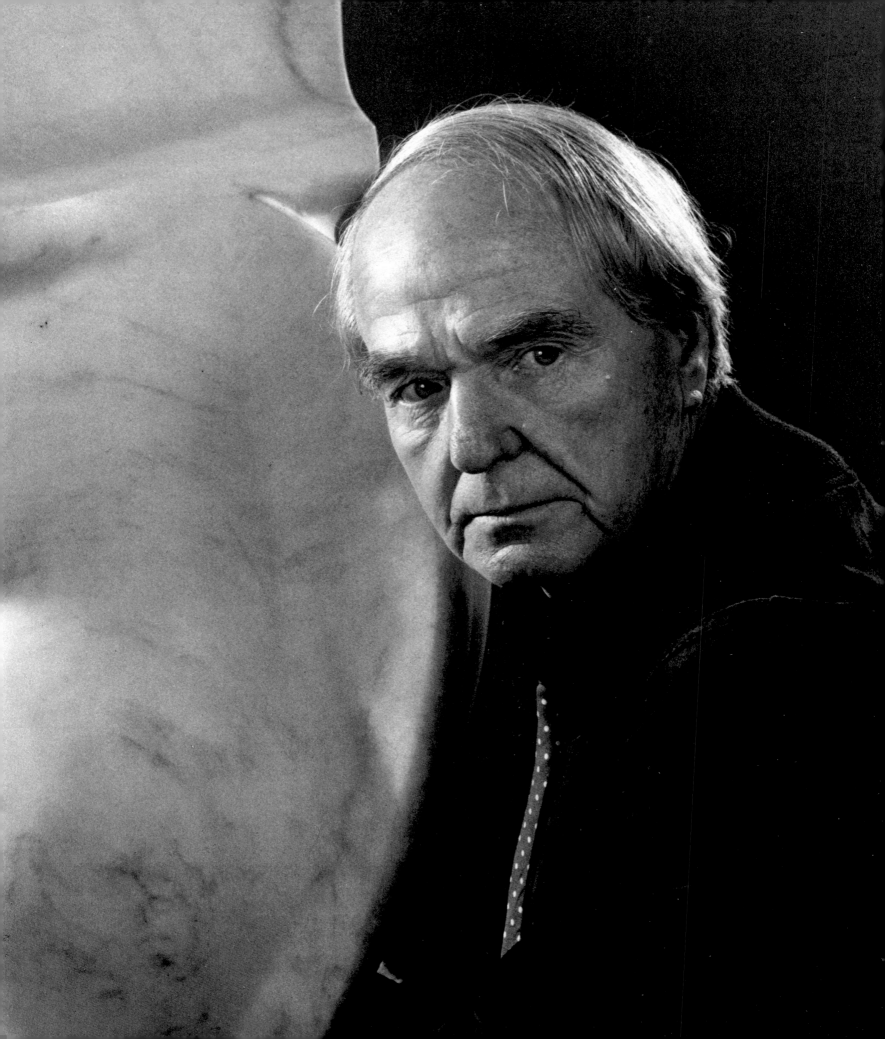

HENRY MOORE
SCULPTURE

with comments by the artist

Introduction by Franco Russoli
Edited by David Mitchinson

M

Copyright © Ediciones Polígrafa SA 1981

Artist's comments © Henry Moore 1981

First published in Great Britain 1981 by
Macmillan London Limited
London and Basingstoke

Associated companies in Auckland, Dallas,
Delhi, Dublin, Hong Kong, Johannesburg,
Lagos, Manzini, Melbourne, Nairobi,
New York, Singapore, Tokyo, Washington
and Zaria

Composition in Garamond by Filmtype Services Limited
Scarborough, England

Colour plates by Reprocolor Llovet
Barcelona -7, Spain

British Library Cataloguing in Publication Data
Moore, Henry, *1898–*
 Henry Moore.
 I. Russoli, Franco
 730'.92'4 NB497.M6

ISBN 0–333–27804–6

Printed in Spain by La Polígrafa, S. A., Barcelona (Spain)
Dep. Leg.: B. 12.101-1981

Contents

Editor's Note

A major illustrated work on the sculptures of Henry Moore was first planned several years ago by Ediciones Polígrafa, Barcelona, in collaboration with the artist. The book was to include all Moore's important sculptures from the 1920s to the present day; its tone was to be popular rather than academic.

Sir Philip Hendy, former director of the National Gallery in London, was invited to write the text. Unfortunately Sir Philip was prevented by ill-health from undertaking the work, and at Henry Moore's suggestion the publishers approached Franco Russoli, director of the Brera Museum in Milan.

Professor Russoli had drafted only three chapters and a short introduction at the time of his sudden death in 1976.

Further plans for the book were frustrated until the spring of 1980, when representatives of the Spanish Ministry of Culture discussed with the British Council and the Henry Moore Foundation plans for a major retrospective exhibition of Moore's work to be held in Madrid during 1981. In the course of these discussions it was decided to go ahead with the long-awaited book, a special edition of which would include a catalogue of the exhibition. The text would be provided by the artist.

I was asked to make a selection from his writings, both published and unpublished, that would explain and illuminate different aspects of the sculptures illustrated. (My selection owes much to familiarity with the research undertaken by my friend and mentor the late Professor Philip James for his book *Henry Moore on Sculpture*.) Where there were no existing statements, Moore agreed to record new material with me.

It was also decided that the text begun by Franco Russoli should be abridged to form an introduction to the book.

Most of the photographs were taken by the artist; some are prints held in the Henry Moore Foundation archives, and a few were specially sought. For the latter I should like to thank Bo Boustedt, Errol Jackson and Gemma Levine.

Among the many people who have contributed towards the production of this book, I should like to thank Kenneth Lyons, the translator of the Russoli manuscript from its original Italian, and Juan Antonio Masoliver who translated the English texts into Spanish; the three designers, Juan Pedragosa and Jordi Herrero in Barcelona and Robert Updegraff in London; and Angela Dyer of Macmillan who assisted me with the many editorial difficulties.

I am indebted to Henry Moore and the Trustees of the Henry Moore Foundation for their guidance and to all my colleagues at the Foundation for their help.

Finally, I should like to thank my good friend Juan de Muga whose enthusiasm and encouragement throughout have been invaluable.

DAVID MITCHINSON

Introduction

Henry Moore has never defined his work in 'abstract' or 'figurative' terms. His art is not preconceived or programmed, but is rather the result of a process of gradual knowledge and experiment in which sensory, conceptual and psychological elements are combined: the work takes shape and is crystallised as the integral symbol of a moment of life, 'an expression of the significance of life, a stimulation to greater effort in living'. In his continual interweaving of the particular and the universal, Moore is seeking to capture the pure emblematic form in which sensation and emotion, individual and linked to a particular moment of life, are fused. He himself once said that 'all art is an abstraction to some degree', an abstraction intended to capture the essence of the real, to recreate by analogy the natural elements in their relationship to the psychology and ideas of man. For Moore, therefore, physical reality is the basis for the construction of a plastic form which conveys not only its visual characteristics but also its psychological and imaginary suggestions. Through a dense network of correspondences and confrontations the artist arrives at a form which sums up in itself the very quality of being.

In the last few years this close attention paid by Moore to the relationships that connect the forms and vital roots of every element of reality seems to have become still more concentrated and evident. We find the reclining figure researched, as it were, within its plastic block; it is built up and modelled, dismantled and then reassembled, re-evoked in its development of structural organism and mechanics. But we also find it observed as an element in a setting, placed as character or architecture against the background of fields and hills, in a romantic Arcadian countryside dappled with flocks of sheep, or looming over the view of a sea traversed by sails.

To his investigation of pure form, of what he once called 'the abstract principles of sculpture', Moore brings the intensity and wholeheartedness of his contemplation of everyday reality, his capacity for research and exuberant fantasy. I am reminded of other statements of his: 'The observation of nature is part of an artist's life, it enlarges his form-knowledge, keeps him fresh and from working only by formula, and feeds inspiration.' The human body, animals, bones, stones and rocks are Moore's models for the formation of a plastic organism, for the 'making' of sculpture. 'Rocks show the hacked, hewn treatment of stone, and have a jagged, nervous block rhythm.' His present work is still consistent with these ideas, expressed over forty years ago, though it is less encumbered by cultural and stylistic preoccupation. In the development of forms that thicken and rise in space, or intersect one another and spring forth like nerves and tendons in the living body of nature, his work is in harmony with the rhythm and breathing of the evolving universe.

In the exploration of curves and joints, of the fabrics and structures that support and bind, Moore goes ever further in his discovery of secret correspondences and metamorphoses: the petrified forest of sculpture is enlivened with fantastic presences and illuminated with psychological revelations. In the romantic, surrealistic territory of the awakening consciousness of our contemporary world, this modern heir to the humanists, advancing towards an identification of the real and the imaginary, of nature and form, remains faithful to his commitment to verify the relationship between the individual and the tangible world.

＊　　　＊　　　＊　　　＊　　　＊

The young Moore was able to bear the hard, painful condition of loneliness, of refusal to compromise in any way, because in his idea of sculpture he had identified his fate as a man: seeking those forms meant getting to know himself, gaining awareness of his relationship to reality.

This ambition had already been nourished for several years. While studying and working at Castleford Grammar School in the north of England, far from the privileged centres of culture and artistic communication, Moore had benefited from the advice and affectionate attention of the school's art mistress, Miss Gostick. In Miss Gostick his vocation and talent had found both cultural and technical guidance; it was probably she who introduced him to the stylistic formulas of the Sezession: a mixture of Minoan, Assyrio-Babylonian and Romanesque-Gothic deriving from the already rather spent influence of Ruskin and Morris and the popular idea of the Arts and Crafts movement, the

whole passed through the filter of Art Nouveau. This, at least, is what is suggested by the pottery Moore decorated at Castleford and the sets and costumes he designed for his theatrical production *Narayana and Bhataryan*, which was staged at the school in 1920.

This evidence from Moore's early years is significant, for it indicates that the young man, untouched by the conditioning of a specific art training, was attempting to use 'modern' forms in his work without going through the stages of conventional apprenticeship. He wanted to express his own world immediately. What he needed, however, was to find reference points for what he was doing in some particular culture.

 ✳ ✳ ✳ ✳ ✳

When Moore finally succeeded in enrolling at Leeds School of Art, in 1919, he was twenty-one years old, with experience of both work – he had taught in an elementary school – and war. He was not a mere boy embarking on the study of art in order to acquire a professional finish for a certain natural talent, but a man who had decided that this profession offered him the best medium in which to express himself and his personal relationship with the world and continue the search for his own identity and for reality. He already had his own concept of sculpture, which was to be modified only slightly by his technical and academic training.

He did, of course, need some knowledge of the tricks of the trade, though certainly not in order to produce banal imitations of the naturalistic aspects of reality and still less to compose decorative or literary variations of stylistic conventions. On the contrary, this knowledge was to help him to the understanding and interpretation of all the expressive possibilities of the material and its working, to allow him to take from it the forms corresponding most exactly to the ideas, sensations and emotions born of his confrontation with reality. To Moore, creating sculpture meant communicating, through the volumes and outlines of a block of material, the vital energy of a body, the entire range of human senses and feelings, the whole organic growth of natural elements, all the suggestions and emotions evoked by the rocks and buildings of his native Yorkshire.

Moore had to go outside the School of Art in order to find some confirmation of his intuition in examples of sculpture that would bear witness to its cultural and poetic validity. They had to be forms that would communicate, as immediately and intensely as possible, the primary impulses of life. His structures had to be elementary but not static. What Moore was seeking at that time were documents of essential sculpture, indications of 'an art not yet strangled by super-

1 No. 30, Roundhill Road, Castleford, Yorkshire: the house where Henry Moore was born, now demolished.

ficial flourishes and ornaments, an art in which inspiration has not yet degenerated into technical artifice and intellectual subtleties', as he himself wrote in 1941, in an essay on primitive art.

It was in Leeds, where he attended art school from 1919 to 1921 on an ex-serviceman's grant, that Moore finally received the revealing indications he had been waiting for. This did not occur at the school, which merely provided him with a technical, craftsman's training. But it was at this time that he met Michael Sadler, Vice-Chancellor of the University of Leeds, a pioneer collector of modern art in England. Sadler, who had works by Cézanne and Gauguin on his walls and had translated Kandinsky, talked to Moore about the paths followed in artistic research from Post-Impressionism onwards. Through him Moore received the first confirmation of his intuitions, the first answers to his questions. Thus he was ready to 'discover' Roger Fry's *Vision and Design*, a book he came across by chance in the public library in Leeds and in which he found the theoretical and historico-critical explanation of his own idea of sculpture. The 'Essay in Aesthetics' by Fry confirmed Moore's own opinion that aesthetic emotion and 'significant form'

II *Henry Moore (bottom left) at an evening class in pottery at Castleford Grammar School, 1919. Miss Gostick is seated on the far left.*
III *Private H.S. Moore (arrowed, lower right) in his platoon of the Civil Service Rifles, Winchester, 1917.*
IV *The artist in his studio at Hammersmith, about 1925.*

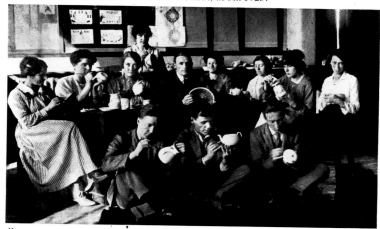

II

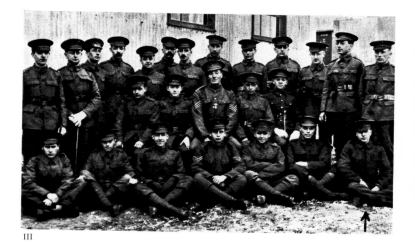

III

IV

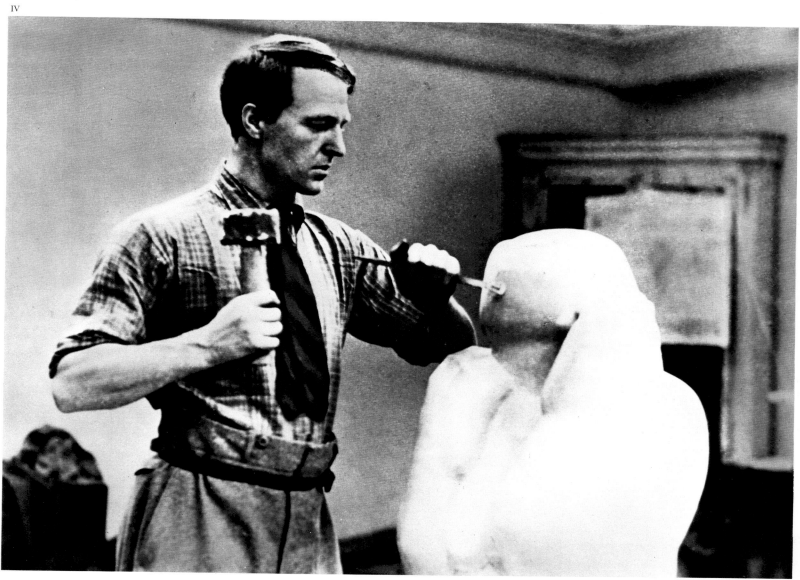

possess a peculiar quality of reality that has nothing to do either with the imitation of certain aspects of the real or with agreeable formal and decorative compositions, and that such 'reality' was expressed just as sincerely and powerfully in the works of Negro and primitive art as in those of Giotto or Masaccio, Cézanne or Picasso.

At about the same time he read Ezra Pound's monograph on Henri Gaudier-Brzeska, published in 1916, which contained reproductions of that sculptor's works and also some of his letters and other writings, and this gave him direct evidence of how other young artists had progressed along the road he himself wanted to travel. This book, says Moore, 'was written with freshness and insight, and Gaudier speaks as a young sculptor discovering things'. According to Gaudier, if an artist wanted to express the vital energy of nature he had to be able to assimilate and blend into a style of his own all the known examples of man's endeavour to give form and face to this primary value, from

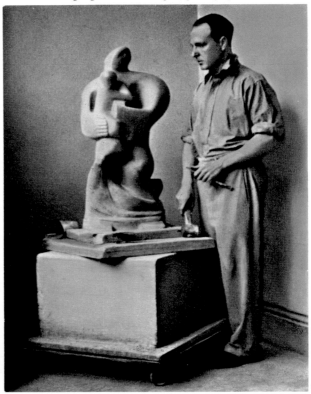

VI

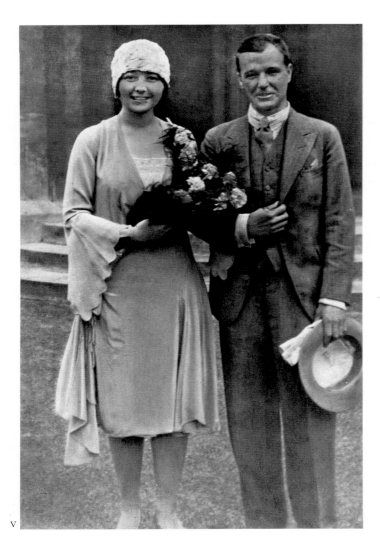

V

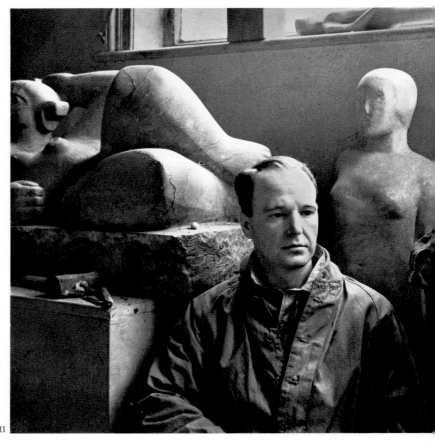

VII

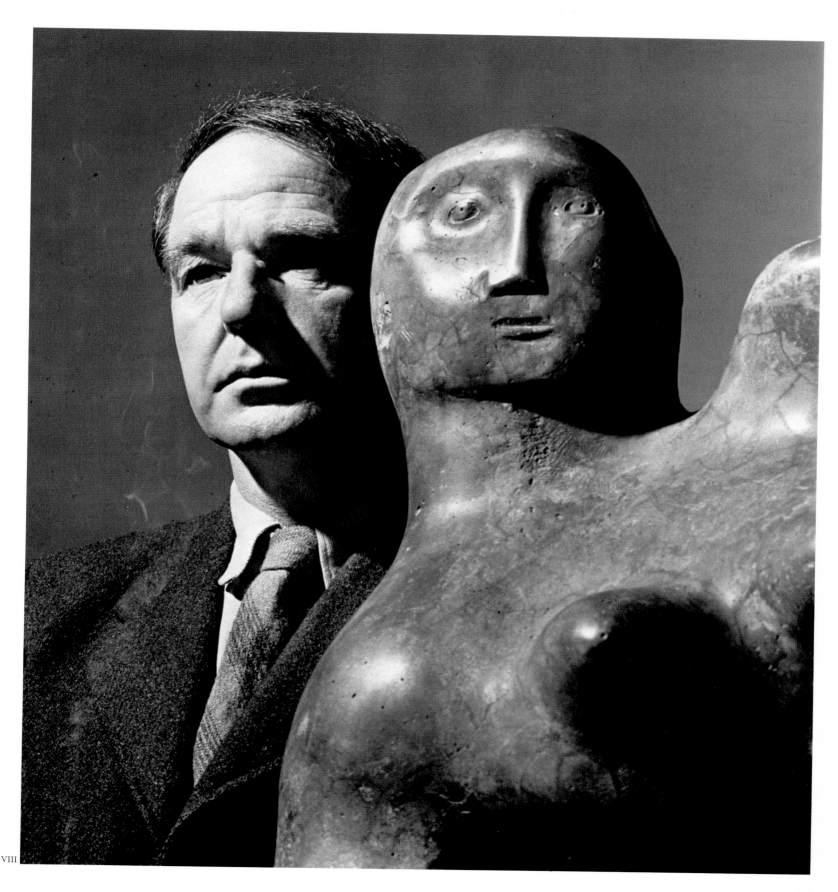

the Palaeolithic to the Egyptian, from the Chinese to the Sumerian, from Archaic Greek to Romanesque, from the art of Africa to that of Mexico.

It must have been with excitement that Moore read Gaudier's decisive condemnation of Greek classicism. To Gaudier, sculpture was 'derivative', devoid of direct energy, 'its sensitivity to form secondary'. In Gaudier's manifesto he also found the simplest definition of his own vision of sculpture: 'Sensitivity to sculpture is the appreciation of masses in their relation to one another. Ability in sculpture is the definition of these masses by means of planes.'

But Moore could not find applications of those principles, or original interpretations of those examples, in the English sculpture of the 1920s and still less in the academic teaching of the Royal College of Art in London. He had to look for them on his own account, in the rooms of the British Museum and the illustrations of books and reviews concerned with ancient and modern art. Having found them, he submitted the works to a long and painstaking comparison with the 'reality' he was looking for. He became convinced that a contemporary sculpture, created in response to the problems of its age, should start at the point that had been reached before the war by those artists who had found in the forms of primitive art a profound accord with their own search for an inner, absolute – and therefore new – truth. He recognised the precedents of his own preoccupations and

IX *Henry Moore at Hoglands, 1946, with the* Reclining Figure *in elmwood (see* figs 185–9).

X *The artist photographing* Standing Figure No. 1 *(see* fig 220) *in 1953, with* Upright Internal/External Form *(see* fig 238) *in elmwood unfinished in the background.*

XI *Henry Moore with* Reclining Figure *1929 (see* fig 26) *at Hoglands in 1949.*

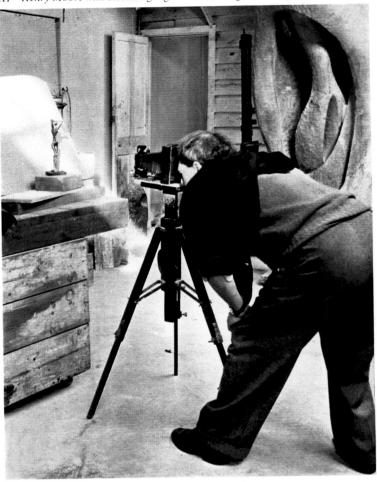

X

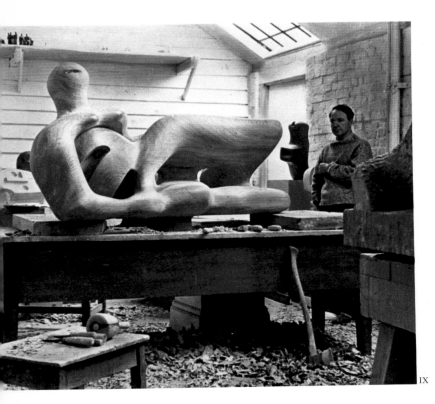

IX

XI

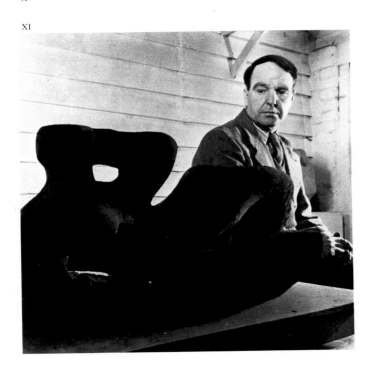

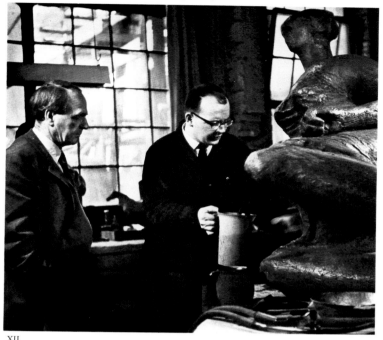

XII

searchings in artists such as Brancusi and Picasso, who had seen, in archaic or primitive sculptures and paintings, models that revealed the fusion between monumentality expressed in blocks and vital energy. And he realised that the only sculptors in England who had followed that path with true originality at that time were Epstein and Gaudier.

Moore now had some kind of bearings for the voyage he was to embark on; from these models he did not, of course, derive any stylistic formulas, but from them he learned how it was possible to make a free, personal interpretation of the repertoire of primitive plastic art. This knowledge helped him to pick out the examples that best responded to his own ideas and his own personality, that would provide the formal and figurative principles which had to be developed before he could give material form to his own poetic vision.

At that time, as we have seen, he wanted to express the vitality of the universe: the harmony between the mysterious existence of nature and the secret current of man's primary feelings – tenderness, passion, energy – in simple, powerful forms. He wanted a form at once monumental and

XIII

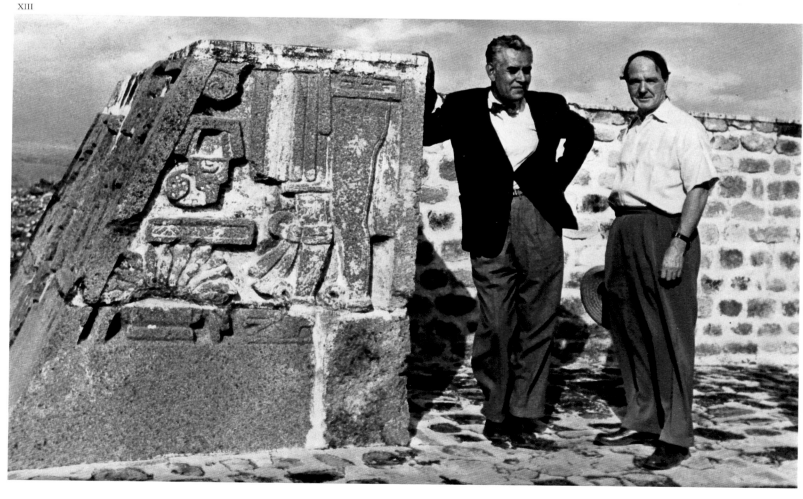

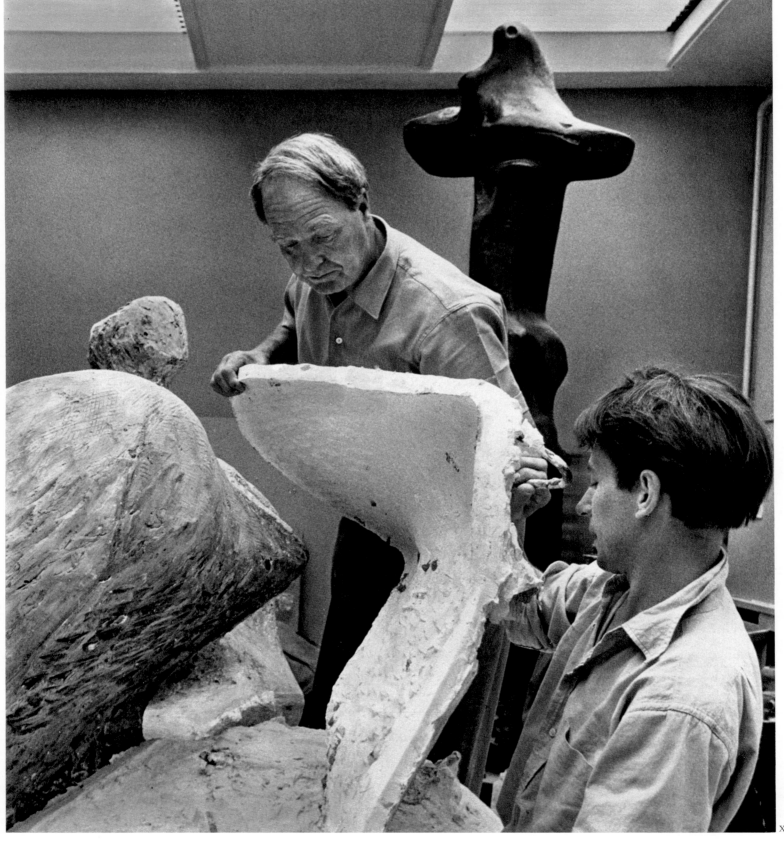

14

XIV *Henry Moore and an assistant making a cast of the working model for* UNESCO
 Reclining Figure *1957 (see* figs 296, 297).

XV *The artist working on the plaster of the* Reclining Figure: Lincoln Center *1963 (see*
 fig 368).

XVI *Henry Moore in the studio at the Henraux stoneyard at Querceta in 1965 carving
 the white Carrara marble* Archer *(see* fig 387).

XVII *With the plaster of* Double Oval *(see* fig 412) *at Hoglands, 1967.*

XVIII *At the stoneyard, Querceta, in 1969.*

XVII

XVIII

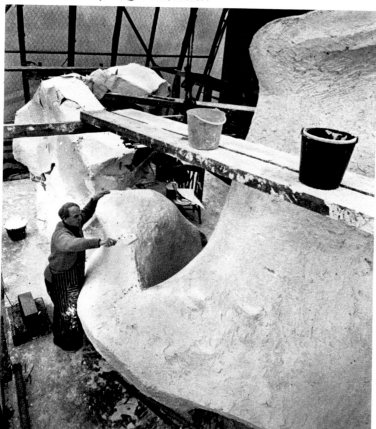

XV

XVI

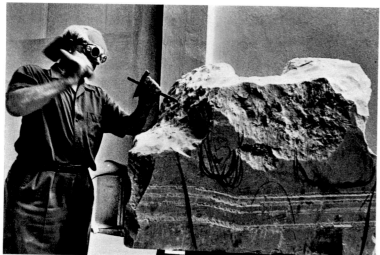

romantic, one that would be, in the words of Herbert Read, 'a concentration of the vital force' of all that exists. Moore, therefore, was not contemplating the ancient and primitive works in the British Museum in order to read their symbolic content or their cultural meaning, but to take from them both the immediate power of their energy and their purely plastic inventiveness.

While constantly broadening his acquaintance with the immense repertoire of universal art, in books, in museums and in collections (undoubtedly a great event in his life was his first visit to Paris, on a Whitsun holiday in 1923, when he received the 'tremendous impact' of the Cézannes in the Pellerin Collection), at the same time Moore was discovering the primary elements of structures and figures that express reality without superfluous veristic details. In the Cycladic sculptures and in Giotto, in Negro figures and in Cézanne, in works from China, Mesopotamia, Egypt or Mexico, in Michelangelo, in the statues of Giovanni Pisano and in the works of Brancusi and Picasso, he saw the common denominator of an articulation of forms reduced to their essentials: the movements within the block, or the physical and spiritual relationship between several organisms in the same surrounding space, expressed with the greatest truth and with the greatest possible economy of descriptive elements.

XIX

XX

XXI

XXII

16

XXIII

XXIV

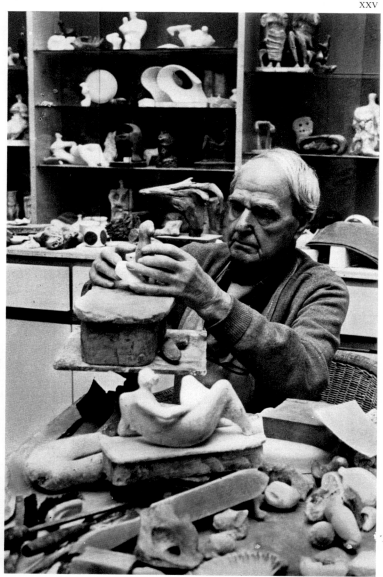

XXV

Taking as his basis the principles of Cézanne, he applied
the teachings of Brancusi ('Simplicity is not the ultimate aim
of art, but we reach it in spite of ourselves as we draw closer
to the real meaning of things') and those of Roger Fry based
on Negro sculpture: 'The Negro artist's plastic sense leads
him to give the greatest possible breadth and relief to the
salient parts of the body, by which he achieves an extraordi-
narily energetic and expressive sequence of planes. Far from
seeing his work in two dimensions, as we Europeans do, the
Negro sculptor tends to underline, so to speak, all three
dimensions of his forms. And it is in this way, I believe, that
he succeeds in giving his figures their disconcerting vitality
and in suggesting that they are not simply echoes of real
figures but have an inner life of their own.'

Moore's investigation of form was, therefore, an attempt
to express reality in action. In extracting geometrical solids
from natural forms, he was searching to achieve not an
abstract harmony but the analogy – in terms of independent
plastic language – of the relationships between a body and its
vital functions. Sculpture had always been the expression of
something that existed in the reality of nature, the life of its
forms a paraphrase of the life of real things. For Moore it
was the composition of the abstract volumes, not the
representation of the external aspects of reality (realism),
that had to communicate the inner force of what existed
(reality). But those 'shapes of masses' always derived from
figures of the real: they were their synthesis, rather than
mere formal inventions devoid of all connection with tangi-
ble reality. Sculpture had to indicate clearly what real object
had excited the artist and stimulated his research. In those
years Moore was trying to bring about the transposition of
the reality of nature into the reality of form, synthesising the
changing spectacle of life in the tautest, most essential

XXVI Henry Moore with the late Franco Russoli, director of the Brera Museum in Milan, 1976. Behind them is Giovanni Bellini's Pietà.
XXVII Henry Moore welcoming Mstislav Rostropovich to the Henry Moore Foundation, Dane Tree House, Much Hadham, in 1980.

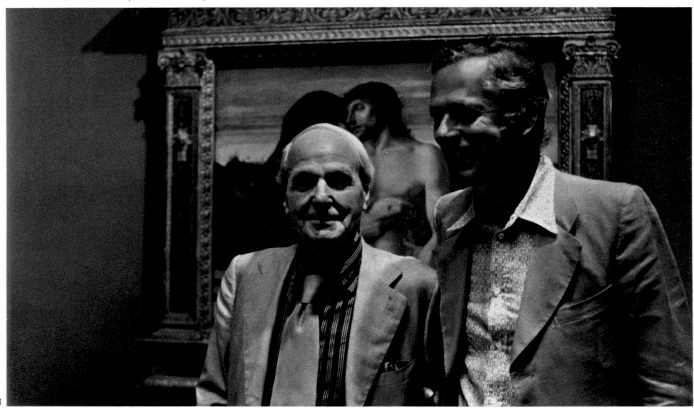

XXVI

XXVII

With the West German Chancellor Herr Schmidt during the unveiling ceremony of
Large Two Forms *(see figs 415, 416) in Bonn, 1979.*

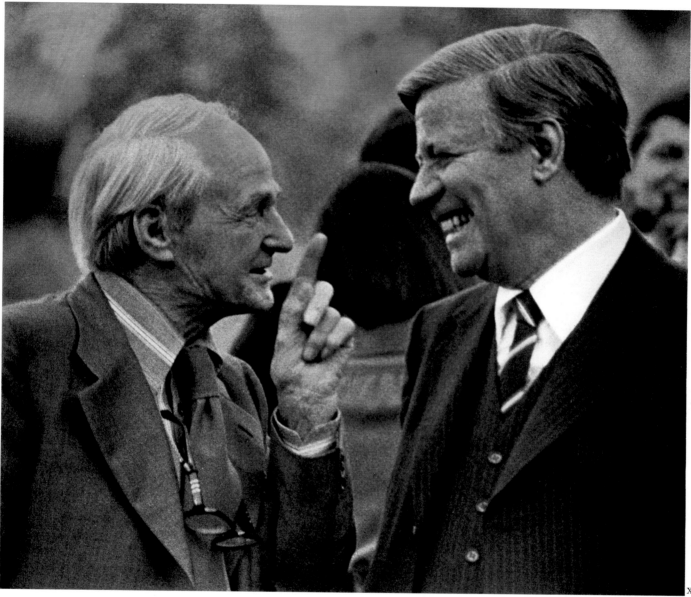

XXVIII

architecture of volumes. He tended not only to enclose the single elements of a figure or a group in dynamically interconnected blocks but also to delimit a spatial cage, a geometric depth within which the sculpture was circumscribed, like a core or nucleus radiating linked energy. Many of the drawings in the sketchbooks of that period show us that he squared off his pages in order to establish not proportions on the surface but three-dimensional proportions – to 'compose in box', as the notes say. What he wanted was a spatiality related to the volume, one that would confine it within precise limits and thus increase its inner vitality. 'Force, power, is made by forms straining or pressing from inside', said Moore, and he bent the appear-

ances of nature until they were condensed into forms imprisoned in geometrical dimensions.

❊ ❊ ❊ ❊ ❊

Moore's experiences gained on the travelling scholarship that took him to France and Italy in 1924 and provided his first encounter with the masterpieces of Mediterranean civilisation, brought on a crisis. In the works of classical and Renaissance art – which he had until then believed to be far removed from his own ideals, confusing them with the tired academicism of the plaster casts he had copied at art school – he now discovered quite different values. As he confessed in 1946: 'I couldn't seem to shake off the new impressions, or

19

make use of them without denying all I had devoutly believed in before. I found myself helpless and unable to work.' If he had, indeed, found confirmation for his own convictions regarding monumentality, the essential structure of vital energy, in the paintings and sculptures of Giotto and Masaccio, the Pisani and Michelangelo, Cézanne and Seurat, other works had revealed to him the poetical possibilities of forms and images that were open and tender rather than block-like and tough.

What Moore had until then seen as the superiority of Indian, Egyptian and Mexican sculpture to that of the Renaissance now seemed less certain. The discovery of another, poetical dimension, and one which he felt to be anything but indifferent or alien to him, disturbed the very foundations of his research, which had hitherto seemed so solid. For about six months, between 1925 and 1926, his activity was affected by such doubts, and his works (with some of which he was so dissatisfied that he destroyed them) betrayed the signs of an uneasy truce between the two different plastic worlds and their ways. The powerful squarings of his volumes were softened into a more graceful and sensitive modelling, the faces lost their arcane simplification and came to be defined in psychological expression. Once again it was the British Museum that helped him to find the way out of his difficulties, in a resolute return to the Mexican and primitive models. At root, however, the 'Italian emotions', even if they were repressed, continued to live and bear fruit in his work. As Moore himself has said: 'The Italian trip was a turning point . . . the effects of that trip never really faded.'

Kenneth Clark, while speaking in his excellent book on Moore's drawings of the dazzling revelation the young artist had received from his first encounter with Masaccio and Michelangelo, asserts that the profound influence of Renaissance art on Moore's work has never been granted the consideration it deserves, whereas that of primitive art has been much exaggerated. 'As it turned out', writes Clark, 'Cycladic and Negro art were as remote from his sense of form as was the sculpture of Brancusi.' This is an opinion which to some extent I share, in the sense that I have been endeavouring to make clear: that Moore's attitude was, and is, fundamentally 'realistic', and that therefore his search for pure, essential forms tended to result in the expression of a moment of life rather than an idealising symbol. Thus his forms were organic even when they took on abstract or purist aspects. There was in them a tendency towards monumentality as the exaltation and condensation of vital energies; in this Moore was seeking a reference to his archaic and primitive models, or perhaps to the synthetic, primordial roughness of Brancusi at his most totemic and ancestral.

Thus Moore creates a monumental, totemic world, in which the dark power of the mysterious energies of life is blended into classical harmony with the rational formative process of every element in nature.

Creating a new form means proposing a different key to the truth, so that we may perceive the metamorphoses through which the unique, eternal presence of this truth passes in its relationship with cultures and individuals; it means reconciling subject and object without permitting one to prevail over the other, in the conviction that they are both indispensable components of life. 'To be an artist is to believe in life.'

FRANCO RUSSOLI

20

The
Sculpture

It is a mistake for a sculptor or a painter to speak or write very often about his job. It releases tension needed for his work. By trying to express his aims with rounded-off logical exactness, he can easily become a theorist whose actual work is only a caged-in exposition of conceptions evolved in terms of logic and words.

But though the non-logical, instinctive, subconscious part of the mind must play its part in his work, he also has a conscious mind which is not inactive. The artist works with a concentration of his whole personality, and the conscious part of it resolves conflicts, organises memories, and prevents him from trying to walk in two directions at the same time.

It is likely, then, that a sculptor can give, from his own conscious experience, clues which will help others in their approach to sculpture.

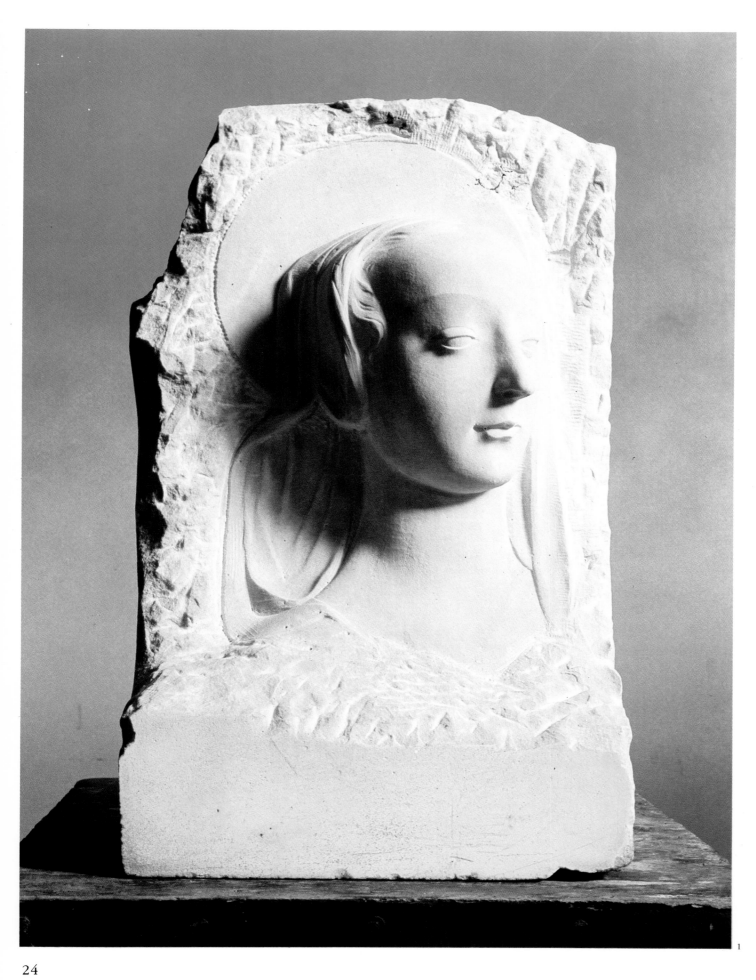

1 Head of the Virgin *1922 H 53.3 cm Marble Mr and Mrs Raymond Coxon, London*
2 Two Heads: Mother and Child *1923 L 19 cm Serpentine Mrs Irina Moore*
3 Figure *1923 H 39.4 cm Verde di Prato Erculiani Bauten Organization*

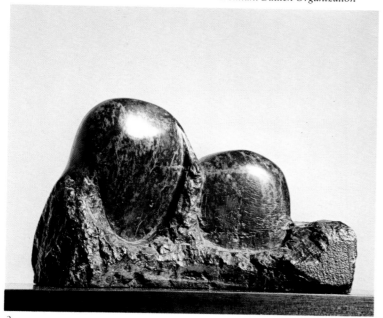

2

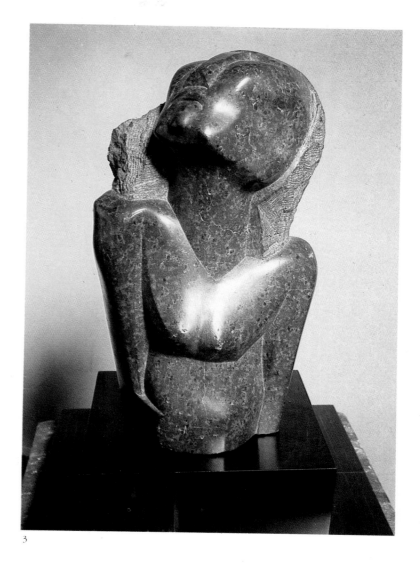

3

The observation of nature is part of an artist's life, it enlarges his form-knowledge, keeps him fresh and from working only by formula, and feeds inspiration.

The human figure is what interests me most deeply, but I have found principles of form and rhythm from the study of natural objects such as pebbles, rocks, bones, trees, plants, etc.

Pebbles and rocks show nature's way of working stone. Smooth, sea-worn pebbles show the wearing away, rubbed treatment of stone and principles of asymmetry.

Rocks show the hacked, hewn treatment of stone, and have a jagged nervous block rhythm.

Bones have marvellous structural strength and hard tenseness of form, subtle transition of one shape into the next and great variety in section.

Trees (tree trunks) show principles of growth and strength of joints, with easy passing of one section into the next. They give the ideal for wood sculpture, upward twisting movement.

Shells show nature's hard but hollow form (metal sculpture) and have a wonderful completeness of single shape.

Flintstones, pebbles, shells and driftwood have all helped me to start off ideas, but far more important to me has been the human figure and its inner skeleton structure. You can feel that a bone has had some sort of use in its life; it has experienced tensions, has supported weights and has actually performed an organic function, which a pebble has not done at all. In themselves pebbles are dead forms, their shape is accidental, and merely to copy them would not in itself create a sculptural form. It is what I see in them that gives them their significance.

25

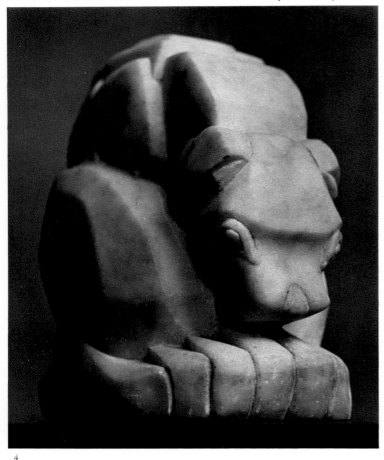

4

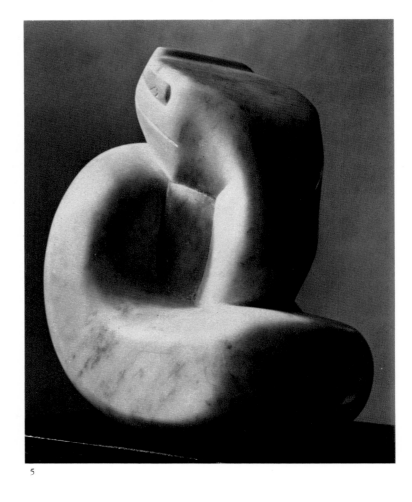

5

Although it is the human figure which interests me most deeply, I have always paid great attention to natural forms, such as bones, shells and pebbles, etc. Sometimes for several years running I have been to the same part of the seashore – but each year a new shape of pebble has caught my eye, which the year before, though it was there in hundreds, I never saw. Out of the millions of pebbles passed in walking along the shore, I choose out to see with excitement only those which fit in with my existing form-interest at the time. A different thing happens if I sit down and examine a handful one by one. I may then extend my form-experience more, by giving my mind time to become conditioned to a new shape.

There are universal shapes to which everybody is subconsciously conditioned and to which they can respond if their conscious control does not shut them off.

Pebbles show nature's way of working stone. Some of the pebbles I pick up have holes right through them.

Besides the human form, I am tremendously excited by all natural forms, such as cloud formations, birds, trees and their roots, and mountains, which are to me the wrinkling of the earth's surface, like drapery. It is extraordinary how closely ripples in the sand on the seashore resemble the gouge marks in wood carving.

26

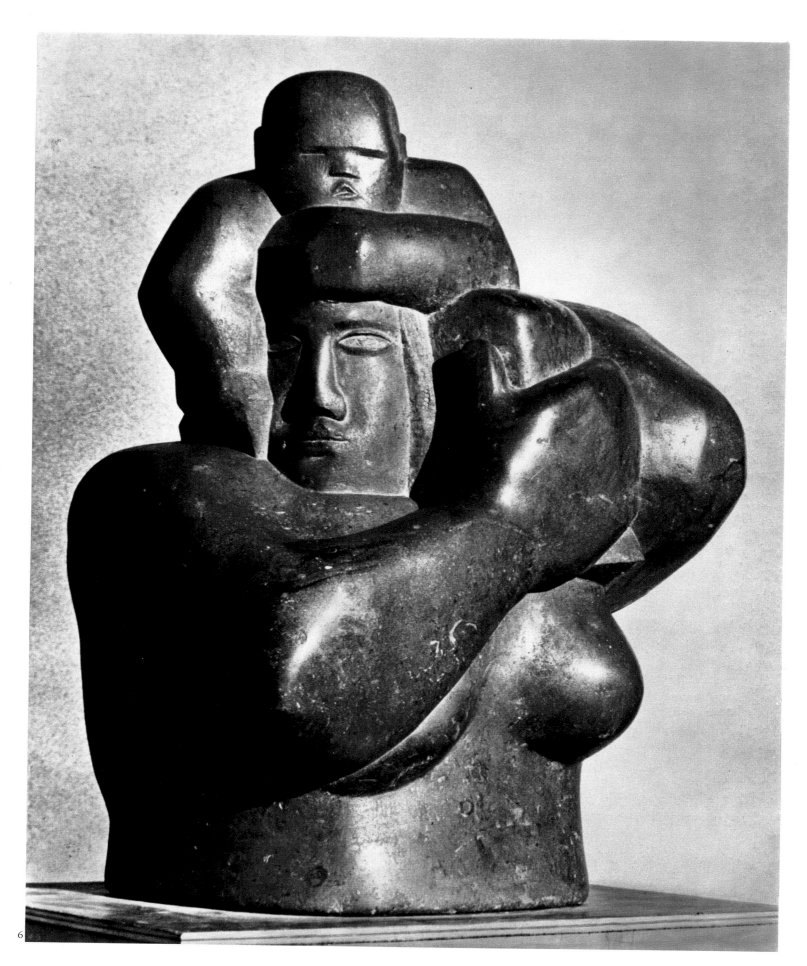

6

7 Head of Girl *1922 H 24.2 cm Wood City Art Gallery, Manchester*
8 Standing Woman *1923 H 30.5 cm Walnut wood City Art Gallery, Manchester*
9 Maternity *1924–5 H 22.9 cm Hopton Wood stone City Art Gallery, Leeds*
10 Mask *1924 H 17.8 cm approx. Verde di Prato Alistair McAlpine, London*
11 Seated Figure *1924 H 25.4 cm Hopton Wood stone The Henry Moore Foundation*
12 Woman with Upraised Arms *1924–5 H 43.2 cm Hopton Wood stone The Henry Moore Foundation*

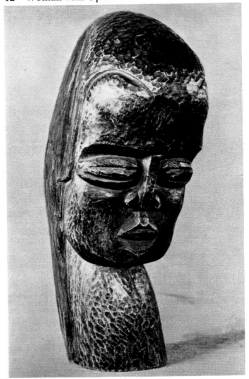

7

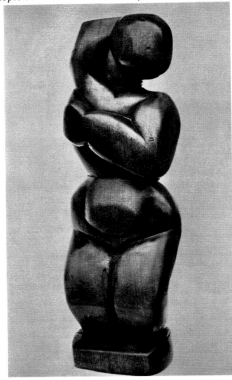

8

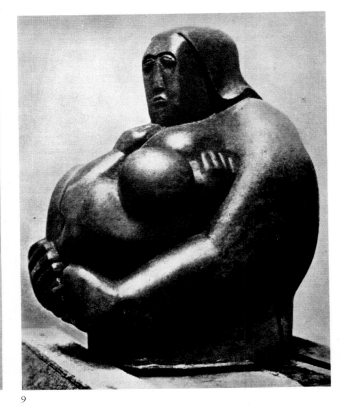

9

10

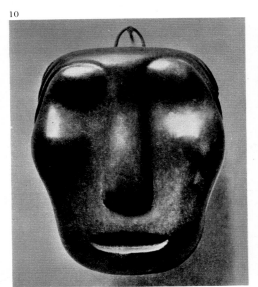

11

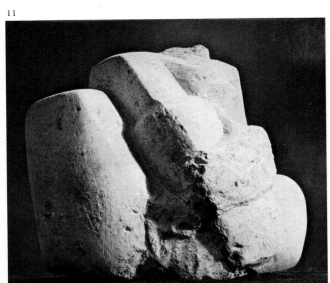

28

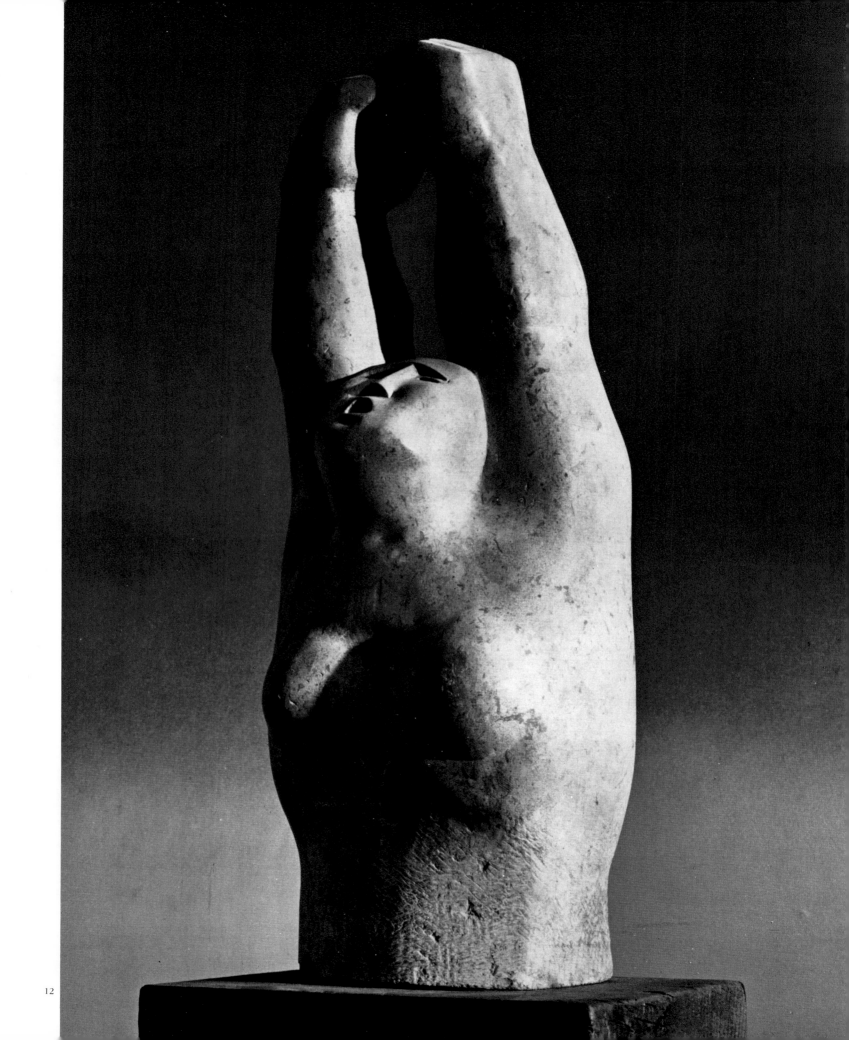

13 Chairback Relief *mid-1920s L 78.7 × 47 cm Teak wood The artist*
14 Chairback Relief *mid-1920s L 78.7 × 47 cm Teak wood The artist*
15 Two Heads *1924–5 H 31.7 cm Mansfield stone The Henry Moore Foundation*

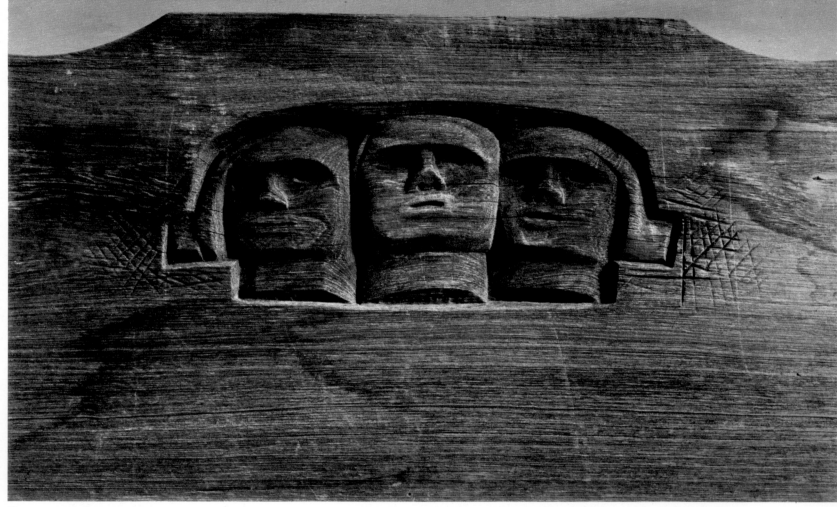

13

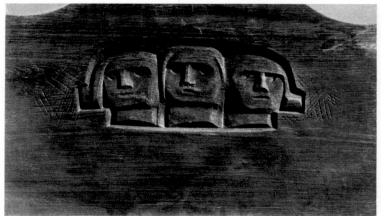

14

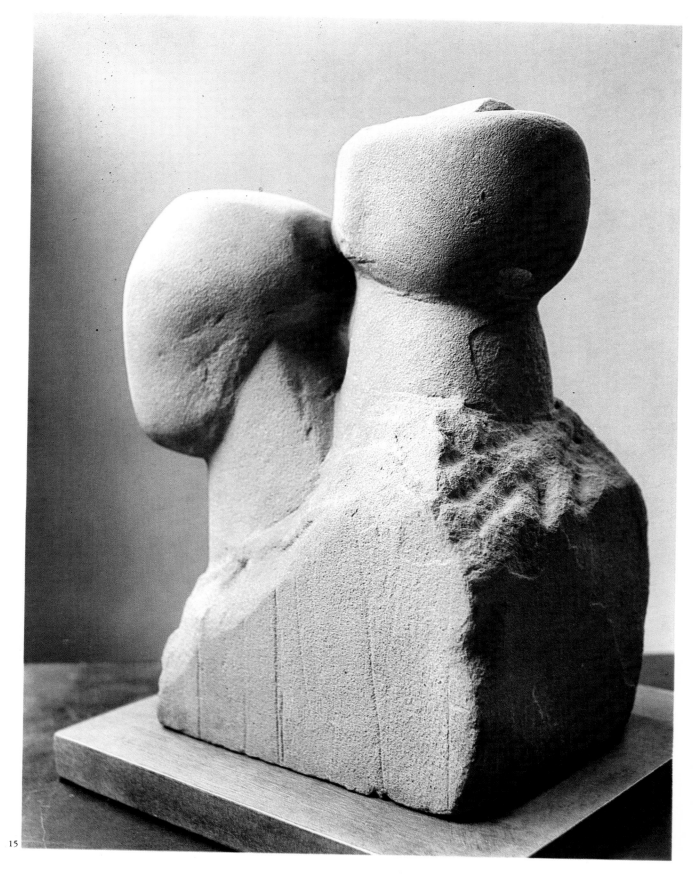

15

16 Head of a Woman *1926 H 22.8 cm Cast concrete City Art Gallery and Museum, Wakefield*
17 Standing Woman *1926 H 86.3 cm Stone Destroyed*
18 Reclining Figure *1926 H 40.6 cm Plaster for bronze Destroyed*
19 Suckling Child *1927 H 43.2 cm Cast concrete Destroyed*
20 Bird *1927 H 22.8 cm Bronze cast Private collection*

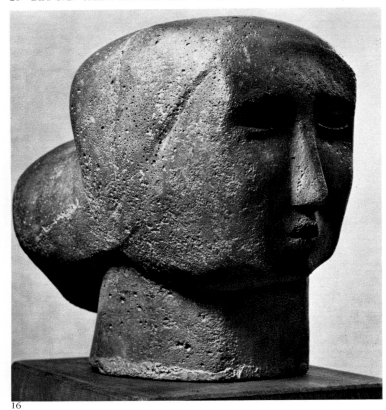

16

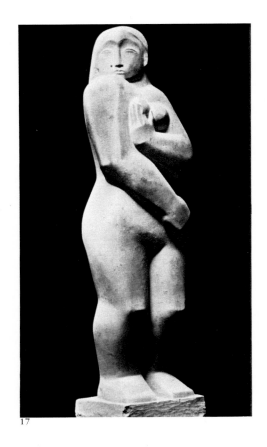

17

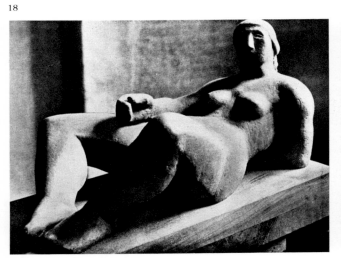

18

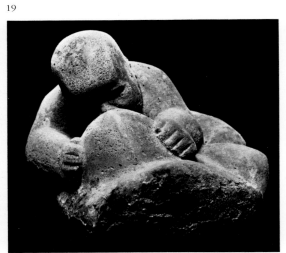

19

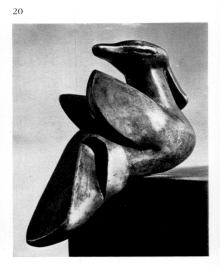

20

21 Garden Relief *1926 H 87.6 cm Portland stone*
22 Garden Relief *1926 H 87.6 cm Portland stone*
23 Garden Relief *1926 H 87.6 cm Portland stone*

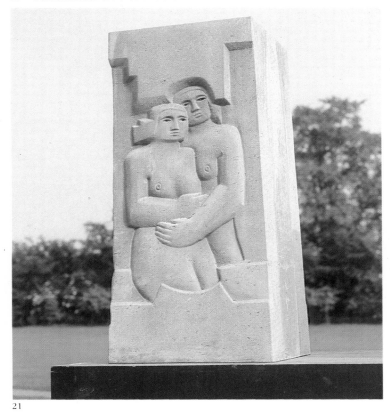

21

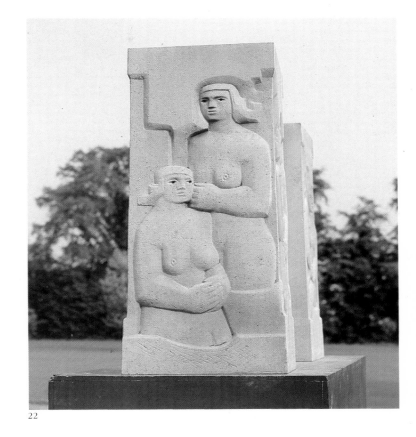

22

23

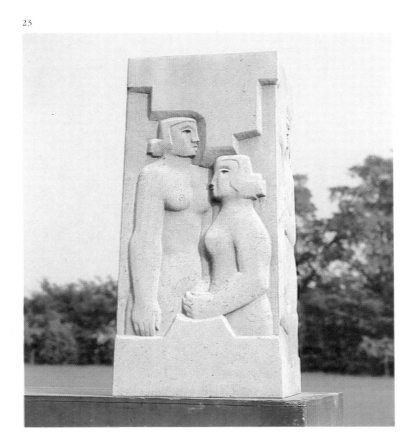

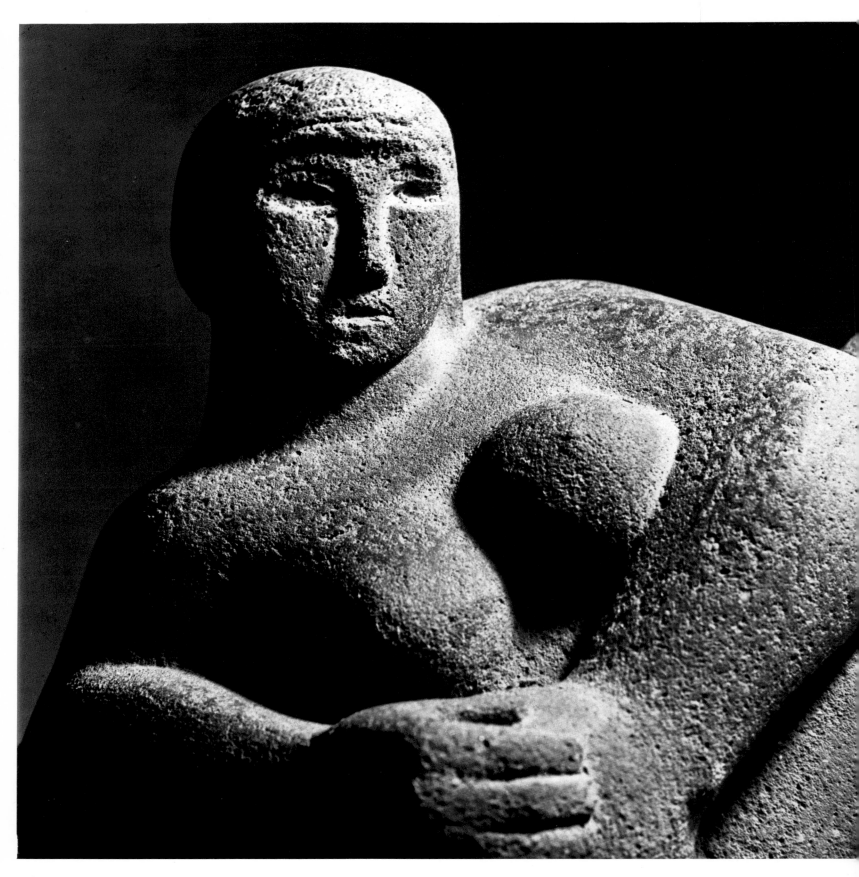

24, 25 Reclining Woman *1927 L 63.5 cm Cast concrete Mrs Irina Moore*
26 Reclining Figure *1929 L 83.8 cm Brown Hornton stone City Art Gallery, Leeds*

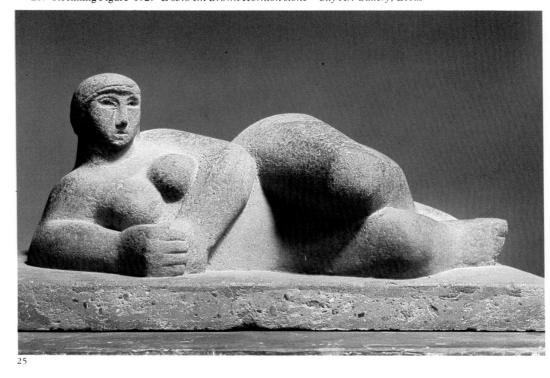

25

24

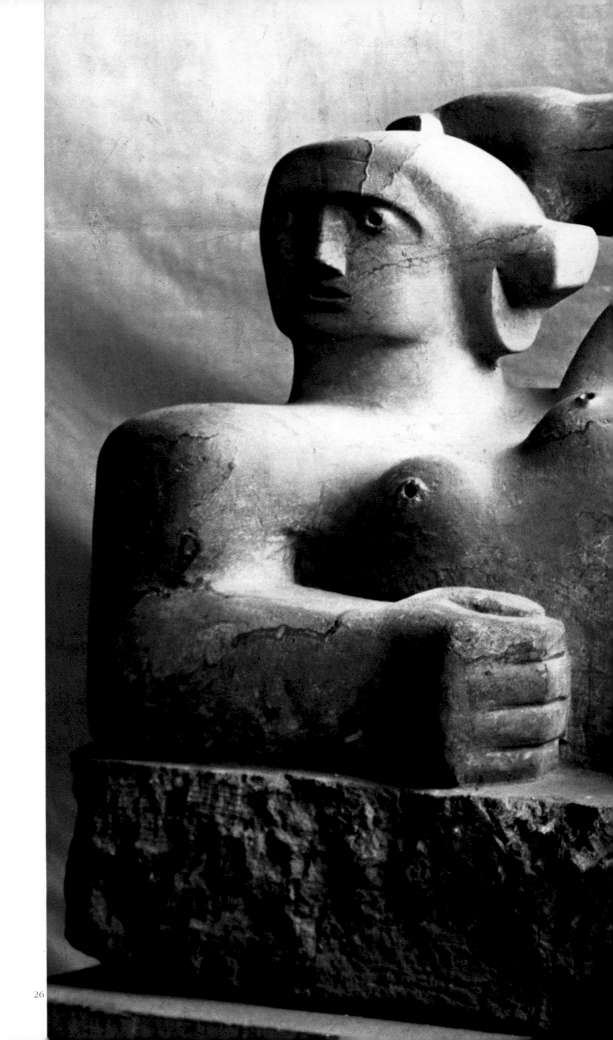

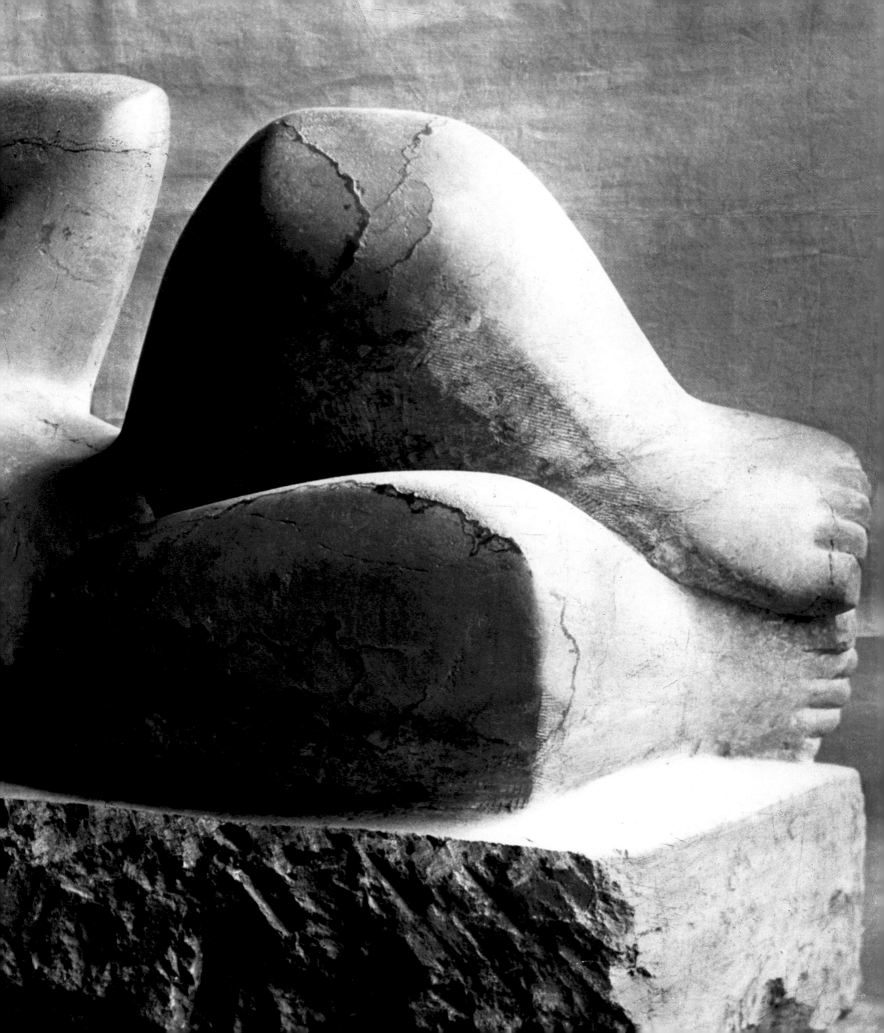

27 West Wind *1928–9 L 2.44 m Portland stone Underground Building, St James's, London*
28 Mask *1929 H 20 cm Cast concrete Mrs Irina Moore*

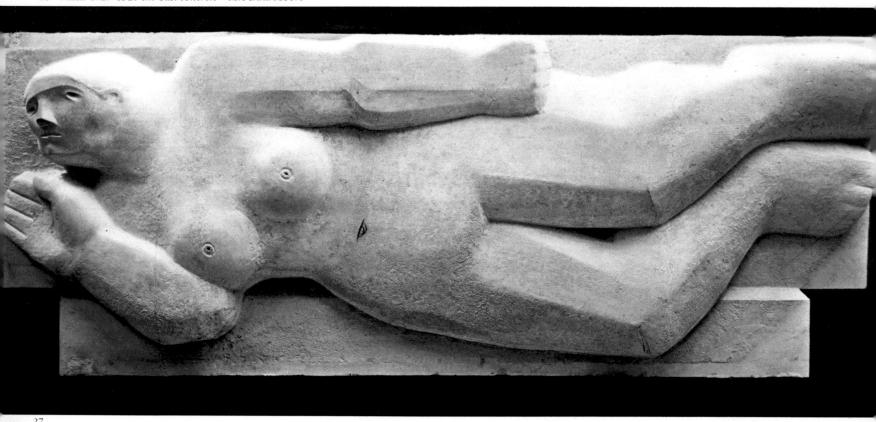

27

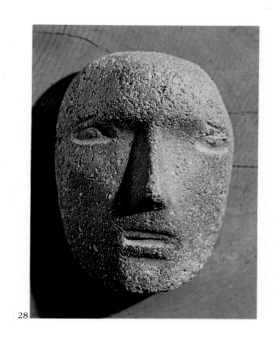

28

In 1928 I agreed to carve a relief (*fig 27*) for the Underground Building at St James's, although I had never felt any desire to make relief sculpture. Even when I was a student I was totally preoccupied by sculpture in its full spatial richness, and if I spent a lot of my time at the British Museum in those days, it was because so much of the primitive sculpture there was distinguished by complete cylindrical realisation. I was extremely reluctant to accept an architectural commission, and relief sculpture symbolised for me the humiliating subservience of the sculptor to the architect, for in ninety-nine cases out of a hundred, the architect only thought of sculpture as a surface decoration, and ordered a relief as a matter of course. But the architect of the Underground Building was persuasive, and I was young and when one is young one can be persuaded that an uncongenial task is a problem that one doesn't want to face up to. So I carved this personification of the West Wind, cutting as deeply as conditions would allow – to suggest sculpture in the round.

29 Mask *1929 L 18.5 cm Stone Private collection*
30 Double Head *1928 H 7.6 cm Bronze, edition of 7*
31 Mask *1927 H 21.6 cm Stone Mrs Irina Moore*
32 Mask *1929 H 21.6 cm Cast concrete Lady Hendy, Oxford*

Masks isolate the facial expression, enabling you to concentrate on the face alone. They have, of course, been used throughout history, particularly as theatrical devices. Although the back of the head can be as beautiful and as interesting to a sculptor, it can't be as expressive, in the ordinary sense of the word, as the face.

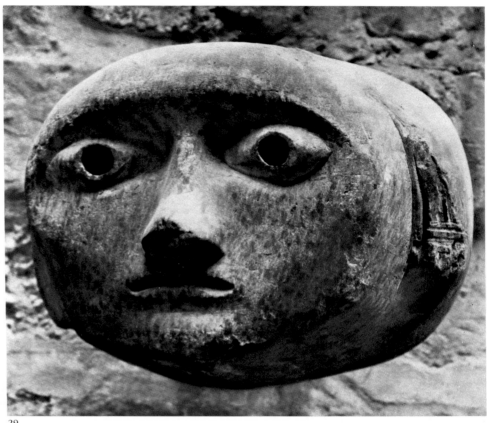

29

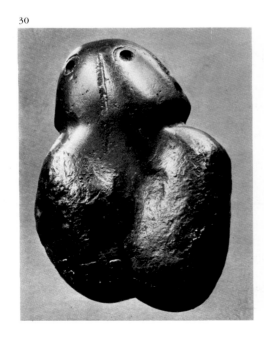

30

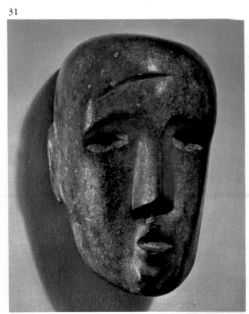

31

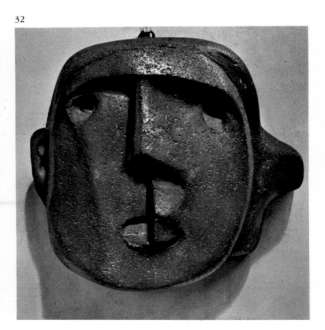

32

33 Half Figure *1929 H 36.8 cm Cast concrete* *The British Council, London*

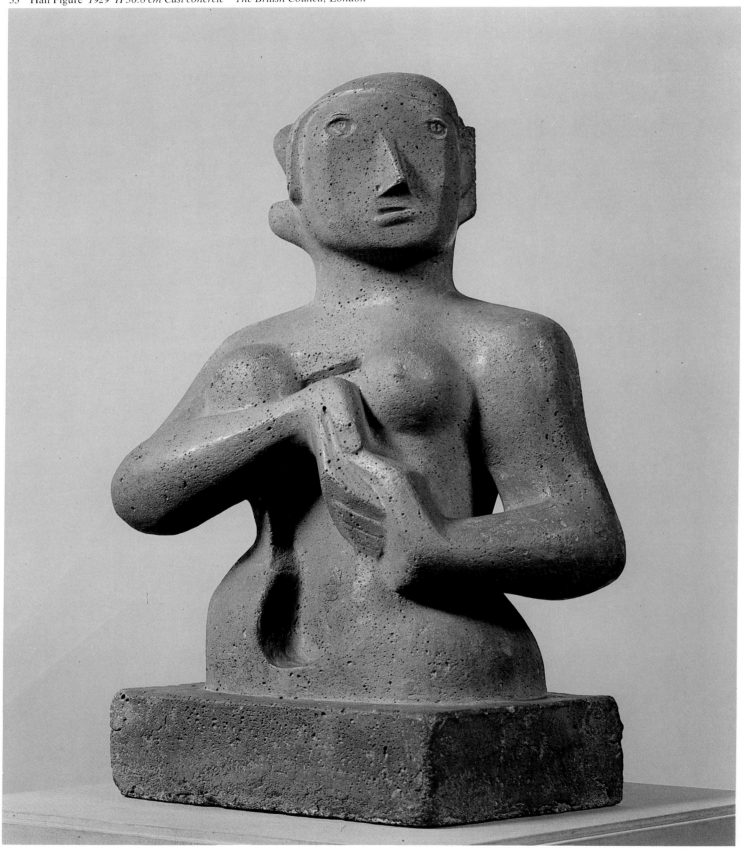

33

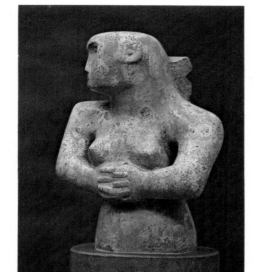

34

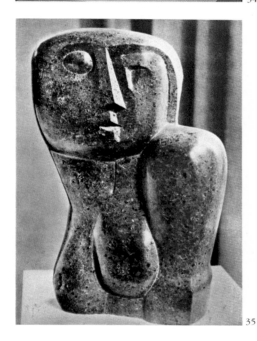

35

34　Figure with Clasped Hands　*1929　H 45.7 cm approx. Travertine marble　Tel Aviv Museum*
35　Head and Shoulders　*1927　H 45.7 cm Verde di Prato　Dr Henry Roland, London*
36　Seated Figure　*1929　H 45.1 cm Cast concrete　The Henry Moore Foundation*

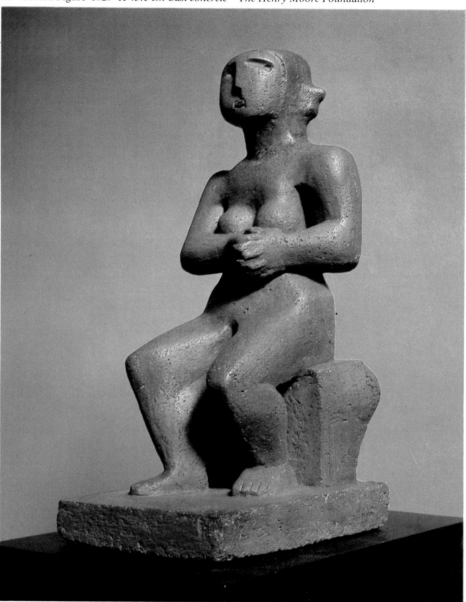

36

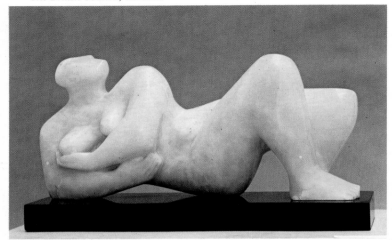

37

The specialisation characteristic of the modern artist seems to have as its counterpart the atomisation of the arts. If a unity could be achieved, say in the building of a new town, and planners, architects, sculptors, painters and all other types of artist could work together from the beginning, that unity, one feels, would nevertheless be artificial and lifeless because it would have been consciously imposed on a group of individuals, and not spontaneously generated by a way of life. That is perhaps the illusion underlying all our plans for the diffusion of culture. One can feed culture to the masses, but that does not mean that they will absorb it. In the acquisition of culture there must always be an element of discovery, of self-help; otherwise culture remains a foreign element, something outside the desires and necessities of everyday life.

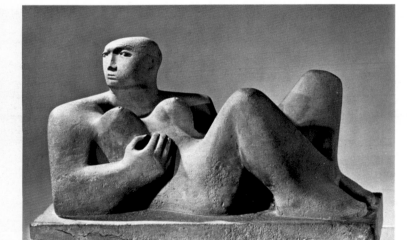

38

39

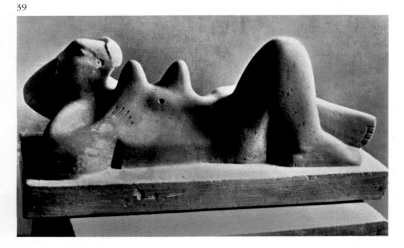

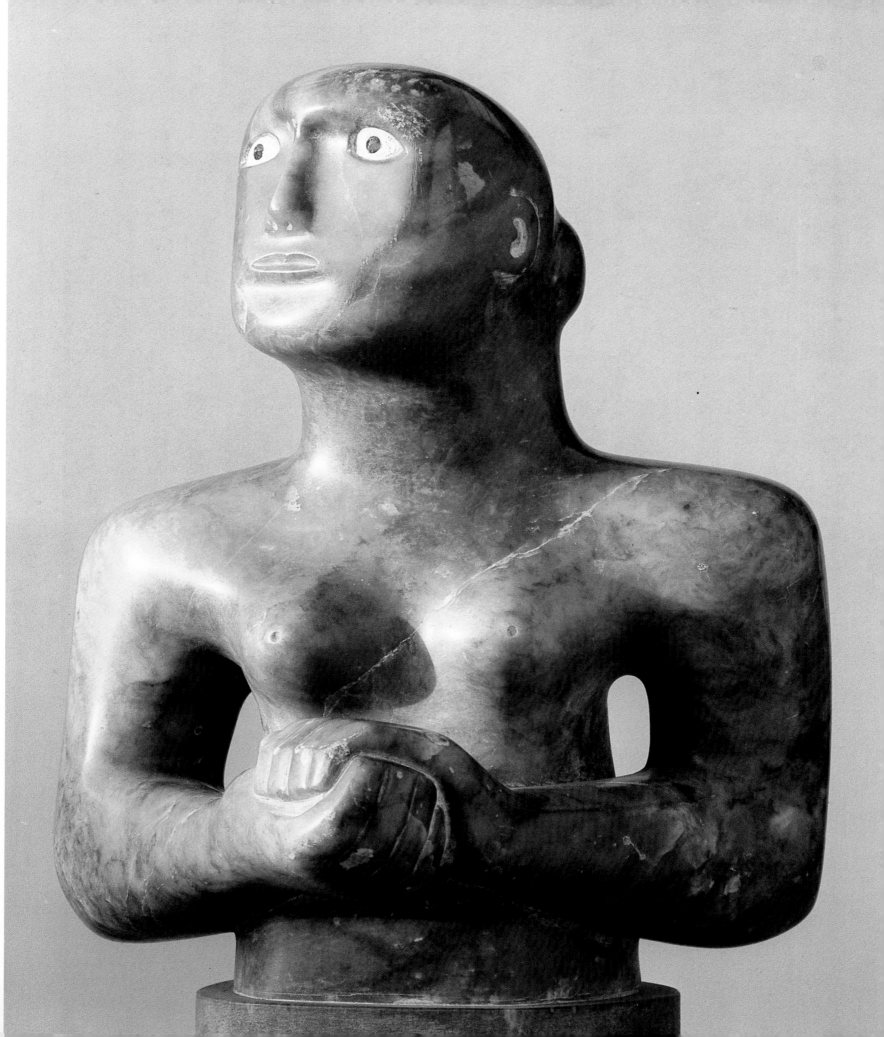

41 Head *1930 H 25.4 cm Slate Mr and Mrs Carlo Ponti, Rome*
42 Head *1929 H 22.8 cm Alabaster Private collection*
43 Mask *1929 H 21.5 cm Lead Lord Clark, Saltwood*
44 Head *1930 H 20.3 cm Ironstone Mr and Mrs Carlo Ponti, Rome*

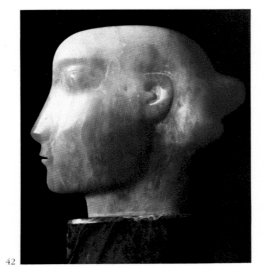

42

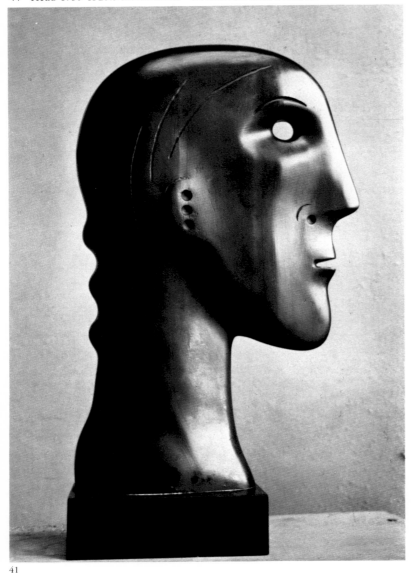

41

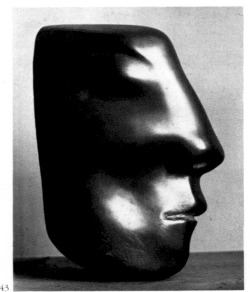

43

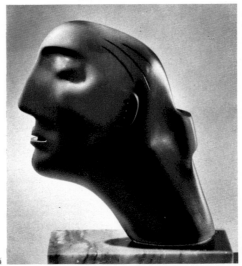

44

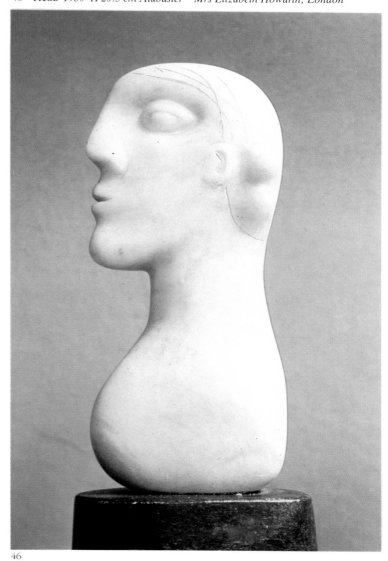

45 Head *1930 H 20.3 cm approx. Ironstone Lord Clark, Saltwood*
46 Head *1930 H 20.3 cm Alabaster Mrs Elizabeth Howarth, London*

46

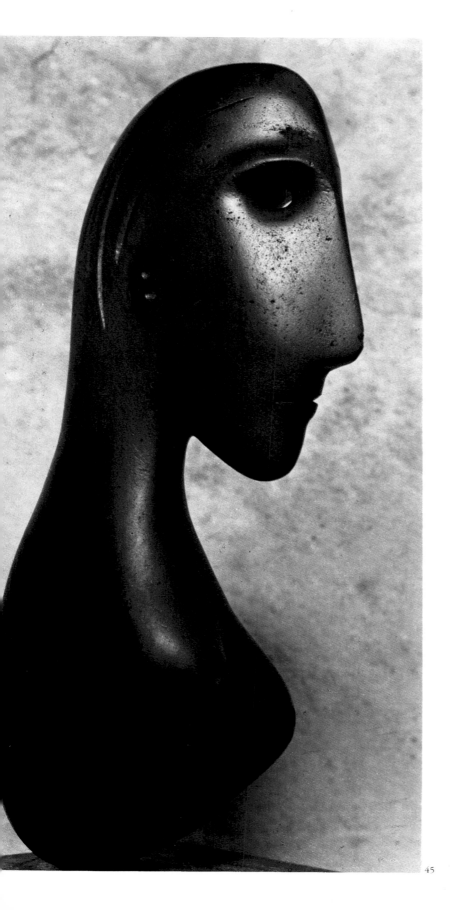

45

Heads are the most expressive part of a human being, so they have always been treated in art as a subject on their own. The artist can use the theme of the human head in many different ways – for portraiture, for expressive purposes in an imaginary head, or as a study for part of a larger work.

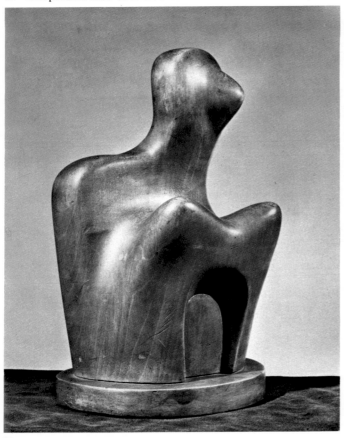

47

A piece of stone can have a hole through it and not be weakened – if the hole is of studied size, shape and direction. On the principle of the arch, it can remain just as strong.

The first hole made through a piece of stone is a revelation. The hole connects one side to the other, making it immediately more three-dimensional. A hole can itself have as much shape-meaning as a solid mass. Sculpture in air is possible, where the stone contains only the hole, which is the intended and considered form.

48

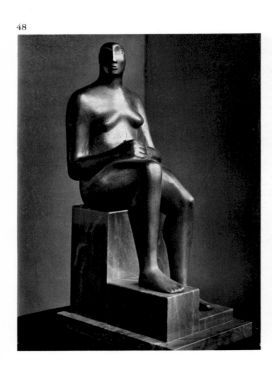

49

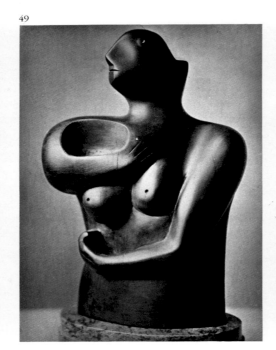

50

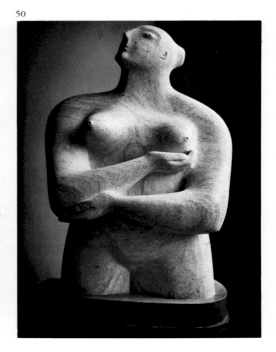

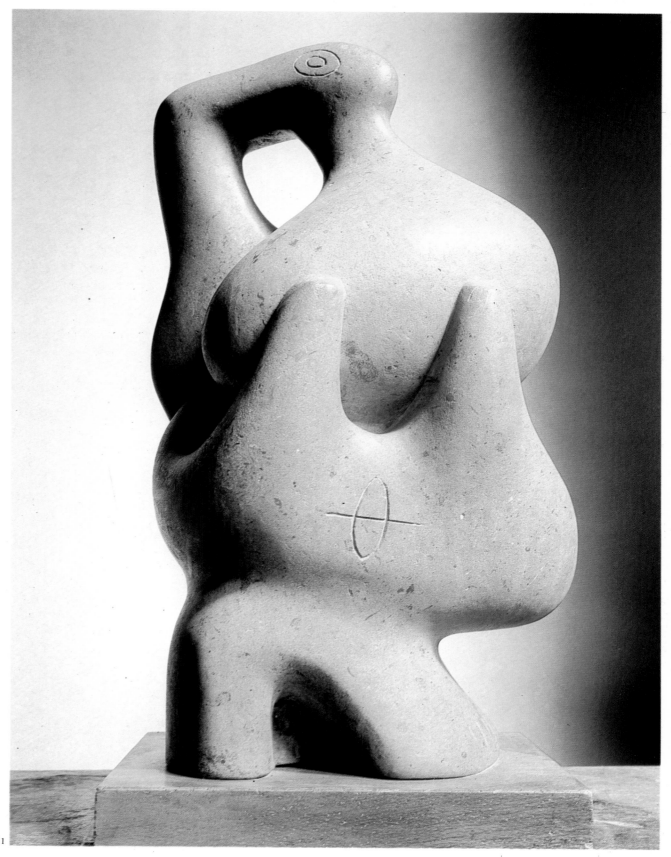

52 Composition *1931 L 41.9 cm Cumberland alabaster The Henry Moore Foundation*
53 Girl *1931 H 73.6 cm Ancaster stone Tate Gallery, London*
54 Mother and Child *1931 H 35.6 cm approx. Burgundy stone Private collection*

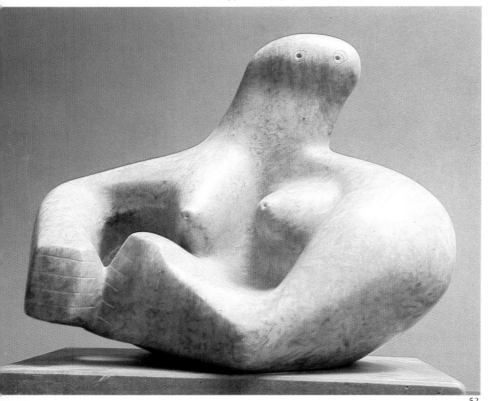

52

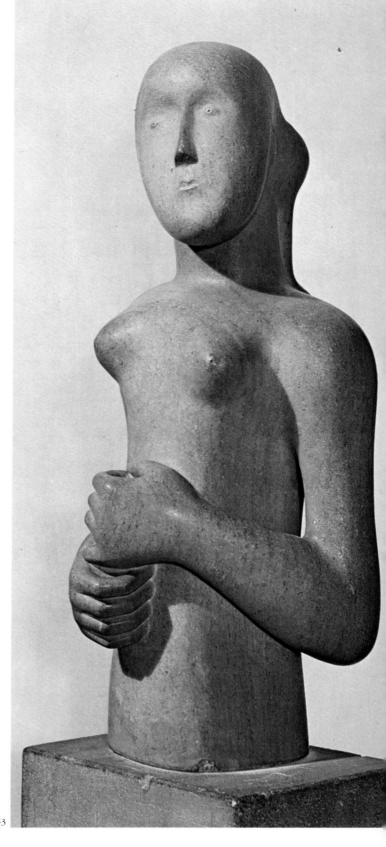

I now use many varieties of marble, but in the early
part of my career I made a point of using native
materials because I thought that, being English, I
should understand our stones. They were cheaper, and
I could go round to a stonemason and buy random
pieces. I tried to use English stones that hadn't been
used before for sculpture. I discovered many English
stones, including Hornton stone, from visiting the
Geological Museum in South Kensington, which was
next door to my college.

53

48

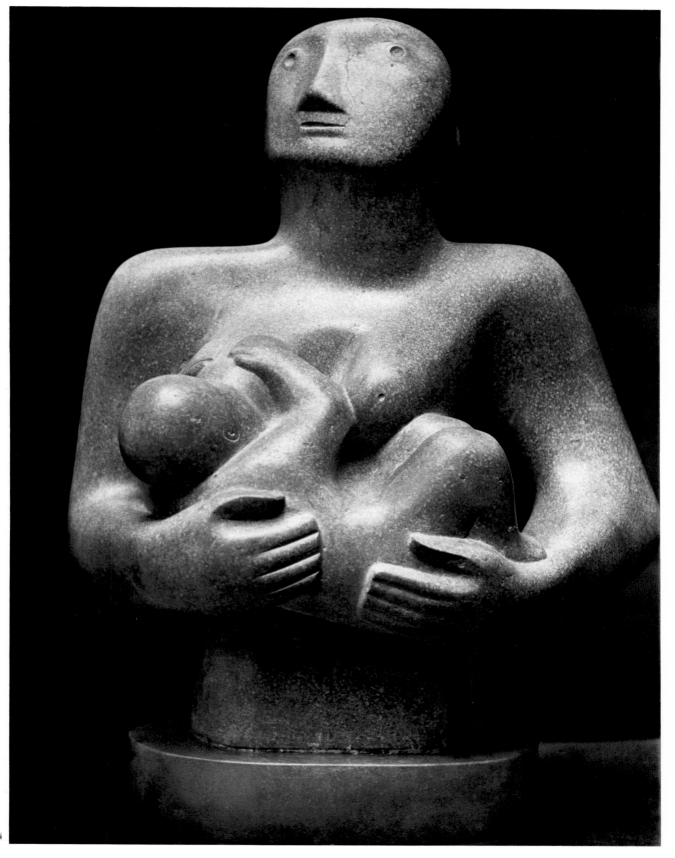

All my sculpture is based on the human figure.

Most artists have obsessions in their subject matter – some may be mainly landscape painters, some mainly figurative, others may do portraits or concentrate on animal painting.

There are three recurring themes in my work: the 'Mother and child' idea, the 'Reclining figure' and the 'Interior/Exterior forms'. Some sculptures may combine two or even all three of these themes.

55
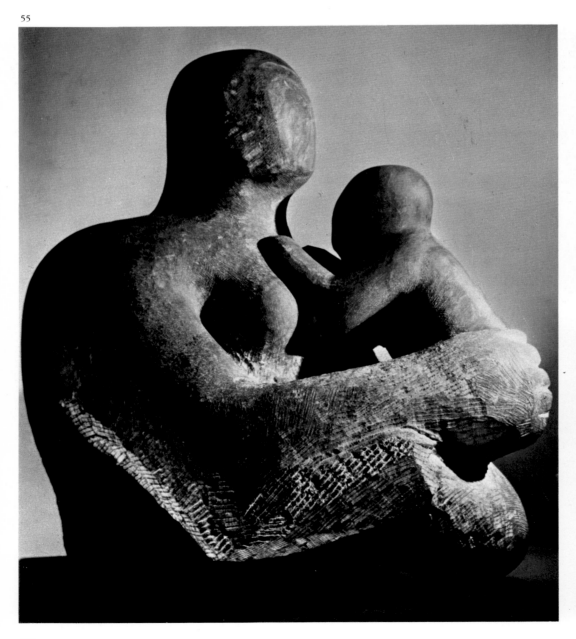

56
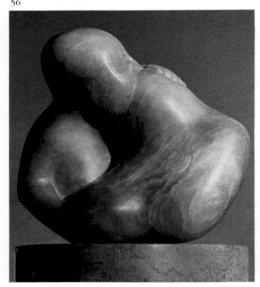

57
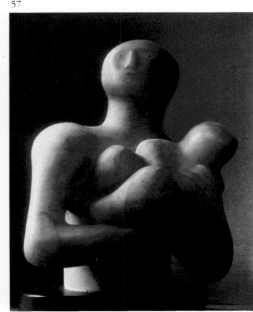

55 Mother and Child *1930–1 H 40.6 cm Cumberland alabaster Lady Anderson*
56 Suckling Child *1930 H 19.7 cm Alabaster The Very Revd Walter Hussey, London*
57 Mother and Child *1930 H 25.4 cm approx. Alabaster Private collection*
58 Mother and Child *1930 H 25.4 cm Ancaster stone Private collection*
59 Mother and Child *1930 H 78.7 cm Ham Hill stone Private collection*
60 Mother and Child *1931 Alabaster Aundh Museum, Bombay*
61 Mother and Child *1931 H 20.3 cm Verde di Prato Michael Maclagan, Oxford*
62 Mother and Child *1931 H 45.7 cm Cumberland alabaster Hirshhorn Museum, Washington DC*
63 Mother and Child *1931 H 76.2 cm approx. Sycamore wood Mr and Mrs Carlo Ponti, Rome*

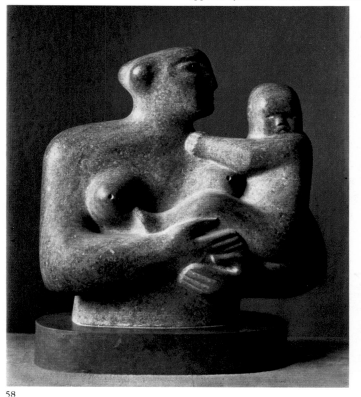

58

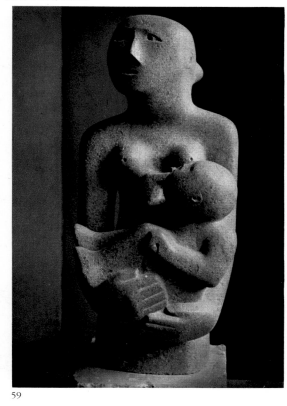

59

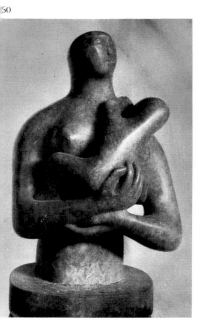

60

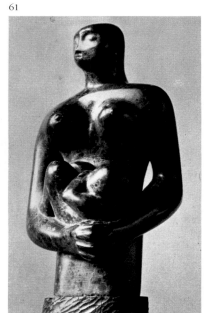

61

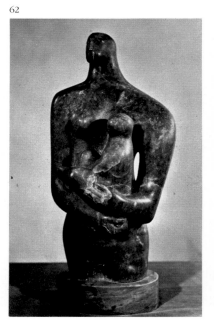

62

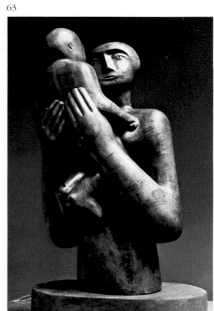

63

64 Reclining Figure *1930 L 53.3 cm Ancaster stone Detroit Institute of Art*
65 Reclining Figure *1930 L 17.8 cm Ironstone Sir Robert and Lady Sainsbury, London*
66 Reclining Figure *1933 L 77.5 cm Carved reinforced concrete Washington University, St Louis*
67 Reclining Figure *1931 L 43.2 cm Bronze, edition of 5*

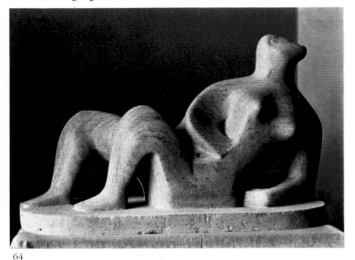

64

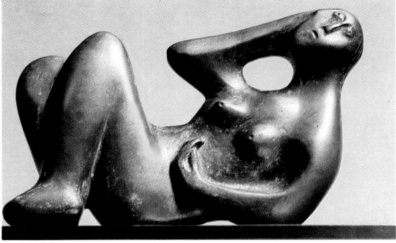

65

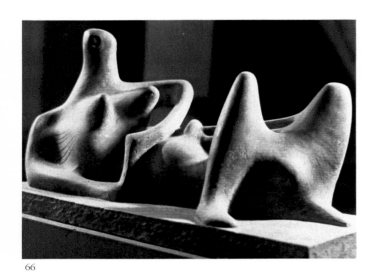

66

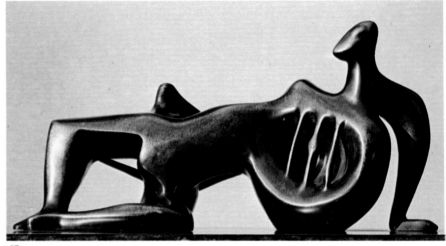

67

The human figure is the basis of all my sculpture, and that
for me means the female nude. In my work, women must
outnumber men by at least fifty to one. Men get brought
in when they are essential to the subject, for example in a
family group. I like women and find the female figure
means more to me than the male. The reclining female
figure is a continually recurring theme in my work.

68 Seated Girl *1931 H 44.5 cm Anhydrite stone Private collection*
69 Composition *1932 H 44.5 cm African wonderstone Tate Gallery, London*
70 Reclining Figure *1932 L 1.09 m Carved reinforced concrete City Art Museum, St Louis*

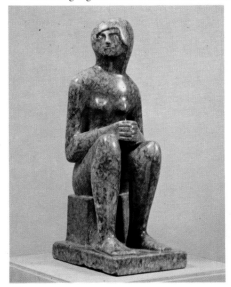

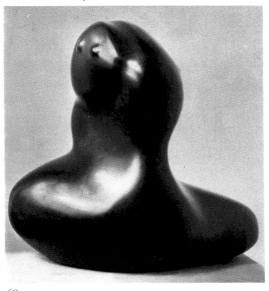

68

69

70

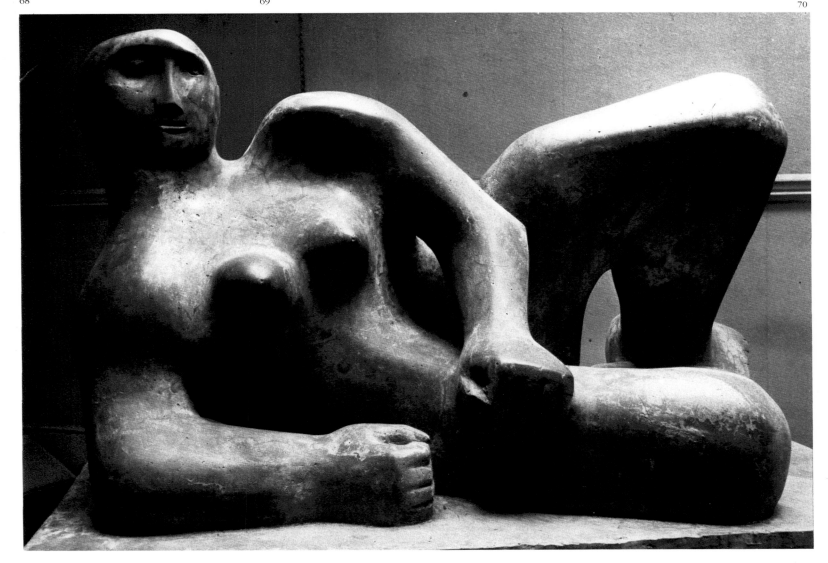

71 Head *1932 H 44.5 cm Carved concrete Mr and Mrs Carlo Ponti, Rome*
72 Composition *1932 H 38.8 cm African wood The Hon. Alan Clark*

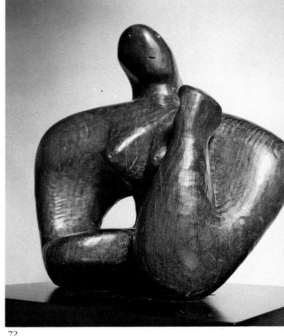

72

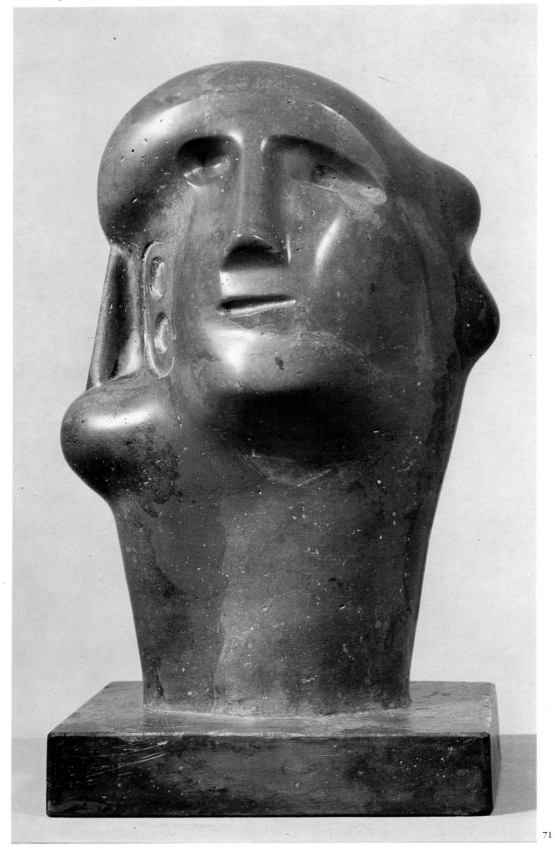

71

73 Composition *1933 H 58.4 cm Carved concrete* *The British Council, London*

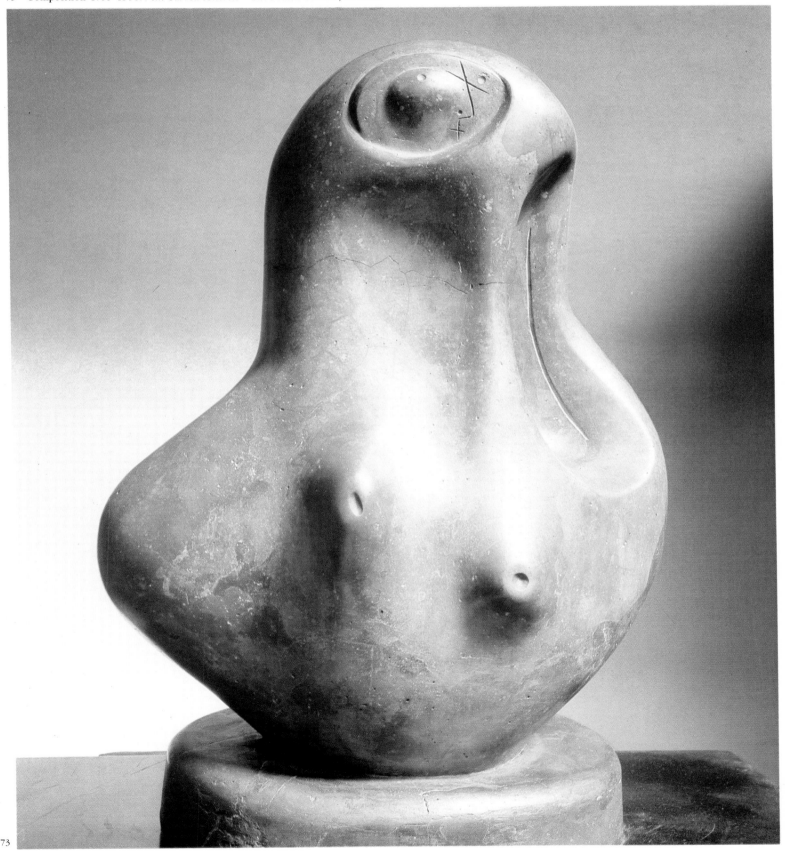

73

74 Girl *1932 H 31.8 cm Boxwood Mr and Mrs I.A. Victor, Dallas*
75 Mother and Child *1932 H 17.8 cm Carved concrete*
76 Figure *1932 H 30.5 cm Boxwood Louis Honig, San Francisco*
77 Half Figure *1932 H 83.8 cm Armenian marble Tate Gallery, London*

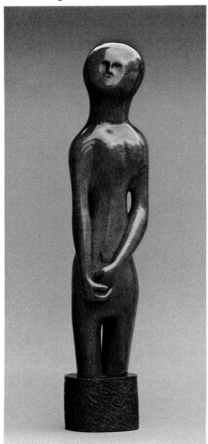

74

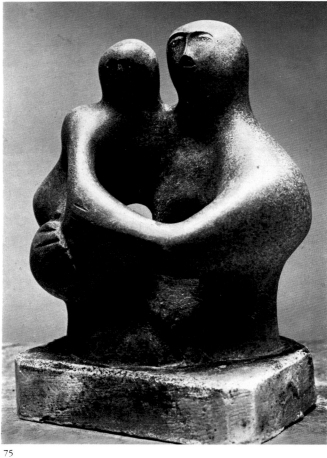

75

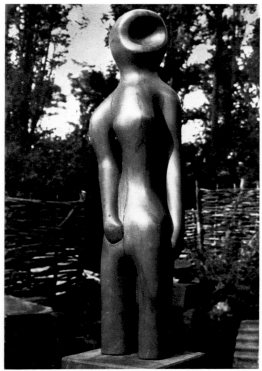

76

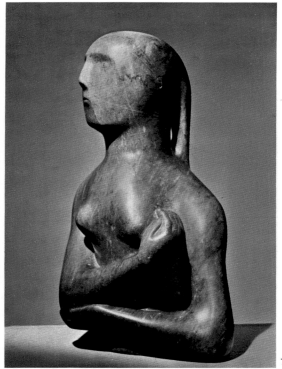

77

78

79 Head and Shoulders *1933 H 25.4 cm approx. African wonderstone Private collection, New York*
80 Figure *1933–4 H 40.6 cm Travertine marble Private collection*
81 Composition *1933 H 45.7 cm approx. Lignum vitae Mrs M. Hill, Ditchling*
82 Composition *1933 L 33 cm African wonderstone*
83 Composition *1933 H 35.6 cm approx. Walnut wood Peter Palumbo, London*
84 Figure *1933–4 H 77.5 cm Corsehill stone Mr and Mrs Carlo Ponti, Rome*
85 Figure *1932 H 36.2 cm Beechwood Ernst Barlach Haus, Hamburg*

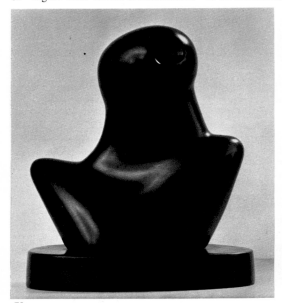
79

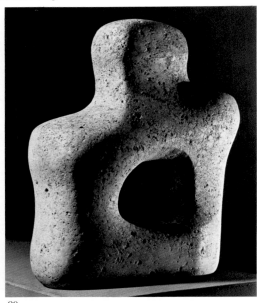
80

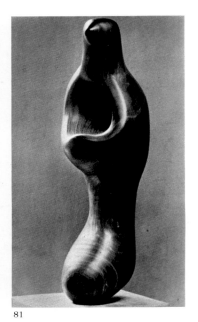
81

82
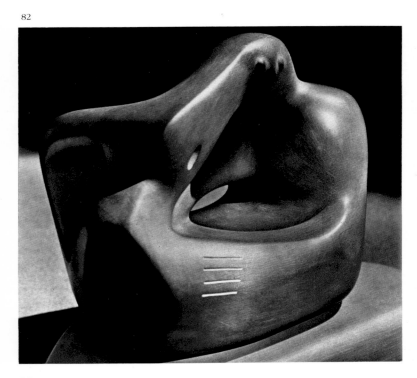

83
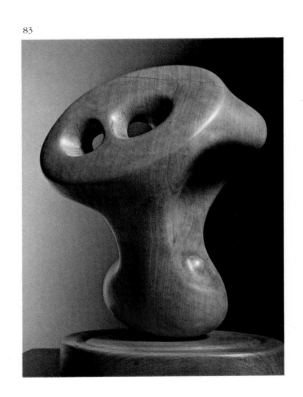

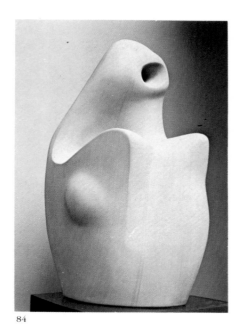

84

85

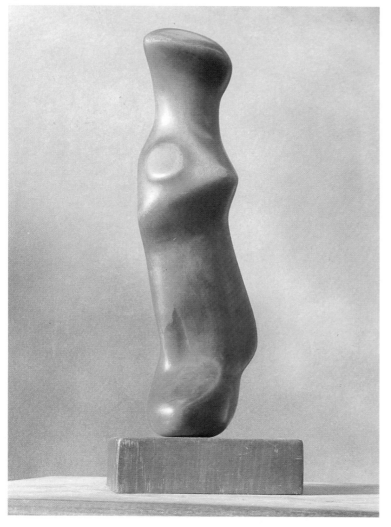

Sculpture, for me, must have life in it, vitality. It must have a feeling for organic form, a certain pathos and warmth. Purely abstract sculpture seems to me to be an activity that would be better fulfilled in another art, such as architecture. That is why I have never been tempted to remain a purely abstract sculptor. Abstract sculptures are too often but models for monuments that are never carried out, and the works of many abstract or 'constructivist' sculptors suffer from this frustration in that the artist never gets around to finding the real material solution to his problems. But sculpture is different from architecture. It creates organisms that must be complete in themselves. An architect has to deal with practical considerations, such as comfort, costs and so on, which remain alien to an artist, very real problems that are different from those which a sculptor has to face . . . A sculpture must have its own life. Rather than give the impression of a smaller object carved out of a bigger block, it should make the observer feel that what he is seeing contains within itself its own organic energy thrusting outwards – if a work of sculpture has its own life and form, it will be alive and expansive, seeming larger than the stone or wood from which it is carved. It should always give the impression, whether carved or modelled, of having grown organically, created by pressure from within.

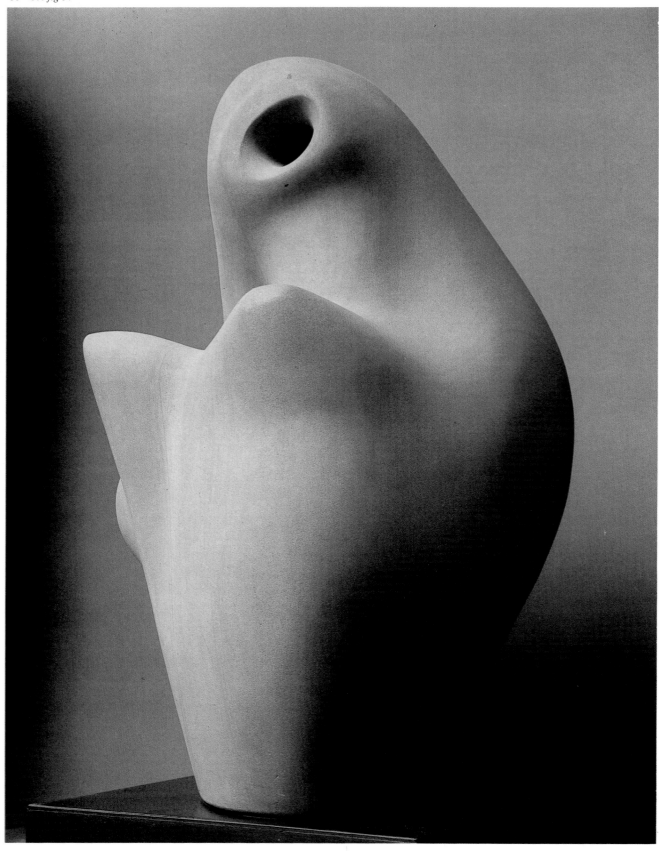

86

87 Reclining Figure *1934–5 L 62.2 cm Corsehill stone The Henry Moore Foundation*

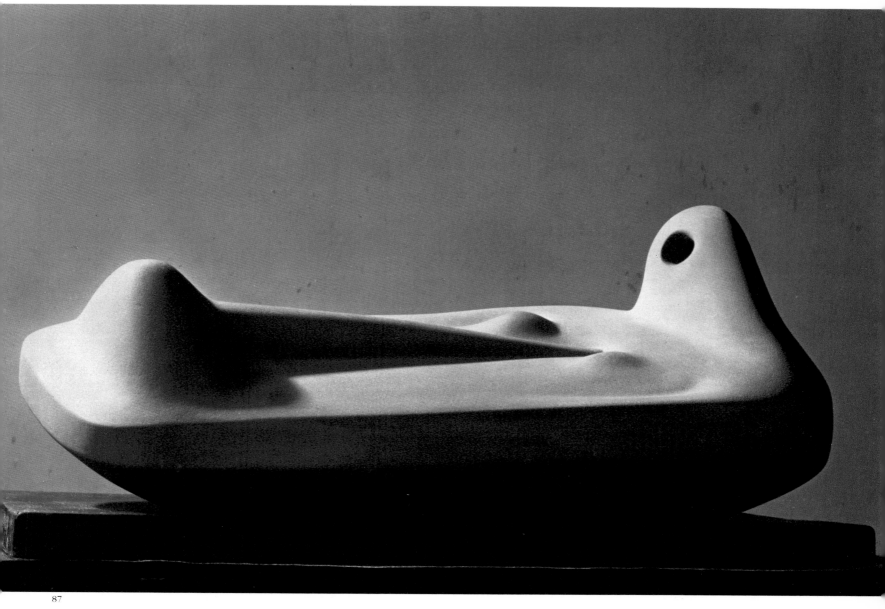

87

88 Four Piece Composition *1934 L 50.8 cm Cumberland alabaster Tate Gallery, London*
89 Composition *1934 L 44.5 cm Bronze, edition of 9*
90 Three Piece Carving *1934 L 43.2 cm Ebony Private collection, Switzerland*

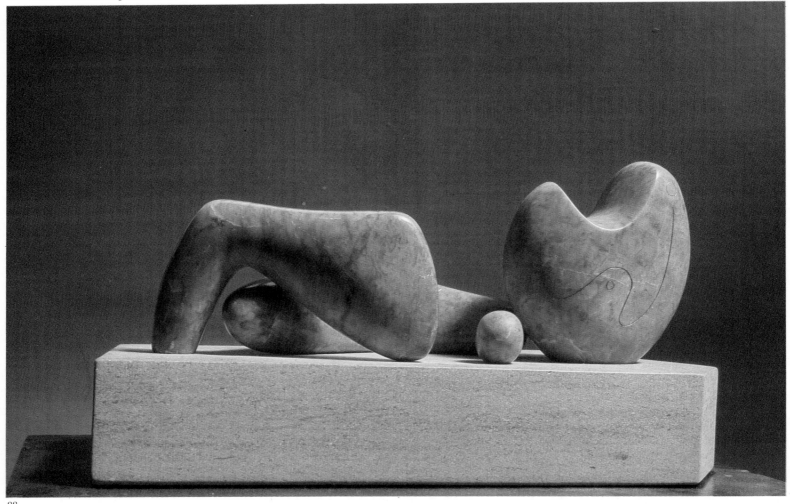

88

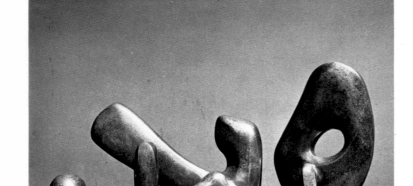

89

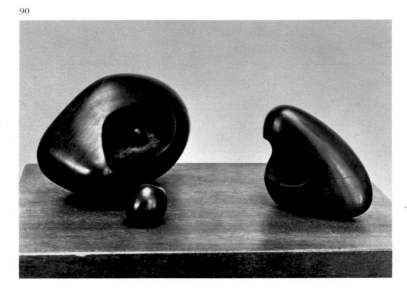

90

91 Two Forms *1934 L 53.3 cm Pynkado wood, oak base Museum of Modern Art, New York*
92 Bird and Egg *1934 L 55.9 cm Cumberland alabaster Private collection*
93 Two Forms *1934 H 18.4 cm Bronze, edition of 6*

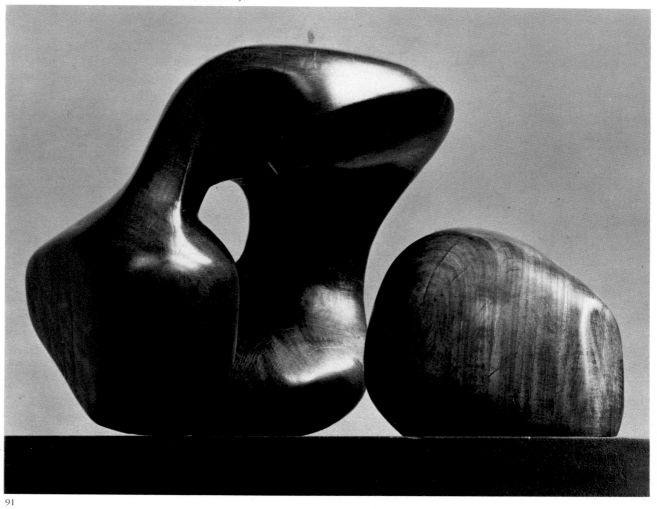

91

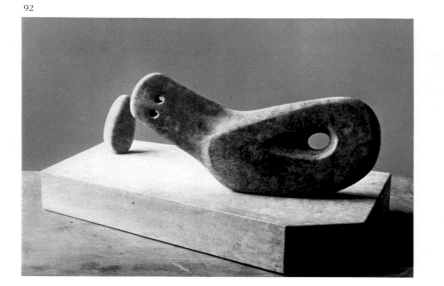

92

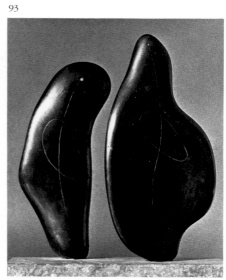

93

94 Square Form *1934 H 31.7 cm Burgundy stone The Henry Moore Foundation*
95 Carving *1935 L 40.6 cm African wood Private collection, Montreal*
96 Sculpture *1934 H 17.8 cm Ironstone Private collection*
97 Carving *1934 H 10.2 cm African wonderstone The Henry Moore Foundation*
98 Family *1935 H 1.01 m Elmwood The Henry Moore Foundation*

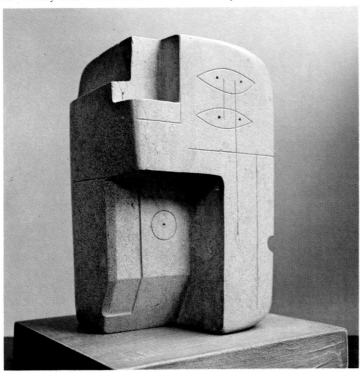

94

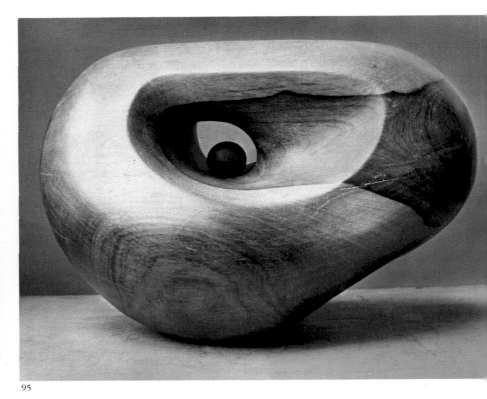

95

96

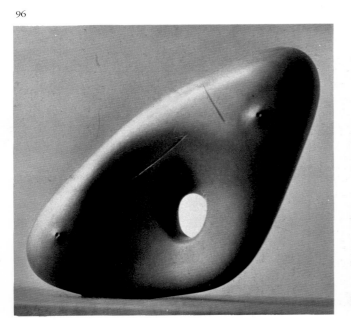

97

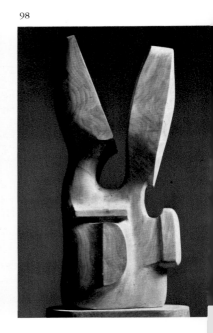

98

99 Hole and Lump *1934 H 68.6 cm Elmwood The Henry Moore Foundation*
100 Carving *1935 H 96.5 cm Walnut wood The Henry Moore Foundation*
101 Figure *1935 H 15.2 cm Bronze, edition of 7*
102 Sculpture *1935 L 55.9 cm White marble Art Institute of Chicago*

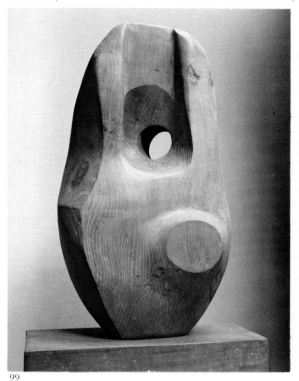

99

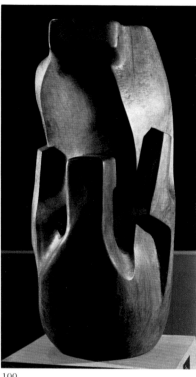

100

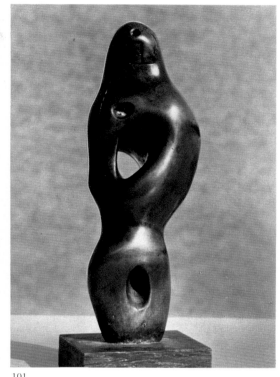

101

102

The liking for holes came about from wanting to make space and three-dimensional form. For me the hole is not just a round hole. It is the penetration through from the front of the block to the back. This was for me a revelation, a great mental effort. It was having the idea to do it that was difficult, and not the physical effort. A very skilled gravestone memorial carver can carve a chain. I remember seeing a gravestone for a sailor, which had an anchor with a chain. The links were free, carved out of a solid piece of marble. It was very cleverly done but it had not required a sculptor to do it.

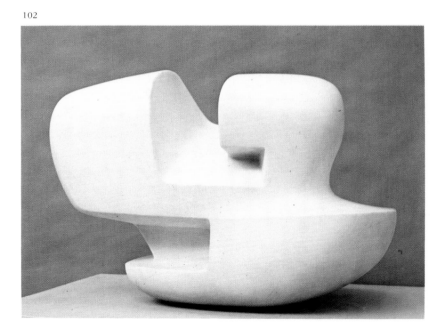

103 Reclining Figure *1935–6 L 88.9 cm Elmwood Albright Knox Art Gallery, Buffalo*

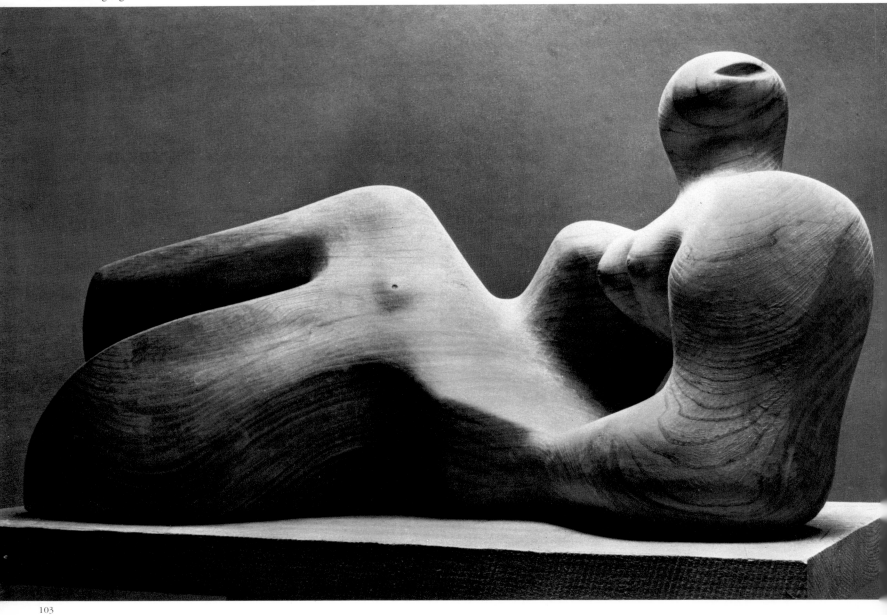

103

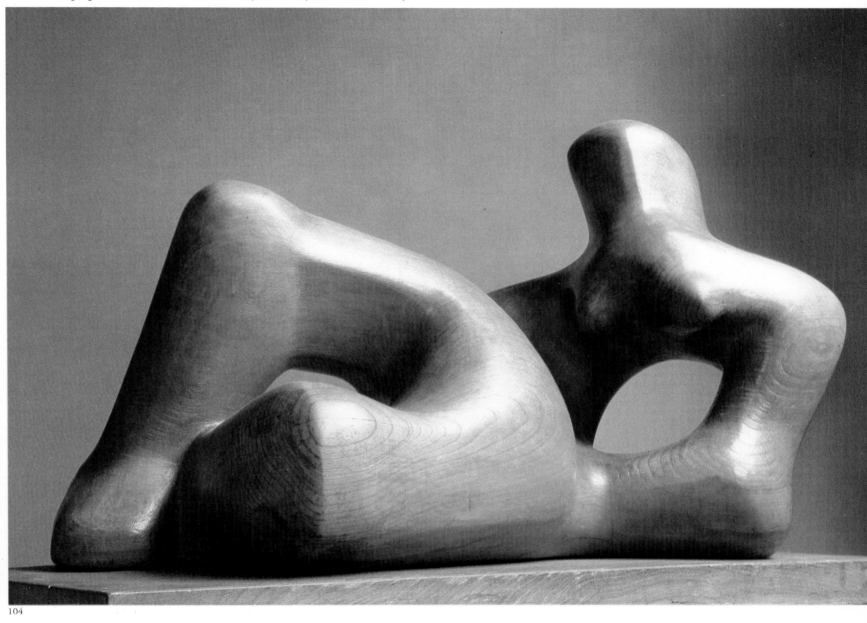

104

105 Four Forms *1936 L 55.9 cm African wonderstone Private collection, USA*
106 Sculpture to hold *1936 L 33 cm Yew wood The late Nelson Rockefeller, New York*
107 Two Forms *1936 H 63.5 cm Brown Hornton stone The Henry Moore Foundation*

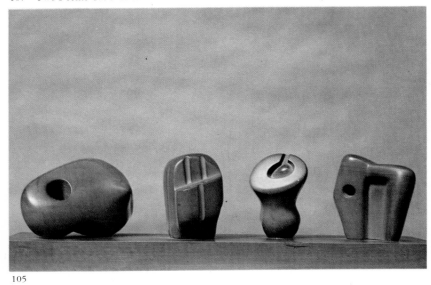

105

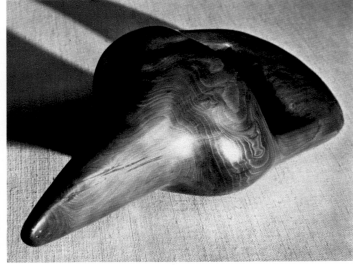

106

107

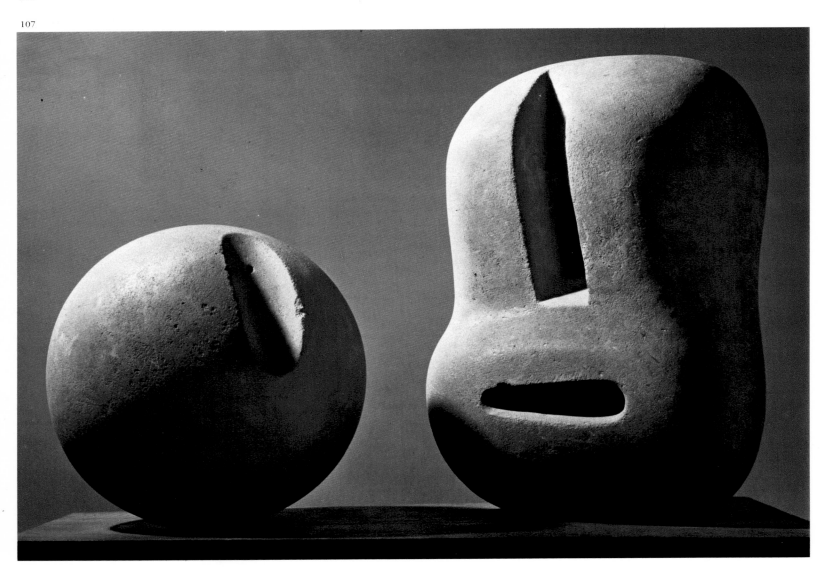

108

109 Two Forms *1936 H 1.06 m approx. Hornton stone Mrs H. Gates Lloyd, Haverford, Pa.*
110 Square Form *1936 L 53.3 cm Brown Hornton stone Dr van der Wal, Amsterdam*
111 Carving *1936 L 50.8 cm approx. Brown Hornton stone Private collection*
112 Head *1936 H 26.7 cm Hopton Wood stone Private collection*

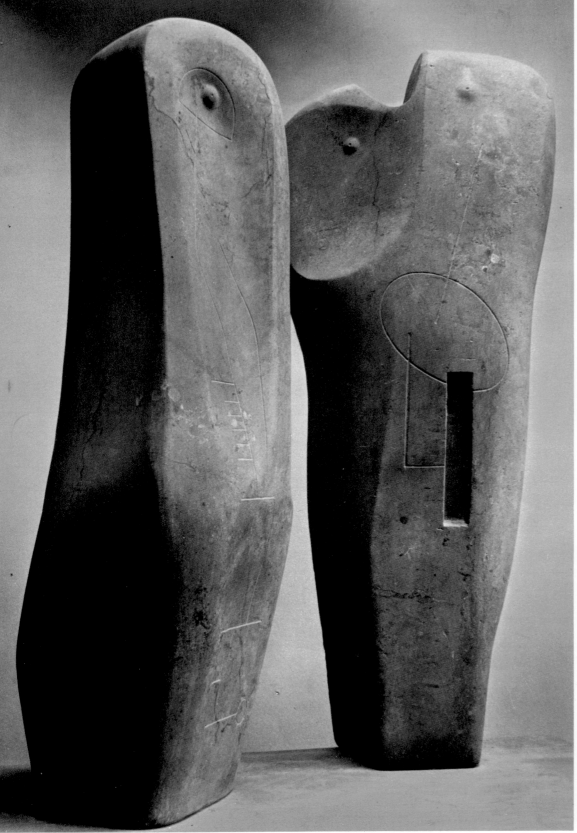

109

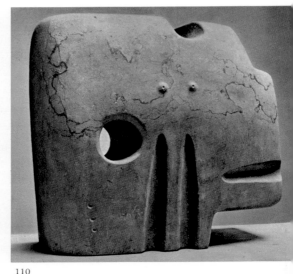

110

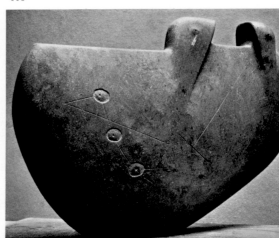

111

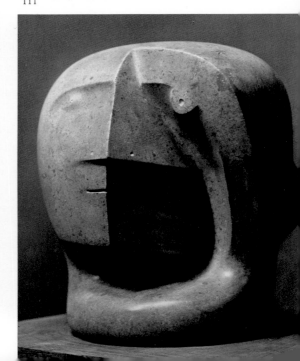

113 Mother and Child *1936 H 1.14 m Green Hornton stone Sir Roland Penrose, London*

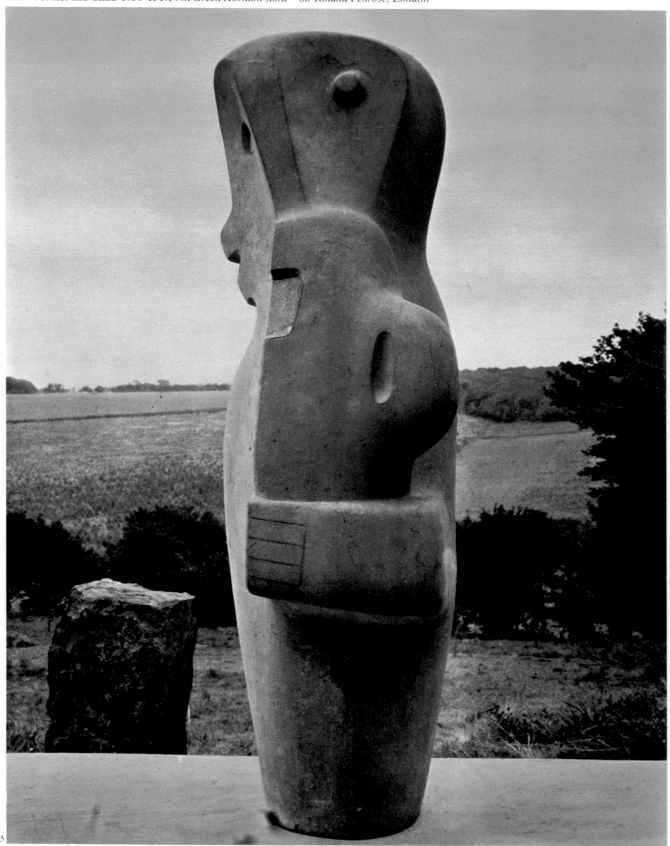

113

114 Carving *1936 H 45.7 cm Travertine marble The Henry Moore Foundation*
115 Head *1937 H 33.7 cm Green serpentine The Henry Moore Foundation*
116 Figure *1937 H 50.8 cm Bird's-eye marble Art Institute of Chicago*
117 Sculpture *1937 L 50.8 cm Hopton Wood stone Private collection*
118 Reclining Figure *1937 L 83.8 cm Hopton Wood stone Miss Lois Orswell, Pomfret, Conn.*

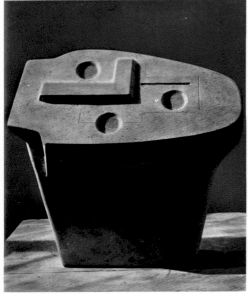

114

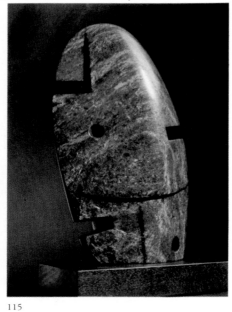

115

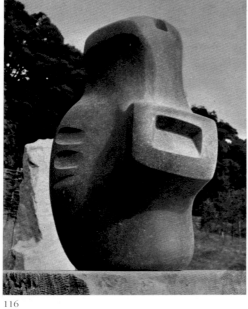

116

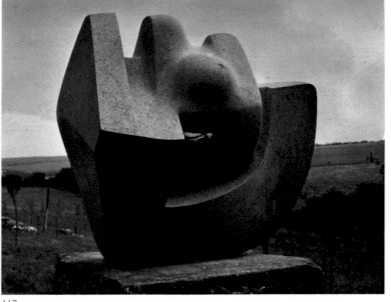

117

118

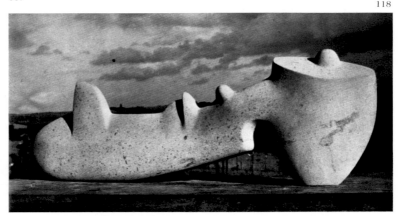

119 Head 1937 *H 53.3 cm Hopton Wood stone Private collection, Switzerland*

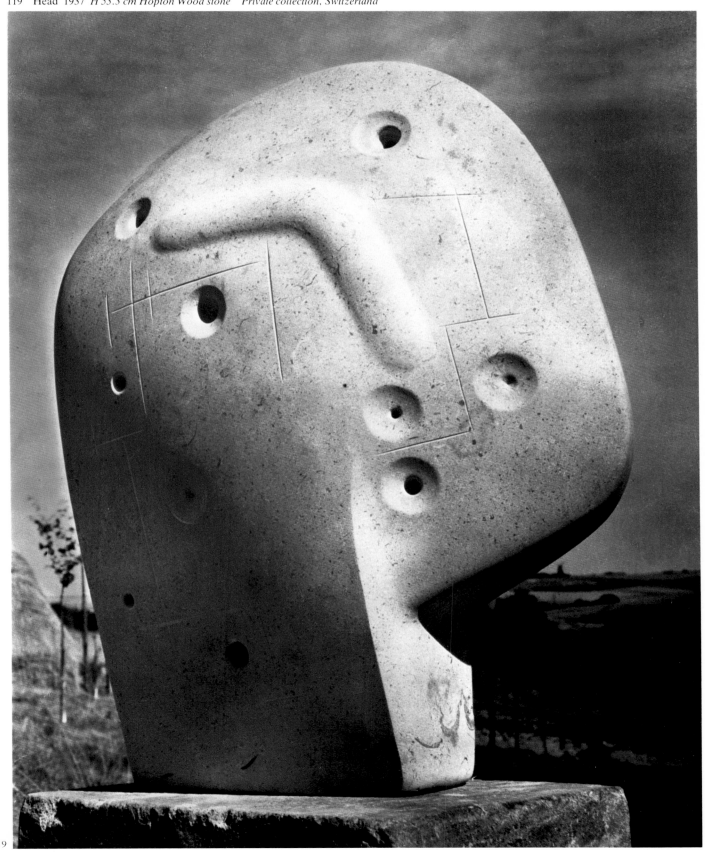

119

120 Recumbent Figure *1938 L 1.39 m Green Hornton stone Tate Gallery, London*
121 Recumbent Figure *1938 L 13 cm Bronze, edition of 9*

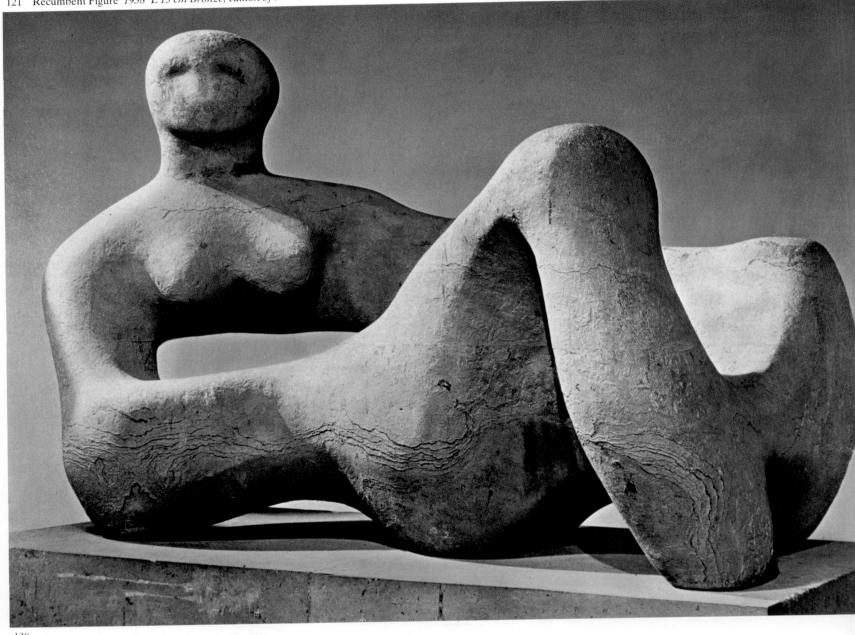

120

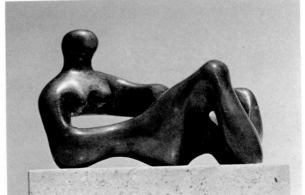

121

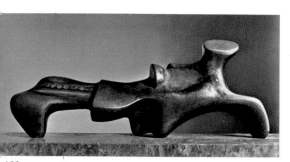

122

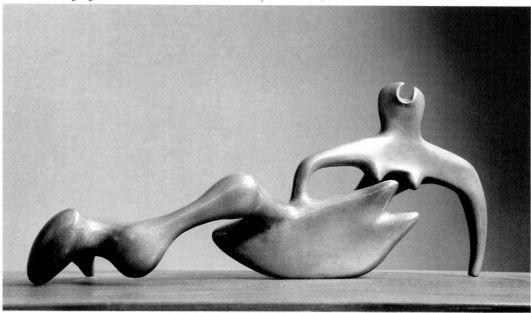

125

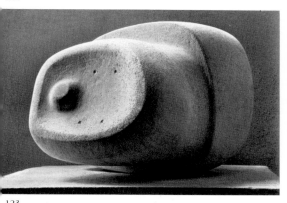

123

124

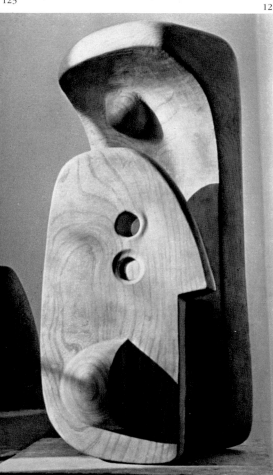

The lead figures came at a stage in my sculpture career when I wanted to experiment with thinner forms than stone could give and, of course, in metal you can have very thin forms. So this thinness that one could make and this desire for making space became something I wanted to do. Yet I couldn't afford in those days to make plasters and have them cast into bronze because I would have had to send them and pay a huge fee to the bronze foundry. Whereas lead I could melt on the kitchen stove and pour it into a mould myself. In fact I ruined my wife's saucepans because the lead was so heavy that it bent the handles and the pans were sometimes put out of shape. But I could mould it myself and do the casting myself and it was soft enough when cast to work on it and give a refinement; I could cut it down thinner, and finish the surface, so for me lead was both economically possible and physically more malleable.

126 Stringed Figure *1939 L 21.6 cm Lead and string Private collection. Sweden*
127 Stringed Mother and Child *1938 L 12.1 cm Lead and string Private collection*
128 Stringed Figure *1939 L 21.6 cm Bronze and string, edition of 8*
129 Stringed Head *1938 H 7.7 cm Bronze and string, edition of 5*
130 Stringed Relief *1937 H 49.5 cm Beechwood and string*
131 Stringed Figure *1937 H 50.8 cm Cherry wood and string Mrs Irina Moore*

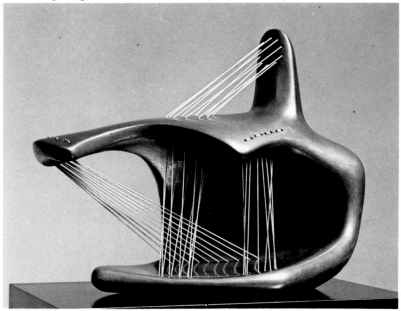

126

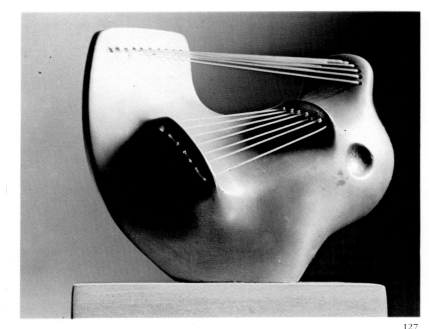

127

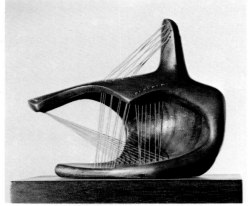

128

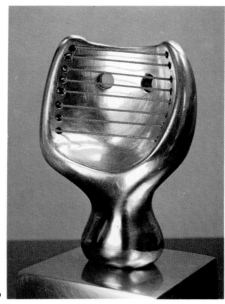

129

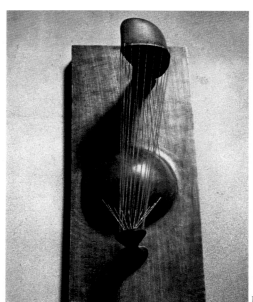

130

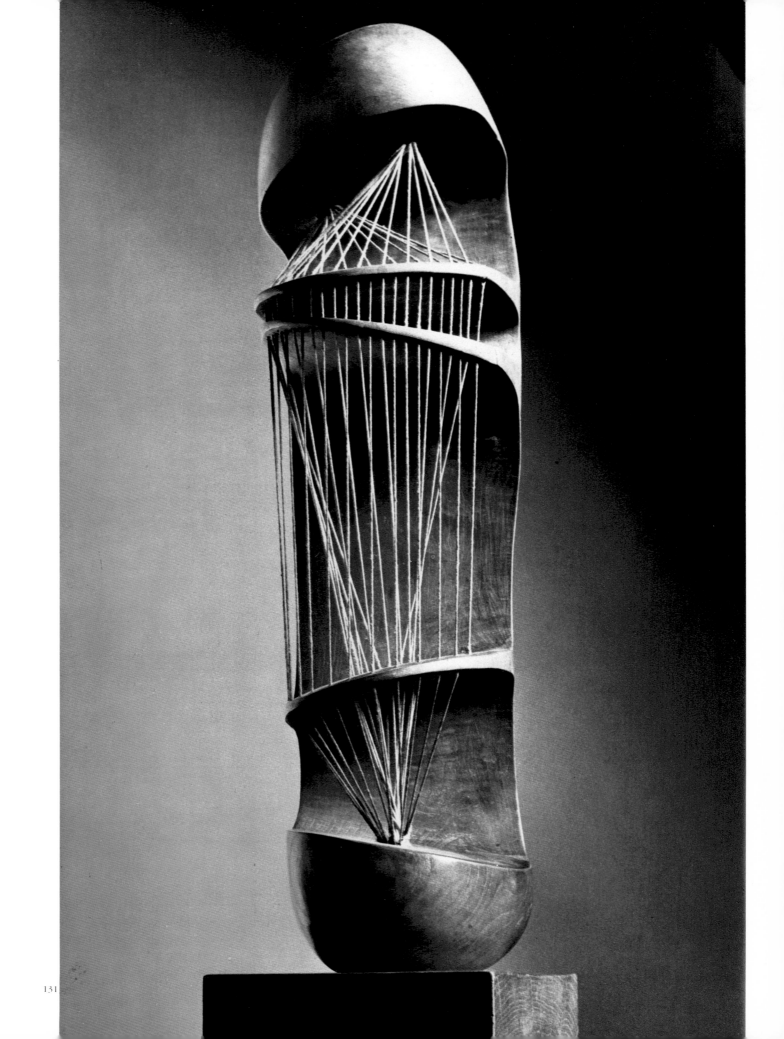

132 Stringed Figure *1938 L 15.2 cm approx. Lignum vitae and string*

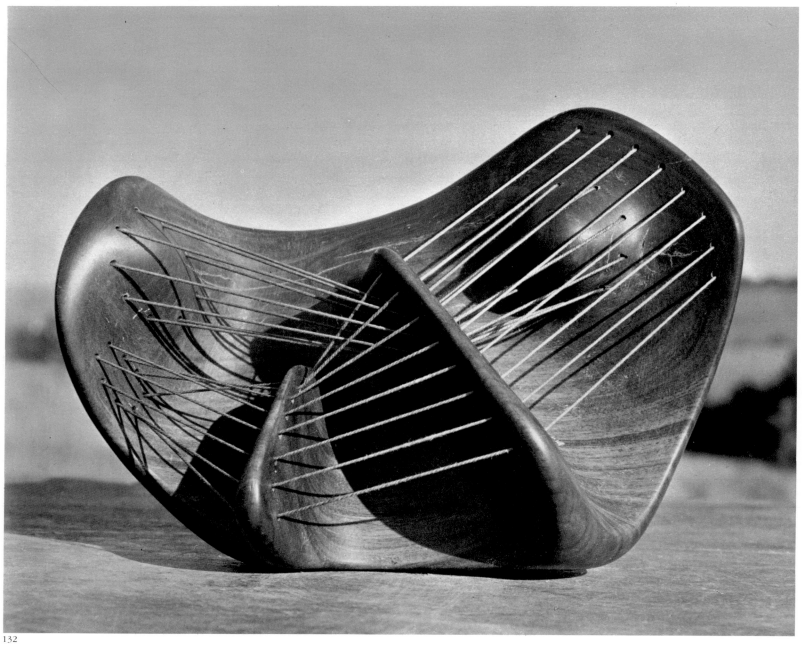

132

133 Stringed Object *1938 L 7 cm Bronze and string, edition of 9*
134 Head *1938 H 20.3 cm Elmwood and string Mr and Mrs Erno Goldfinger, London*
135 Mother and Child *1938 H 12.7 cm Plaster and twine, for lead and wire*
136 Stringed Figure: Bowl *1938, cast 1967 H 54.6 cm Bronze and string, edition of 9*
137 Stringed Figure *1938, cast 1966 H 12.1 cm Bronze and string, edition of 8*

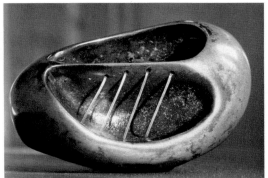

133

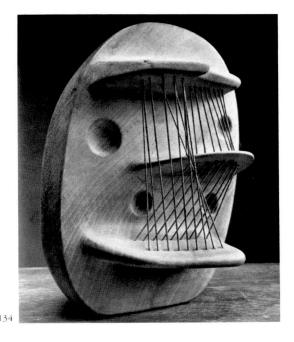

134

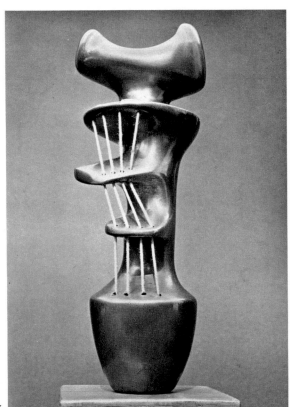

136

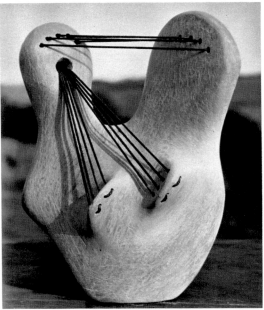

135

137

138 Stringed Figure *1939 L 25.4 cm Bronze and string, edition of 9*
139 Stringed Figure *1939 H 22.8 cm approx. Bronze and string, edition of 9*

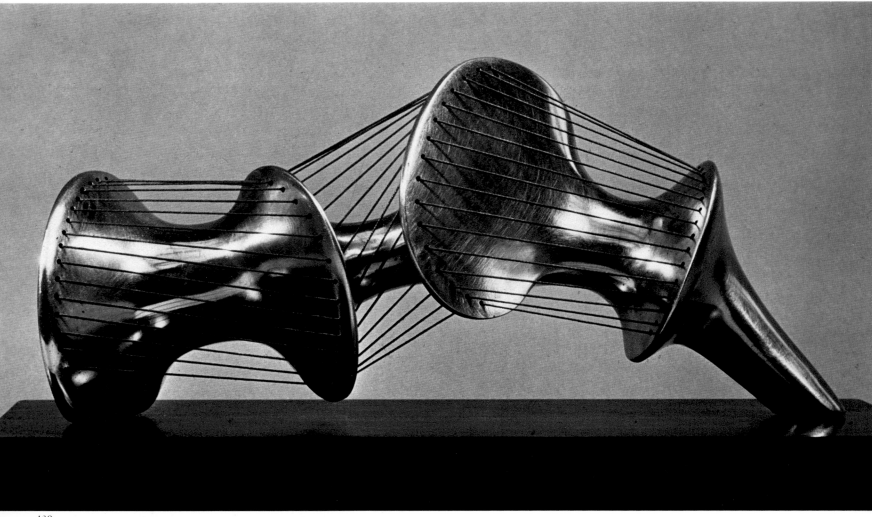

138

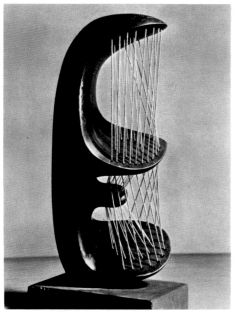

139

140 The Bride *1939–40 H·23.8 cm Lead and wire Museum of Modern Art, New York*
141 Mother and Child *1939 L 19 cm Bronze and string, edition of 7*

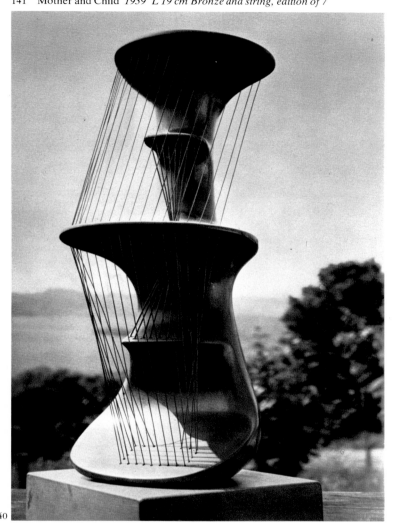

140

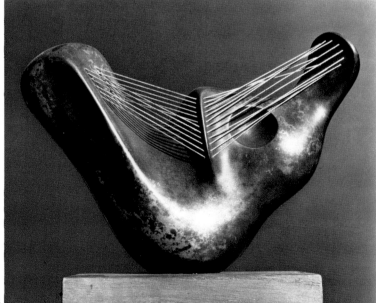

141

At one period just before the war, in 1938, I began the most abstract side of my work – the stringed figures . . . I had gone one day to the Science Museum at South Kensington and had been greatly intrigued by some of the mathematical models; you know, those hyperbolic paraboloids and groins and so on, developed by Lagrange in Paris, that have geometric figures at the ends with coloured threads from one to the other to show what the form between would be. I saw the sculptural possibilities of them and did some. I could have done hundreds. They were fun, but too much in the nature of experiments to be really satisfying. That's a different thing from expressing some deep human experience one might have had. When the war came I gave up this type of thing. Others like Gabo and Barbara Hepworth have gone on doing it. It becomes a matter of ingenuity rather than a fundamental human experience.

Undoubtedly the source of my stringed figures was the Science Museum. Whilst a student at the RCA I became involved in machine art, which in those days had its place in modern art. Although I was interested in the work of Léger, and the Futurists, who exploited mechanical forms, I was never directly influenced by machinery as such. Its interest for me lies in its capacity for movement, which, after all, is its function.

I was fascinated by the mathematical models I saw there, which had been made to illustrate the difference of the form that is halfway between a square and a circle. One model had a square at one end with twenty holes along each side, making eighty holes in all. Through these holes strings were threaded and led to a circle with the same number of holes at the other end. A plane interposed through the middle shows the form that is halfway between a square and a circle. One end could also be twisted to produce forms that would be terribly difficult to draw on a flat surface. It wasn't the scientific study of these models but the ability to look through the strings as with a bird cage and to see one form within another which excited me.

142 Stringed Reclining Figure *1939 L 25.4 cm Lead and string* Private collection
143 Head *1939 H 14 cm Bronze and string, edition of 6*
144 Stringed Ball *1939 H 8.9 cm Bronze and string, edition of 9*

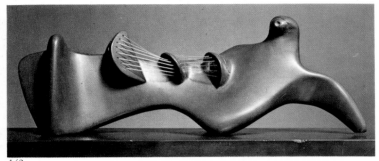

142

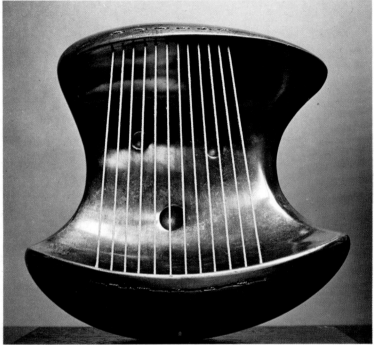

143

144

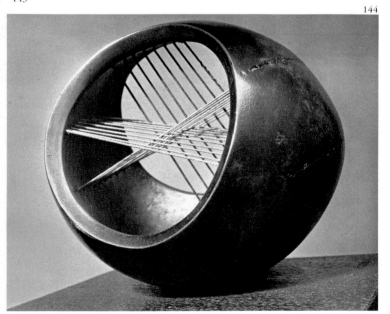

The *Bird Basket* (*fig 145*) to me is one of the special stringed figures that I made. It is called the Bird Basket because it has the handle of a basket over the top and strings that show the little inner piece as a bird inside a cage. And the title is a mixture of the two forms. Also what makes me treat it as something special in my mind is that lignum vitae is one of the hardest woods in nature. It is actually a wood that sinks in water, one of the few woods whose density is such that it sinks. Most wood, however heavy, will float. It can also take a very beautiful surface and very thin edges like those at the left-hand side. Also too it was more in a way like carving a stone and at that time I still preferred stone to any other material.

145 Bird Basket *1939 L 41.9 cm Lignum vitae and string Mrs Irina Moore*

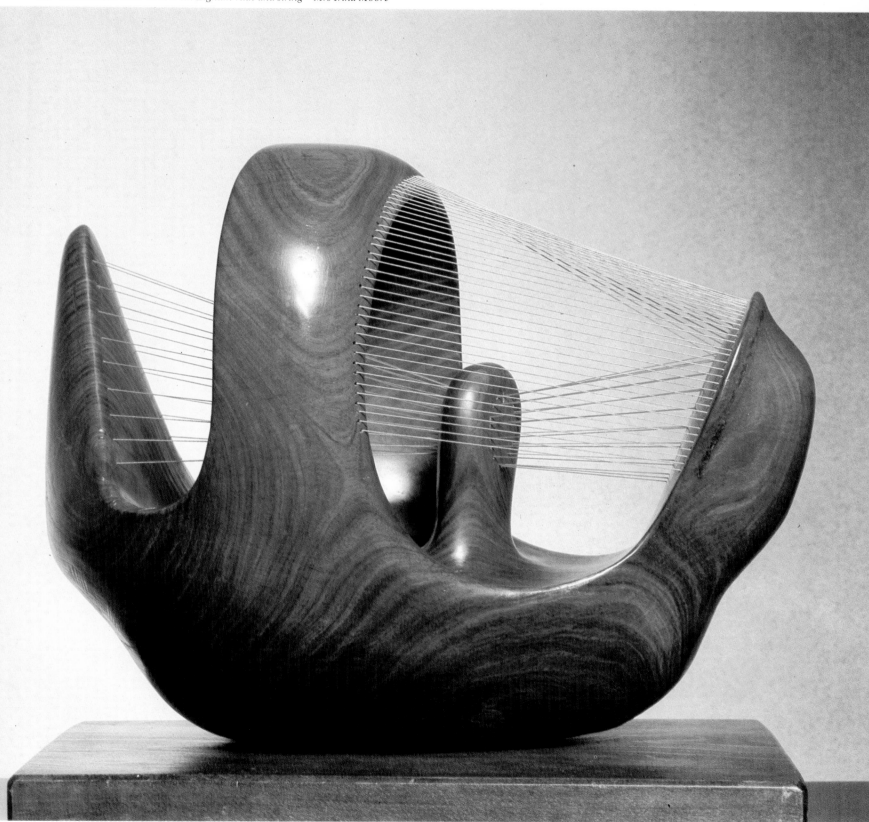

145

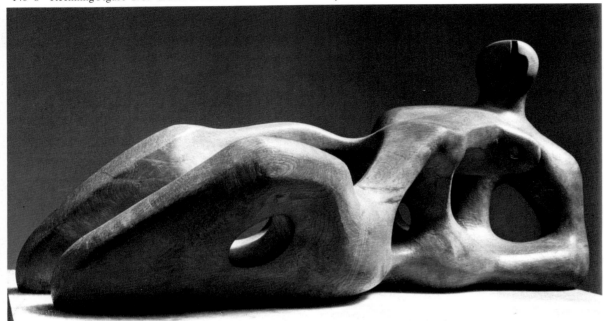

146

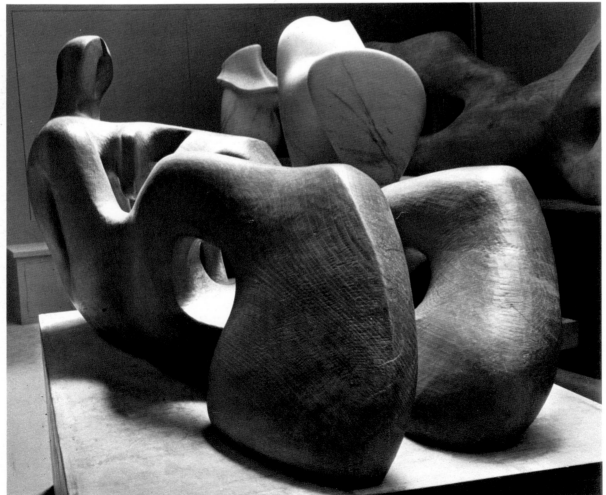

147

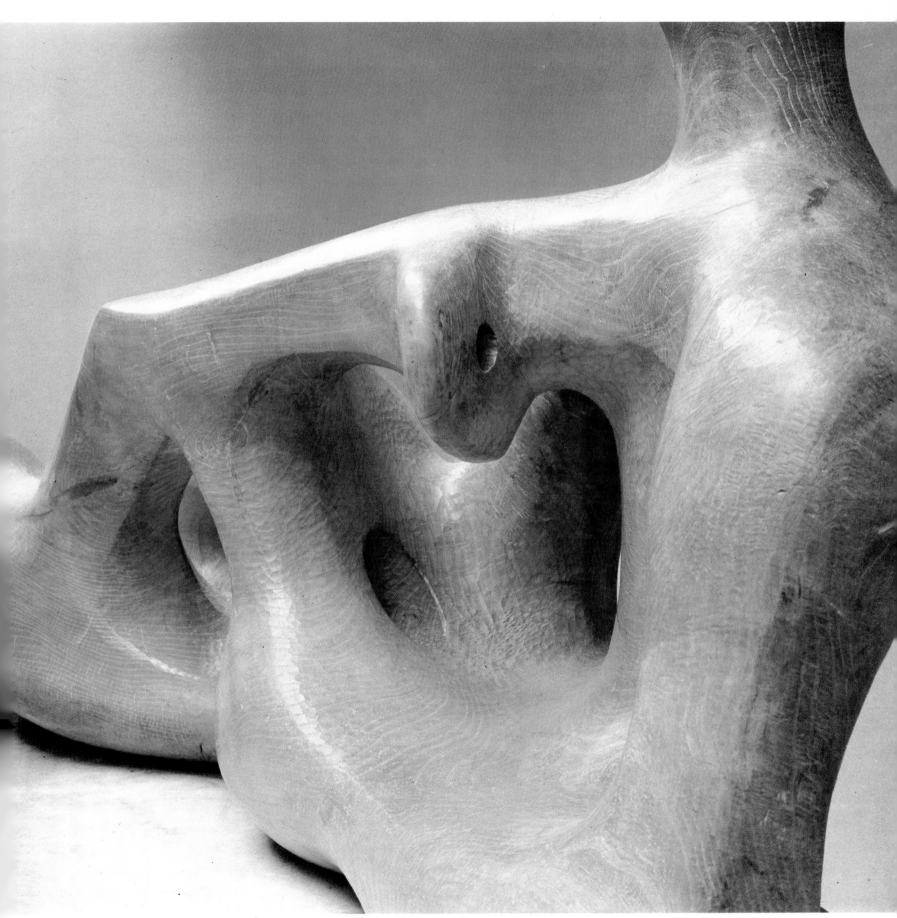

149 Reclining Figure *1939 L 22.8 cm Lead* *Private collection*
150 Reclining Figure *1938 L 14 cm Bronze, edition of 9*
151 Reclining Figure: Snake *1939–40 L 28.9 cm Bronze, edition of 9*
152 Reclining Figure: One Arm *1938, cast 1969 L 30.5 cm Bronze, edition of 9*
153 Reclining Figure *1939 L 29.8 cm Bronze, edition of 2*

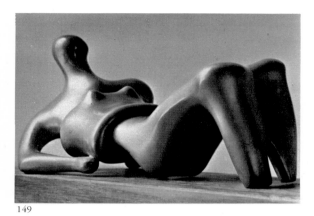

149

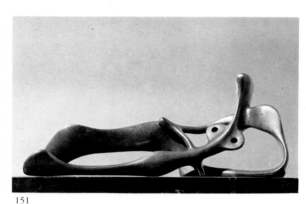

150

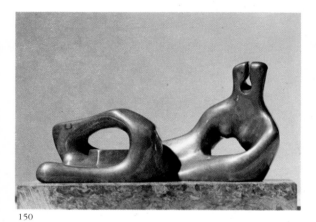

151

152

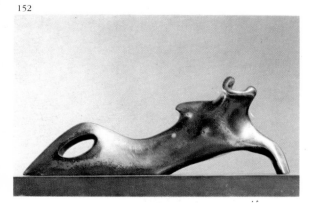

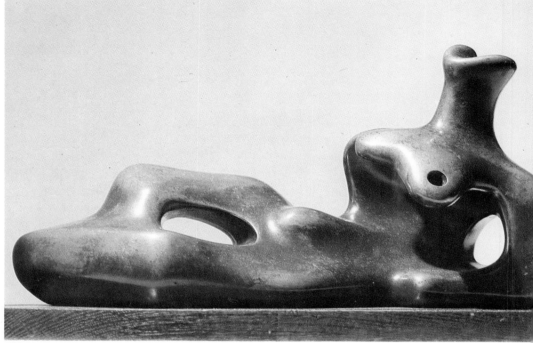

153

There are three fundamental poses of the human figure. One is standing, another is seated, and the third is lying down. Now if you like to carve the human figure in stone, as I do, the standing pose is no good. Stone is not so strong as bone, and the figure will break off at the ankles and topple over. The early Greeks solved this problem by draping the figure and covering the ankles. Later on they supported it against a silly tree trunk.

But with either the seated or reclining figure one doesn't have this worry. And between them are enough variations to occupy any sculptor for a lifetime. In fact if I were told that from now on I should have stone only for seated figures I should not mind at all.

But of the three poses, the reclining figure gives the most freedom, compositionally and spatially. The seated figure has to have something to sit on. You can't free it from its pedestal. A reclining figure can recline on any surface. It is free and stable at the same time. It fits in with my belief that sculpture should be permanent, should last for eternity.

154 The Helmet *1939–40 H 29.2 cm Bronze, edition of 2*

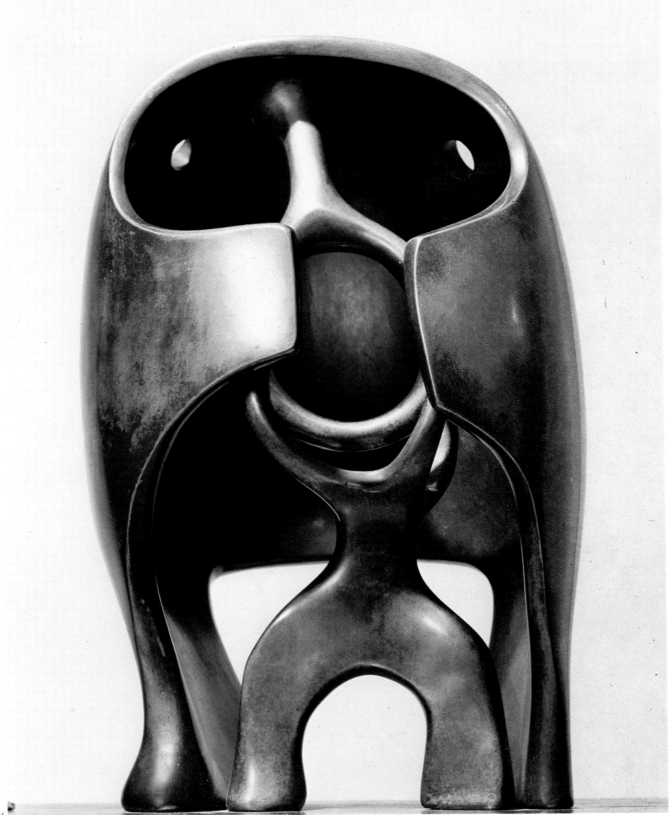

154

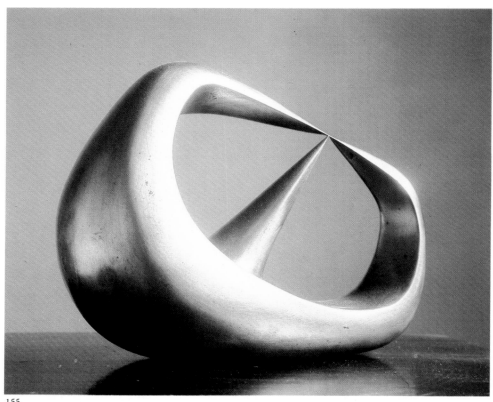

155

In 1940 I made a sculpture with three points, because this pointing has an emotional or physical action in it where things are just about to touch but don't. There is some anticipation of this action. Michelangelo used the same theme in his fresco on the ceiling of the Sistine Chapel, of God creating Adam, in which the forefinger of God's hand is just about to touch and give life to Adam. It is also like the points in the sparking plug of a car, where the spark has to jump across the gap between the points.

There is a very beautiful early French painting (Gabrielle d'Estrées with her sister in the bath), where one sister is just about to touch the nipple of the other. I used this sense of anticipation first in the *Three Points* of 1940, but there are other, later works where one form is nearly making contact with the other. It is very important that the points do not actually touch. There has to be a gap.

155, 156 Three Points *1939–40 L 19 cm Cast iron The Henry Moore Foundation*

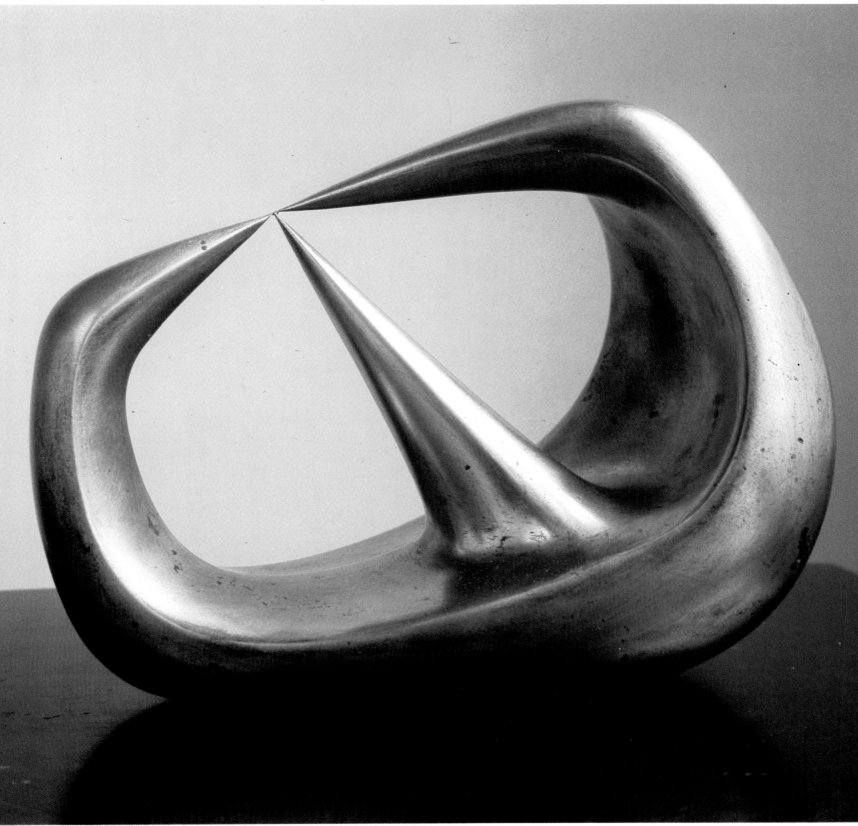

156

When I was first asked to carve a Madonna and Child for St Matthew's, Northampton, although I was very interested I wasn't sure whether I could do it, or whether I even wanted to do it. One knows that religion has been the inspiration of most of Europe's greatest painting and sculpture, and that the church in the past has encouraged and employed the greatest artists; but the great tradition of religious art seems to have got lost completely in the present day, and the general level of church art has fallen very low (as anyone can see from the affected and sentimental prettinesses sold for church decoration in church art shops). Therefore I felt it was not a commission straightway and lightheartedly to agree to undertake, and I could only promise to make notebook drawings from which I would do small clay models, and only then should I be able to say whether I could produce something which would be satisfactory as sculpture and also satisfy my idea of the Madonna and Child theme as well.

There are two particular motives or subjects which I have constantly used in my sculpture in the last twenty years; they are the Reclining Figure idea and the Mother and Child idea. (Perhaps of the two the Mother and Child has been the more fundamental obsession.) I began thinking of the *Madonna and Child* for St Matthew's by considering in what ways a Madonna and Child differs from a carving of just a Mother and Child – that is, by considering how in my opinion religious art differs from secular art.

It's not easy to describe in words what this difference is, except by saying in general terms that the Madonna and Child should have an austerity and a nobility, and some touch of grandeur (even hieratic aloofness) which is missing in the everyday Mother and Child idea. Of the sketches and models I have done, the one chosen has, I think, a quiet dignity and gentleness. I have tried to give a sense of complete easiness and repose, as though the Madonna could stay in that position for ever (as, being in stone, she will have to do). The Madonna is seated on a low bench, so that the angle formed between her nearly upright body and her legs is somewhat less than a right angle, and in this angle of her lap, safe and protected, sits the Infant.

The Madonna's head is turned to face the direction from which the statue is first seen, in walking down the aisle, whereas one gets the front view of the Infant's head when standing directly in front of the statue.

In sculpture, which is related to architecture, actual life-size is always confusing, and as St Matthew's is a large church, spacious and big in scale too, the *Madonna and Child* is slightly over life-size. But I did not think it should be much over life-size as the sculptor's real and full meaning is to be got only by looking at it from a rather nearer view, and if from nearby it seems too colossal it would conflict with the human feeling I wish to express.

157 Madonna and Child *1943 H 15.9 cm Bronze, edition of 7*
158 Madonna and Child *1943 H 14.7 cm Bronze, edition of 7*
159 Madonna and Child *1943 H 15.9 cm Bronze, edition of 7*
160 Madonna and Child *1943 H 15.2 cm Bronze, edition of 7*
161 Madonna and Child *1943 H 18.4 cm Terracotta Lord Clark, Saltwood*

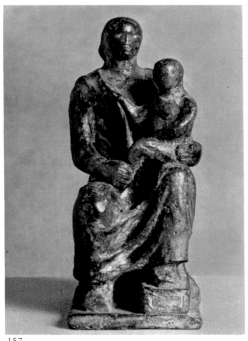

157

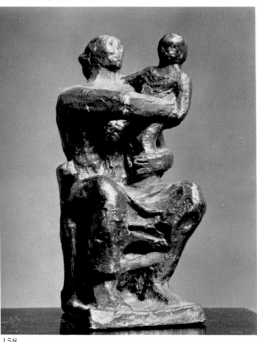

158

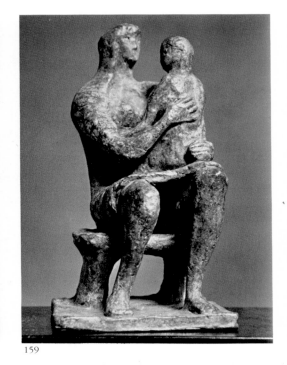

159

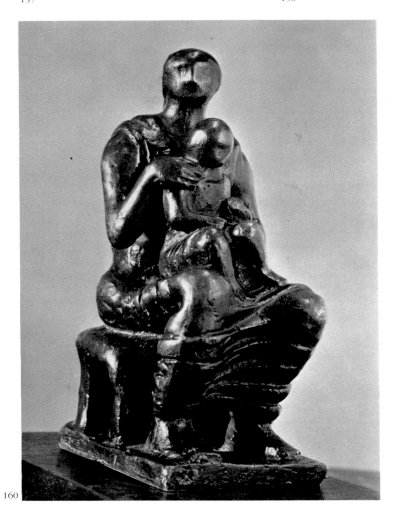

160

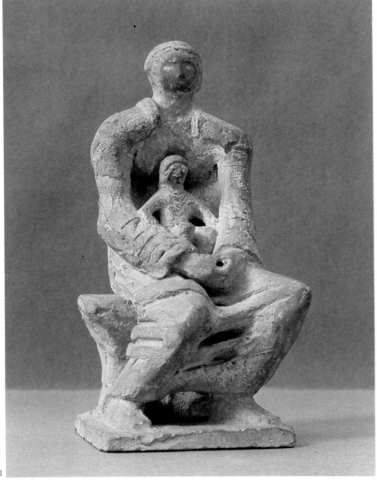

161

162–5 Madonna and Child *1943–4 in progress*
166–9 Madonna and Child *1943–4 H 1.50 m Hornton stone Church of St Matthew, Northampton*

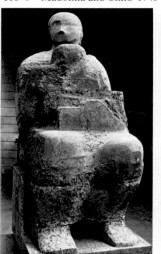

162

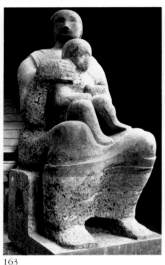

163

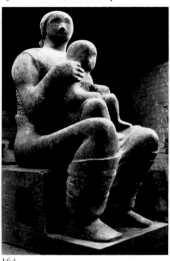

164

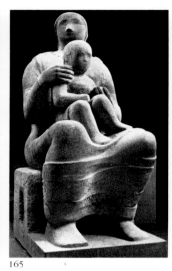

165

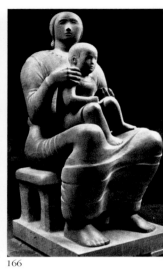

166

167

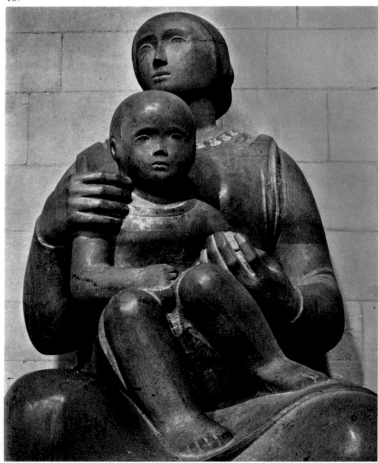

168

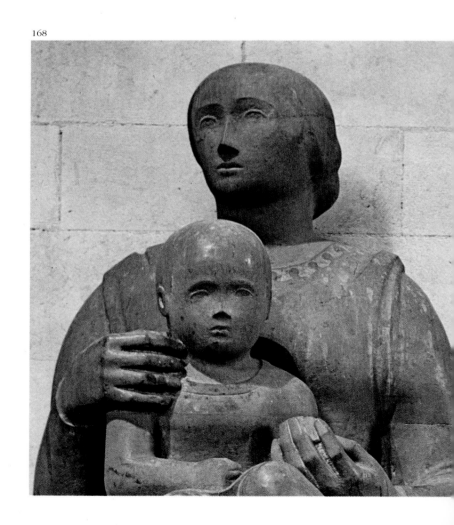

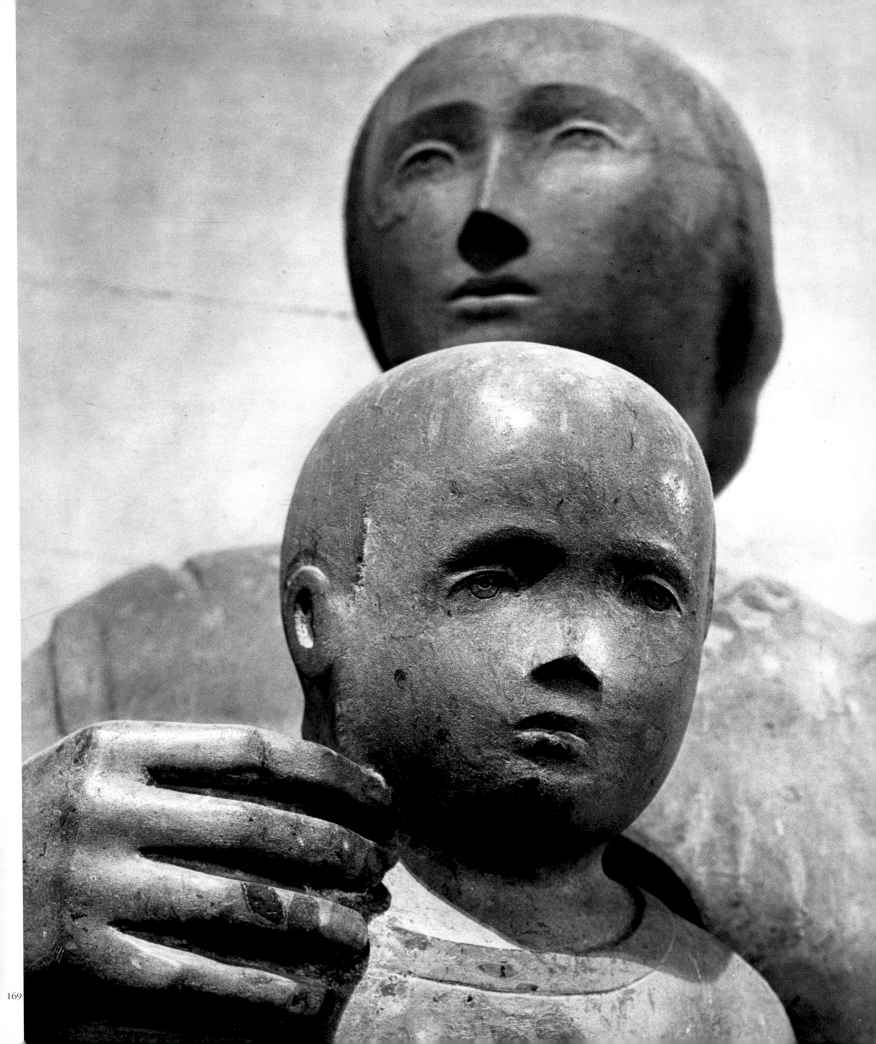

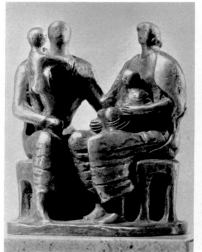

170

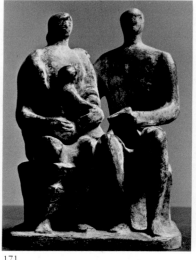

171

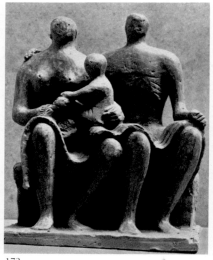

172

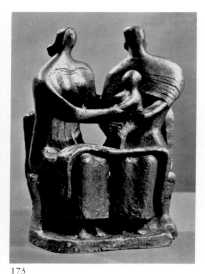

173

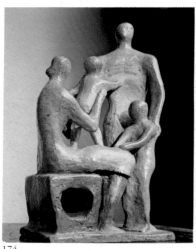

174

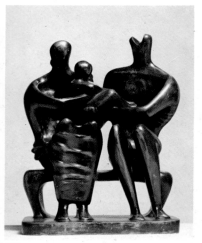

175

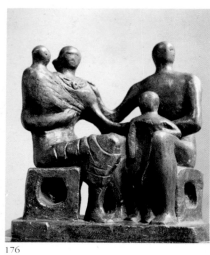

176

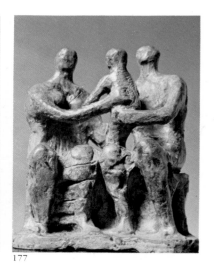

177

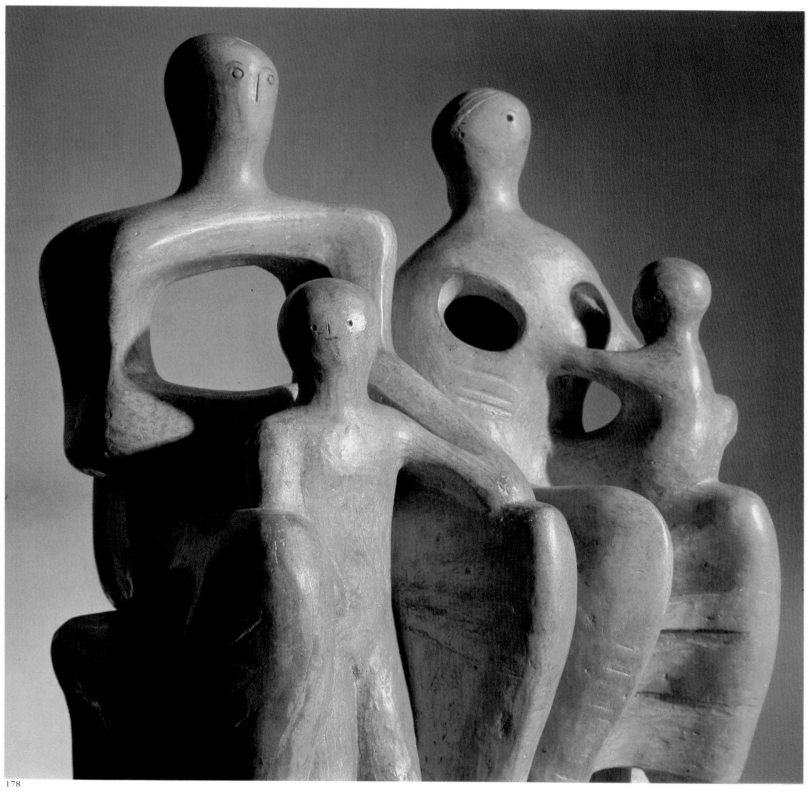

178

179 Reclining Figure *1945 L 38.1 cm Bronze, edition of 7*
180 Reclining Figure *1945 L 18.4 cm Terracotta The Henry Moore Foundation*
181 Reclining Figure *1945 L 17.8 cm Bronze, edition of 7*
182 Reclining Figure *1946 L 43.2 cm Bronze, edition of 4*

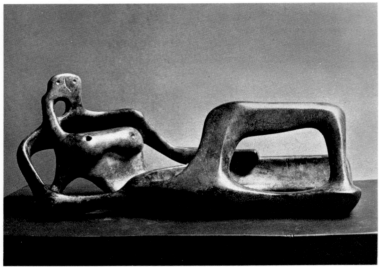

179

182

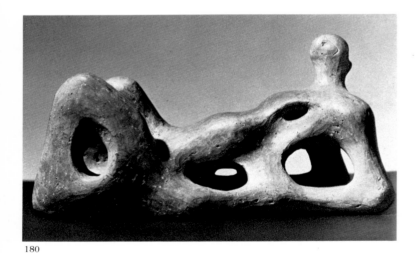

180

181

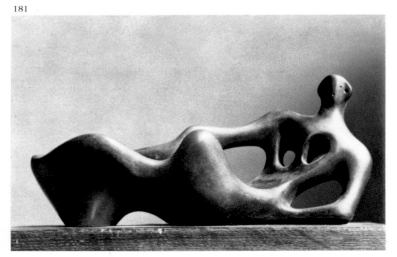

I think the figure I carved in 1945 and 1946 (*figs 183, 184*) in memory of Christopher Martin has found a perfect setting in the grounds of Dartington Hall. The figure is a memorial to a friend who loved the quiet mellowness of this Devonshire landscape. It is situated at the top of a rise, and when one stands near it and takes in the shape of it in relation to the vista one becomes aware that the raised knee repeats or echoes the gentle roll of the landscape. I wanted it to convey a sense of permanent tranquillity, a sense of being from which the stir and fret of human ways had been withdrawn, and all the time I was working on it I was very much aware that I was making a memorial to go into an English scene that is itself a memorial to many generations of men who have engaged in a subtle collaboration with the land. Obviously, it would be out of place in a wilder, more rugged setting.

183, 184 Memorial Figure *1945–6 L 1.42 m Hornton stone Dartington Hall, Devon*

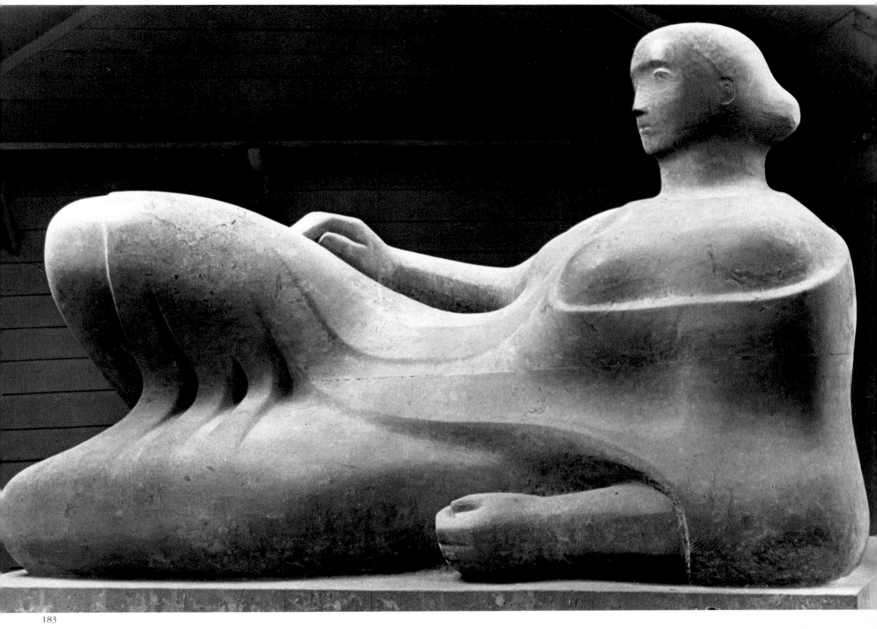

183

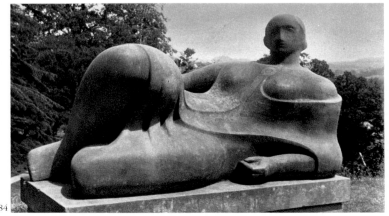

184

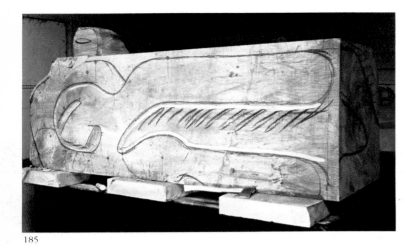

185

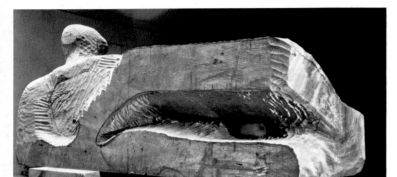

186

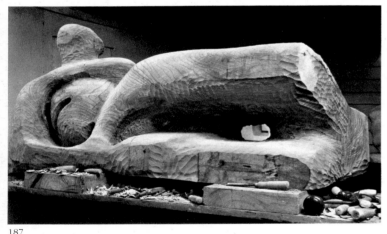

187
188

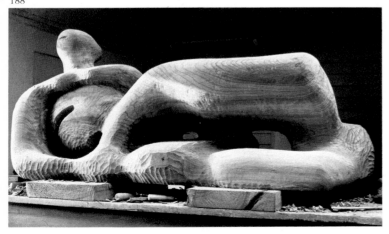

To begin with I didn't much like working in wood. You can't knock great big chunks off a piece of wood – you have to saw them. But you can only saw in a straight line. And the finishing of wood is (or was) a slower process because you have to cut across the grain instead of down it. Otherwise it splits. But later I began to like wood very much even in the big scale. Now the wood in England that you can get in big sizes is elm because the elm tree grows very thick. Unfortunately one may now find that elm disease is reducing the available large trunks.

What wood can do that stone doesn't is still give you the sense of it having grown, whereas stone doesn't grow – it's a deposit. Also for me the grain of the wood plays a part and makes it alive.

185–8 Reclining Figure *1945–6 in progress*
189 Reclining Figure *1945–6 L 1.90 m Elmwood Private collection, Italy*

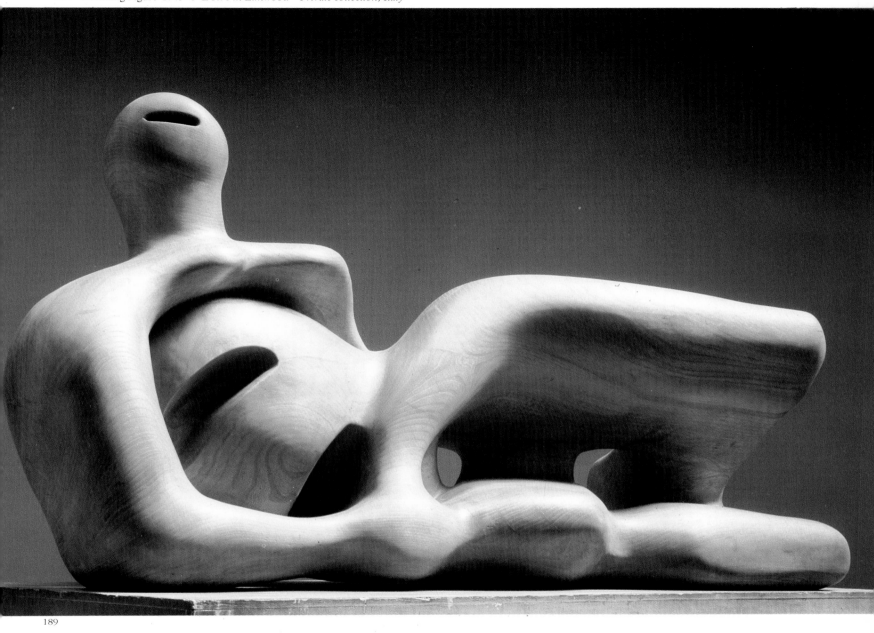

189

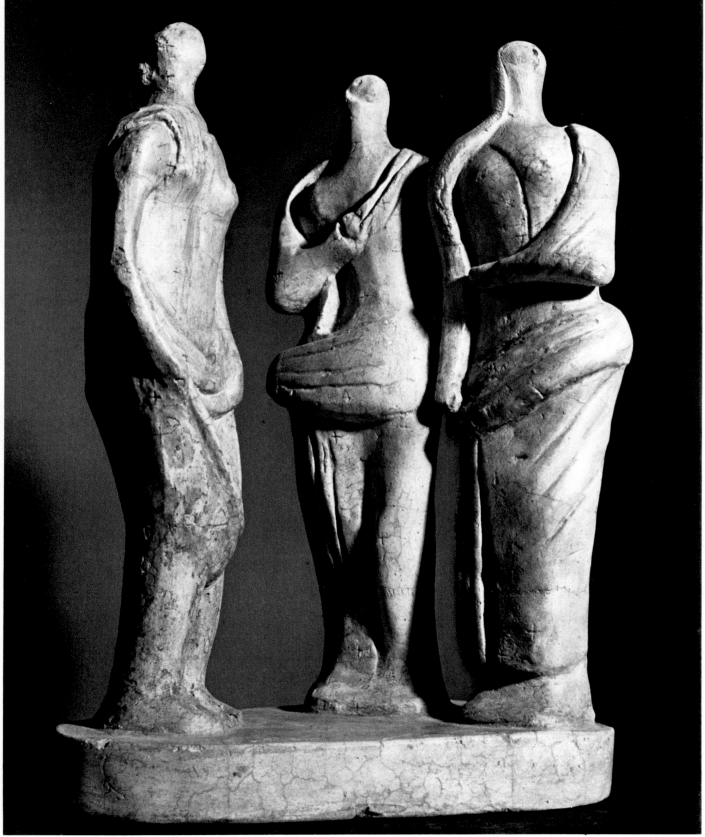

The three Battersea Standing Figures in Darley Dale sandstone are probably the first big sculptures that showed the influence of my war drawings. Although the figures are static, I made them look into the distance, as if they were expecting something dramatic to happen. Drama can be implied without the appearance of physical action.

191, 192 Three Standing Figures *1947–8 H 2.13 m Darley Dale stone* *Battersea Park, London*

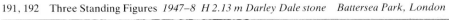

191

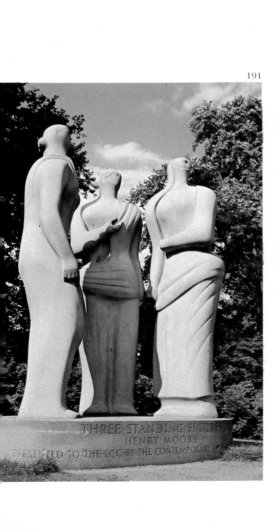

192

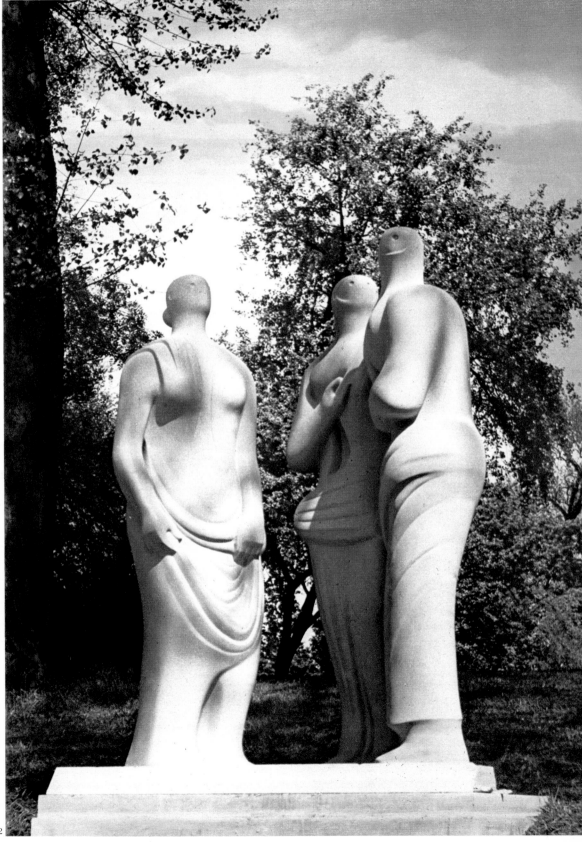

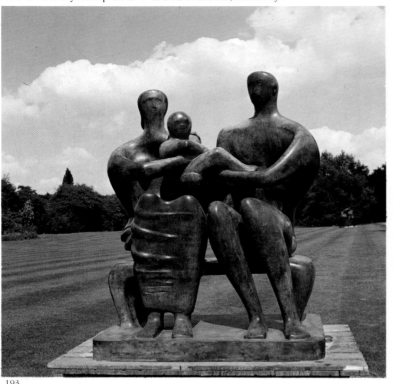

193

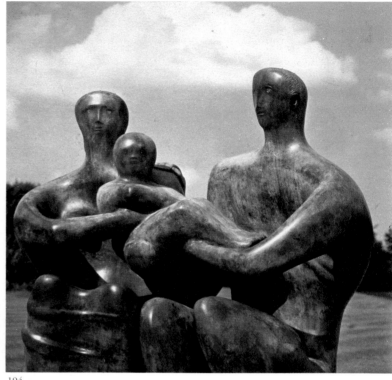

194

The idea for a Family Group sculpture came out of a discussion I had around 1934 with Henry Morris, the pioneer of village college schools, together with Walter Gropius, the German architect engaged to design the first of these schools at Impington, a village near Cambridge. I was not often asked to do a special sculpture in those days. Usually I would do what I liked and if it sold, it sold. But I admired them both, Gropius as an architect and a past director of the Bauhaus and Henry Morris as a great educator. Henry Morris explained his hopes that by a full use of the school buildings and facilities in the evenings and also throughout the weekends parents would further their own education and, in consequence, there would be a better parent–student relationship with teachers and more community life in the village.

After some thought, I came to the idea of the Family Group, making the connection between family and school. Unfortunately, the money for the project ran short, and the sculpture never materialised. But Henry Morris had many young disciples in the educational world, and one of them, John Newsom, some years later became the director of education for the county of Hertfordshire. He remembered the unrealised

Impington sculpture project, and he asked me if I was still interested in the Family Group as a subject. I was, and this is what led to the completed sculpture now in front of the Barclay School, Stevenage. The school was designed by a very good group of English architects.

In the sculpture the child is shown in the arms of his parents, as though the two arms come together and a knot is tied by the child. It is as though they are pulling with their arms and the knot that connects both parents is the child. This did not come into my mind at the time of doing it.

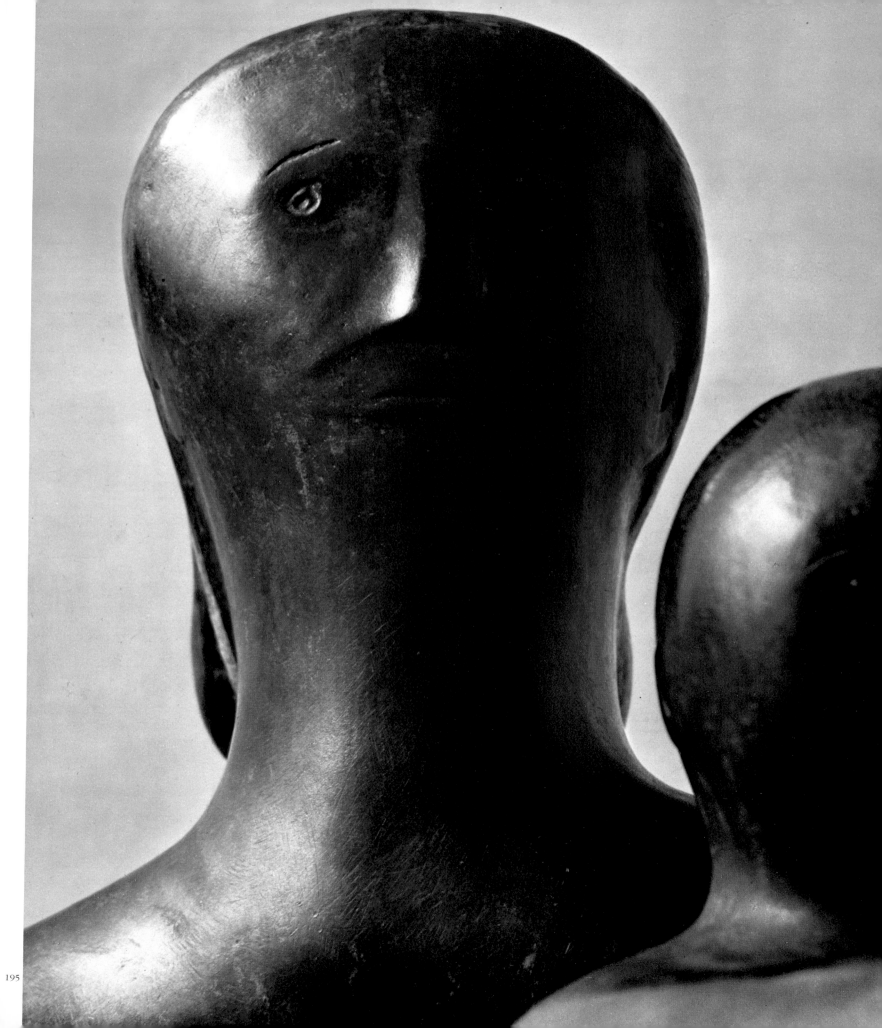

196 Seated Figure *1949 H 25.4 cm with base Bronze, edition of 7*
197 Seated Figure *1949 H 43.2 cm Bronze, edition of 5*
198 Madonna and Child *1948–9 H 1.22 m Hornton stone St Mary's Church, Barham, Suffolk*

196

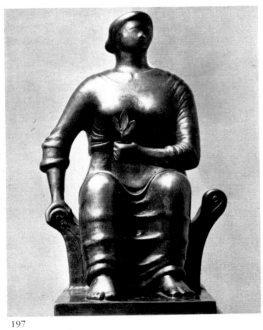

197

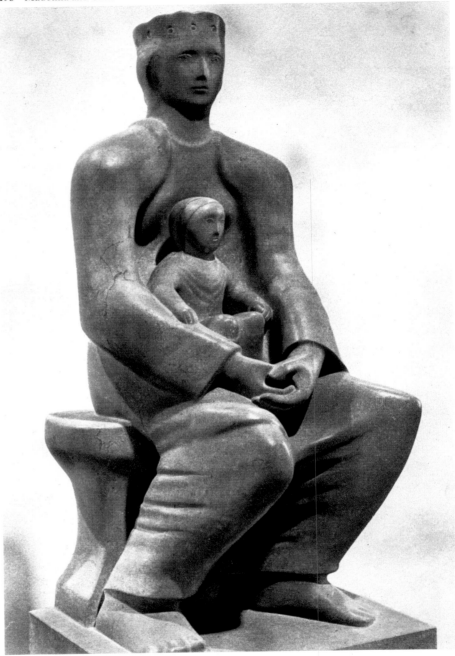

198

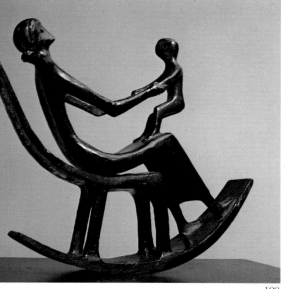

199

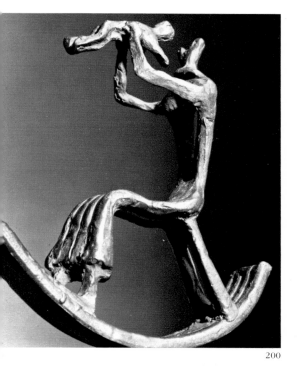

200

201

The rocking chair sculptures were done for my daughter Mary, as toys which actually rock. I discovered while doing them that the speed of the rocking depended on the curvature of the base and the disposition of the weights and balances of the sculpture, so each of them rocks at a different speed.

202 Five Figures (Interiors for Helmets) *1950 H 12.7 cm Lead The Henry Moore Foundation*
203 Maquette for Strapwork Head *1950, cast 1972 H 10.2 cm Bronze, edition of 9*
204 Maquette for Openwork Head and Shoulders *1950 H 15.2 cm Bronze*
205 Maquette for Openwork Head No. 2 *1950 H 14.6 cm Bronze Mrs A. Pitt*

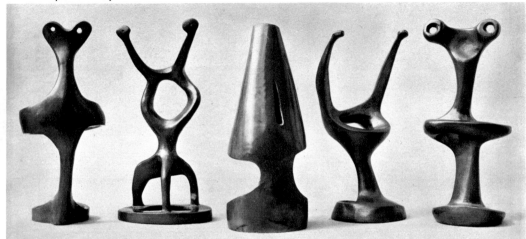

202

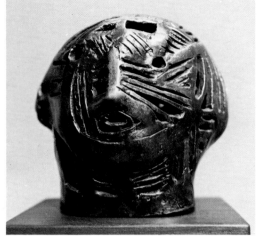

203

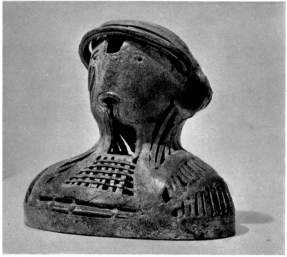

204

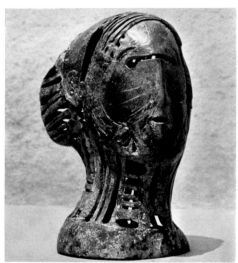

205

In 1950 I still found it too costly to have all my metal sculptures cast into bronze, and so some of my ideas were conceived to be cast by myself into lead, for lead has a much lower melting point than bronze, and I could use ordinary cooking pans and my wife's kitchen stove to melt the lead.

To realise the form of this particular sculpture (*fig 209, overleaf*) with its thin outer shell, and its separate interior piece, I had to work in some material other than clay or plaster. I decided I would model direct in wax (this would also mean I could later use the 'cire-perdue' [lost wax] method of metal casting).

When casting metal it is necessary to make the mould, into which the molten metal is poured, out of a material which will withstand great heat without disintegrating. Such a material can be made by mixing

with water one part of plaster of Paris and two parts 'grog' (i.e. powdered stoneware).

Out of this material I made a solid shape similar to the outside form of the HELMET, over this shape I modelled the exterior part of the HELMET, in wax, about one centimetre in thickness. I then covered this with an outer mould (also a mixture of plaster and grog).

The whole was then baked in a brick kiln, during which process the wax melts and is lost leaving nothing in its place, and into this empty space the molten lead was poured. Thus was produced in lead an exact replica of the original modelled wax.

The interior form I also modelled in wax, but without any core or armature in it . . . then this wax was also covered with a mould of plaster and grog, baked in a kiln, and then filled with molten lead.

106

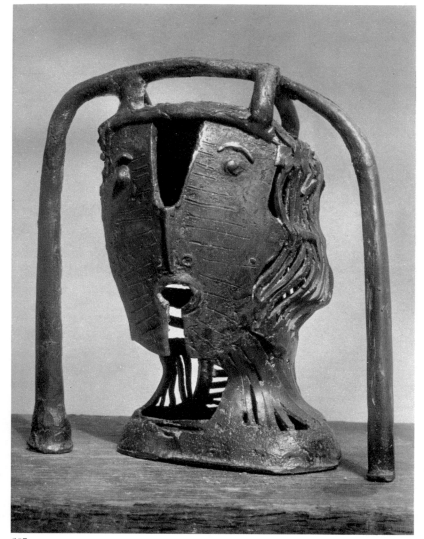

206 207

However, the Exterior and the Interior forms now existing in lead did not have the exactitude of shape and surface which I wanted and I spent several days working directly on both parts of the sculpture, with progressively finer grades of files, finally finishing with pumice powder and metal polish, and so arriving at a surface unique to lead – a kind of bloom entirely different to unpolished lead.

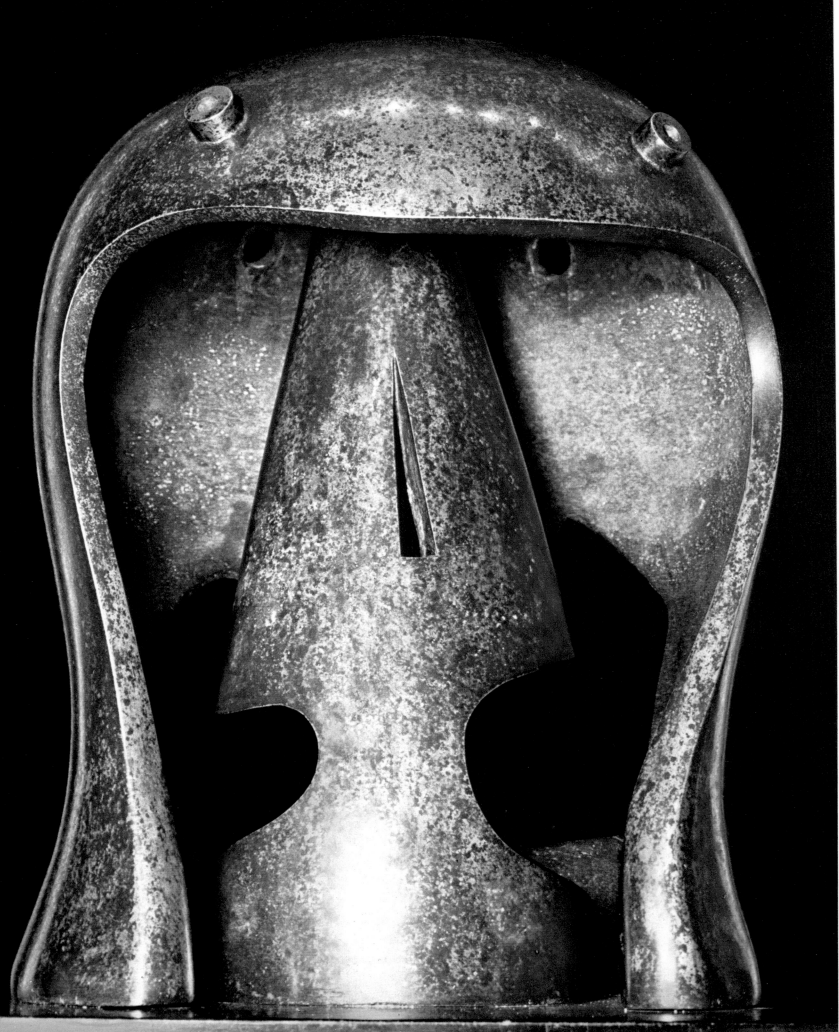

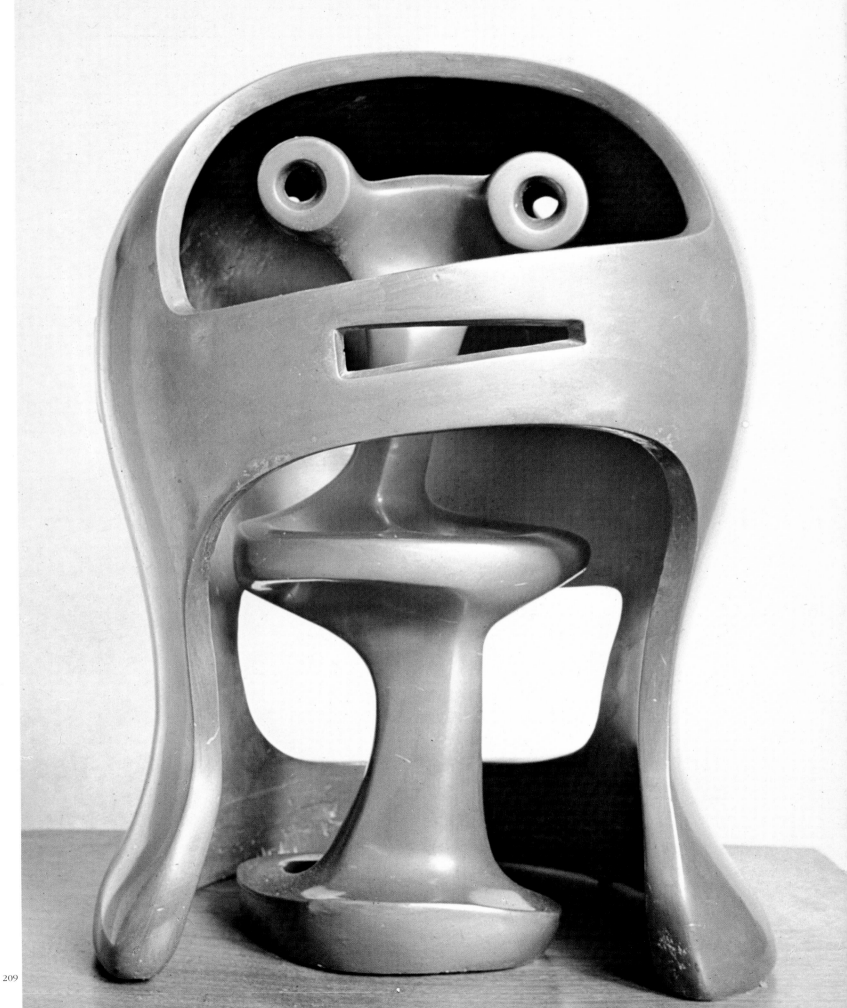

210 Double Standing Figure *1950 H 2.18 m Bronze, edition of 2*
211, 212 Standing Figure *1950 H 2.18 m White marble The Henry Moore Foundation*
213 Standing Figure *1950 H 2.18 m Fibreglass The Henry Moore Foundation*

210

211

212

The sky is one of the things I like most about 'sculpture with nature'. There is no background to sculpture better than the sky, because you are contrasting solid form with its opposite – space. The sculpture then has no competition, no distraction from other solid objects. If I wanted the most foolproof background for a sculpture I would always choose the sky.

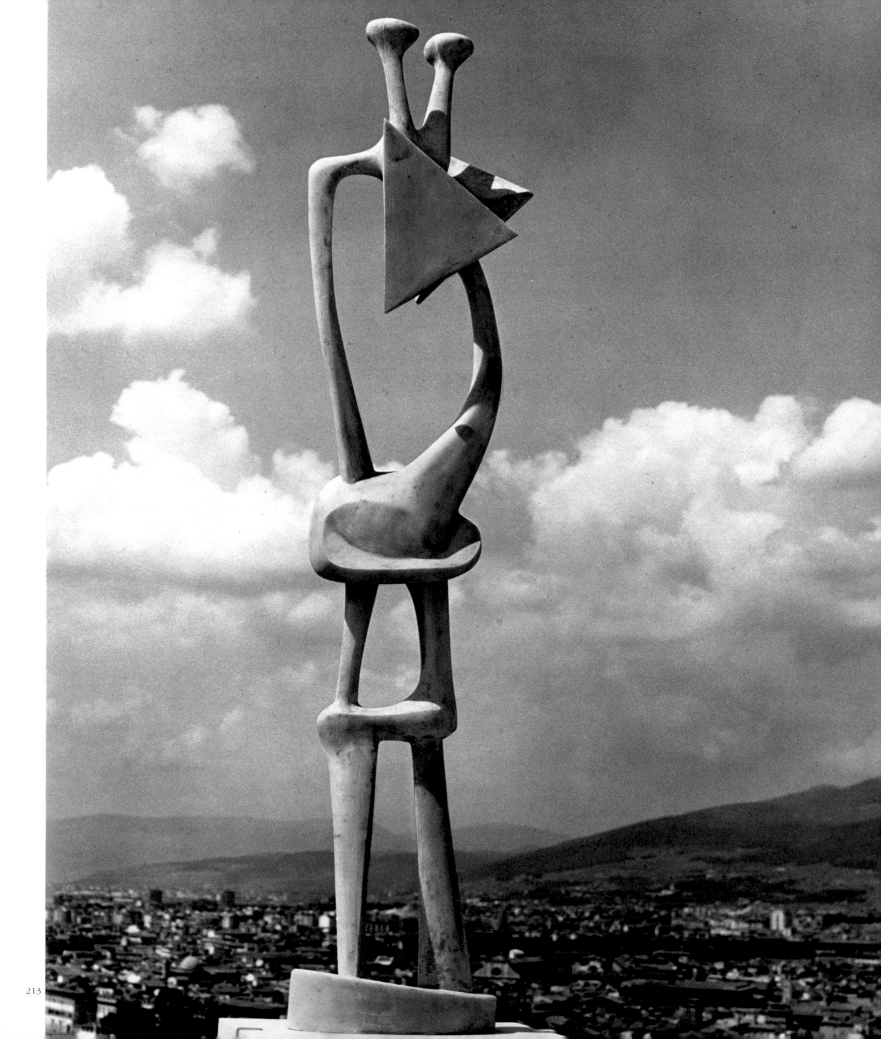

214

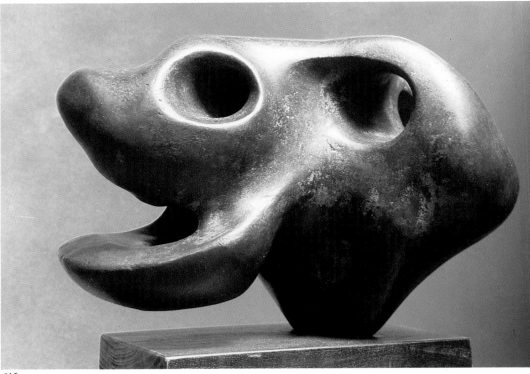

215

216

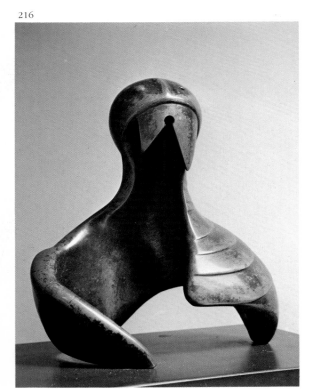

Eventually I found that form and space are one and the same thing. You can't understand space without understanding form.

For example, in order to understand form in its complete three-dimensional reality you must understand the space that it would displace if it were taken away. You can't measure a space without measuring from one point to another. The heavens have space that we can understand because there are points – the stars and the sun – that are different distances away from each other. In the same way we can only see space in a landscape by relating the foreground and middle distance to the far distance. To understand the distance from my thumb to my forefinger needs exactly the same understanding as distances in landscape.

217 Three Standing Figures *1953 H 71.1 cm Bronze, edition of 8*
218 Standing Figure No. 4 *1952 H 24.8 cm Bronze, edition of 9*
219 Standing Figure No. 2 *1952 H 27.9 cm Bronze, edition of 9*
220 Standing Figure No. 1 *1952 H 24.2 cm Bronze, edition of 9*
221 Leaf Figures 3 and 4 *1952 H 49.5 cm Bronze, edition of 11*

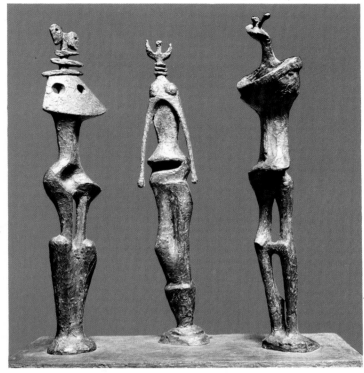

217

218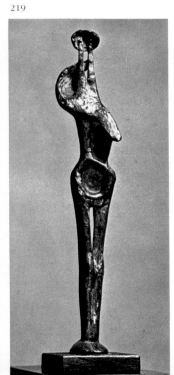

219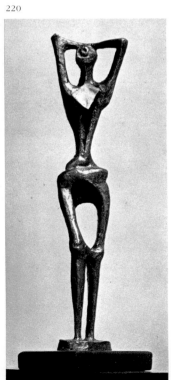

220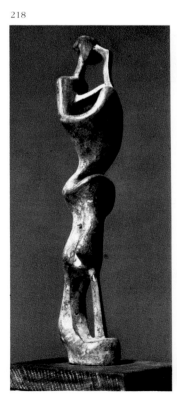

221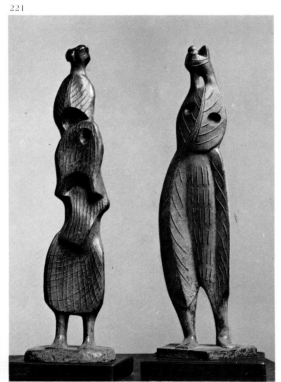

222 Mother and Child on Ladderback Rocking Chair *1952 H 21 cm Bronze, edition of 9*
223 Mother and Child on Ladderback Chair *1952 H 40.6 cm Bronze, edition of 7*
224 Reclining Figure No. 4 *1954 L 58.4 cm Bronze, edition of 7*
225 Reclining Figure No. 1 *1952 L 20.3 cm Bronze, edition of 9*

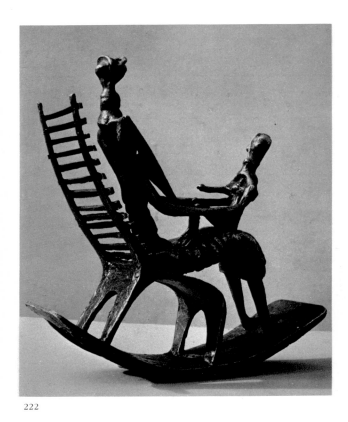

222

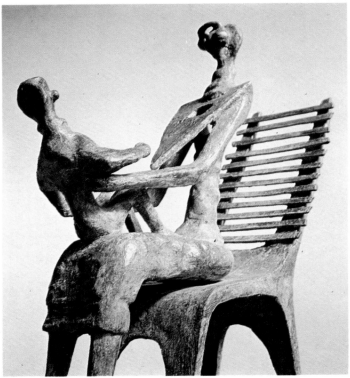

223

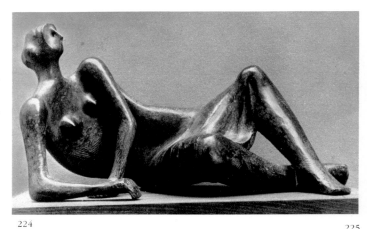

224

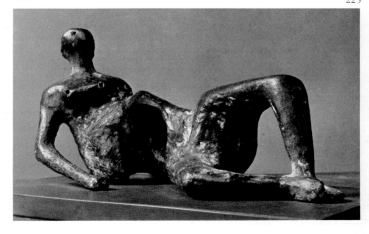

225

226 Reclining Figure No. 2 *1953 L 91.4 cm Bronze, edition of 7*
227 Mother and Child *1953 H 50.8 cm Bronze, edition of 8*
228 Reclining Figure No. 5 *1952 L 21.6 cm Bronze, edition of 9*
229 Reclining Figure No. 3 *1952 L 21 cm Bronze, edition of 9*
230 Draped Reclining Figure: Fragment *1953 L 16 cm Bronze, edition of 9*

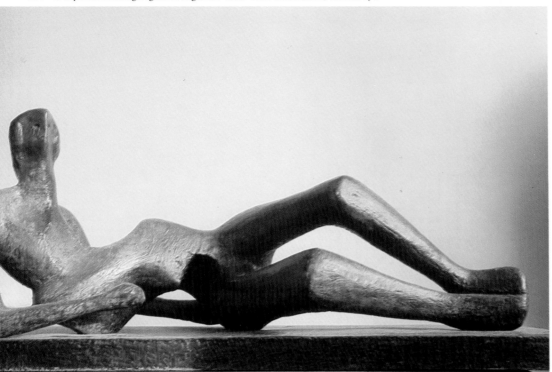

226

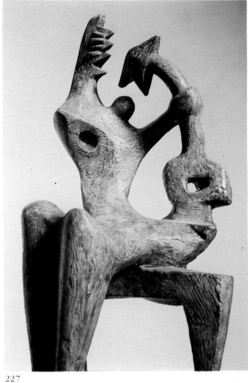

227

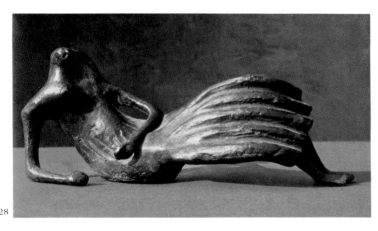

228

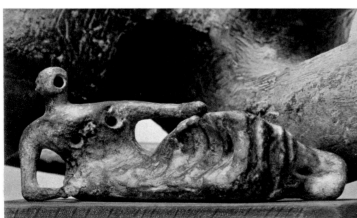

229

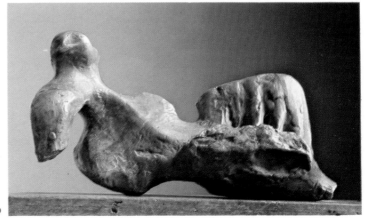

230

115

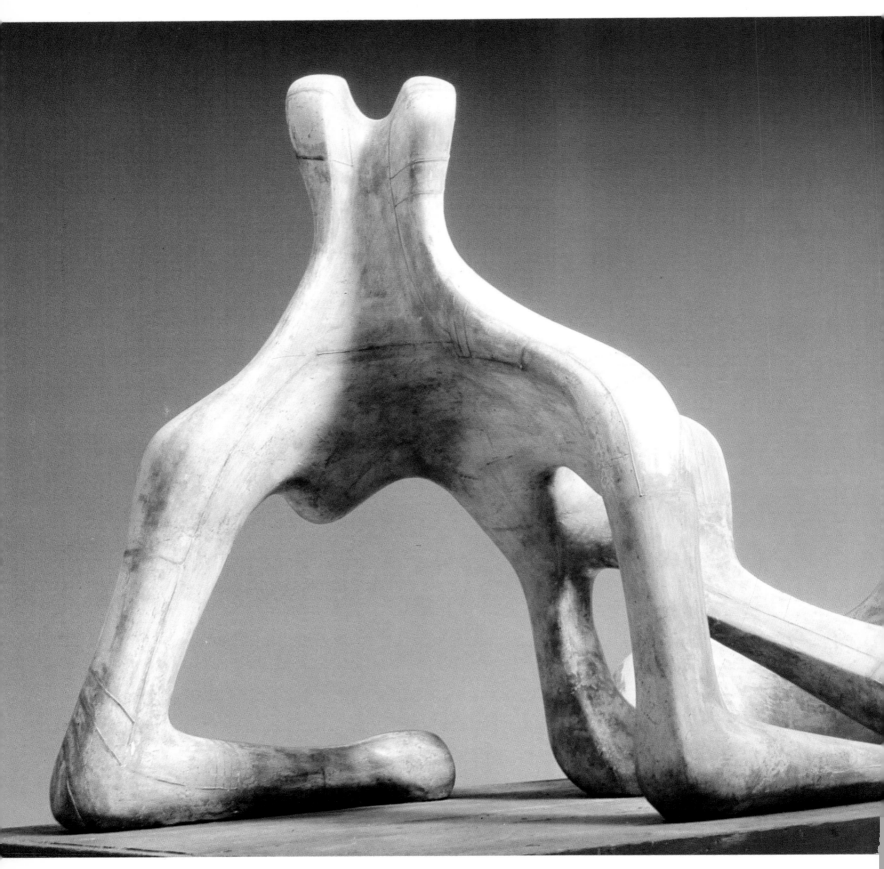

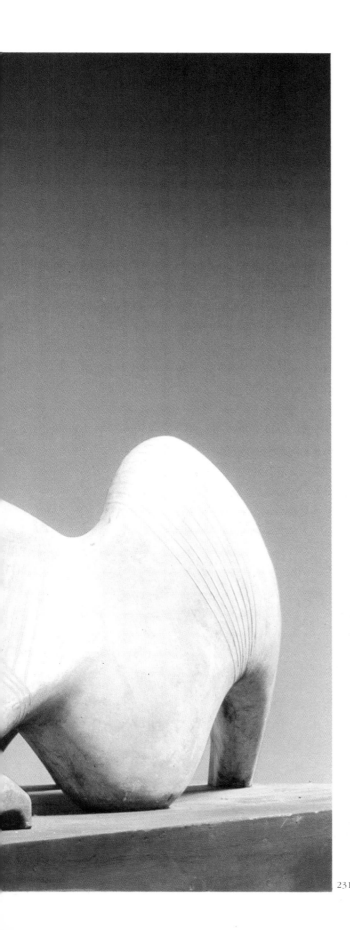

231

231, 233, 234 Reclining Figure *1951 L 2.28 m Plaster Tate Gallery, London*
232 Reclining Figure *1951 L 2.28 m Bronze, edition of 5*

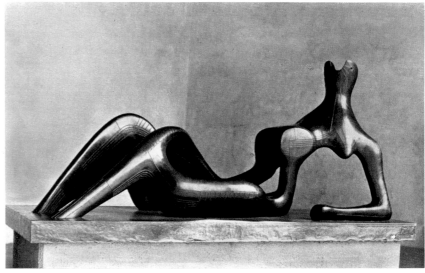

232

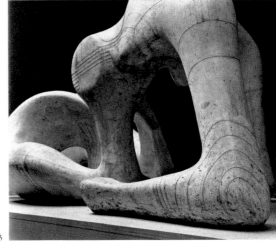

233

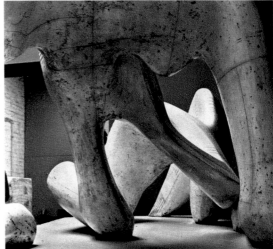

234

235 Reclining Figure *1953–4 L 2.13 m Bronze, edition of 6*
236 Working Model for Reclining Figure *1953–4 L 53.3 cm Bronze, edition of 9*
237 Reclining Figure *1953 L 2.13 m Plaster for bronze*
238 Upright Internal/External Form *1953–4 H 2.61 m Elmwood Albright Knox Art Gallery, Buffalo*
239 Upright Internal/External Form: Flower *1951 H 66.1 cm Bronze, edition of 6*
240 Upright Internal/External Form *1952–3 H 2 m Bronze, edition of 3*

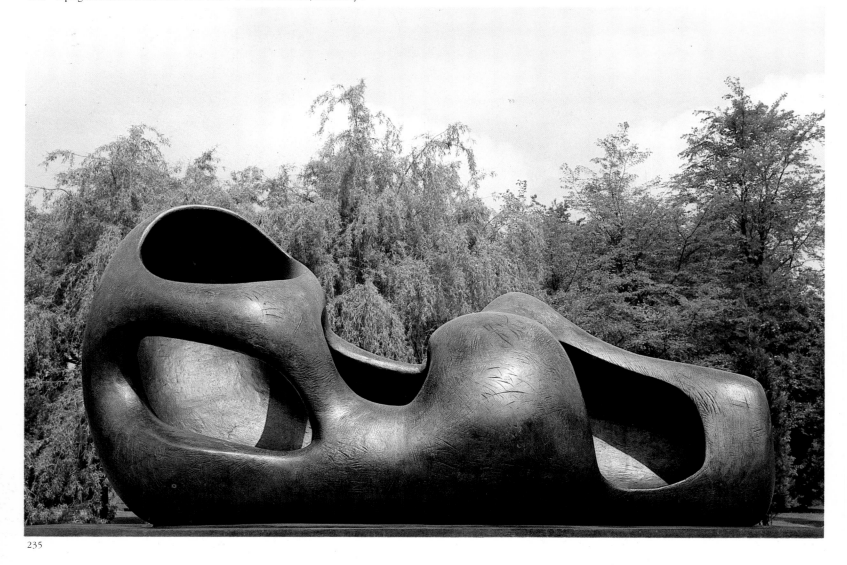

235

236

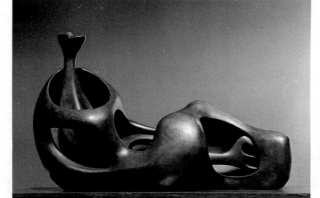

237

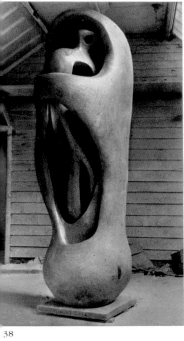

238

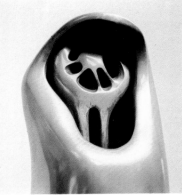

239

240

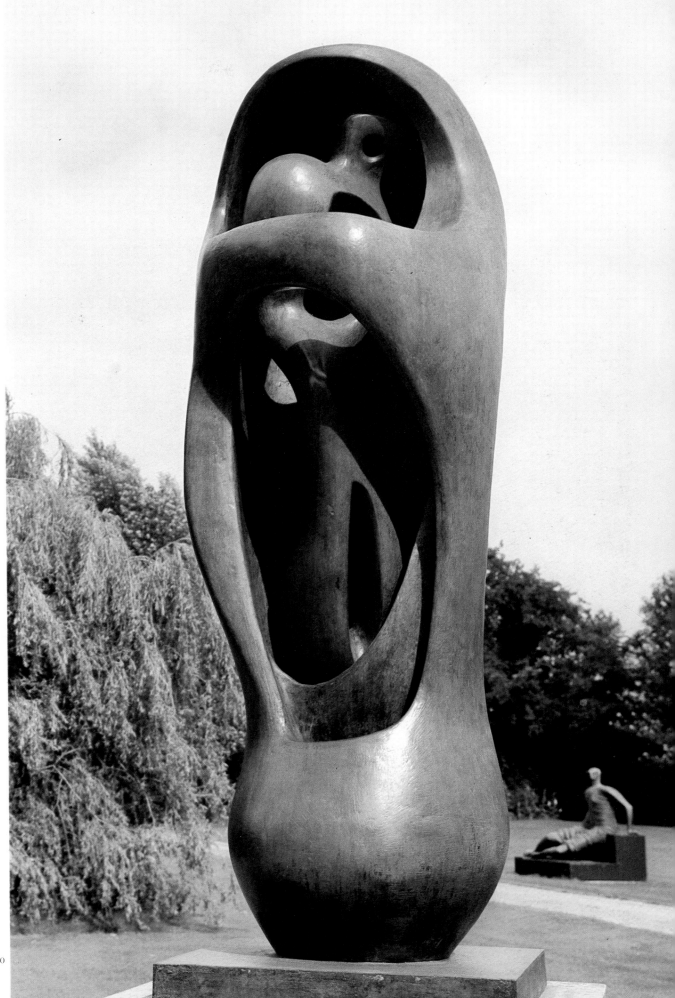

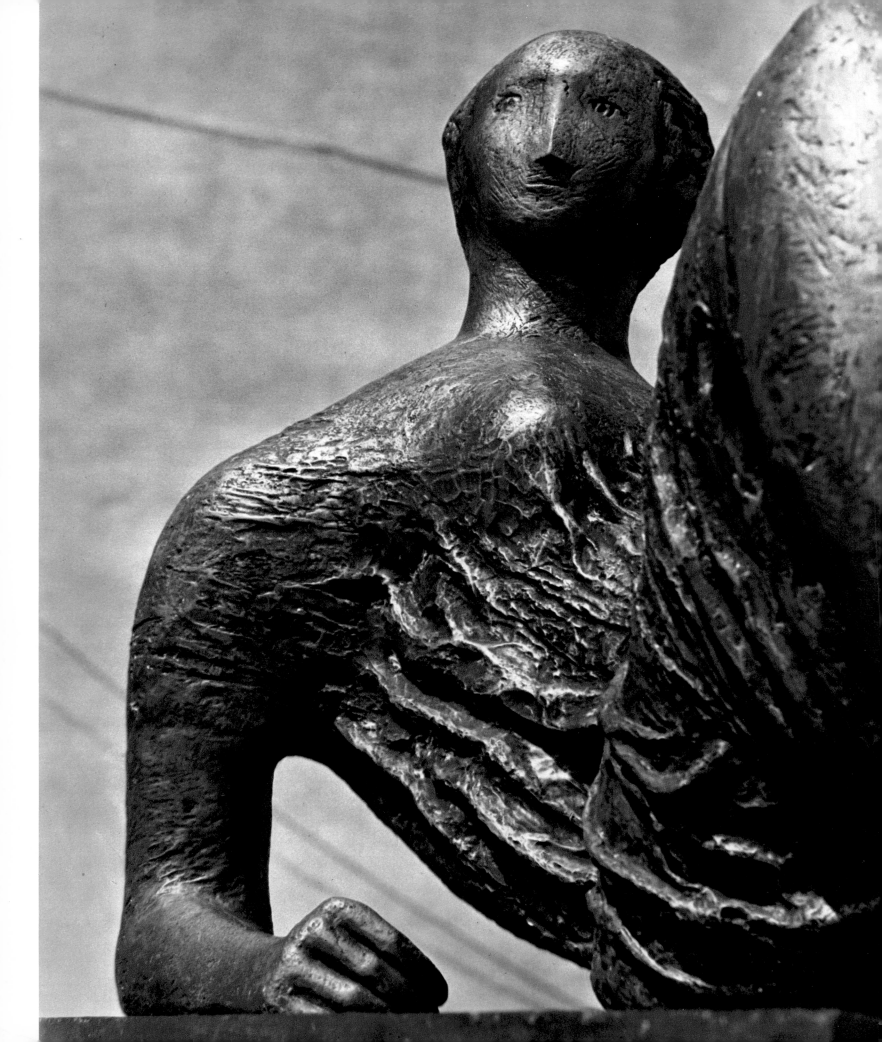

241–3 Draped Reclining Figure *1952–3 L 1.57 m Bronze, edition of 3*
244 Draped Torso *1953 H 88.9 cm Bronze, edition of 4*

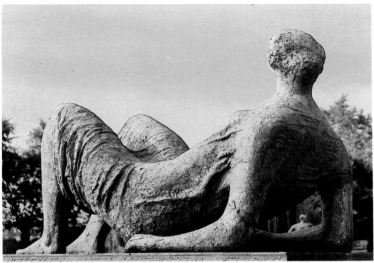

242

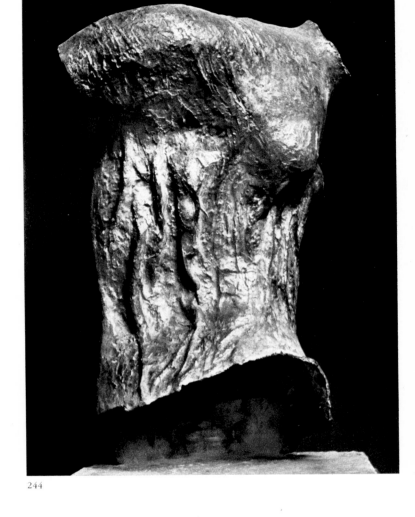

244

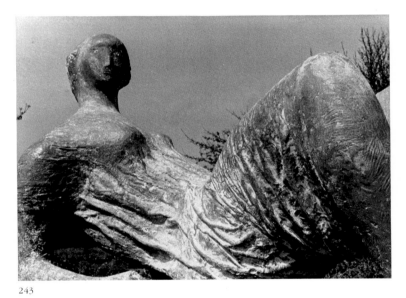

243

I have tried in this figure (*figs 241–3*) to use drapery from what I think is a sculptural point of view.

Drapery played a very important part in the shelter drawings I made in 1940 and 1941 and what I began to learn then about its function as form gave me the intention, some time or other, to use drapery in sculpture in a more realistic way than I had ever tried to use it in my carved sculpture. And my first visit to Greece in 1951 perhaps helped to strengthen this intention. So . . . I took the opportunity of making this draped figure in bronze.

Drapery can emphasise the tension in a figure, for where the form pushes outwards, such as on the shoulders, the thighs, the breasts, etc., it can be pulled tight across the form (almost like a bandage), and by contrast with the crumpled slackness of the drapery which lies between the salient points, the pressure from inside is intensified.

Drapery can also, by its direction over the form, make obvious the section, that is, show shape. It need not be just a decorative addition, but can serve to stress the sculptural idea of the figure.

Also in my mind was to connect the contrast of the sizes of folds, here small, fine and delicate, in other places big and heavy, with the form of mountains, which are the crinkled skin of the earth.

Although static, this figure is not meant to be in slack repose, but, as it were, alerted.

245–7 King and Queen *1952–3 L 1.64 m Bronze, edition of 5*
248 Study for Head of Queen No. 2 *1952, cast 1973 H 23.5 cm Bronze, edition of 9*

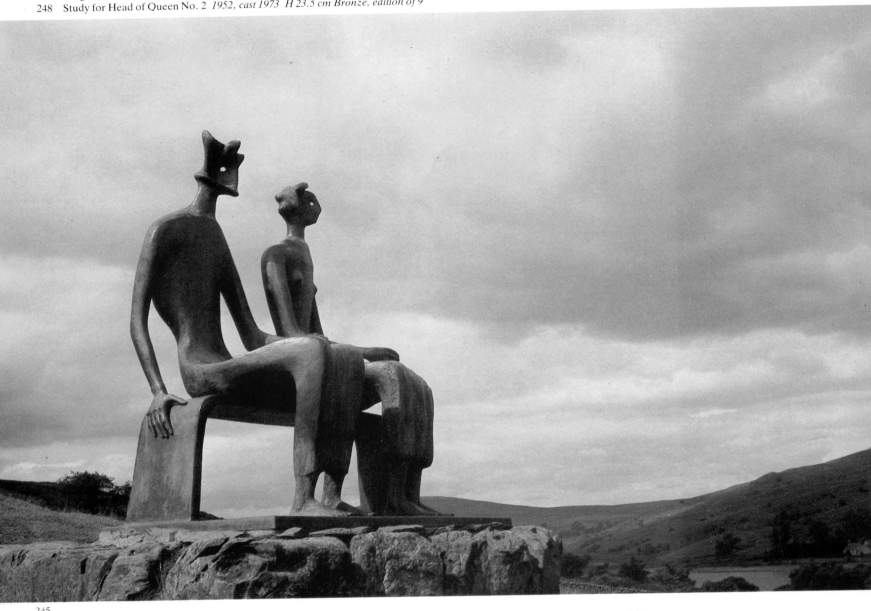

245
246

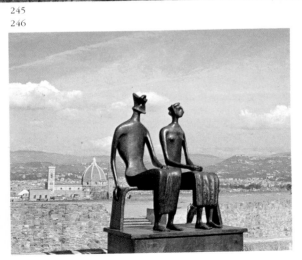

247

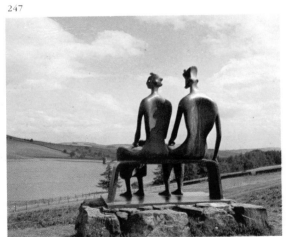

248

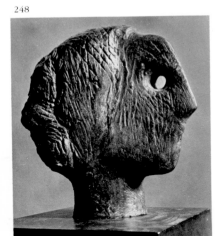

Perhaps the 'clue' to the group (*figs 245–7*) is the King's head, which is a combination of a crown, beard and face symbolising a mixture of primitive kingship and a kind of animal, Pan-like quality. The King is more relaxed and assured in pose than the Queen, who is more upright and consciously queenly. When I came to do the hands and feet of the figures they gave me a chance to express my ideas further by making them more realistic – to bring out the contrast between human grace and the concept of power in primitive kingship.

249 Hand Relief No. 2 *1952, cast 1963 30.5 × 33 cm Bronze, edition of 6*
250 Study for Hands of Queen *1952 H 12.7 cm Bronze, edition of 11*
251 Hands of King *1952–3 H 27.3 cm Bronze, unique cast*

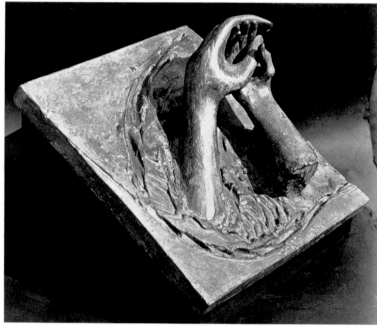

249

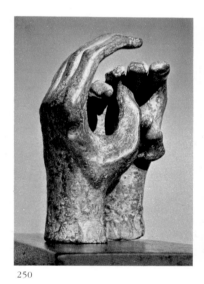

250 251

I have always loved hands, in common with most past sculptors. Rodin, for instance, made a very special study of hands. The first sculpture I did, or at least the sculpture that helped me to win a Royal Exhibition Scholarship to the RCA, was the modelling of a hand from life. Casts of this hand were later sent round to all the art schools as an example of how it should be done. I remember I enjoyed doing it quite enormously.

252 Working Model for Time-Life Screen *1952 38.1 cm × 1 m Bronze, edition of 9*
253 Time-Life Screen *in progress*

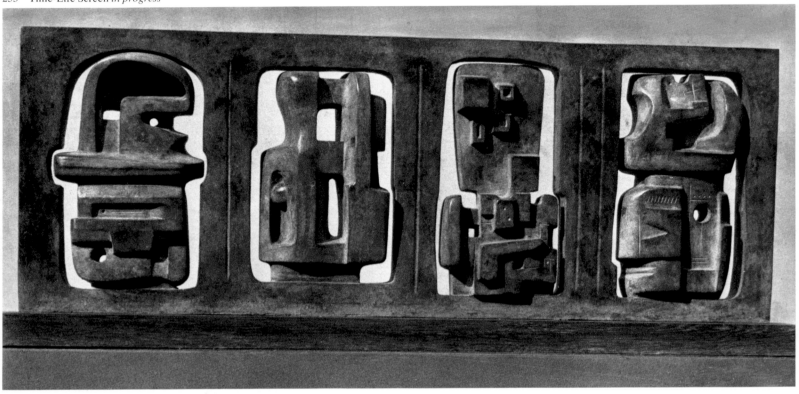

252

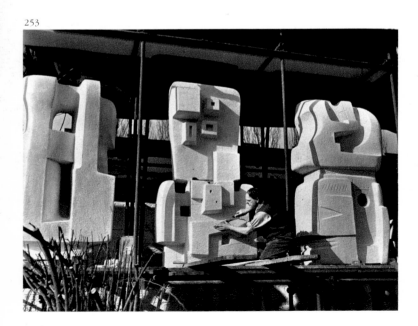

253

Long before the carvings themselves were ready I had to decide upon the shape and size of the openings of the screen, so that the architect could get it prepared and built into position before the carvings arrived on the site. The four big stones themselves were carved on a scaffolding erected in my garden – and, of course, without the stone frame screen round them. By the time I realised that they didn't really need a screen at all, the screen had been made and was in position on the building, and all I could do was to arrange for the openings to be made larger, that is to say as large as possible without weakening the structure of the screen. I found too that my project really demanded a turntable for each of the carvings, so that they could be turned, say, on the first of each month, each to a different view, and project from the building like some of those half animals that look as if they are escaping through the walls in Romanesque architecture. I wanted them to be like half-buried pebbles whose form one's eye instinctively completes.

254 Time-Life Screen *1952–3 3.04× 8.07 m Portland stone Time-Life Building, London*

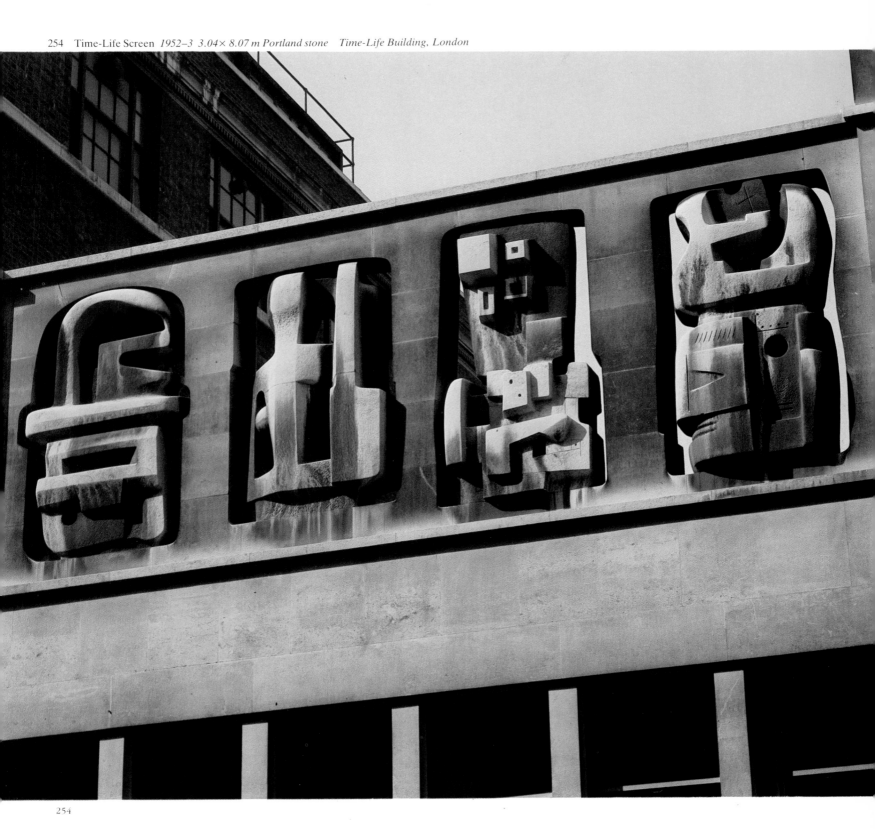

254

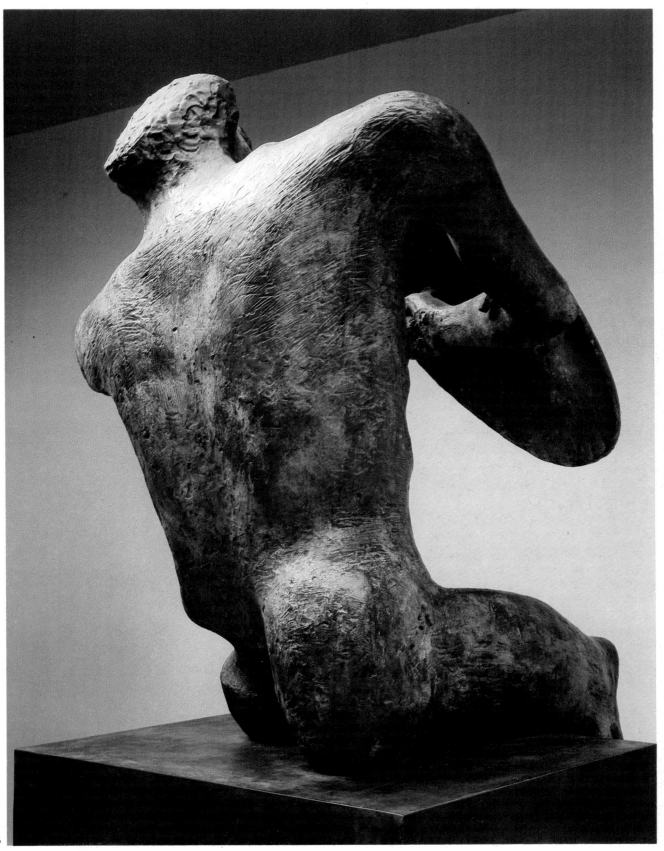

257–60 Harlow Family Group *1954–5 H 1.63 m Hadene stone* *Harlow Art Trust, Harlow, Essex*

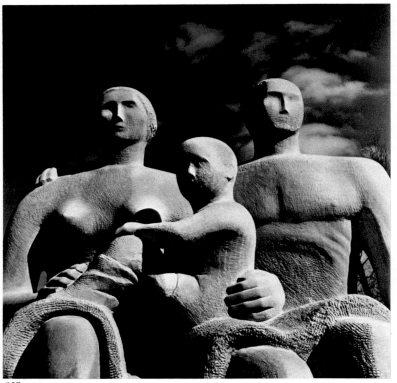

257

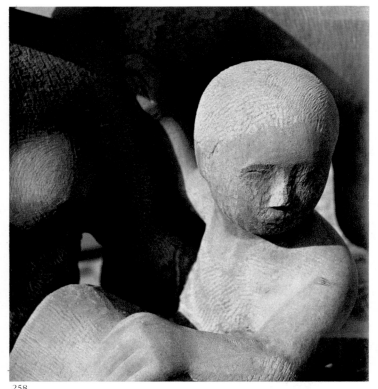

258

The architect of the New Town of Harlow, together with a few people who lived in Harlow, thought that their New Town should not be completely bare of art, and they formed the Harlow Art Trust.

The Art Trust asked me for a piece of sculpture – they hoped a family group. Harlow being so near my home in Much Hadham, and many of the Trust members being my friends, I wanted to help, so I carved this piece for them and helped to choose a most pleasant site for it – near the old church on a grassy slope with lots of open space – where it could be seen from a long distance as people approached the New Town.

Unfortunately this sculpture has been moved from its original site, which proved to be too open, too countrified and unprotected. It was seriously damaged by vandalism – the child's head eventually was broken off. After I repaired the sculpture, it was decided to place it in the town's central square and on a high pedestal for protection.

259

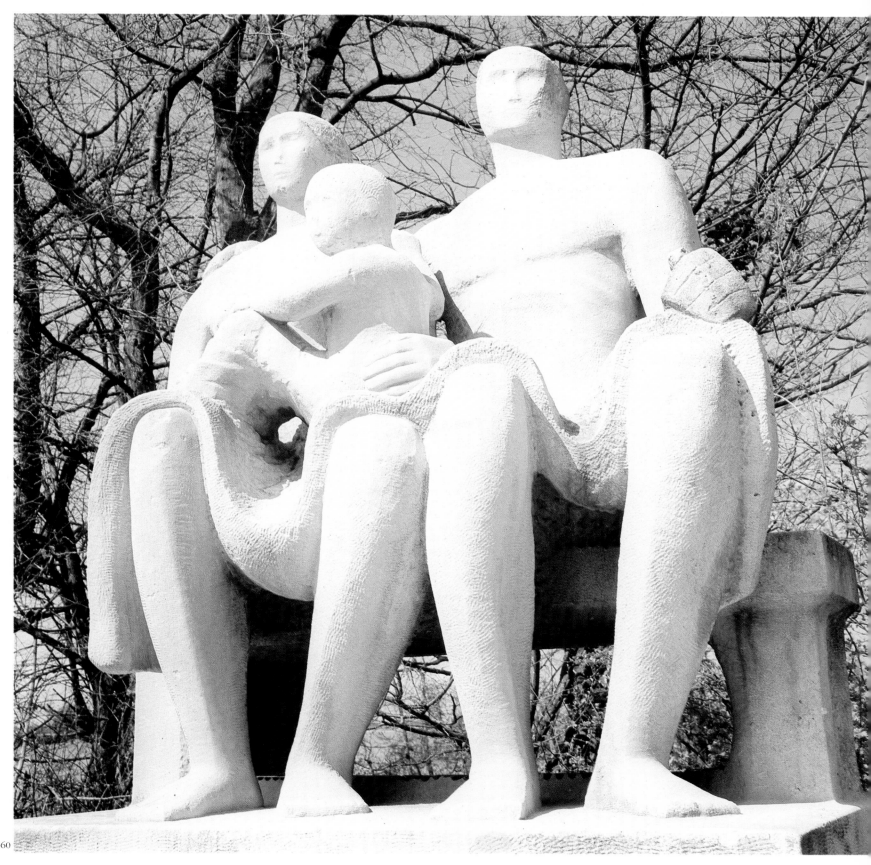

261 Seated Woman: One Arm *1956, cast 1964 H 20.3 cm Bronze, edition of 9*
262 Seated Torso *1954 L 49.5 cm Bronze, edition of 9*

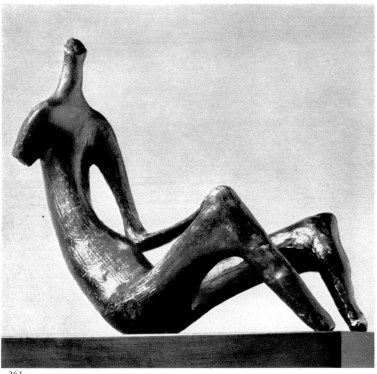

261

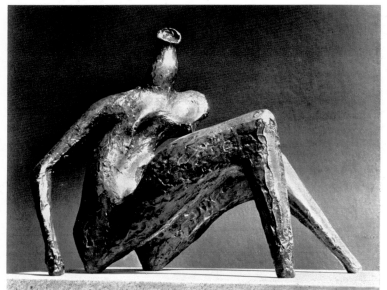

262

One of the things I would like to think my sculpture has is a force, is a strength, is a life, a vitality from inside it, so that you have a sense that the form is pressing from inside trying to burst or trying to give off the strength from inside itself, rather than having something which is just shaped from outside and stopped. It's as though you have something trying to make itself come to a shape from inside itself. This is, perhaps, what makes me interested in bones as much as in flesh because the bone is the inner structure of all living form. It's the bone that pushes out from inside; as you bend your leg the knee gets tautness over it, and it's there that the movement and the energy come from. If you clench a fist, you get in that sense the bones, the knuckles pushing through, giving a force that if you open your hand and just have it relaxed you don't feel. And so the knee, the shoulder, the skull, the forehead, the part where from inside you get a sense of pressure of the bone outwards – these for me are the key points.

You can then, as it were, between those key points have a slack part, as you might between the bridge of a drapery and the hollow of it, so that in this way you get a feeling that the form is all inside it, and this is what also makes me think that I prefer hard form to soft form. For me, sculpture should have a hardness, and because I think sculpture should have a hardness fundamentally I really like carving better than I like modelling. Although I do bronzes, I make the original in plaster which is then turned into bronze, and although anyone can build a plaster up as soft mixture, that mixture hardens and I then file it and chop it and make it have its final shape as hard plaster, not as a soft material.

263 Animal Head *1956 L 55.9 cm Bronze, edition of 10*
264 Bird *1955 L 14 cm Bronze, edition of 12*

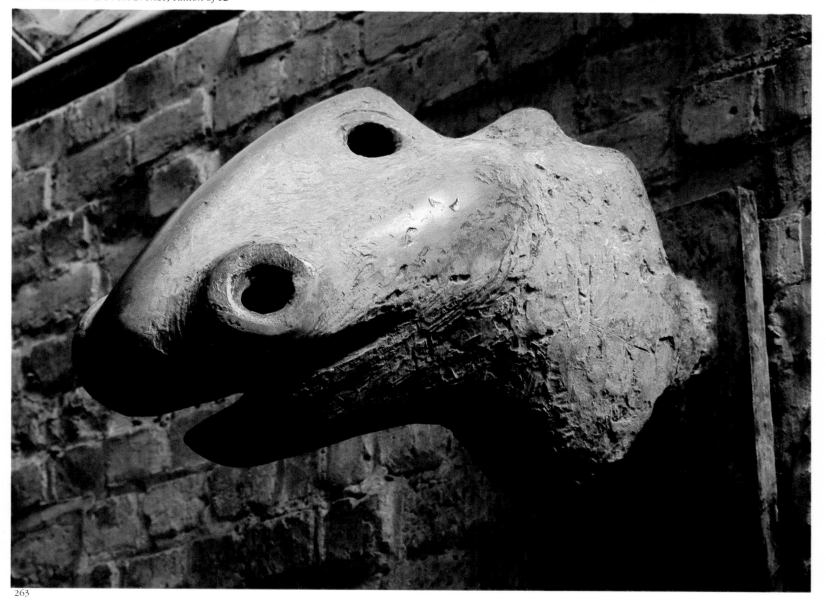

263

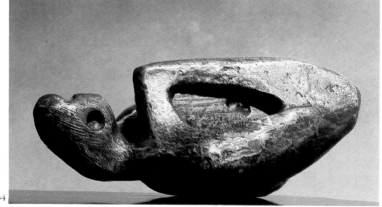

264

265 Head: Lines *1955 H 29.8 cm Bronze, edition of 7*
266 Three Forms Relief *1955 18.4 × 32.4 cm Bronze, edition of 12*

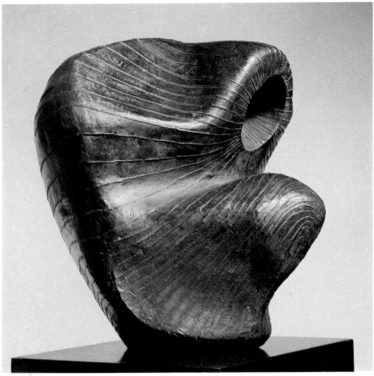

265

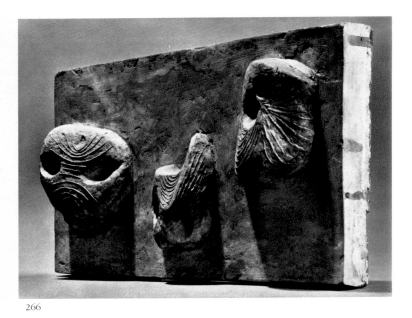

266

Relief sculptures tell best when they get a side light. This relief (*fig 267*) is, unhappily, on a wall facing north and is best photographed only in the summer time – either early in the morning or in late evening when, for short spells, it catches the sun.

This leads me to say that architects often forget about the sun when choosing a site for a sculpture. I think it is because they design their building indoors and often choose what looks like the right spot for a sculpture only from their plans, forgetting the existence and direction of outdoor sunshine.

I made the design for this wall sculpture to be built in brick, but not being a practised bricklayer, I did not myself build it. Holland having little stone of its own, the traditional building material is brick, and Dutch bricklayers are very highly skilled. (The ornamental brickwork on much of their early architecture is marvellous.) I was told not to feel restricted in designing the relief by considerations of the technique of bricklaying, since Dutch bricklayers can build almost anything.

Some of the figures are animal forms with eyes and heads and gave the bricklayers a chance to show what they could do It was a most interesting experience for me. I had fun. I enjoyed it.

267 Wall Relief *1955 8.6 × 19.21 m Brick Bouwcentrum, Rotterdam*

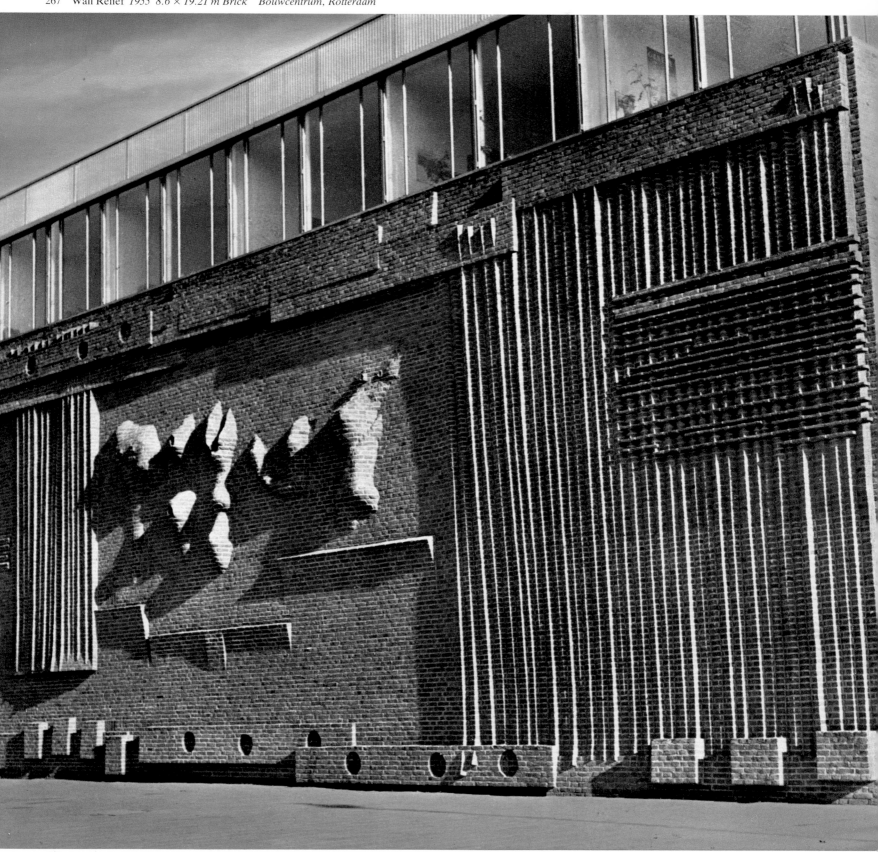

267

In 1955 I was asked to consider making a sculpture for the courtyard of a new building in Milan.

I visited the site and a lone Lombardy poplar growing behind the building convinced me that a vertical work would act as the correct counterfoil to the horizontal rhythm of the building. This idea grew ultimately into the *Upright Motives*.

Back home in England I began a series of maquettes. I started by balancing different forms one above the other – with results rather like the North West American totem poles – but as I continued the attempts gained more unity, also perhaps became more organic – and then one in particular (later to be named *Glenkiln Cross*) took on the shape of a crucifix – a kind of worn-down body and a cross merged into one.

When I came to carry out some of these maquettes in their final full size, three of them grouped themselves together, and in my mind assumed the aspect of a crucifixion scene as though framed against the sky above Golgotha. (But I do not especially ask others to find this symbolism in the group.)

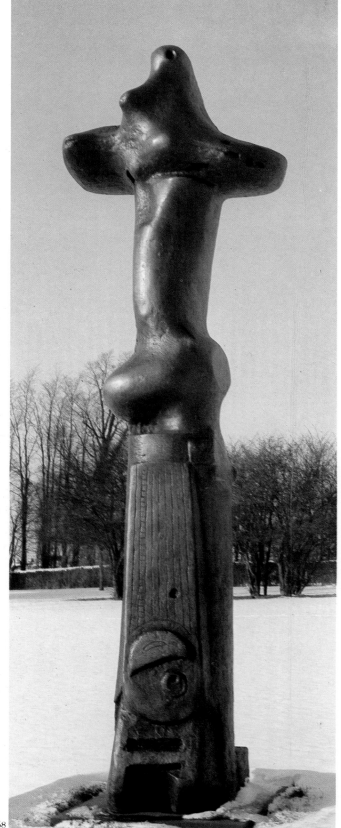

268

268 Upright Motive No. 1: Glenkiln Cross *1955–6 H 3.35 m Bronze, edition of 6*
269 Three Upright Motives: Nos. 1, 2 and 7 *1955–6 Bronze*
270 Upright Motive No. 5 *1955–6 H 2.13 m Bronze, edition of 7*
271 Upright Motive No. 8 *1955–6 H 1.98 m Bronze, edition of 7*

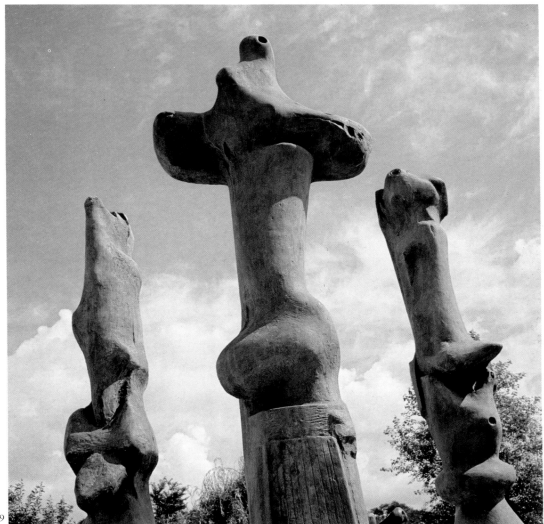
269

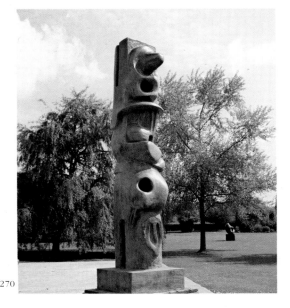
270

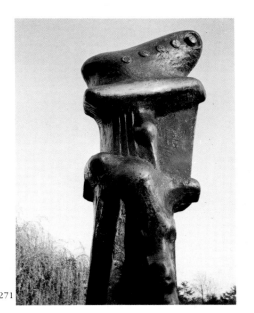
271

272, 273 Reclining Figure *1956 L 2.44 m Bronze, edition of 8*
 274 Upright Figure *1956–60 H 2.74 m Elmwood Solomon R. Guggenheim Museum, New York*

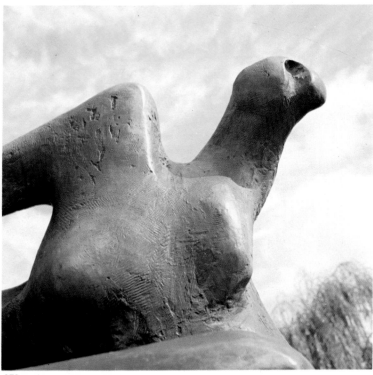

272

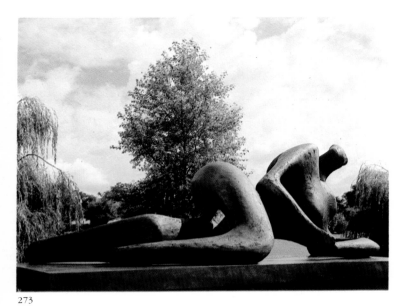

273

This elmwood sculpture (*fig 274*) began as a reclining figure but there came a stage when to get at some parts and to see it while I was carving, I put it upright, and it became instead of a static figure one that was actually climbing – a figure in action, and I liked this. It gave me completely fresh thoughts about it. I altered some little bits and it has remained an upright sculpture ever since, even though it began as a reclining figure. It's an ascending figure going up into the sky.

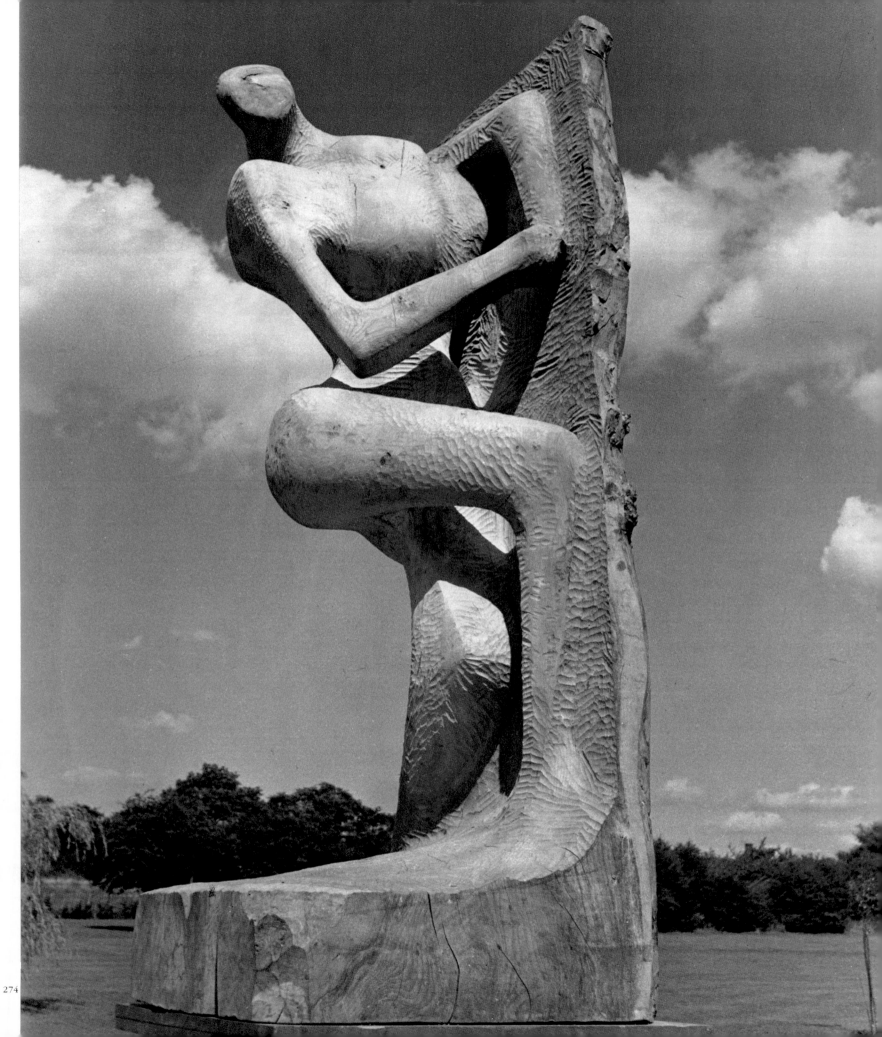

274

275 Maquette for Fallen Warrior *1956 L 22.8 cm Bronze, edition of 9*
276, 277 *Plaster model for* Falling Warrior *in progress*
278, 279 Falling Warrior *1956–7 L 1.47 m Bronze, edition of 10*

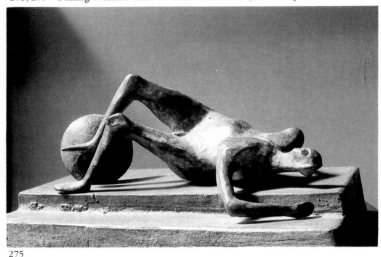

275

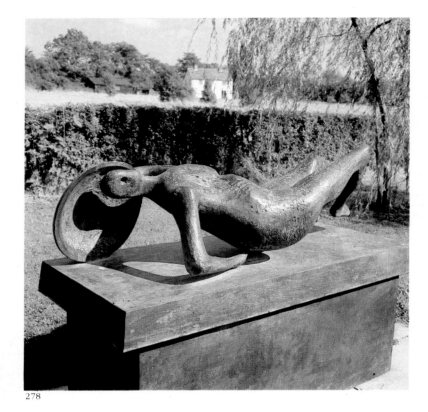

278

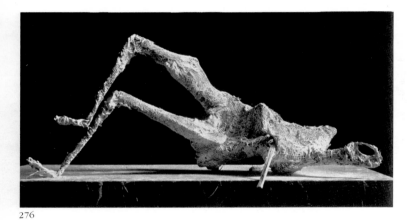

276

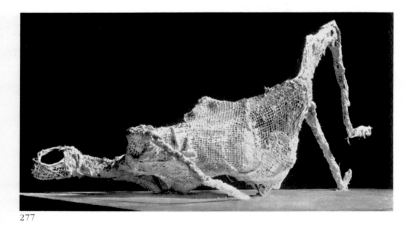

277

In the *Falling Warrior* sculpture I wanted a figure that was still alive. The pose in the first maquette was that of a completely dead figure and so I altered it to make the action that of a figure in the act of falling, and the shield became a support for the warrior, emphasising the dramatic moment that precedes death.

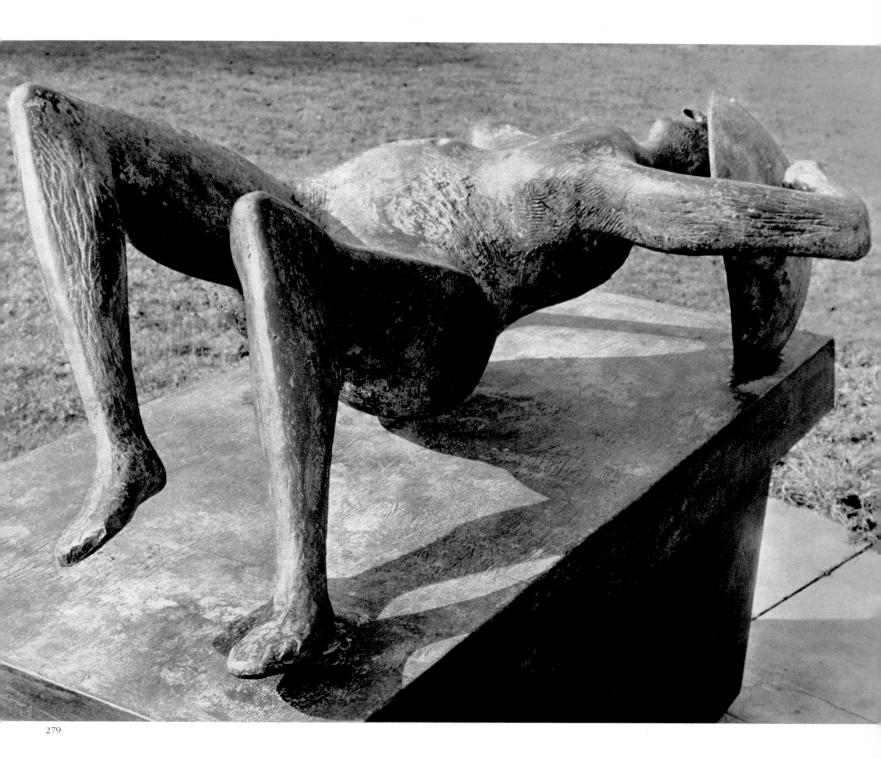

279

280 Seated Girl *1956 H 21 cm Bronze, edition of 9*
281 Mother and Child No. 4 *1956 L 17.1 cm Bronze, edition of 9*
282 Seated Woman with Book *1956, cast 1964 H 20.3 cm Bronze, edition of 9*
283 Armless Seated Figure against Round Wall *1957 H 27.9 cm Bronze, edition of 12*
284 Reclining Figure: Goujon *1956, cast 1971 L 24 cm Bronze, edition of 9*
285 Seated Figure on Circular Steps *1957 L 26 cm Bronze, edition of 9*
286 Woman with Cat *1957 H 21.6 cm Bronze, edition of 2*
287 Seated Woman with Crossed Feet *1957, cast 1965 H 11.4 cm Bronze, edition of 6*
288 Draped Reclining Figure *1957 L 73.6 cm Bronze, edition of 11*

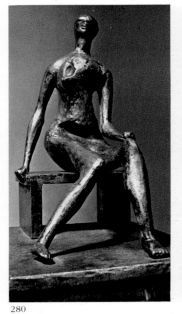
280

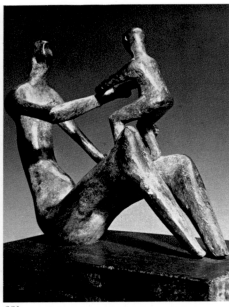
281

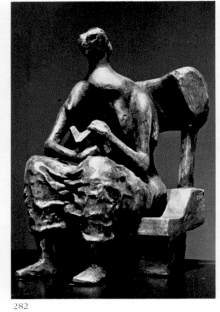
282

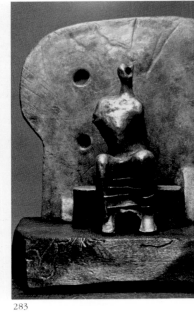
283

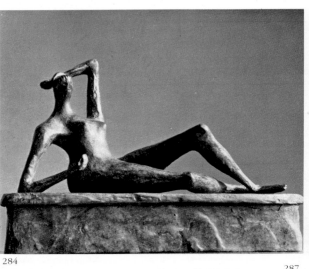
284

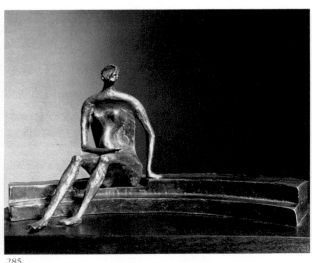
285

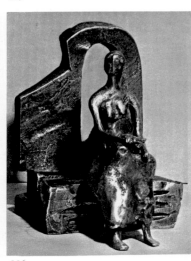
286

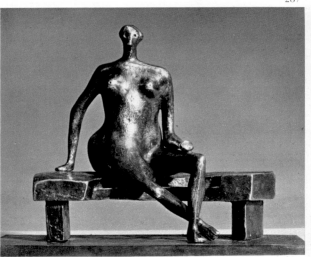
287

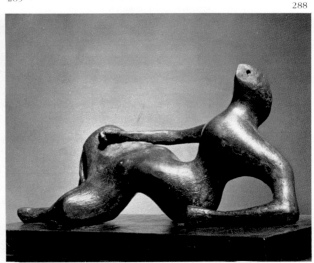
288

289 Girl Seated against Square Wall *1958 H 1.01 m Bronze, edition of 12*
290, 291 Mother and Child with Apple *1956 H 74.3 cm Bronze, edition of 10*
292 Seated Figure against Curved Wall *1956–7 L 81.2 cm Bronze, edition of 12*
293 Mother and Child *1958, cast 1974 H 11 cm Bronze, edition of 7*
294 Reclining Figure *1957 L 69.8 cm Bronze, edition of 12*

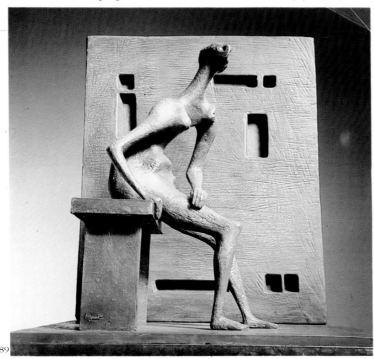

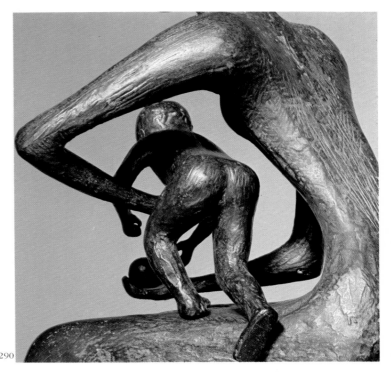

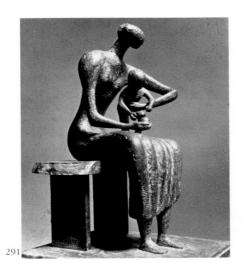

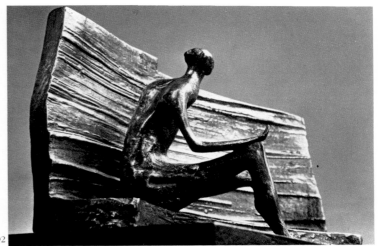

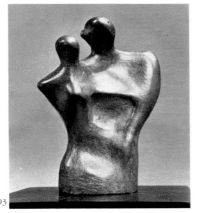

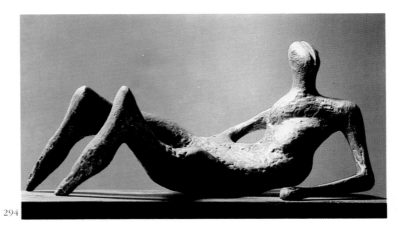

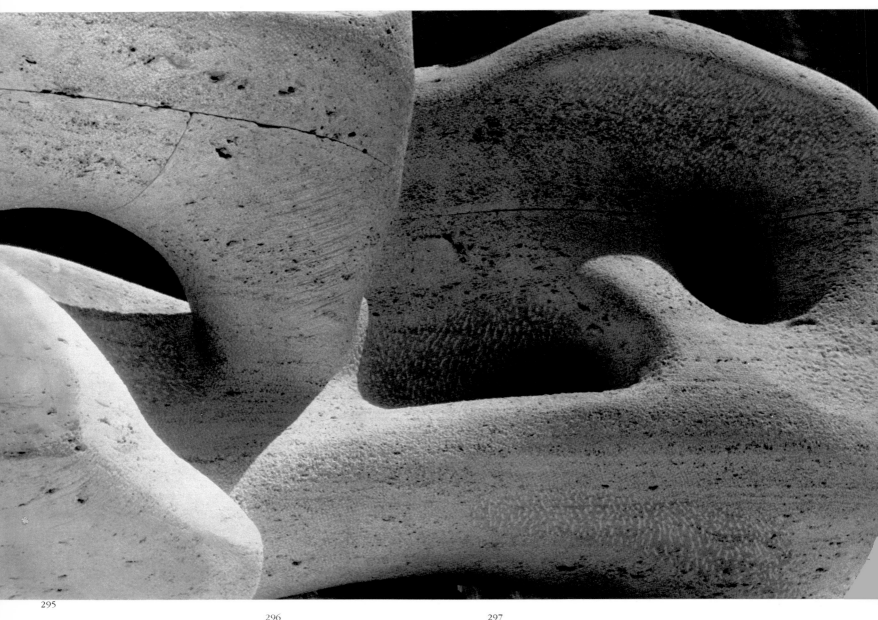

295

296

297

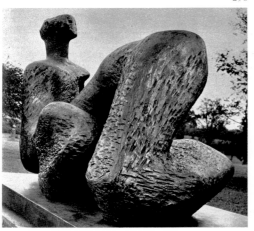

UNESCO originally asked me for a bronze. I did some drawings with that in mind, but as I thought about it, I realised that since bronze goes dark outdoors and the sculpture would have as its background a building that is mostly glass, which looks black, the fenestration would have been too much the same tone, and you would have lost the sculpture. So then I worked on the idea of siting the figure against a background of its own, but then, inside the building you wouldn't have had a view of the sculpture. Half the views would have been lost. So I finally decided the only solution was

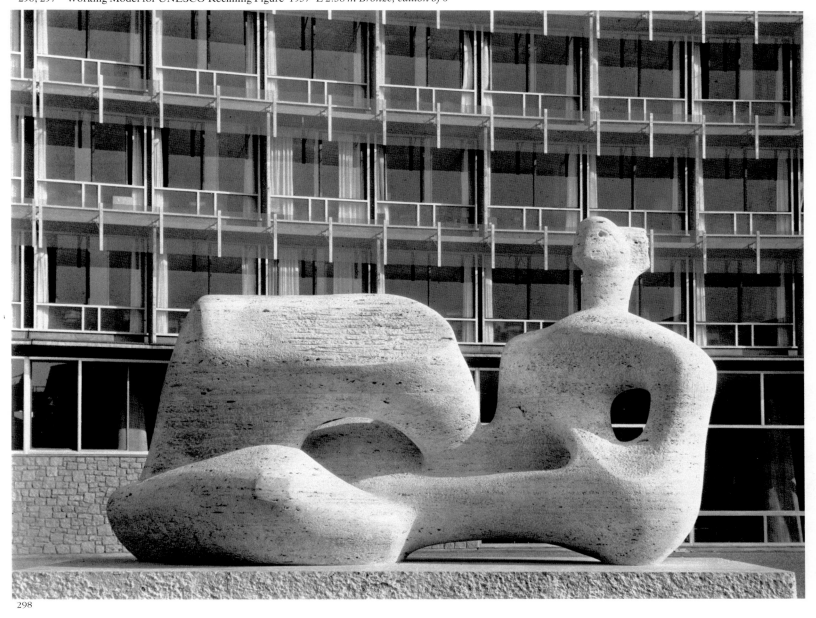

298

to use a light-coloured stone they'd used for the top of the building – travertine. It's a beautiful stone. I'd always wanted to do a large piece in it. At the unveiling it looked too white – all newly carved stone has a white dust on it – but on my last trip to Paris, I went to UNESCO, and saw that it's weathering nicely. In ten or twenty years' time with the washing of the Paris rain, it will be fine. Half of Rome is built of travertine.

Of course, it was a harder job than it would have been if I'd done it in bronze. When you carve, you're dealing with the absolute final piece. The practical problems are much greater than those you have with a large bronze. If I'd done it in bronze, the original

would have been in plaster, and hollow. I'd have cut it up and shipped it off to the bronze founder, and the practical problems would have been his.

When I'm doing pieces for bronze I work occasionally in soft clay which has to be cast in plaster. Generally, though, I work directly in plaster, building it up on a wooden framework. I put it on with a trowel or a spatula. It hardens in a quarter of an hour, and I can cut it down and build it up again.

143

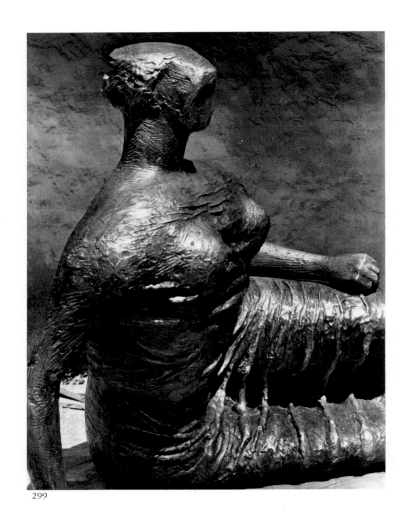

299

I knew that the big, draped, seated figure (*figs 300, 301*) was going to be shown out of doors and this created the problem that the folds in the drapery could collect dirt and leaves and pockets of water. I solved it by making a drainage tunnel through the drapery folds between the legs. I found that using drapery in sculpture was a most enjoyable exercise in itself.

299, 302, 303 Draped Reclining Woman *1957–8 L 2.08 m Bronze, edition of 6*
300, 301 Draped Seated Woman *1957–8 H 1.85 m Bronze, edition of 6*

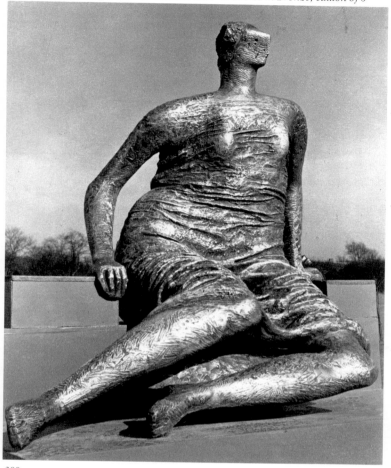

300

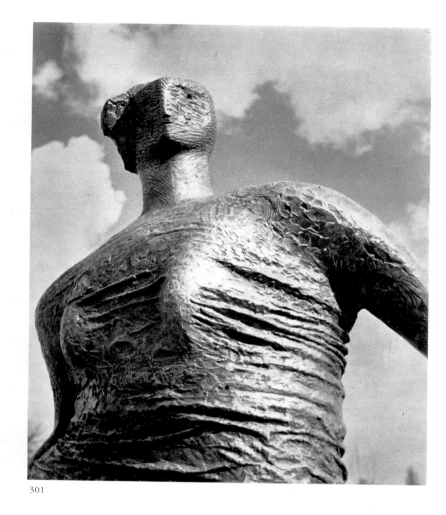

301

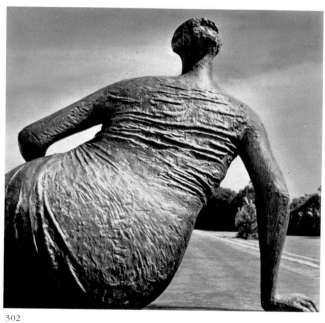

302

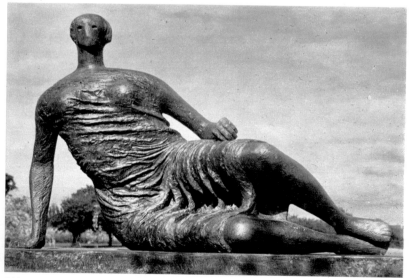

303

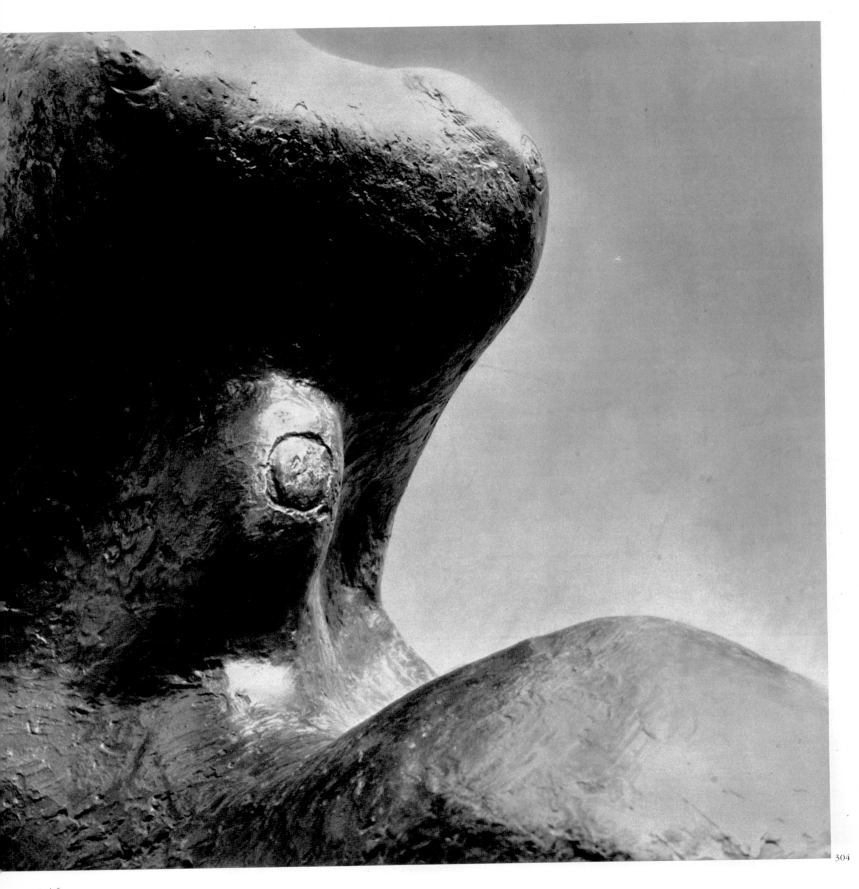

304, 305　Woman　*1957–8　H 1.52 m Bronze, edition of 8*
306, 307　Seated Woman　*1957　H 1.44 m Bronze, edition of 6*

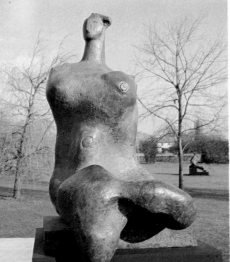

305

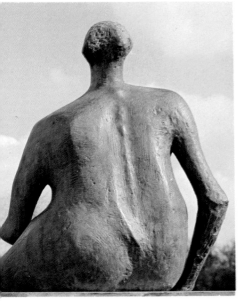

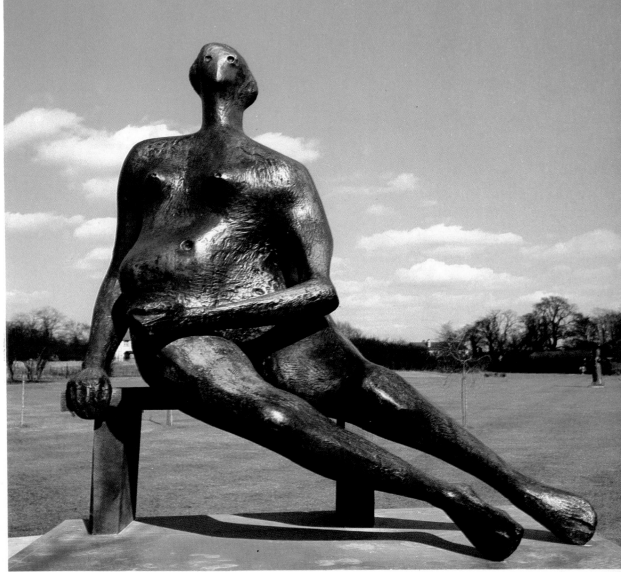

306　　307

Right from the beginning I have been more interested in the female form than in the male. Nearly all my drawings and virtually all my sculptures are based on the female form. *Woman* has that startling fullness of the stomach and the breasts. The smallness of the head is necessary to emphasise the massiveness of the body. If the head had been any larger it would have ruined the whole idea of the sculpture. Instead the face and particularly the neck are more like a hard column than a soft goitred female neck.

Woman emphasis fertility like the Paleolithic Venuses in which the roundness and fullness of form is exaggerated.

308 Horse *1959 H 19 cm Bronze, edition of 2*
309 Rearing Horse *1959, cast 1972 H 20.3 cm with base*
 Bronze, edition of 9

308

309

Although my work is fundamentally based on the human figure – and it's the human figure that I have studied, drawn from, modelled as a student, and then taught for many years at college – because the human being is an animal and alive, naturally one is also interested in animal forms which again are organic, alive and can move. I see a lot of connections between animals and human beings and I can get the same kind of feelings from an animal as from the human being. There can be a virility, a dignity or there can be a tenderness, a vulnerability. To me they are all organic life and life that can move, which is different from plant life which ordinarily is rooted. Of course the human figure is still the most interesting for me because it expresses one's own feelings, but animal form is still very alive. I can see animals in anything, really.

310 Bird *1959 L 38.1 cm Bronze, edition of 12*
311 Fledgling *1960 L 17.8 cm Bronze, edition of 9*
312 Headless Animal *1960 L 24.2 cm Bronze, edition of 6*
313 Animal Form *1959 H 34.3 cm Bronze, edition of 8*
314 Sheep *1960 L 24.2 cm Bronze, edition of 9*

310

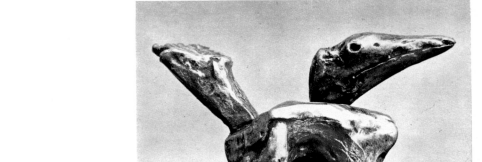

311

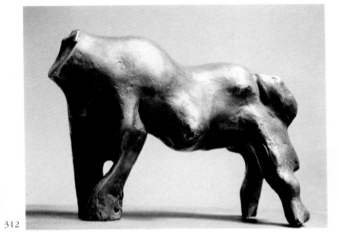

312

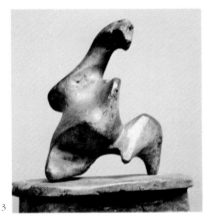

313

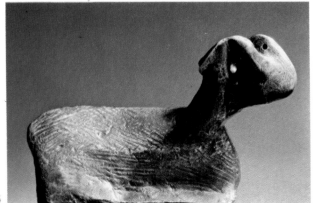

314

315 Three Quarter Figure *1961 H 38.1 cm Bronze, edition of 9*
316 Seated Figure with Arms Outstretched *1960 H 16 cm Bronze, edition of 9*
317 Helmet Head No. 3 *1960 H 29.2 cm Bronze, edition of 10*
318 Sculptural Object *1960 H 46.3 cm Bronze, edition of 10*
319 Square Head *1960 H 28 cm Bronze, edition of 9*
320 Mother and Child *1959 L 49.5 cm Bronze, edition of 6*
321 Two Seated Figures against Wall *1960 H 48.2 cm Bronze, edition of 12*

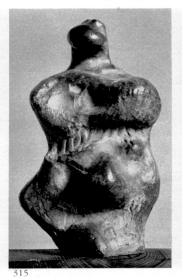

315

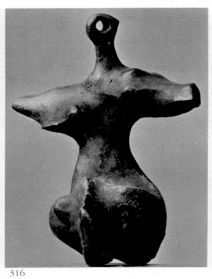

316

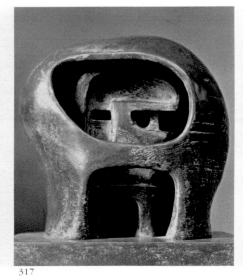

317

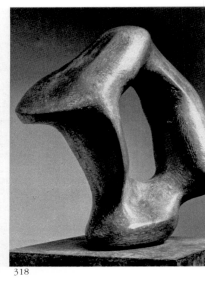

318

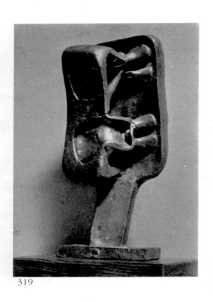

319

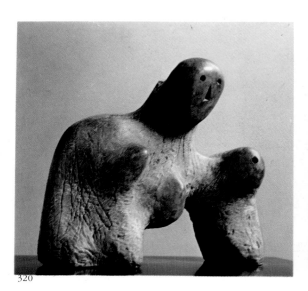

320

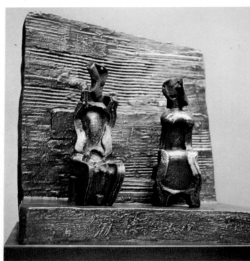

321

322 Three Part Object *1960 H 1.23 m Bronze, edition of 9*
323 Relief No. 1 *1959 H 2.23 m Bronze, edition of 6*
324 Three Motives against Wall No. 2 *1959 L 1.08 m Bronze, edition of 10*
325 Three Motives against Wall No. 1 *1958 L 1.06 m Bronze, edition of 12*

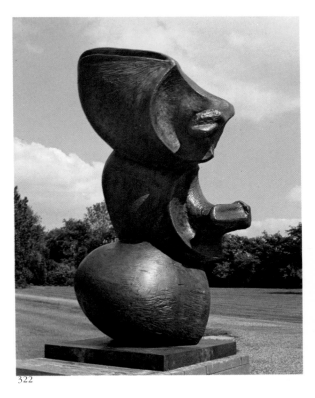
322

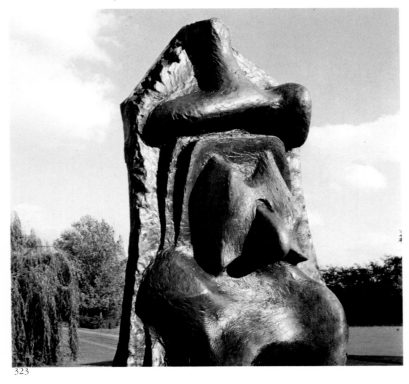
323

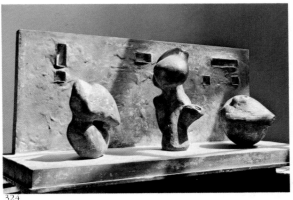
324

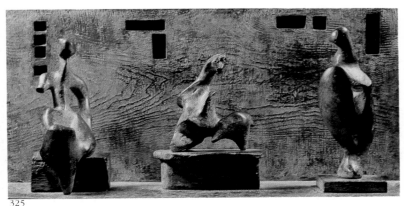
325

Sometimes I make ten or twenty maquettes for every one that I use in a large scale – the others may get rejected. If a maquette keeps its interest enough for me to want to realise it as a full-size final work, then I might make a working model in an intermediate size, in which changes will be made before going to the real, full-sized sculpture. Changes get made at all these stages.

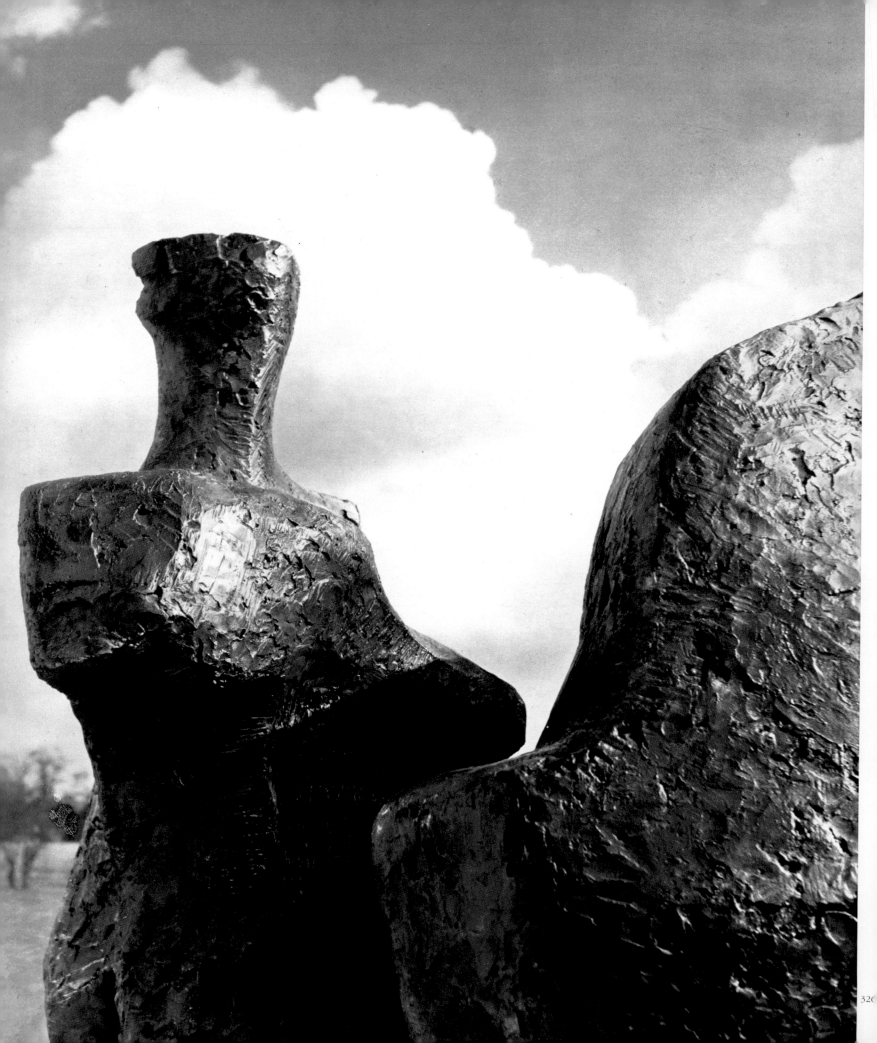

326–8 Two Piece Reclining Figure No. 1 *1959 L 1.93 m Bronze, edition of 6*
329 *Henry Moore at work on* Reclining Figure *1959–64*

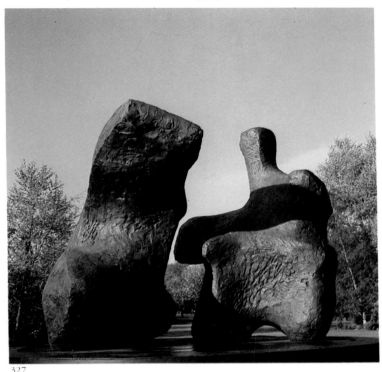

327

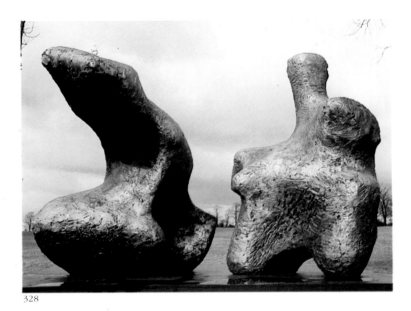

328

My *Two Piece Reclining Figure No. 1* of 1959 is a mixture of rock form and mountains combined with the human figure. I didn't reason it out like this, but I think that this is the explanation. Breaking it in half made it a less obvious, a less realistic figure. In the maquette the leg and the head end were joined but when I came to enlarge the sculpture there was a stage when the junction between the leg and head didn't seem necessary. Then I realised that dividing the figure into two parts made many more three-dimensional variations than if it had just been a monolithic piece.

This was something I'd wanted to do in sculpture for a long time. It led on to several other two-piece sculptures and eventually to three-piece ones. As early as 1932 I had divided figures up into two, three or four parts, and so this wasn't an entirely new thing for me, but now I was using the space more sculpturally than I had earlier.

The leg end began to remind me as I was doing it of Seurat's *Le Bec du Hoc*, which Kenneth Clark owned. I had seen it on numerous occasions and have always admired it tremendously.

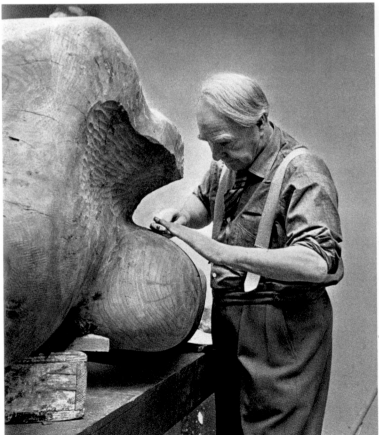

329

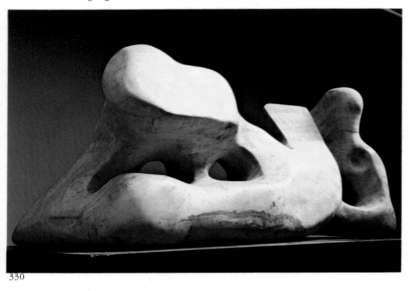

330

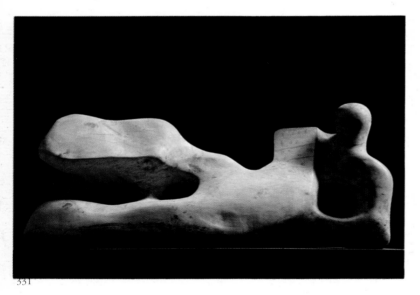

331

332

I like working with elmwood because its big grain makes
it suitable for large sculptures, and because of the cool
greyness of the wood. An interesting point about
working with wood is that it must come from a live tree.
Dead wood, by which I mean wood from a tree that has
died, has no qualities of self-preservation and rots away.
 Finishing a large wood sculpture is like a nibbling
mouse gnawing a hole in a wall.

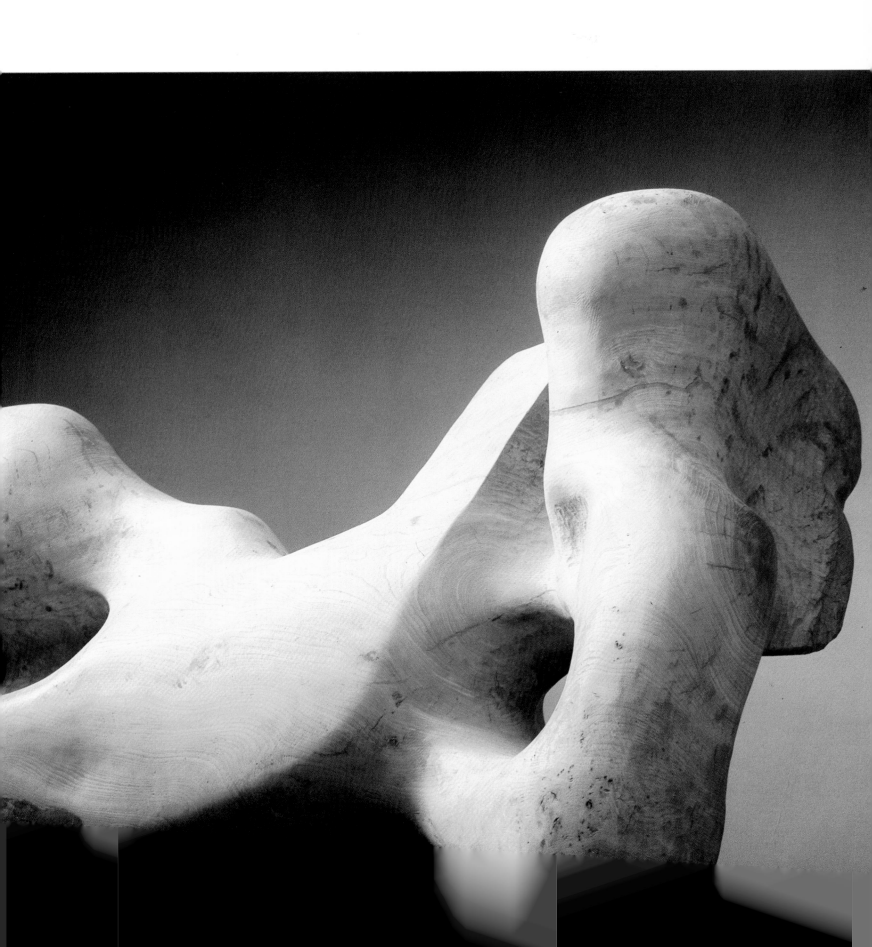

333, 334 Two Piece Reclining Figure No. 2 *1960 L 2.59 m Bronze, edition of 7*

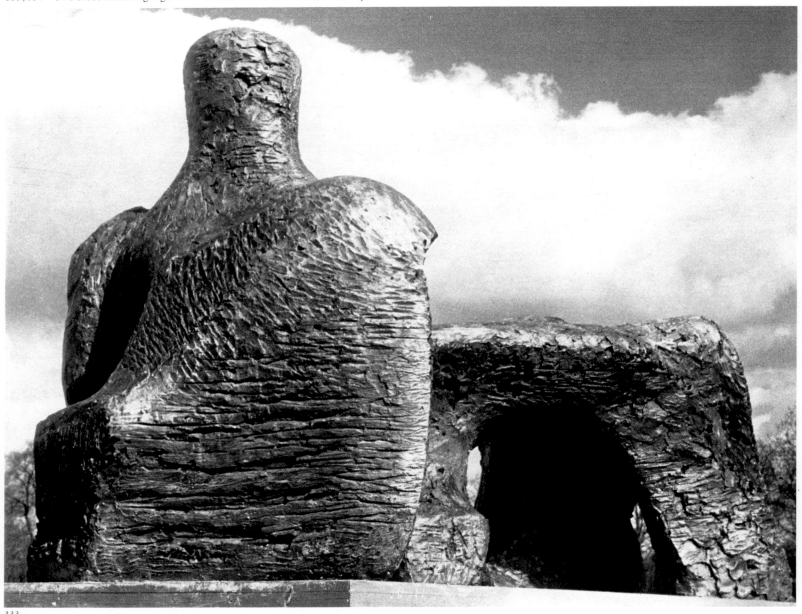

333

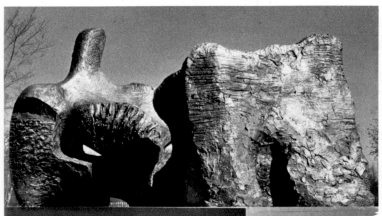

334

I realised what an advantage a separated two-piece composition could have in relating figures to landscape. Knees and breasts are mountains. Once these two parts become separated you don't expect it to be a naturalistic figure; therefore, you can justifiably make it like a landscape or a rock. If it is a single figure, you can guess what it's going to be like. If it is in two pieces, there's a bigger surprise, you have more unexpected views; therefore the special advantage over painting – of having the possibility of many different views – is more fully exploited.

The front view doesn't enable one to foresee the back view. As you move round it, the two parts overlap or they open up and there's space between. Sculpture is like a journey. You have a different view as you return. The three-dimensional world is full of surprises in a way that a two-dimensional world could never be . . .

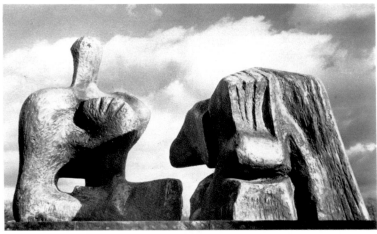

335

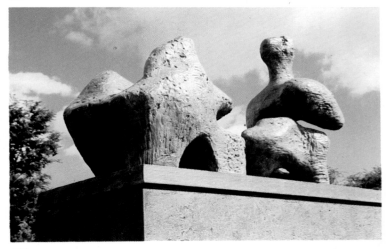

336 337

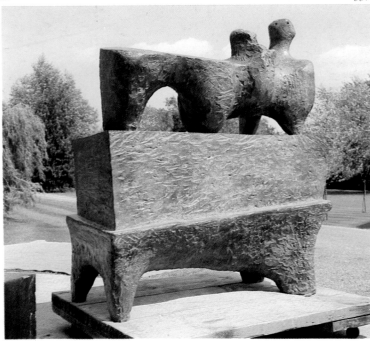

338–40 Reclining Mother and Child *1960–1 L 2.19 m Bronze, edition of 7*

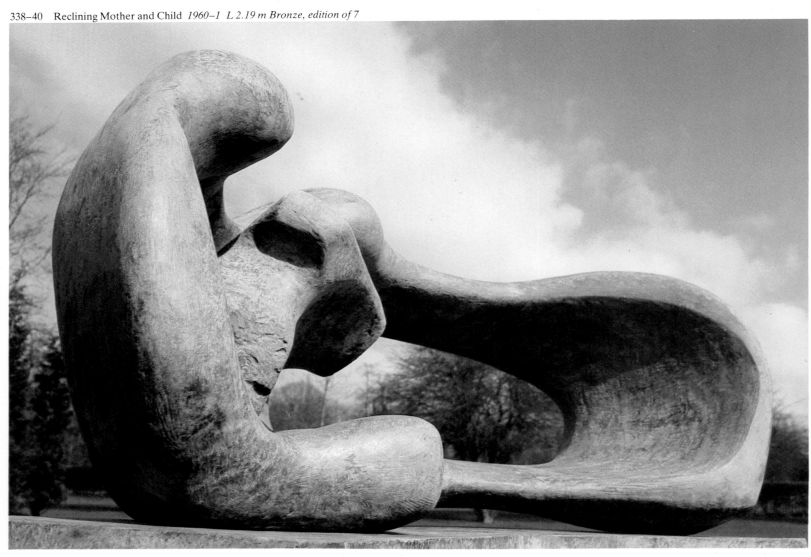

338

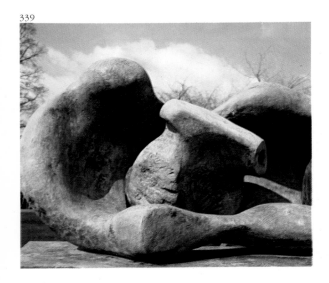

339

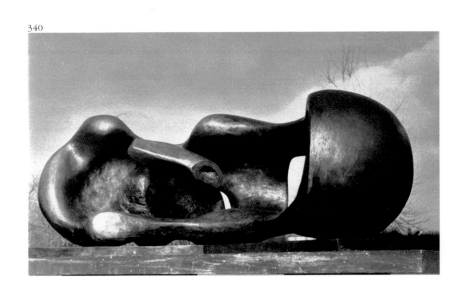

340

341 Seated Woman: Thin Neck *1961 H 1.62 m Bronze, edition of 7*

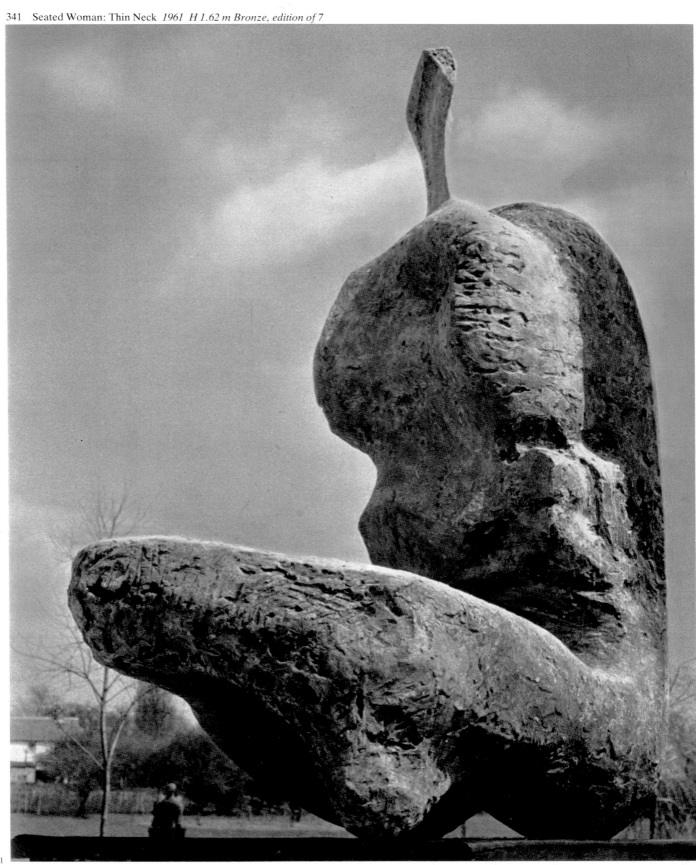

341

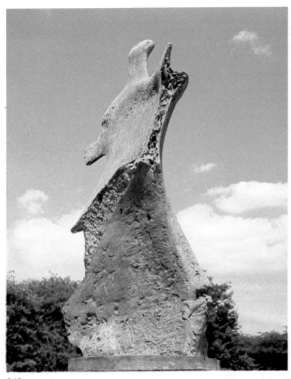

342

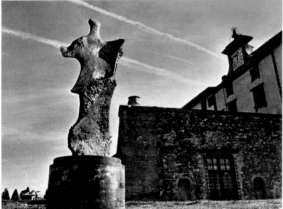

343

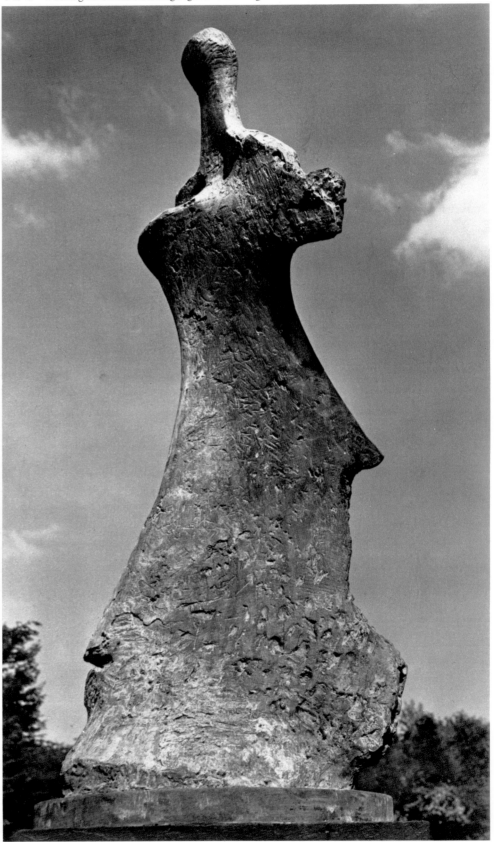

344

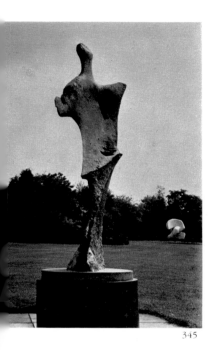

345

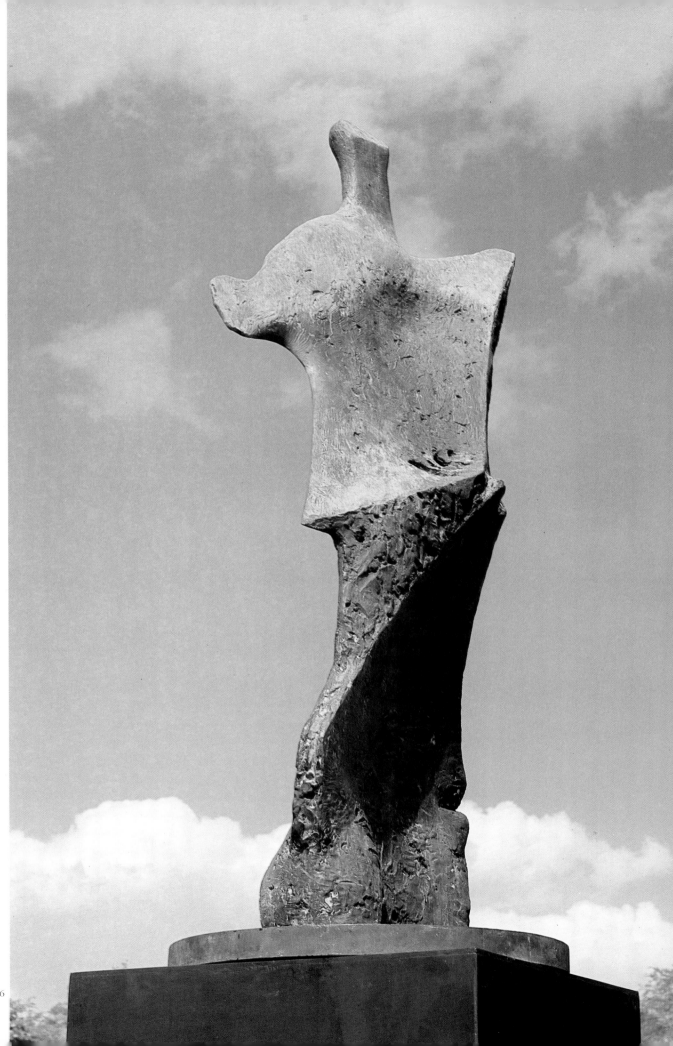

346

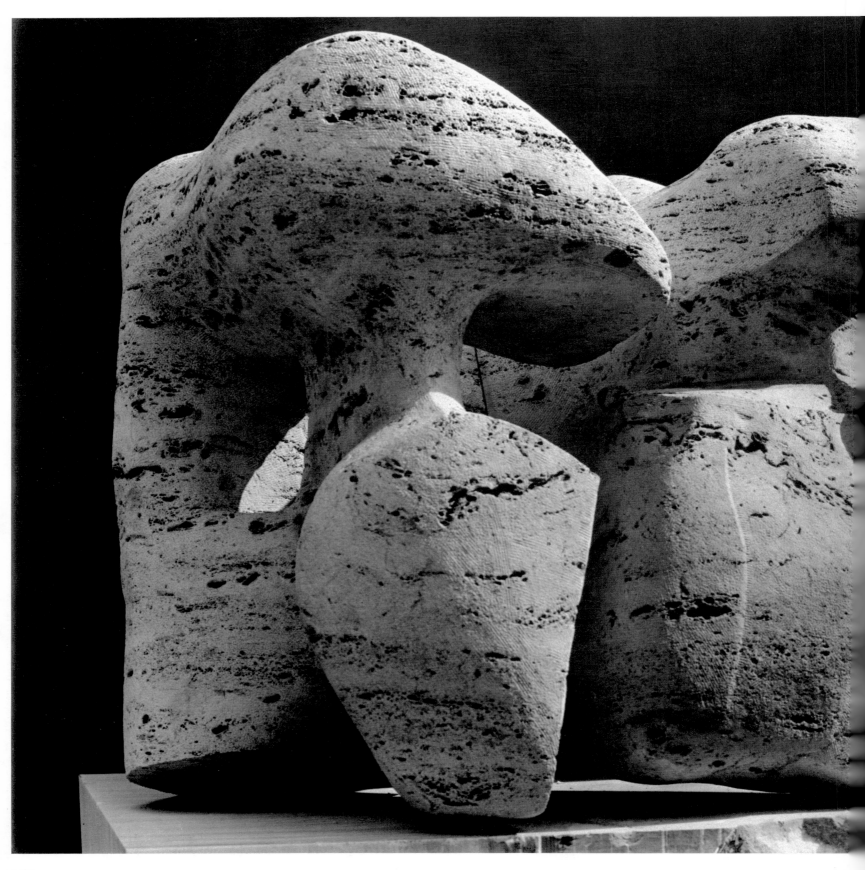

347, 348 Stone Memorial *1961–9 L 1.80 m Travertine marble National Gallery, Washington DC*
349 Large Slow Form *1962–8 L 77 cm Bronze, edition of 9*

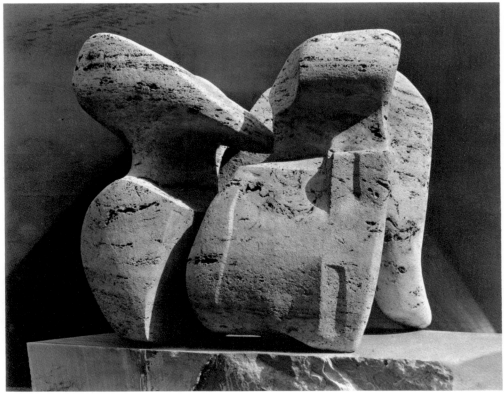

348

347

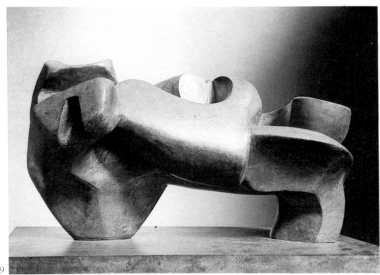

349

350 Reclining Figure: Bunched *1961–9 L 1.90 m Yellow travertine marble Lord and Lady Rayne, London*
351, 352 Three Piece Reclining Figure No. 1 *1961–2 L 2.87 m Bronze, edition of 7*

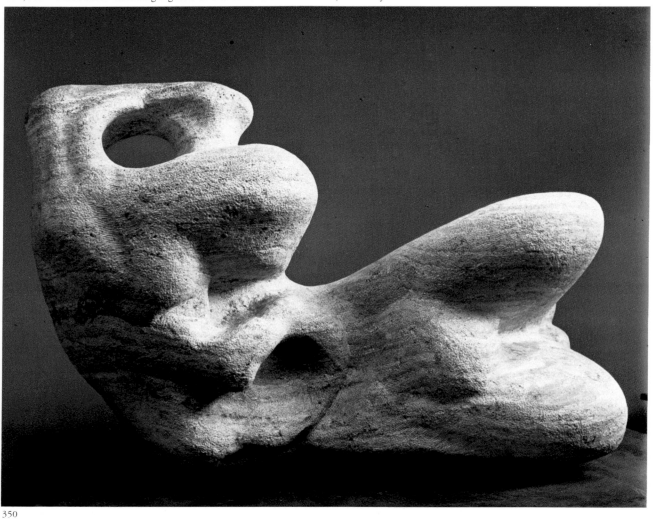

350

351

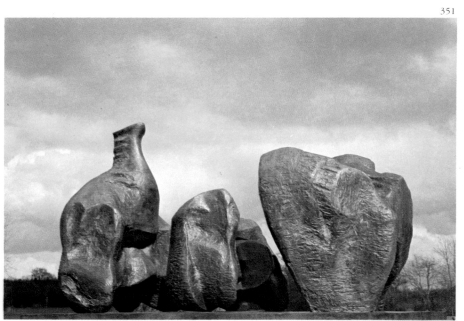

352

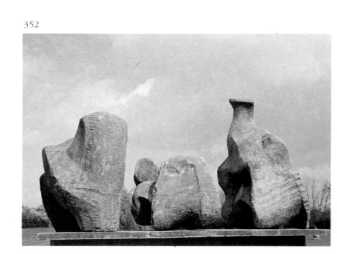

353, 354 Three Piece Reclining Figure No. 2: Bridge Prop *1963 L 2.51 m Bronze, edition of 6*

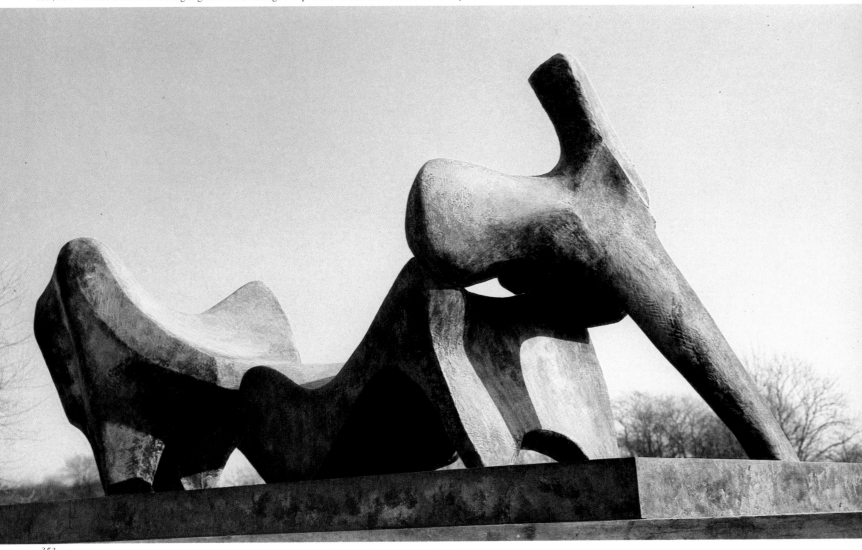

353

The two words Bridge and Prop came about because if one looks at the sculpture, with its base at eye level, then it makes a series of arches, or bridges (it reminded me while doing it of the views underneath Waterloo Bridge from the Embankment, which I often pass when taking a taxi from Liverpool Street Station to the West End).

354

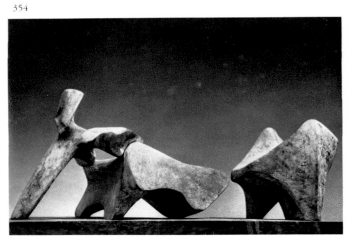

Bronze is a wonderful material, it weathers and lasts in all climates. One only has to look at the ancient bronzes, for example, the Marcus Aurelius equestrian statue in Rome. I love to stand beneath this statue, because it is so big. Under the belly of the horse, the rain has left marks which emphasise the section where it has run down over the centuries. This statue is nearly two thousand years old, yet the bronze is in perfect condition. Bronze is really more impervious to the weather than most stone.

I like working on all my bronzes after they come back from the foundry. A new cast to begin with is just like a new-minted penny, with a kind of slight tarnished effect on it. Sometimes this is all right and suitable for a sculpture, but not always. Bronze is very sensitive to chemicals, and bronze naturally in the open air (particularly near the sea) will turn with time and the action of the atmosphere to a beautiful green. But sometimes one can't wait for nature to have its go at the bronze, and you can speed it up by treating the bronze with different acids which will produce different effects. Some will turn the bronze black, others will turn it green, others will turn it red.

In doing your sculpture you have imagined a certain quality in the bronze. No sculptor works direct in bronze; you can't take a solid piece of bronze and cut it to the shape you want, so all sculptors who intend having their work in bronze are working with a mental idea of what it is going to look like, while they make it in some other material.

I usually have an idea, as I make a plaster, whether I intend it to be a dark or a light bronze, and what colour it is going to be. When it comes back from the foundry I do the patination and this sometimes comes off happily, though sometimes you can't repeat what you have done other times. The mixture of bronze may be different, the temperature to which you heat the bronze before you put the acid on to it may be different. It is a very exciting but tricky and uncertain thing, this patination of bronze.

And also afterwards you can then work on the bronze, work on the surface and let the bronze come through again, after you've made certain patinas. You rub it and wear it down as your hand might by a lot of handling. From this point of view bronze is a most responsive and unbelievably varied material, and it will go on being a favourite material for sculptors. You can, in bronze, reproduce any other material you care to.

355 Knife Edge Two Piece *1962–5 L 3.65 m Bronze, edition of 3*

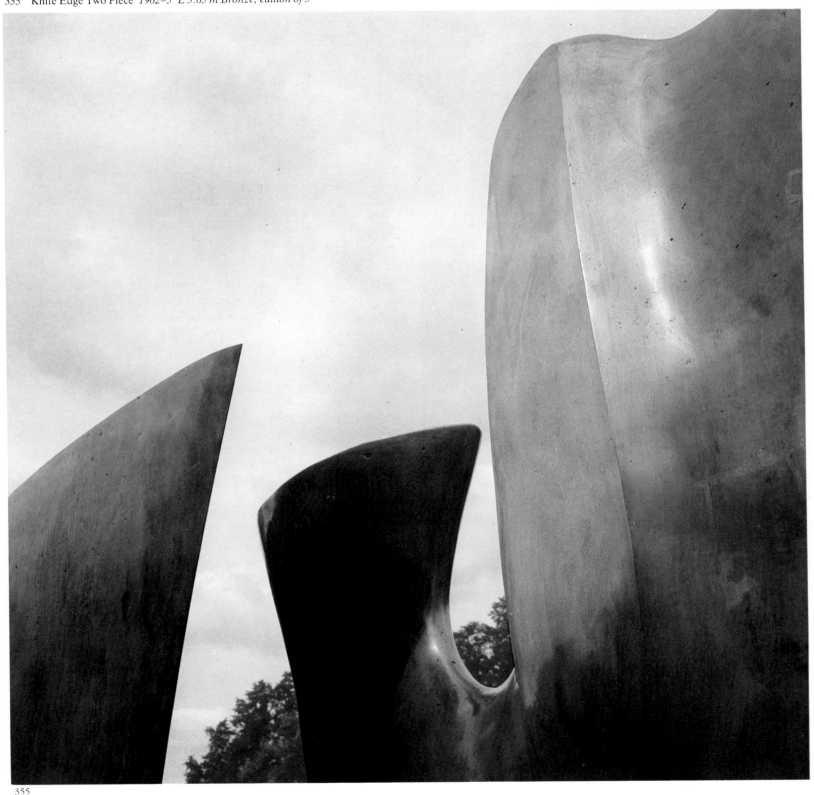

355

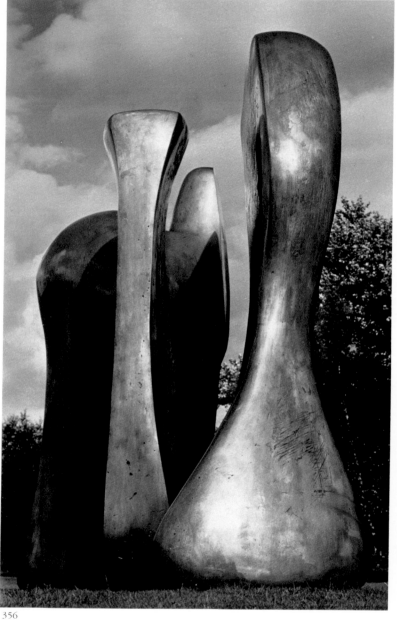

356

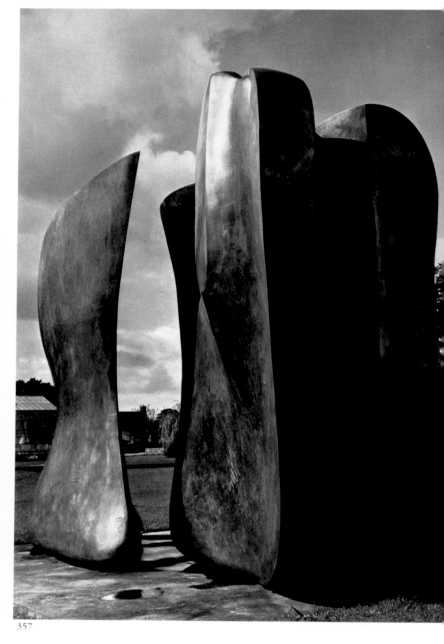

357

There are many structural and sculptural principles to be learnt from bones – e.g. that in spite of their lightness they have great strength. Some bones such as the breastbones of birds have the lightweight fineness of a knife blade. Finding such a bone led to me using this knife-edge thinness in 1961 in a sculpture *Seated Woman: Thin Neck* (*fig 341*).

In this figure the thin neck and head, though by contrast with the width and bulk of the body, gives more monumentality to the work. Later in 1961 I used this knife-edged thinness throughout a whole figure, and produced the *Standing Figure: Knife Edge* (*figs 342–6*).

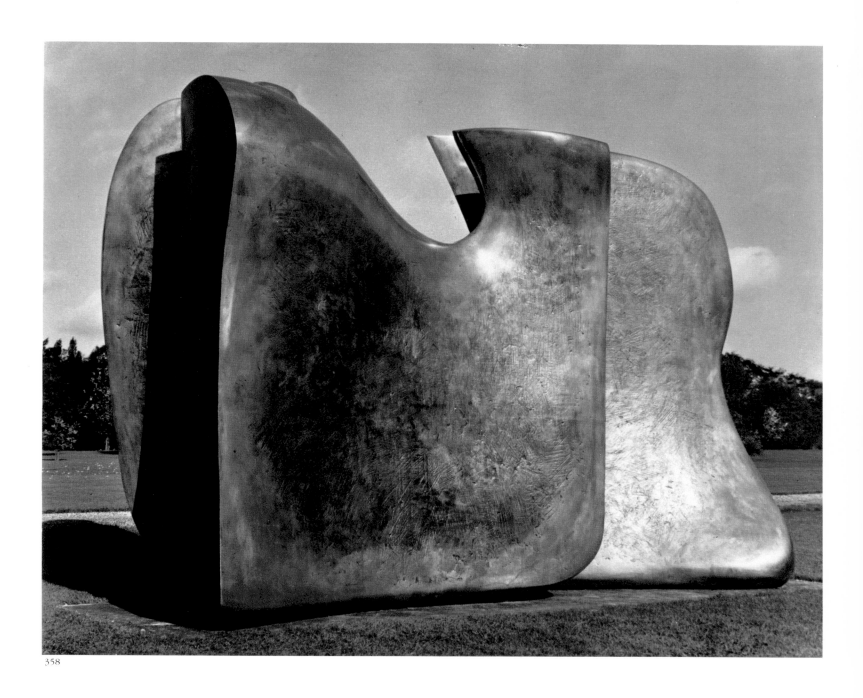

358

359–62 Locking Piece *1963–4 H 2.92 m Bronze, edition of 3*

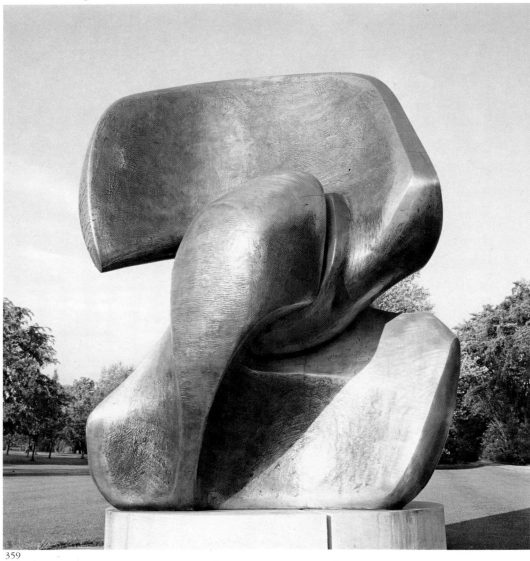

359

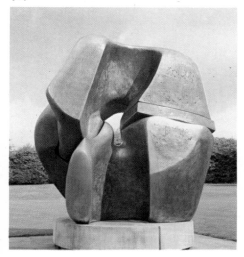

360

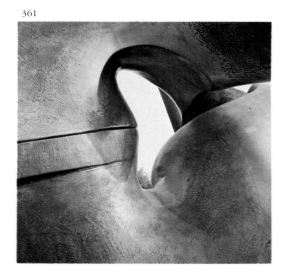

361

Sculpture has some disadvantages compared with painting, but it can have one great advantage over painting, that it can be looked at from all round – and if this attribute is used and fully exploited then it can give to sculpture a continual, changing, never-ending surprise and interest.

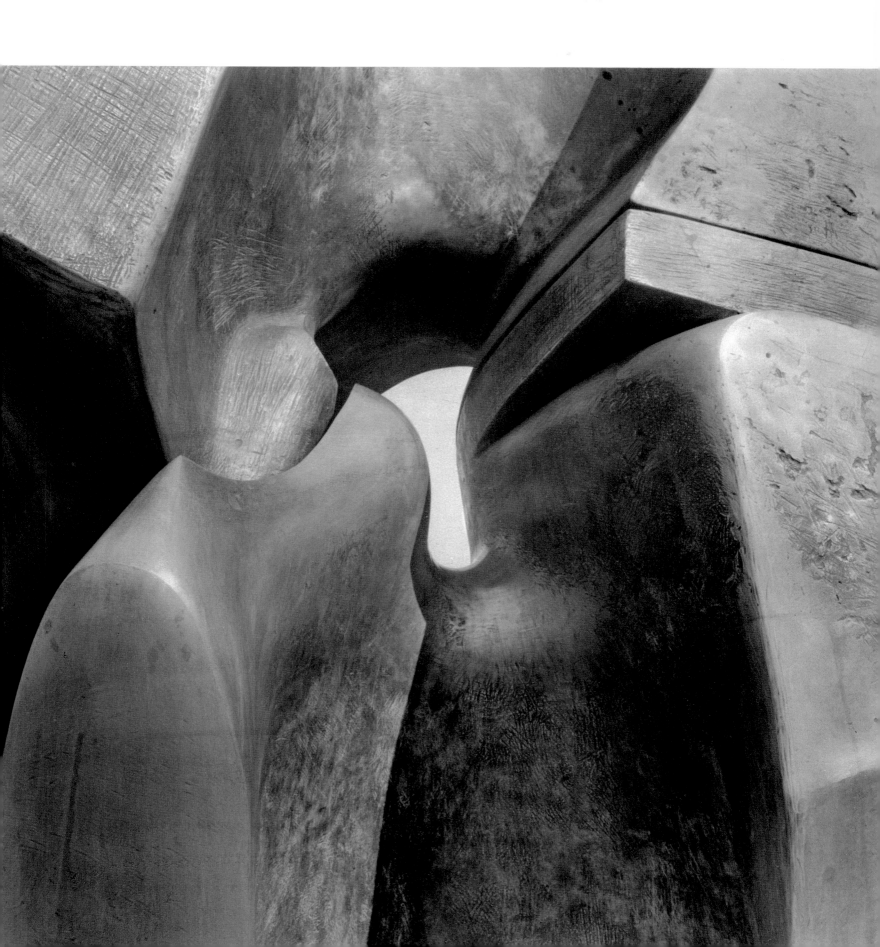

363–5 Two Piece Reclining Figure No. 5 *1963–4 L 3.72 m Bronze, edition of 3*

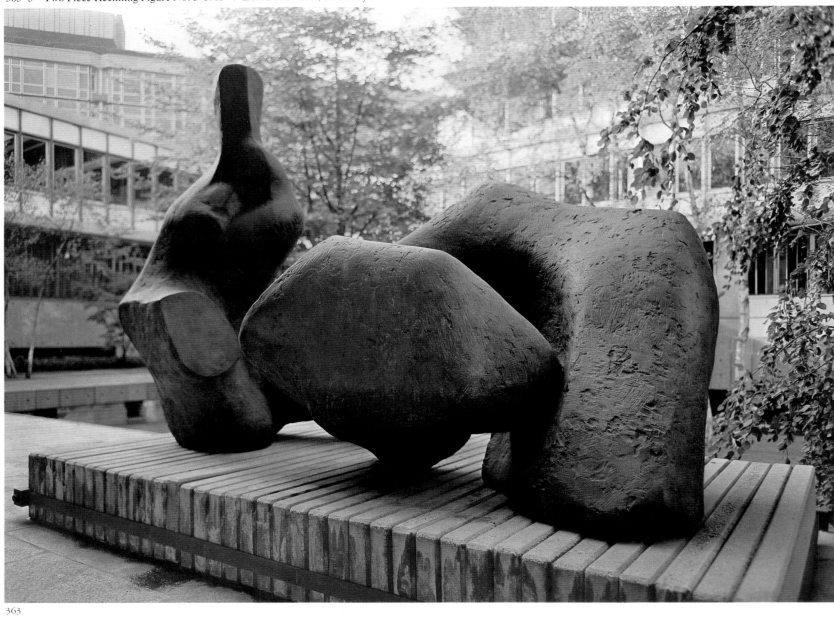

363

364

365

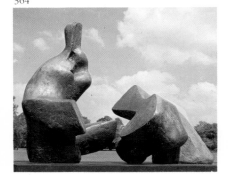

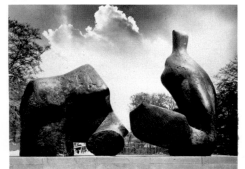

366, 367 Working Model for Reclining Figure: Lincoln Center *1963–5 L 4.27 m Bronze, edition of 2*
 368 Reclining Figure *1963 L 8.54 m Bronze, unique cast Lincoln Center for the Performing Arts, New York*

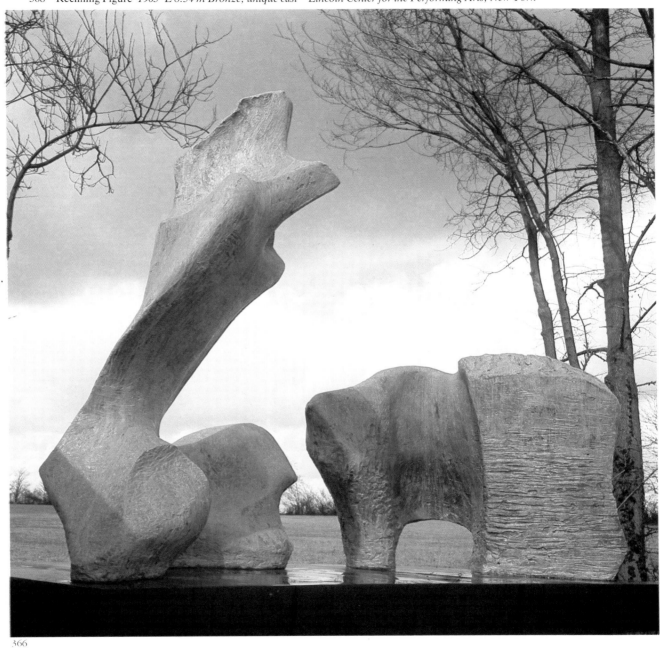

366

367

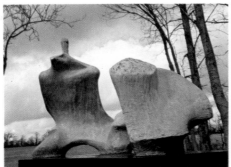

368

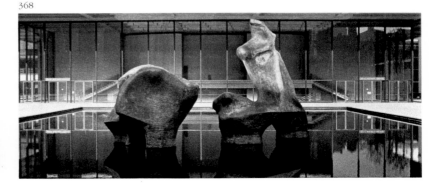

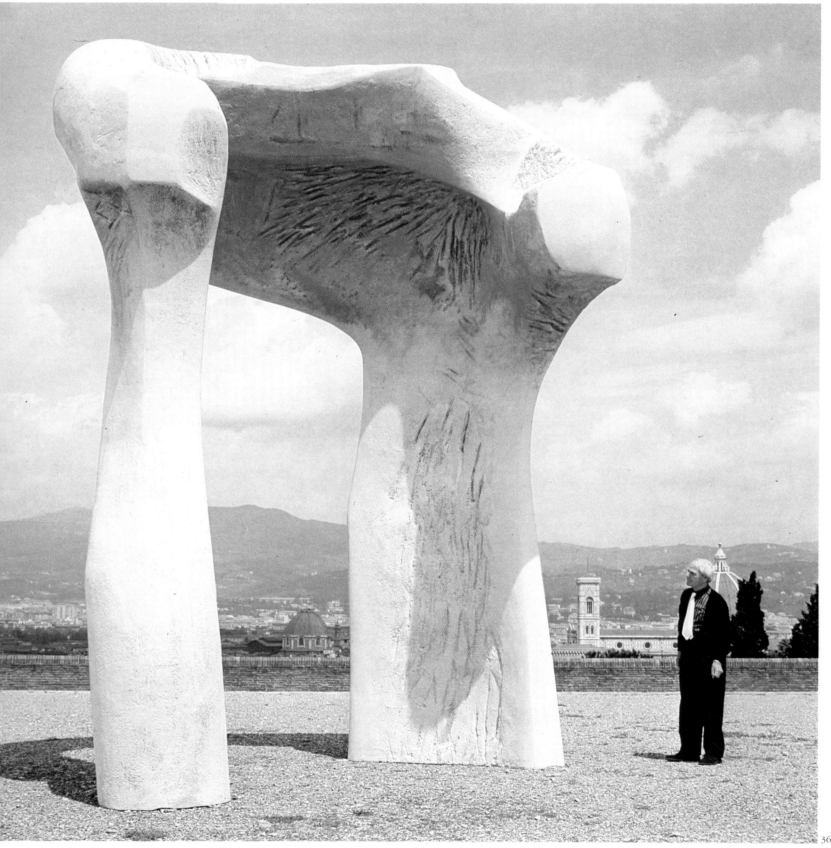

369

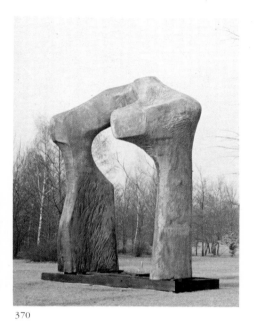

370

370, 371 The Arch *1963–9 H 6 m approx. Bronze, edition of 3*

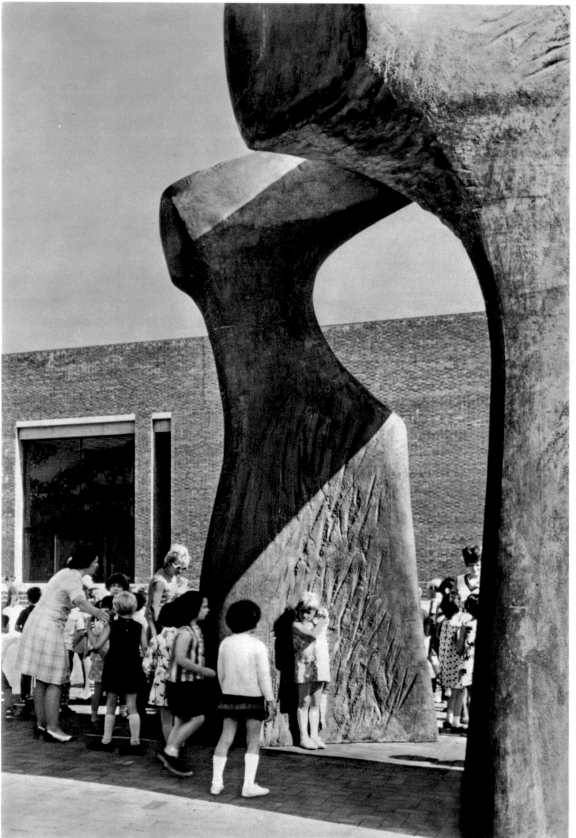

371

372, 373 Helmet Head No. 4 *1963 H 47.6 cm Bronze, edition of 6*
374 Thin Head *1964, cast 1969 H 12.1 cm with base Bronze, edition of 9*
375 Divided Head *1963 H 34.9 cm Bronze, edition of 9*
376 Moon Head *1964 H 30.5 cm Porcelain, edition of 6*

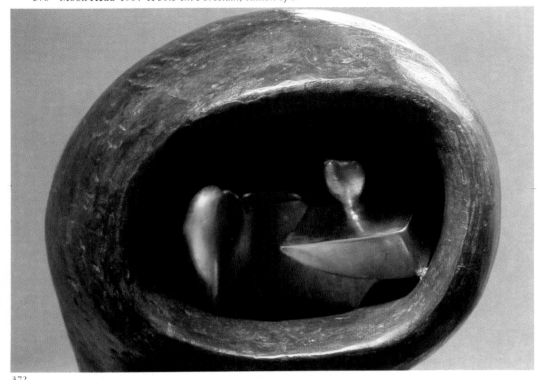

372

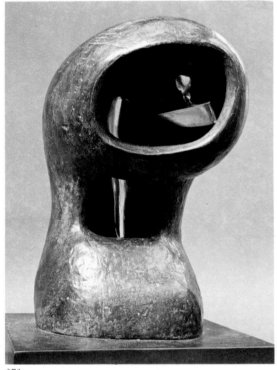

373

374

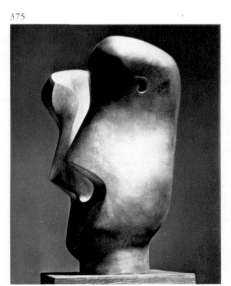

375

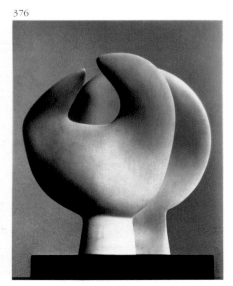

376

377 Moon Head *1964 H 57 cm Bronze, edition of 9*

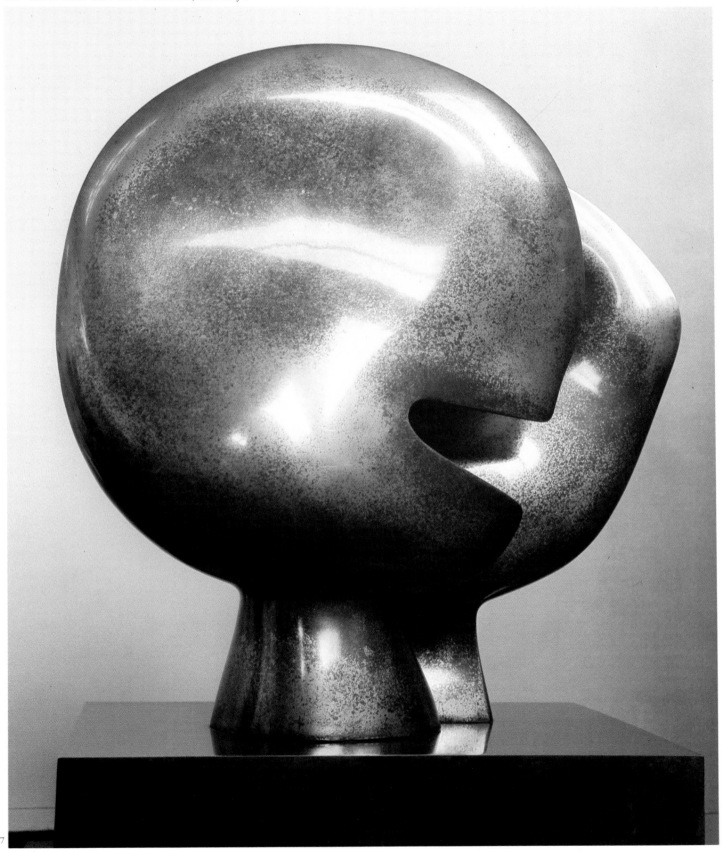

377

378, 381 Atom Piece *1964–5 H 1.19 m Bronze, edition of 6*
379 *Henry Moore supervising the installation of* Nuclear Energy *in Chicago, 1967*
380 Nuclear Energy *1964–5 H 3.66 m Bronze, unique cast University of Chicago*

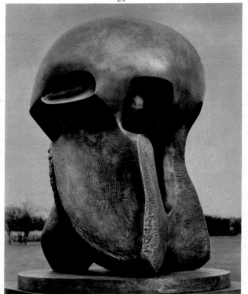

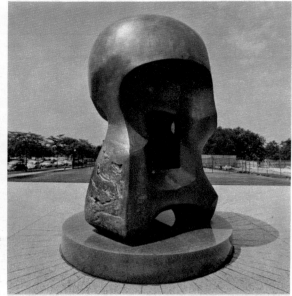

378

379

380

It's a rather strange thing really, but I'd already done the idea for this sculpture before Professor McNeill and his colleagues from the University of Chicago came to see me one Sunday morning to tell me about the whole proposition. They told me (which I'd only vaguely known) that Fermi, the Italian nuclear physicist, started the first successful controlled nuclear fission in a temporary building. I think it was a squash court – a wooden building – which from the outside looked entirely unlike where a thing of such an important nature might take place. But this experiment was carried on in secret and it meant that by being successful Man was able to control this huge force for peaceful purposes as well as destructive purposes. They came to tell me they thought that the site of such an important event in history ought to be marked and they wondered whether I would do a sculpture which would stand on the spot. Behind it later was going to be a building for the university, I think a library.

As they told me the story and the situation, I gradually remembered that only a fortnight previously I'd been working in my little maquette studio (because I was trying to think as they told me what form or what shape such an idea brought to my mind) and the story reminded me of a sculpture I'd already done about six inches high which was just a maquette for an idea. I said to them that I thought I had done the idea as far as I would be able to and I showed them the maquette, and I said, 'I'm going to make this sculpture into a working model', because the maquette was only about

six inches in height. I said to them, 'Would you wait until I've made this working model which will be about four or five feet in height and then when you see it, we could come to a decision whether it would really be suitable for your purpose?' When I had made this working model I showed it to them and they liked my idea because the top of it is like some large mushroom, or a kind of mushroom cloud. Also it has a kind of head shape like the top of the skull but down below is more an architectural cathedral. One might think of the lower part of it being a protective form and constructed for human beings and the top being more like the idea of the destructive side of the atom. So between the two it might express to people in a symbolic way the whole event.

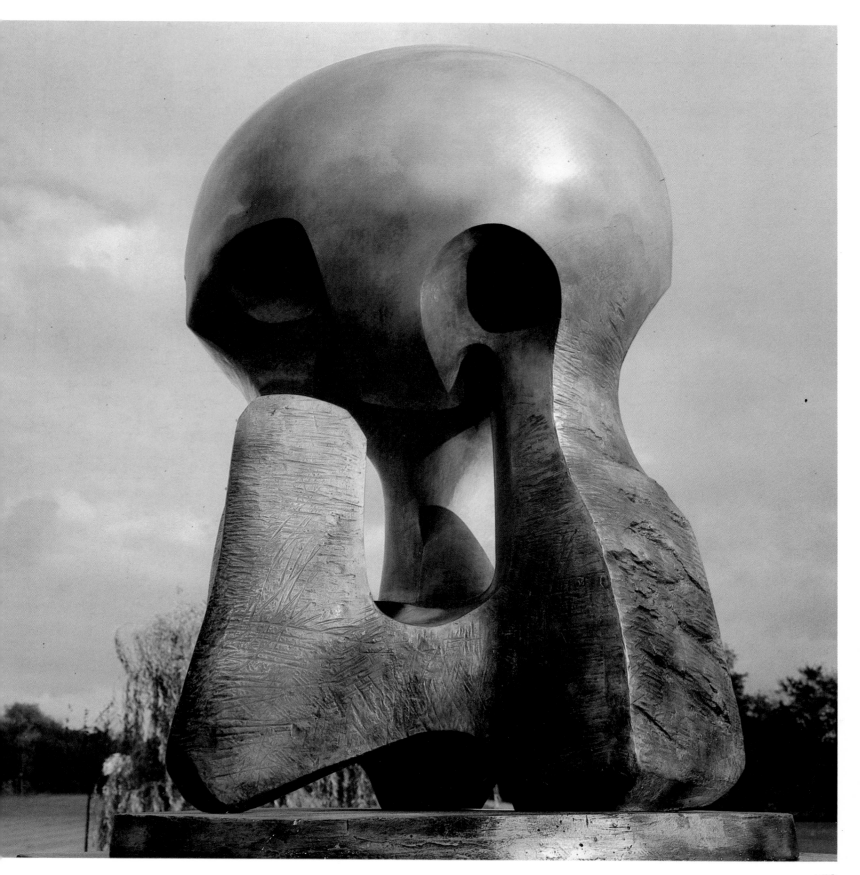

382 Working Model for Three Way Piece No. 1: Points *1964 H 63.5 cm Bronze,
 edition of 7*
383–6 Three Way Piece No. 1: Points *1964–5 H 1.92 m Bronze, edition of 3*

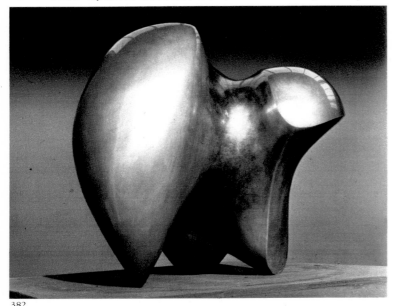

382

I no longer use drawing directly for my sculpture. A drawing can only show one view and to turn a single drawing into sculpture, as I used to do, all the other views had to be invented. But that first view remained too important, too much the 'key' view.

For many years now, I have wanted my sculpture to be interesting from all viewpoints, and so I work not from drawings but from small maquettes which can be held in one hand and looked at and worked on from all angles.

383

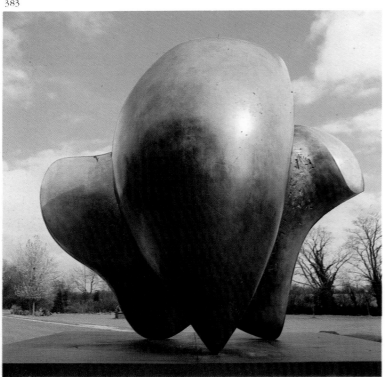

384

Sculpture fully in the round has no two points of view alike. The desire for form completely realised is connected with asymmetry. For a symmetrical mass being the same from both sides cannot have more than half the number of different points of view possessed by a non-symmetrical mass.

Asymmetry is connected also with the desire for the organic (which I have) rather than the geometric.

Organic forms though they may be symmetrical in their main disposition, in their reaction to environment, growth and gravity, lose their perfect symmetry.

385

386

387 Archer *1965 H 80 cm White marble Mr and Mrs G. Didrichsen, Finland*
388–90 Three Way Piece No. 2: (The) Archer *1964–5 L 3.4 m Bronze, edition of 2*

387

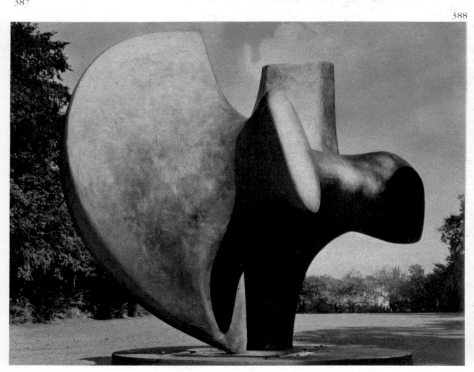

388

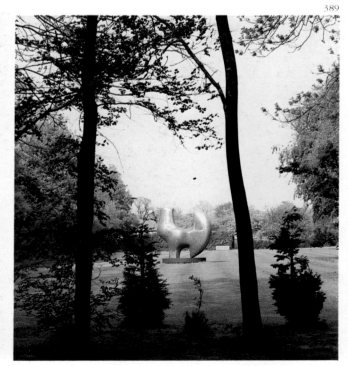

389

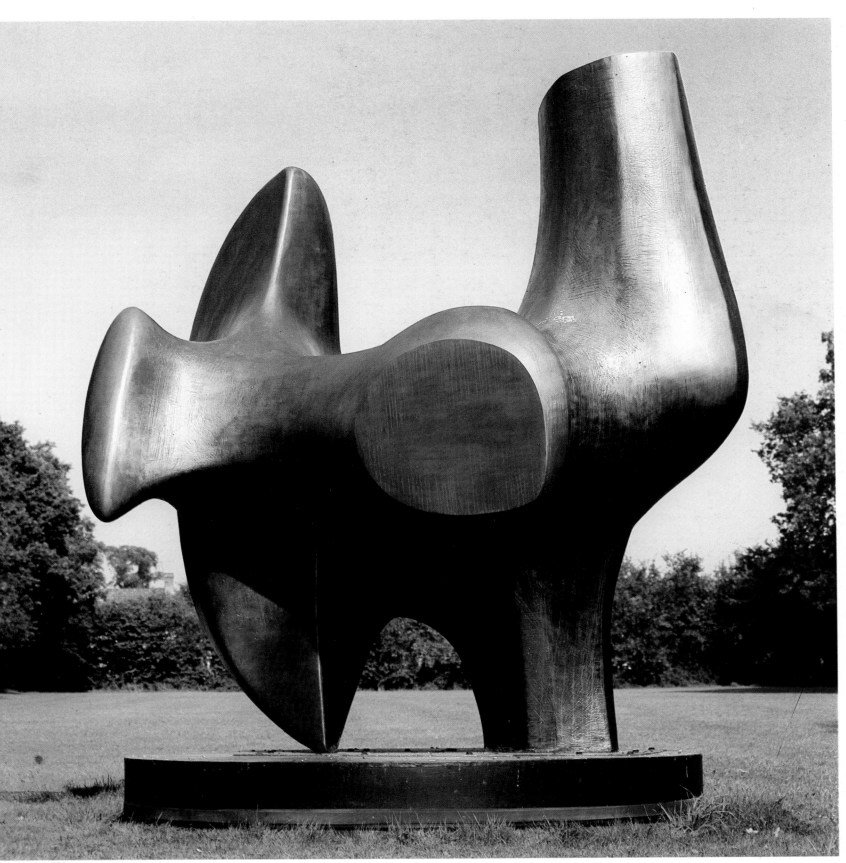

390

391 Two Forms *1964 L 45.7 cm White marble Mr and Mrs Jan Hartmann, Michigan*
392 Torso *1966 H 60.3 cm White marble Dr and Mrs W. Staehelin, Zurich*
393 Oval Sculpture *1964 H 44.5 cm White marble David Rockefeller, New York*
394 Reclining Form *1966 L 1.13 m White marble*

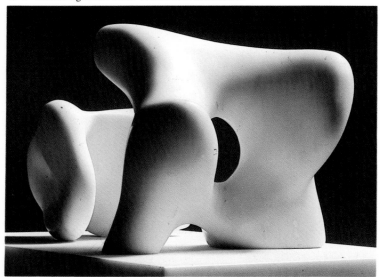

391

Whilst touching some sculptures can give pleasure, touch itself is certainly not a criterion of good sculpture. A particular pebble or a marble egg may be delightful to feel or hold because it is very simple in shape and very smooth, whereas if it were the same shape but with a prickly or cold surface, you would not like touching it. Of course you can tell the shape of something if you can put your hands all round it. But it is impossible for a blind person to tell you the shape of a building. The same applies to a large sculpture, in that, although the sense of touch is fundamentally important and implied, it is not physically necessary to touch a sculpture in order to understand its form.

392

393

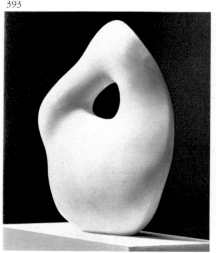

394

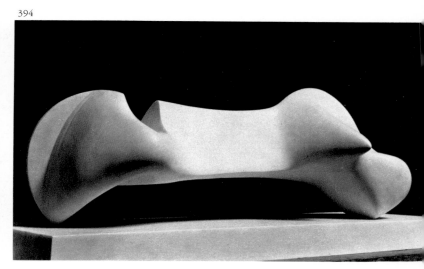

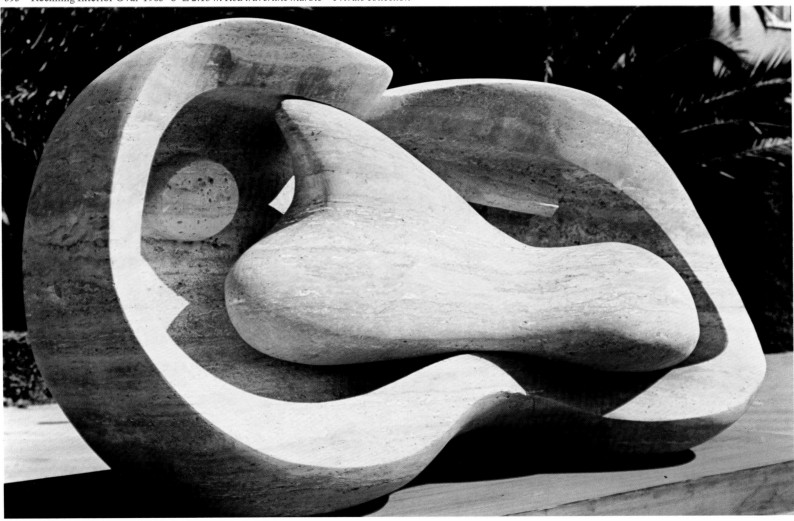

395

Architecture and sculpture are both dealing with the relationship of masses. In practice architecture is not pure expression but has a functional or utilitarian purpose, which limits it as an art of pure expression. And sculpture, more naturally than architecture, can use organic rhythms. Aesthetically architecture is the abstract relationship of masses. If sculpture is limited to this, then in the field of scale and size architecture has the advantage; but sculpture, not being tied to a functional and utilitarian purpose, can attempt much more freely the exploration of the world of pure form.

396–8 Three Rings *1966 L 99.7 cm Rosa Aurora marble*
 Mr and Mrs Gordon Bunshaft, New York
399, 400 Three Rings *1966 L 2.69 m Red travertine marble*
 Mr and Mrs Robert Levi, Maryland

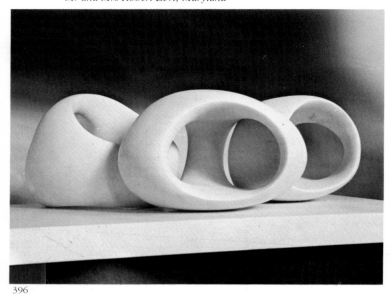

396

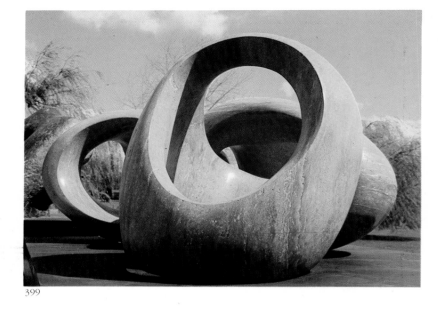

399

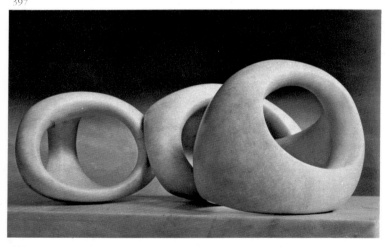

397

I made the maquette for this sculpture very small as a ring with three holes which could be worn three ways – with the finger through any pair of holes.

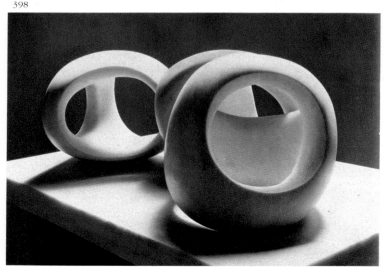

398

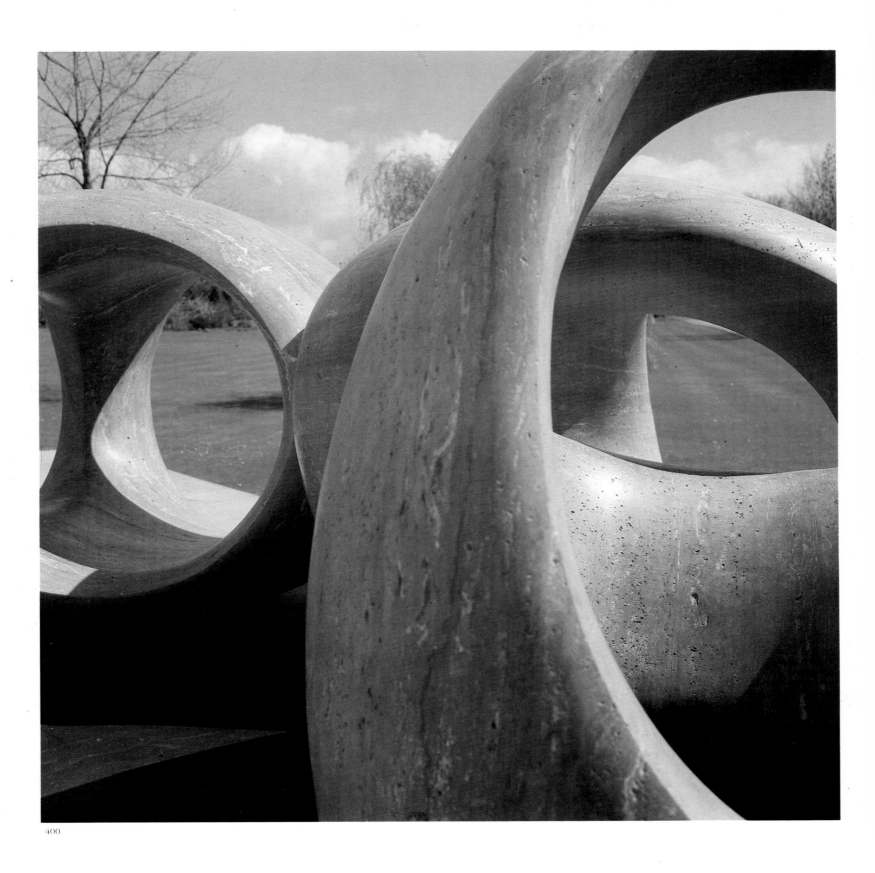

401 Two Three Quarter Figures on base *1965, cast 1969 H 19.4 cm Bronze, edition of 9*
402 Owl *1966 H 20.3 cm Bronze, edition of 5*
403 Standing Figure: Shell Skirt *1967 H 17.8 cm Bronze, edition of 9*
404 Standing Girl: Bonnet and Muff *1966, cast 1968 H 23.5 cm Bronze, edition of 7*
405 Doll Head *1967, cast 1969 H 10.5 cm Bronze, edition of 9*
406 Reclining Figure: Cloak *1967 L 37 cm Bronze, edition of 9*

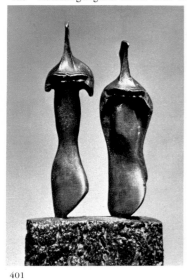

401

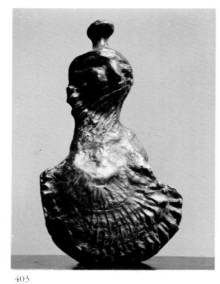

402

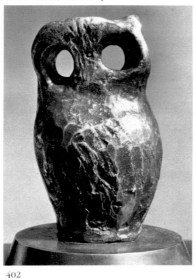

403

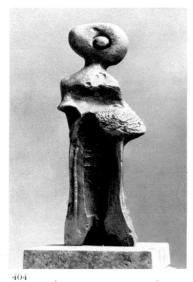

404

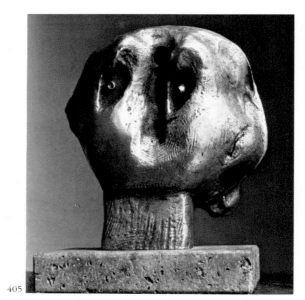

405

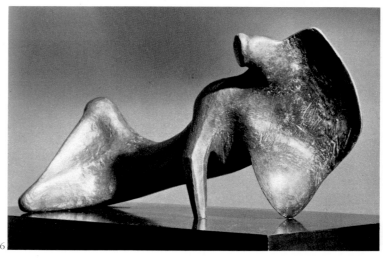

406

407, 408 Two Piece Sculpture No. 7: Pipe *1966 L 94 cm Bronze, edition of 9*

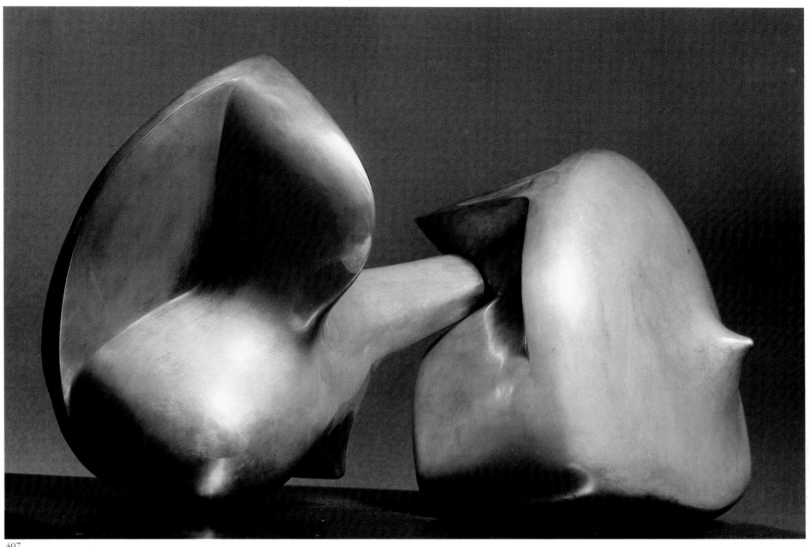

407

408

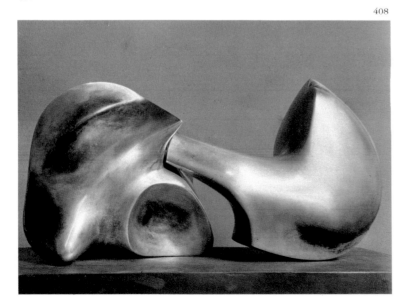

409 Helmet Head No. 5 *1966 H 41.9 cm Bronze, edition of 2*
410 Double Oval *1966 L 96.5 cm with base Rosa Aurora marble Private collection*
411 Double Oval *1966 in progress*

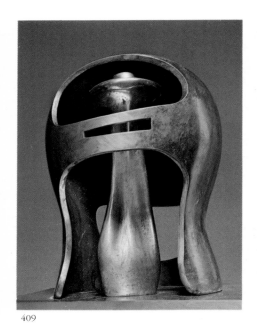

409

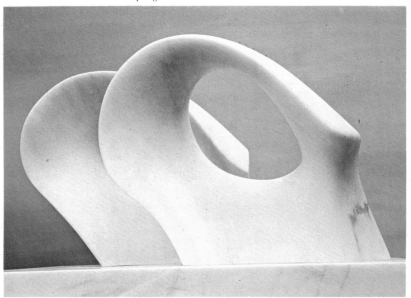

410

411

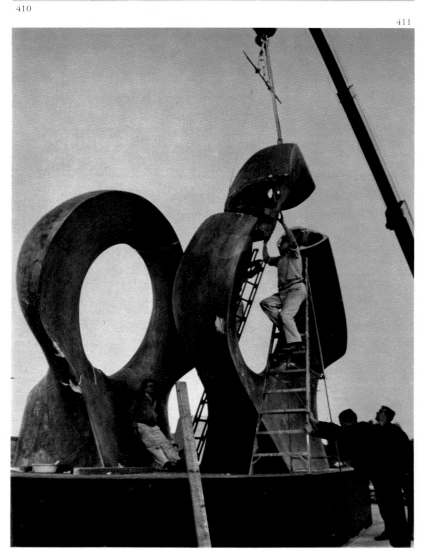

412　Double Oval　*1966　L 5.38 m Bronze, edition of 2*

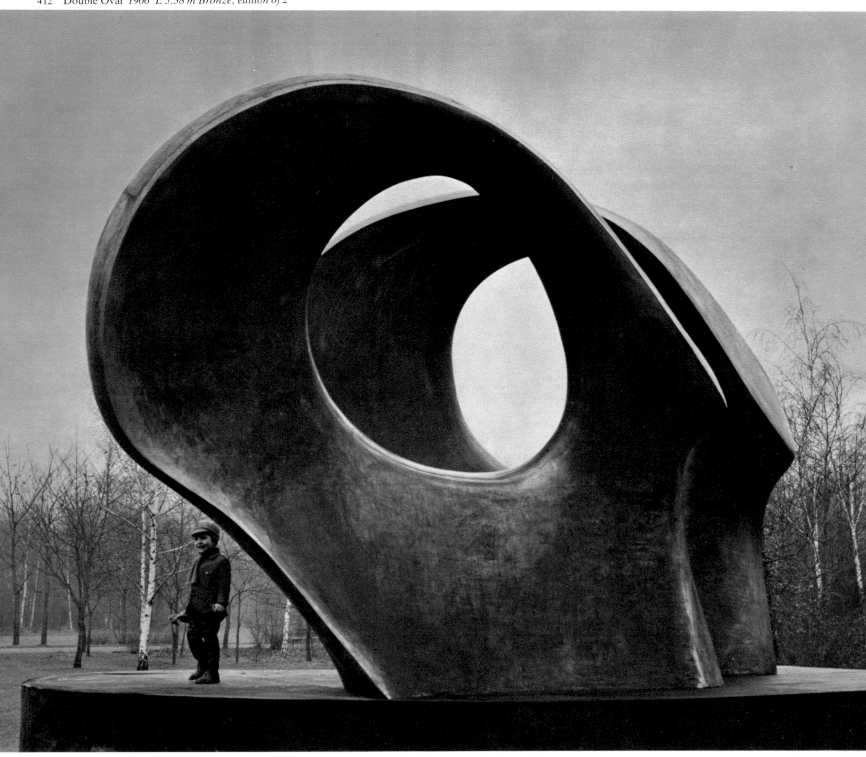

412

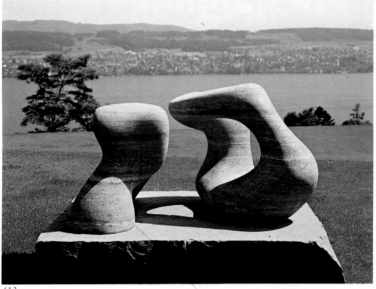

413

The fibreglass cast of this sculpture (*fig 414*) is now
placed down in a lower field at Hoglands. I can't get
about so easily on foot as I used to, and I now like to
take friends occasionally and drive round the sculpture
in the car, hoping they will see the point on sculpture
generally that I like to make – that is, that sculpture
should have hundreds of different views from all round
it, just as a human figure has. You can't learn the
human figure by the front view, or side view, and leave
the others. You should look and be able to see from
above, from below, all round it, and in the changing
light. I will defy anybody looking at any one view to
give an idea of what it would be like from a view at
right angles to that. Therefore as you go round there is
this continuous changing of forms with each other.

Although the forms are simple it doesn't mean that if
you want to make the thing interesting you have to put
a lot of detail in it. That is, you would not put features
on the back of a head to make the head as interesting as
the face, because it's the difference between the back of
the head and the front of the face of the human being
which makes it interesting. But this doesn't mean that
the back has no shape.

A sculpture should be like nature, living nature, not
a kind of static nature. Organic nature, whatever you
would like to call it, is different from all round. And
that's what I think sculpture should be like to keep up
its continual interest.

414 Large Two Forms *1966–9 L 6.09 m approx. Fibreglass* The Henry Moore Foundation

415, 416 Large Two Forms *1966–9 L 6.09 m approx. Bronze, edition of 4*

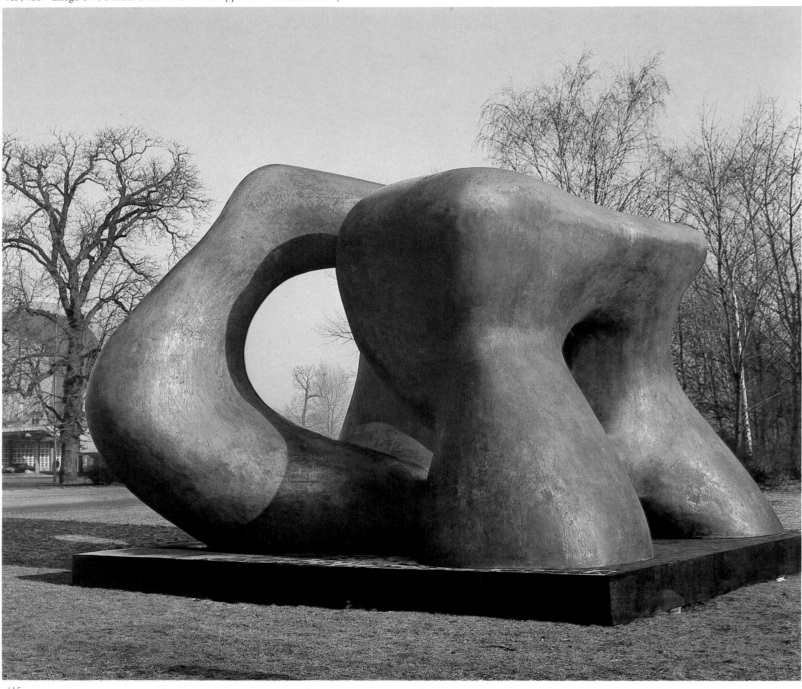

415

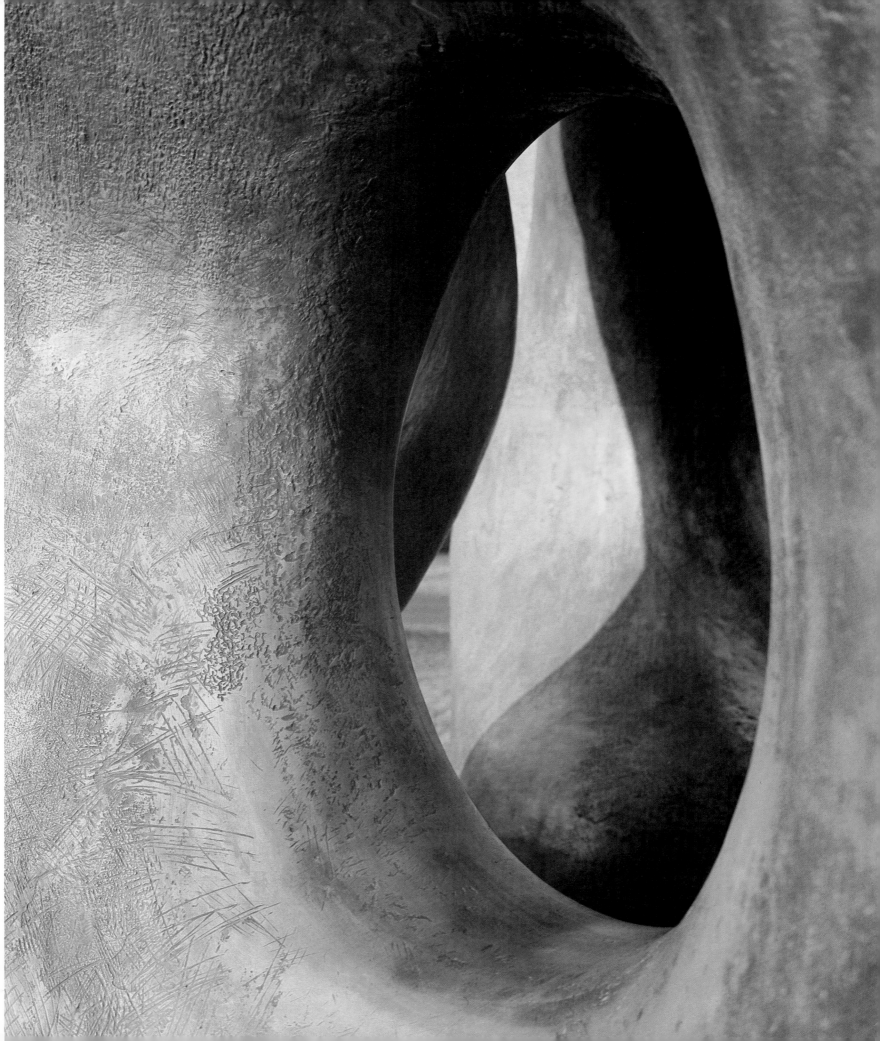

417 Two Nuns *1966–9 H 1.51 m White marble Mr and Mrs Leigh Block,
 Chicago*
418 Bust of a Girl: Two Piece *1968 H 78.1 cm Rosa Aurora marble
 Private collection, Japan*
419 Upright Form *1966 H 60.3 cm White marble Private collection, Chicago*
420 Girl: Half Figure *1967 H 85.1 cm Rosa Aurora marble*

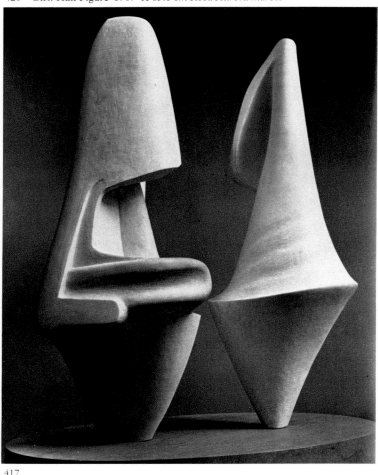

417

Carving is a straightforward process of having hard material and knocking, carving or bursting pieces off. The tools we have now for stone carving begin with what is called a pitcher, or a boaster, with which whole corners can be broken off. All stones tend to have a direction in which they break most easily because of their grain formation. Next comes the punch, or point, and we burst the stone all round with the point when we hit it. That allows us to get large amounts off at a time. After that comes a claw tool, which is really a series of punches and points all in one instrument. When used on the stone, it leaves a series of parallel grooves. This was a favourite tool of Michelangelo's. Next comes the chisel, which is flat.

Michelangelo used his marble very soon after it was quarried, and this made what is a hard stone much quicker to carve.

418

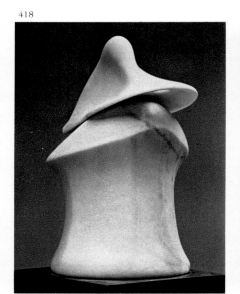

419

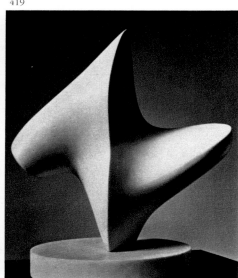

420

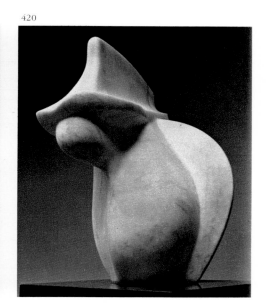

421 Sculpture with Hole and Light *1967 L 1.27 m Red travertine marble Rijksmuseum Kröller Müller, Otterlo, Holland*

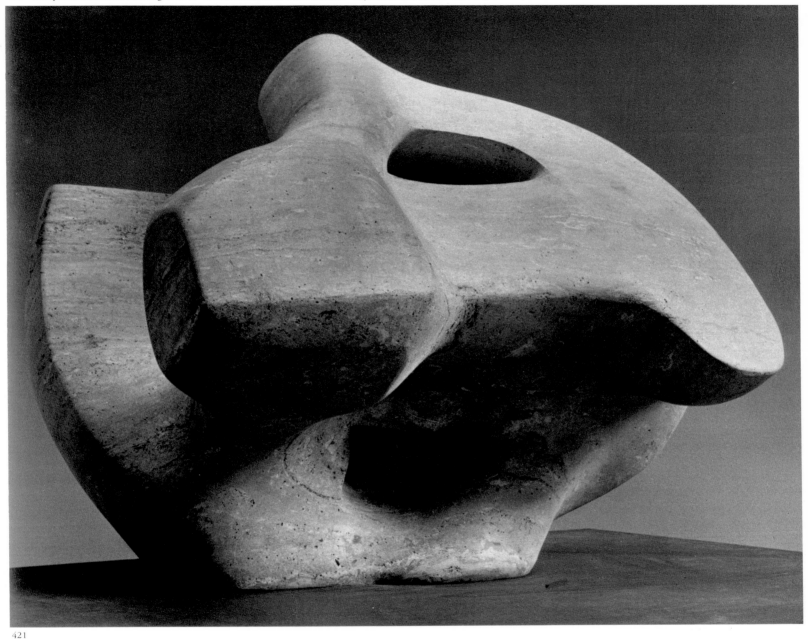

421

422

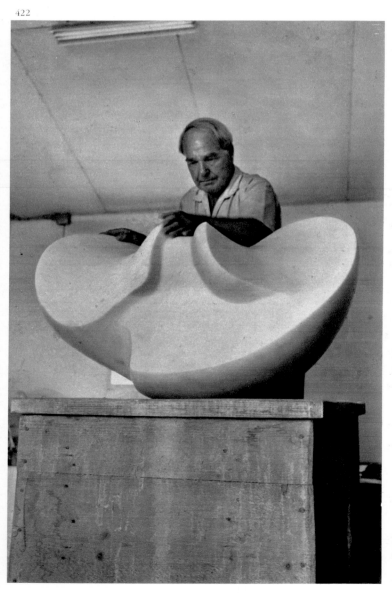

423

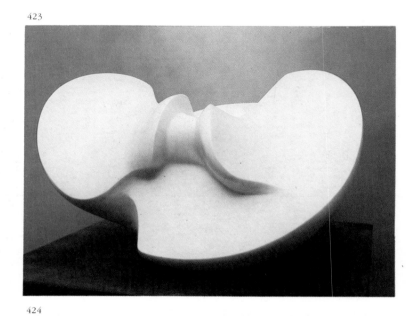

424

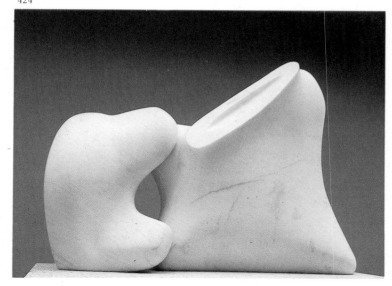

422 *Henry Moore with* Divided Oval: Butterfly *at the Henraux stoneyard, Querceta, 1967*
423 Divided Oval: Butterfly *1967 L 91.4 cm White marble Stanley Seeger, Sutton Place, Surrey*
424, 425 Mother and Child *1967 L 1.30 m Rosa Aurora marble The Henry Moore Foundation*

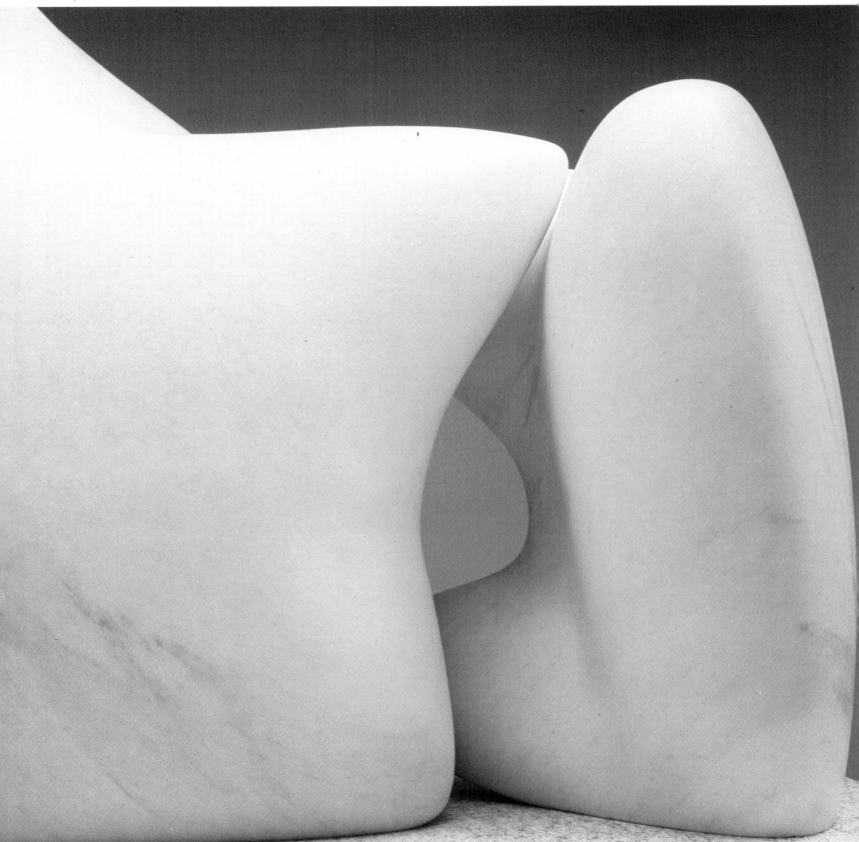

426 Torso *1967 H 1.06 m Bronze, edition of 9*

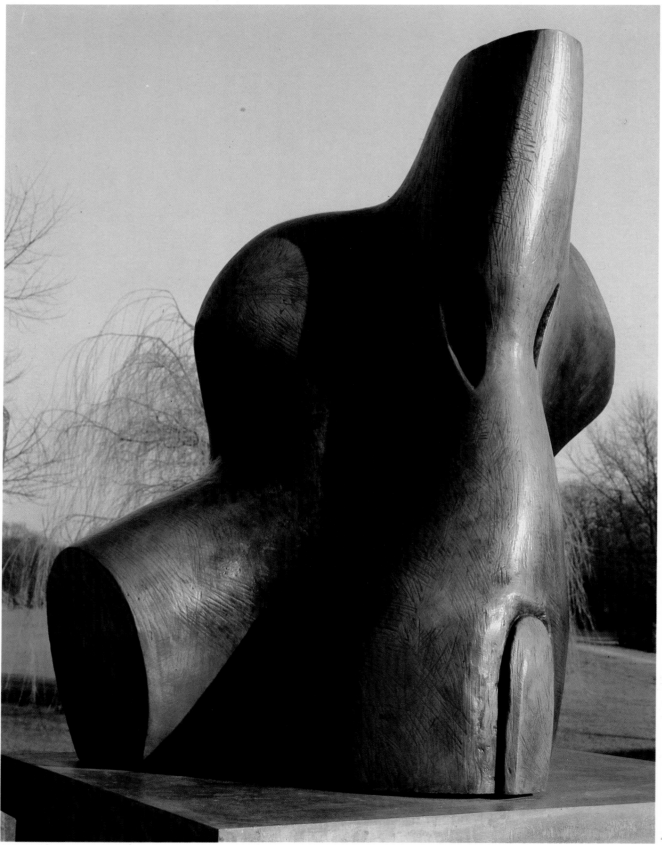

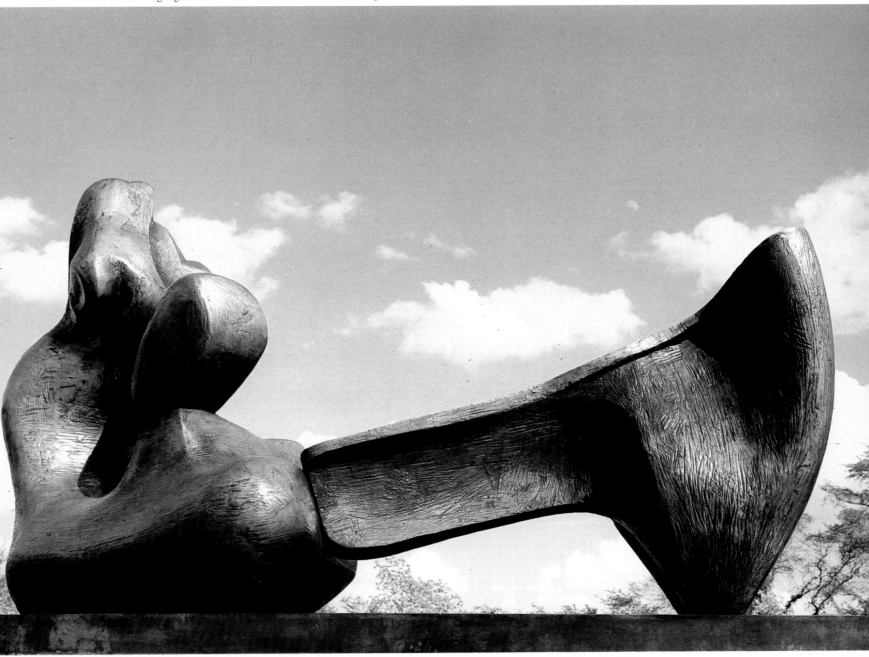

427

Out of doors in England the light is as good for
sculpture as anybody could want. You have to make
strong forms that really exist because they are not for
ever flattered or exaggerated by sunlight.

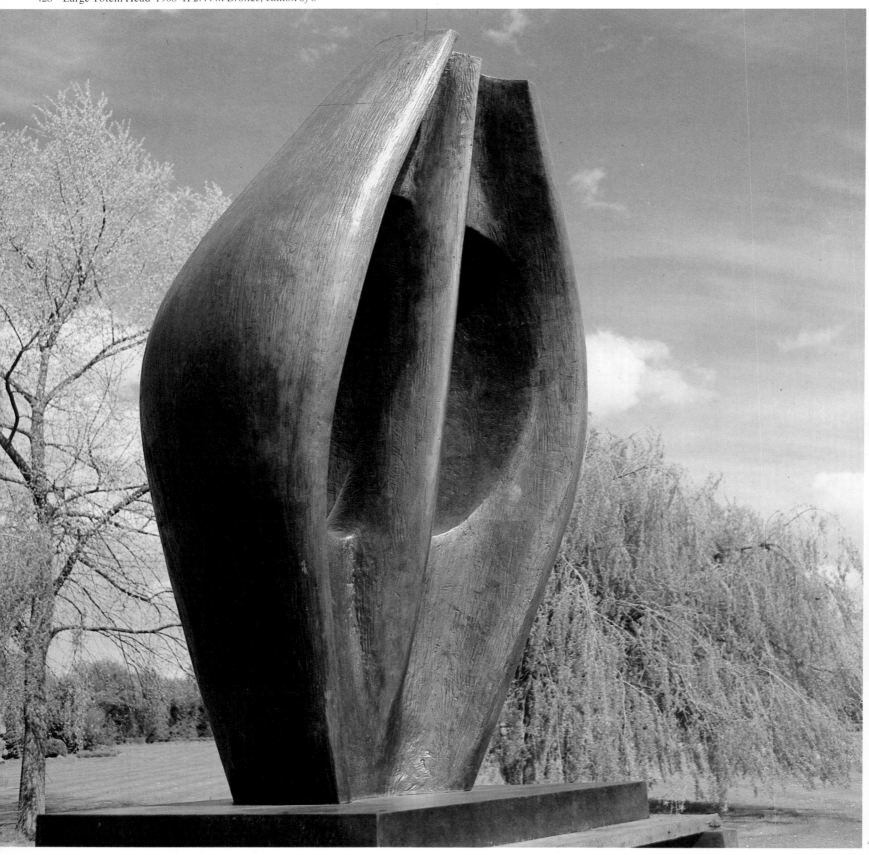

429 Two Piece Sculpture No. 10: Interlocking *1968 L 91 cm Bronze, edition of 7*

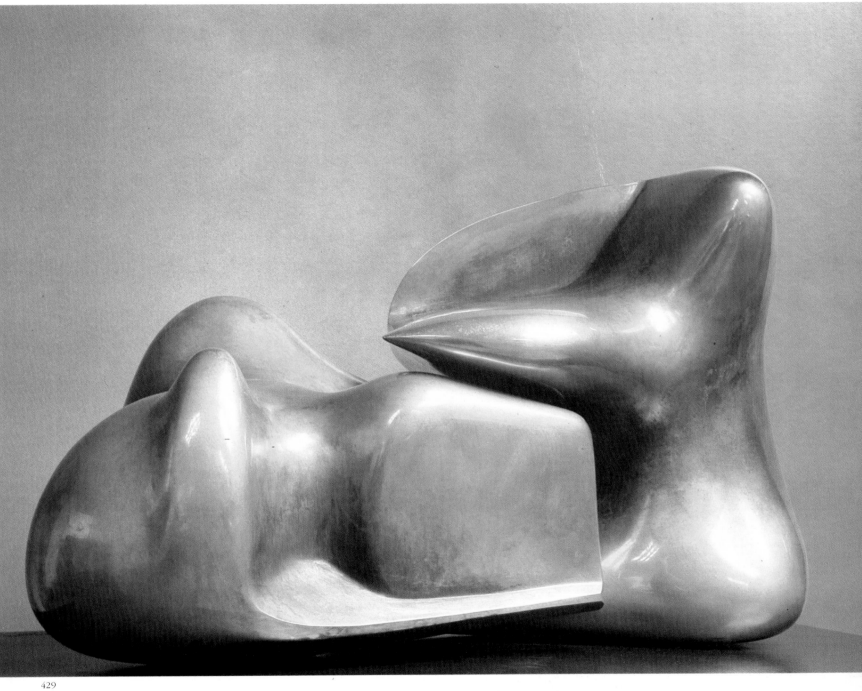

429

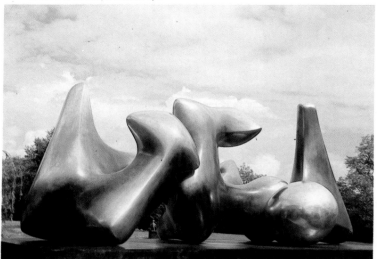

430 Working Model for Three Piece No. 3: Vertebrae *1968*
 L 2.34 m Bronze, edition of 8

430

Sculpture should always at first sight have some obscurities, and further meanings. People should want to go on looking and thinking; it should never tell all about itself immediately. Initially both sculpture and painting must need effort to be fully appreciated, or else it is just an empty immediacy like a poster, which is designed to be read by the people on top of a bus in half a second. In fact all art should have some more mystery and meaning to it than is apparent to a quick observer.

In my sculpture, explanations often come afterwards. I do not make a sculpture to a programme or because I have a particular idea I am trying to express. While working, I change parts because I do not like them in such a way that I hope I am going to like them better. The kind of alteration I make is not thought out; I do not say to myself – this is too big, or too small. I just look at it and, if I do not like it, I change it. I work from likes and dislikes, and not by literary logic. Not by words, but by being satisfied with form. Afterwards I can explain or find reasons for it, but that is rationalisation after the event. I can even look at old sculptures and find meaning in them and explanations which at the time were not in my mind at all – not consciously anyway.

Each of the forms, although different, has the same basic shape. Just as in a backbone which may be made up of twenty segments where each one is roughly like the others but not exactly the same . . . This is why I call these sculptures *Vertebrae*. The two or three forms are basically alike but are arranged to go with each other in different positions.

The sculptor's life is one of thinking, reacting, or making, expressing himself through form, through shape – for me the three-dimensional world is unending.

431, 433 Two Piece Carving: Interlocking *1968 L 71.1 cm White marble Private collection*
432 Two Piece Sculpture No. 11 *1968 L 10.2 cm Bronze, edition of 10*

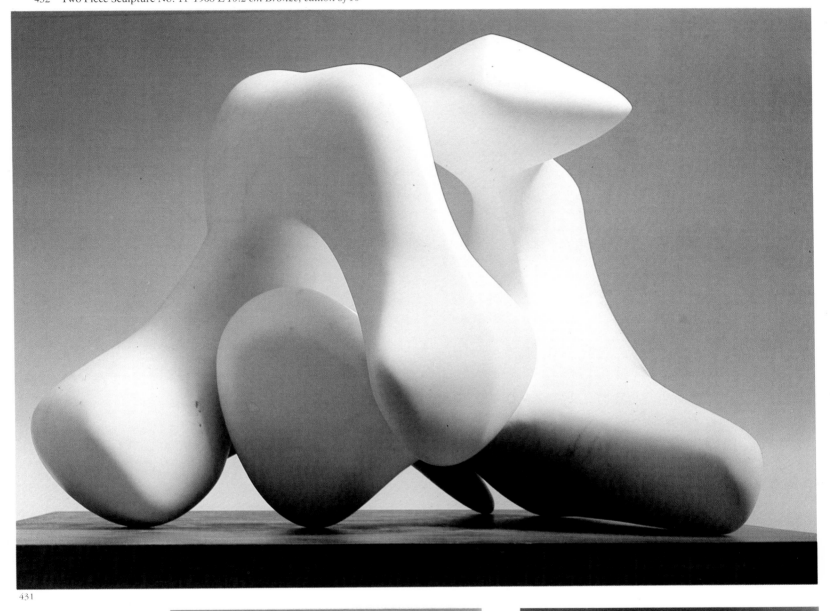

431

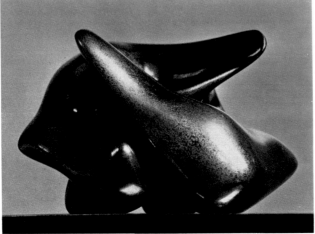

432

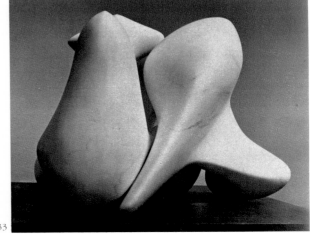

433

434–7 Interlocking Two Piece Sculpture *1968–70 L 3.15 m White marble Roche Foundation, Basel*

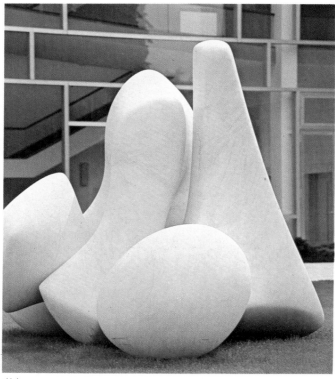

434

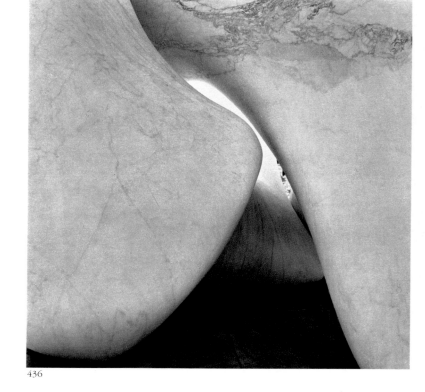

436

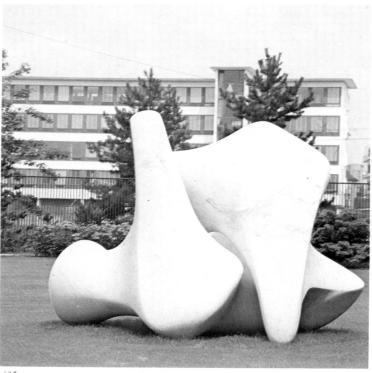

435

If you have a sculpture with architecture, it needs to be very big. Modern architecture, with its height and massiveness, calls for a sculpture of a much bigger size than in previous times.

No architectural site ever seems to be perfect. There are always compromises to be made between the sculpture and the architecture. When a sculpture is put in a niche in a wall it can only be seen as a frontal piece. My aim is to make sculpture which is interesting from all angles. In my opinion you can treat sculpture in relation to architecture, rather like you treat pictures and sculpture inside a house. It can be movable, and fit into changing conditions.

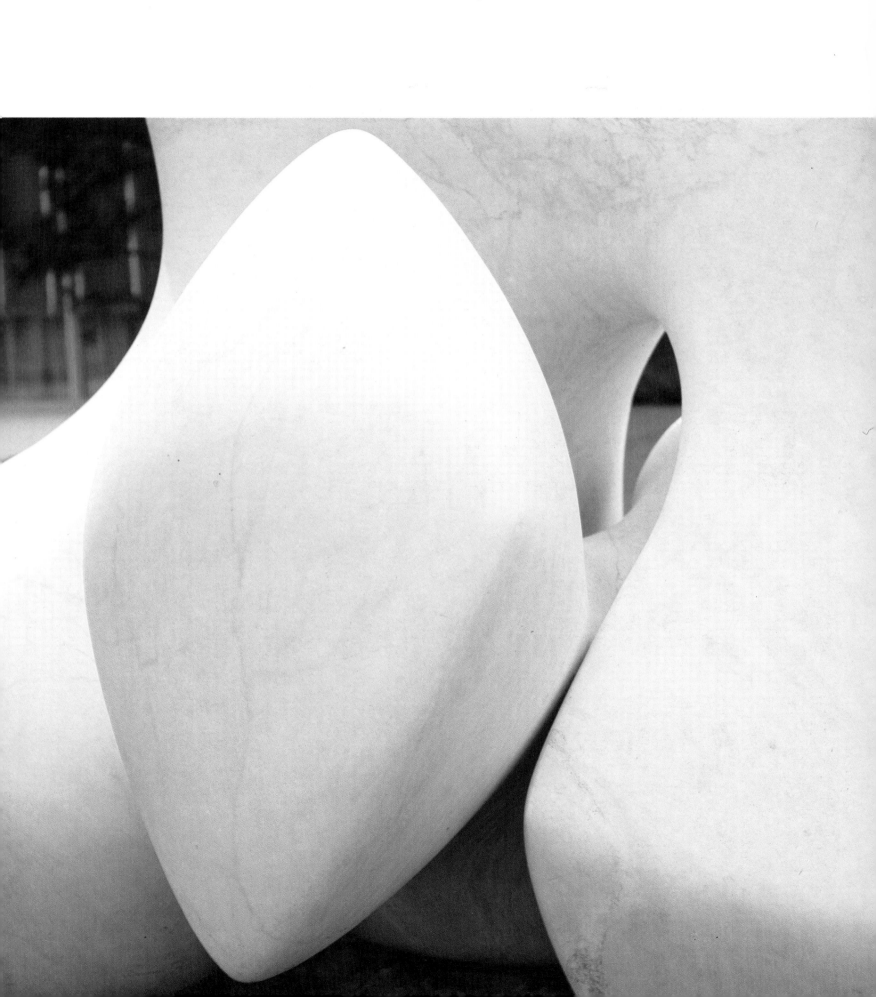

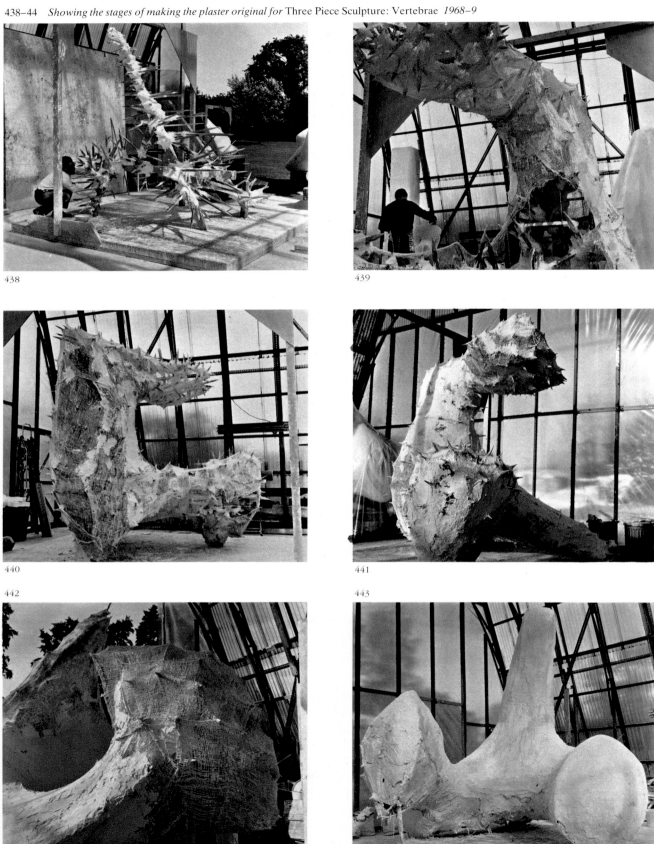

438

439

440

441

442

443

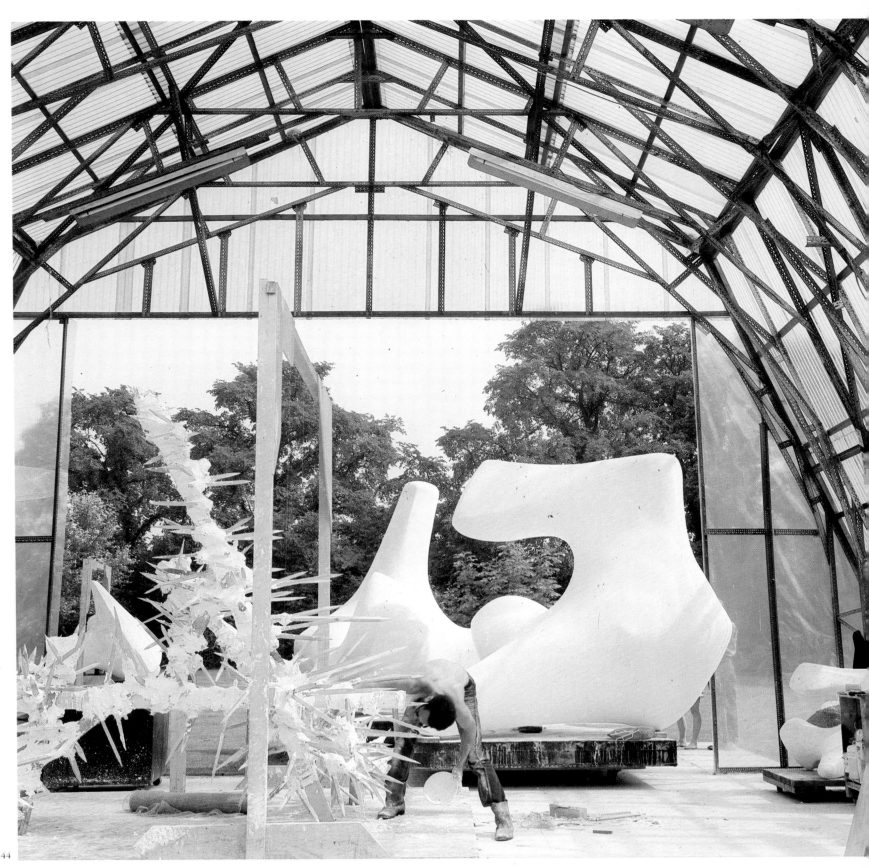

445, 446 Three Piece Sculpture: Vertebrae *during casting and welding at the Herman Noack Foundry, West Berlin, 1969*

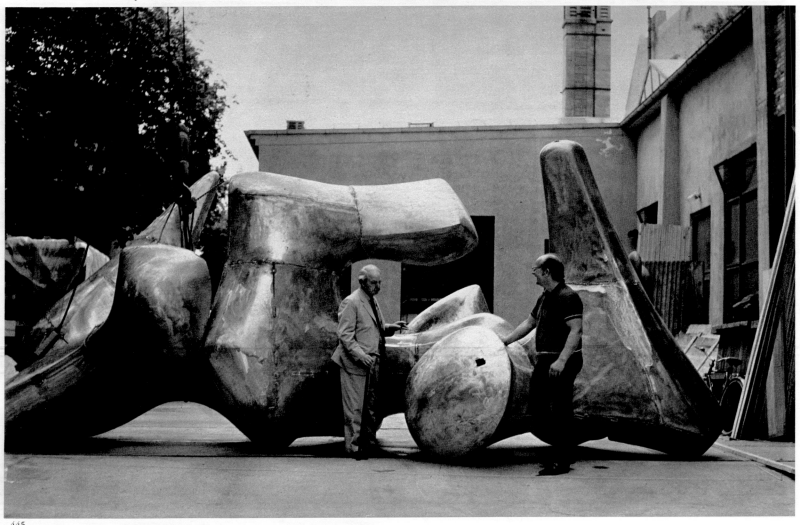

445

446

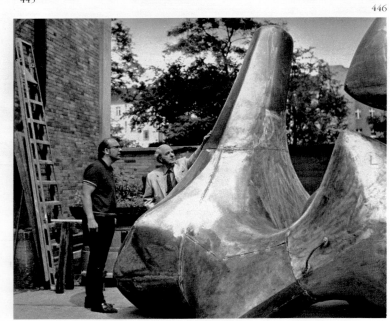

447, 448 Three Piece Sculpture: Vertebrae *1968–9 L 6.84 m approx. Bronze, edition of 3*

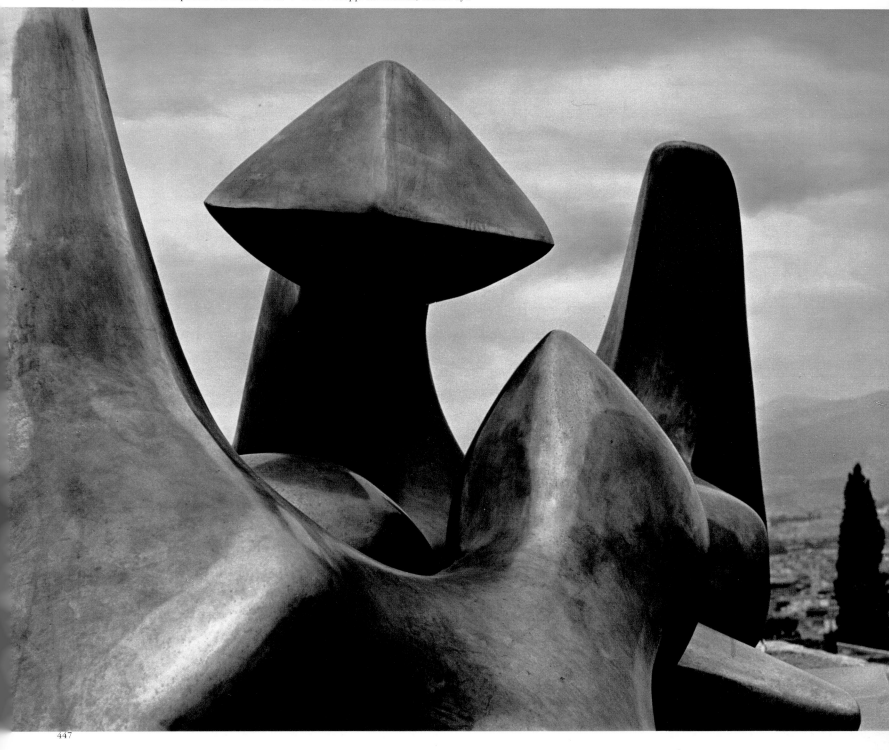

447

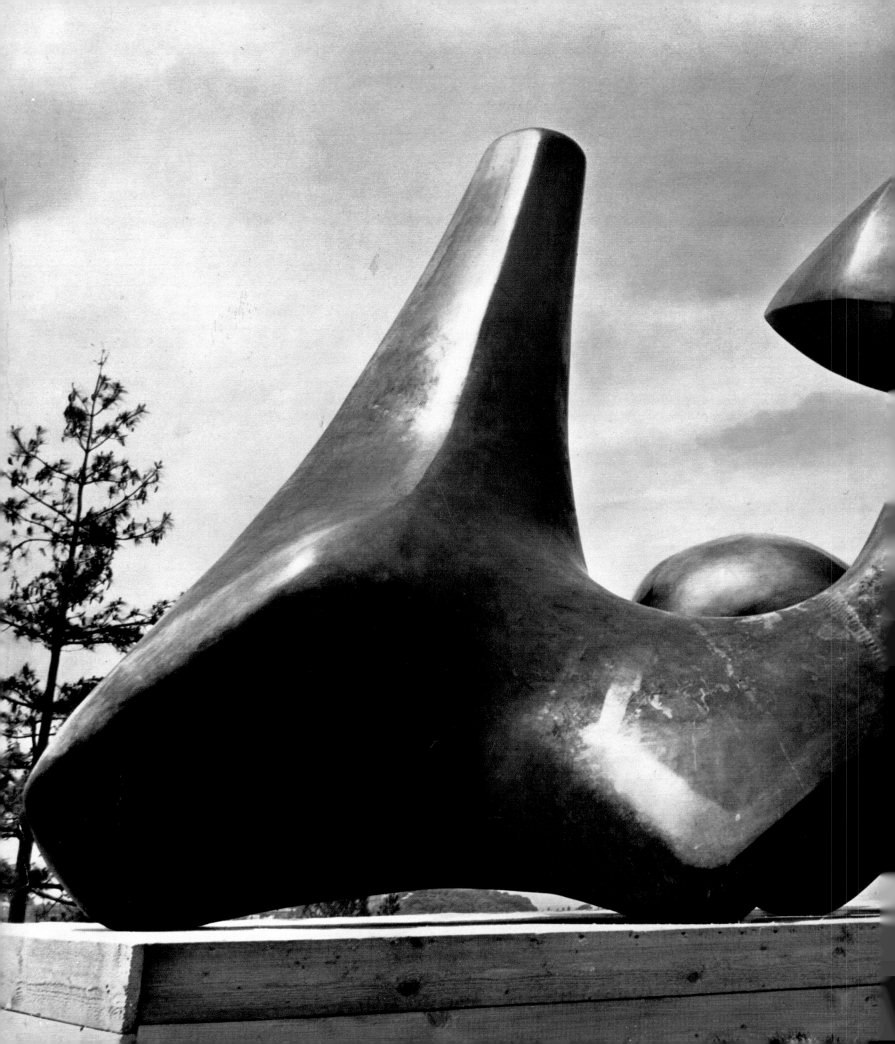

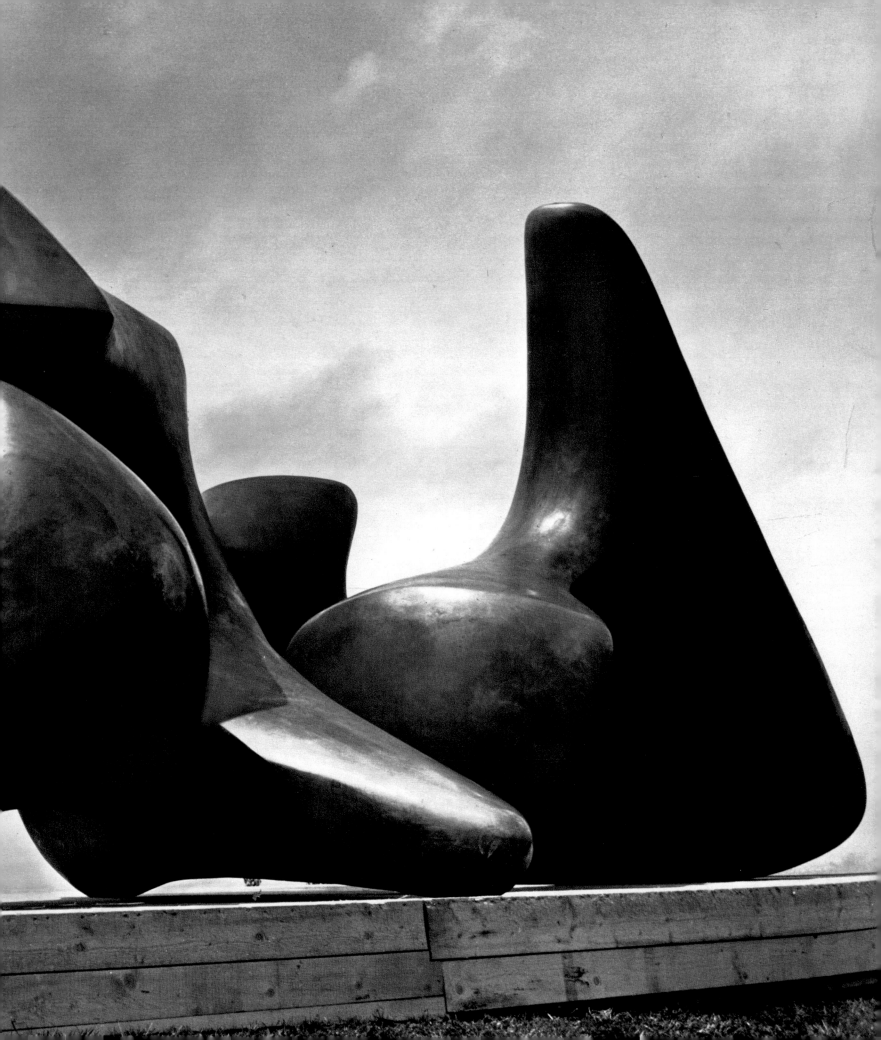

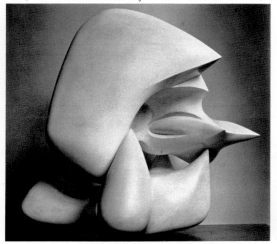

449

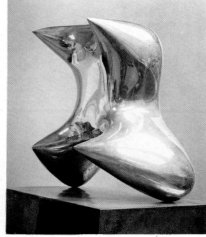

450

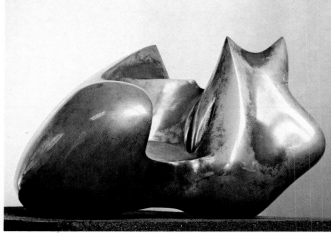

451

452

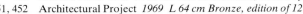

The title of any sculpture can come about for a descriptive reason. It may be that I want to explain to my wife or one of my assistants what sculpture I am talking about and I may say 'you know – the one that's got two points', and that may become its title. My titles are sometimes descriptive to give the main theme of the work. Sometimes a title may be just given a number where I have done a lot of other sculptures on the same theme like the *Upright Motives*, and to describe every one of them I call them No. 1, No. 2 and so on. Sometimes they are just titles of convenience.

Talking about one's sculpture can be a help I suppose to other people, to know the cardinal points or message that the spectator might look for. But it is a very small part of the work. The work itself might take six months but the explanation of the work can be done in a couple of minutes.

The *Spindle Piece* (*fig 453*) is a variation of the *Three Points* (*figs 155–6*) which I made in 1939. Here again the points are used to give action, inwards in the case of the *Three Points*, but here to give action outwards.

453 Large Spindle Piece *1968–74 H 3.35 m Bronze, edition of 6*

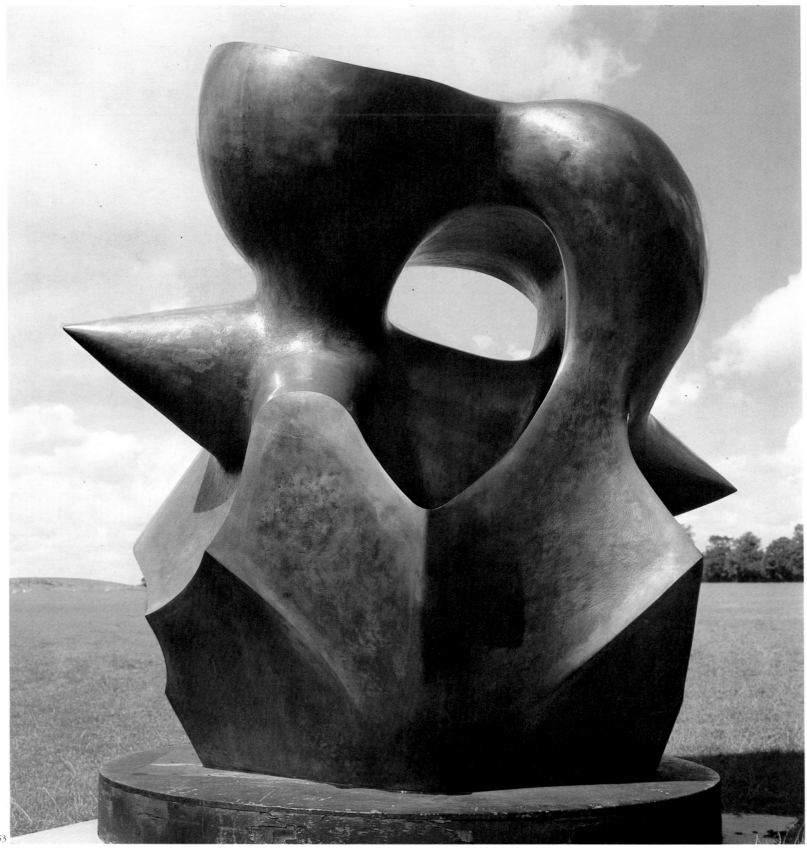

453

454–7 Oval with Points *1968–70 H 3.27 m Bronze, edition of 6*

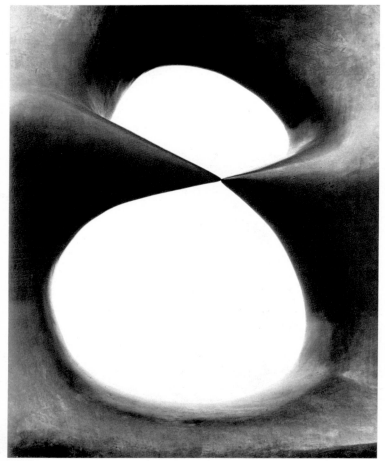

454

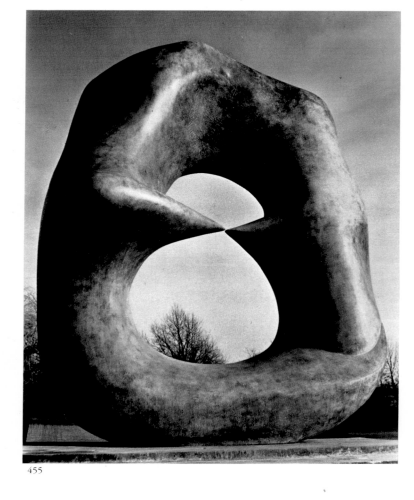

455

456

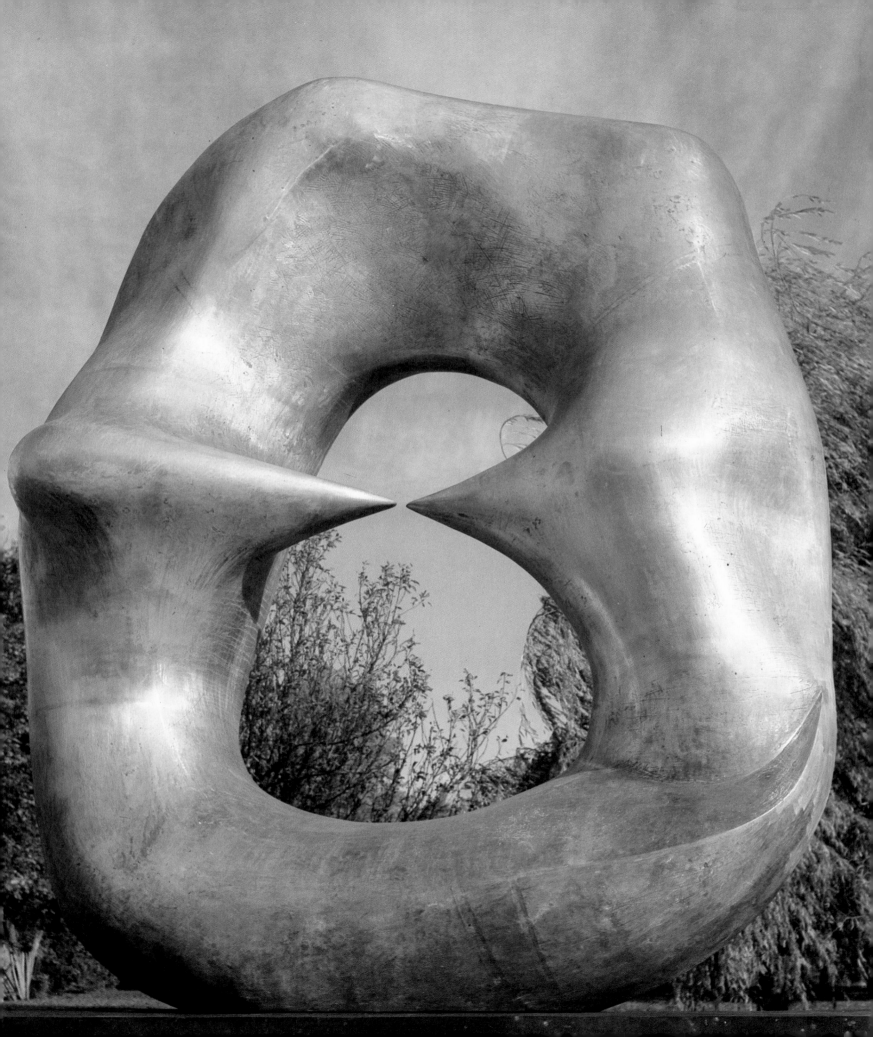

458, 459 Square Form with Cut *1969 L 1.40 m Black marble*
Private collection, Spain
460 Square Form with Cut *in Rio Serra marble being taken in sections over the walls of the Forte di Belvedere, Florence, 1972*

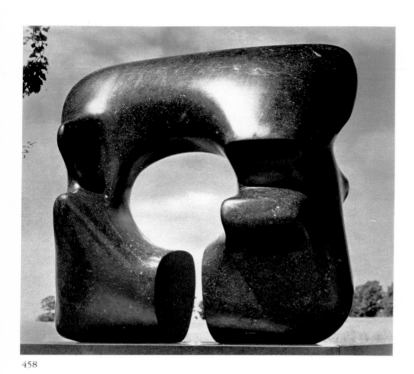

458

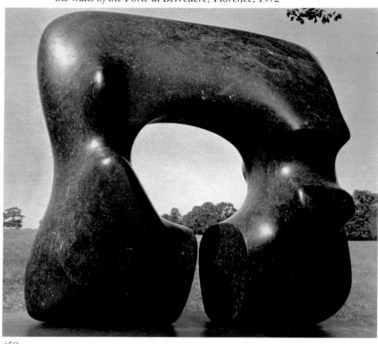

459

Often at the maquette stage, where I can hold the sculpture in my hands, I decide if I want it life-size, well over life-size, or under life-size – that is its actual 'physical' size. Ordinarily I like to think that a sculpture, if really what I like and any good, can be enlarged, not indefinitely, but within reason, to a monumental scale. I would like all the ideas I make for outdoor sculpture to have that kind of scale to them. Indoor sculpture is a different thing – a life-size figure inside a museum will seem life-size. That same life-size figure out in a big open space will seem much less than life-size.

Black is a disappearing colour in nature; there is more black in a photograph because the light comes from the sky and gives black shadows down below. White is the most obtrusive colour. We have a small white cast of the *Square Form With Cut* in one of the fields, and I have moved it because as you came in to the field you saw it first, and the white was such an absolutely obtrusive colour that the cast of the *Large Two Forms* (*fig 414*) did not catch your eye at all. If you want something to disappear in nature, make it really dark. That is why I suggest all the pedestals for my sculpture should be darker than neutral grey.

We had a problem with the large sculptures in Florence where everything had to be got over the parapet of the Forte di Belvedere. Because I wanted the *Large Two Forms* to be in the exhibition, the only way to do it was to make a cast from the original in fibreglass. This fibreglass can be made a colour which makes it look like marble – that is a permanent material. People don't know this until they go up to it and knock it, or touch it, or give it a very close inspection. Here or there in the book we may find illustrations of sculpture in fibreglass, but this is only because a fibreglass cast has been made as a substitute for another material for practical reasons.

461–88 Square Form with Cut *1969–71 L 5.42 m Rio Serra marble* *Showing various stages of erection at the Forte di Belvedere Exhibition, Florence, 1972*

461

462

463

464

465

466

467

468

469

471
472

73
474
475

76
477
478

 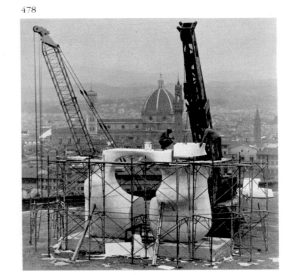

221

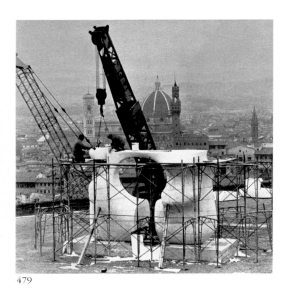

479

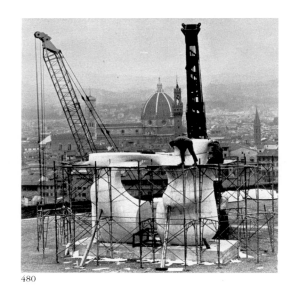

480

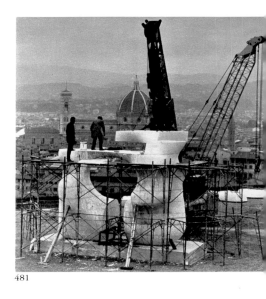

481

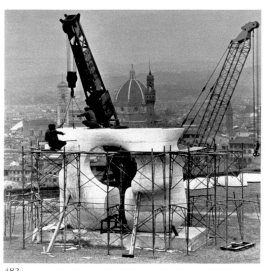

482

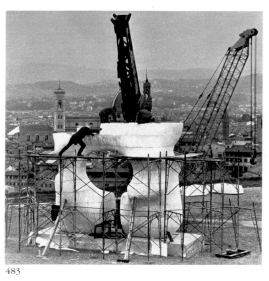

483

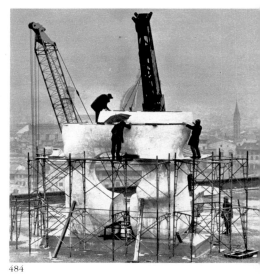

484

485

486

487

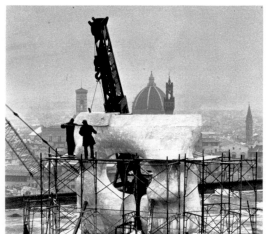

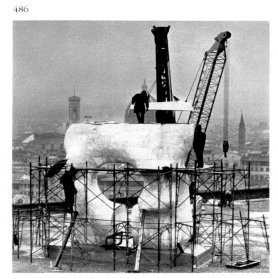

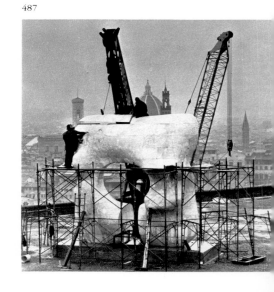

222

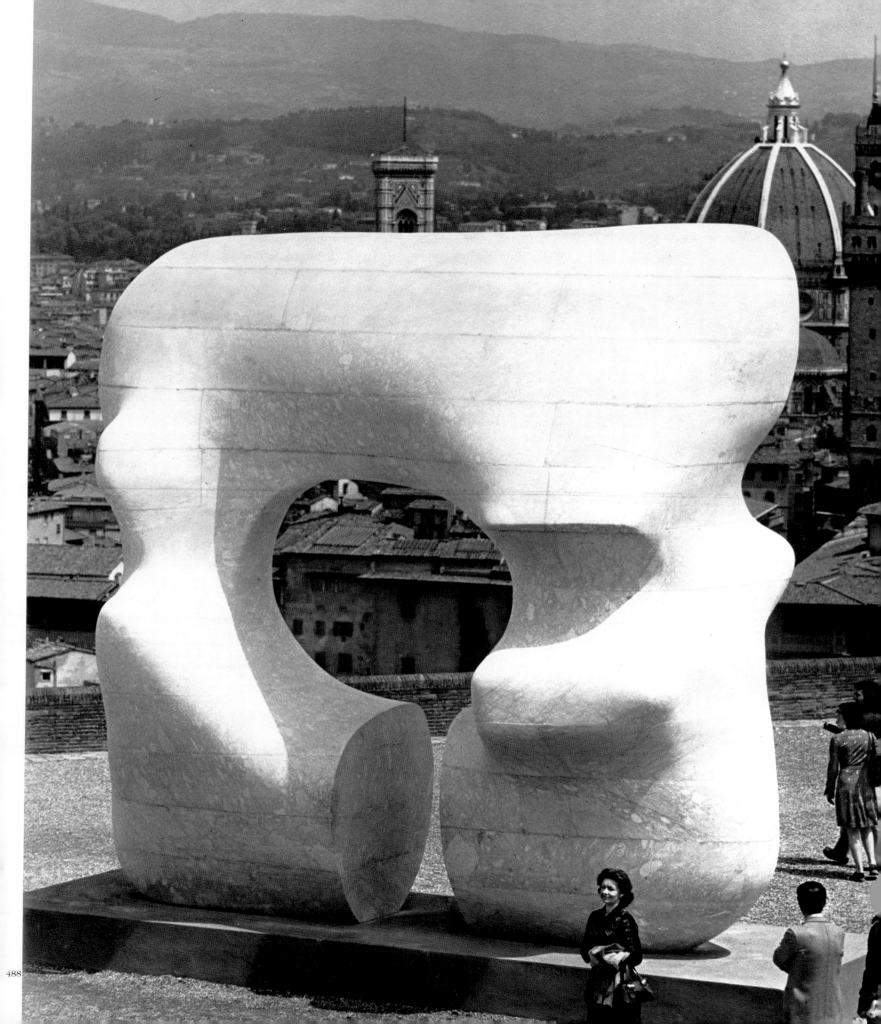

When I first began doing sculpture about 1922 or so, I often worked direct in a piece of stone or wood, which might have been not a geometric shape but just an odd random block of stone that one found cheaply in some stonemason's yard, or a log of wood which was a natural shape, and then I'd make a sculpture, trying to get as big a sculpture out of that bit of material as I could, and therefore one would wait until the material suggested an idea.

Nowadays I don't work so much in that way, as I have an idea, or an idea comes to me, and then I find the material to make it in, and to do that, the ideas that I am concerned with, I'll produce several maquettes – sketches in plaster – not much bigger than one's hand, certainly small enough to hold in one's hand, so that you can turn them around as you shape them and work on them without having to get up and walk around them, and you have a complete grasp of their shape from all around the whole time. If the form, the idea that you're doing is much bigger than that, then to see what it's like on the other side, you have to get up, walk around it, and this restricts your imagining and grasping what it's like as you can when it's small.

But all the time that I am doing this small model, in my mind it isn't the small model that I'm doing, it's the big sculpture that I intend to do. It's as though one were drawing in a little sketchbook a tiny little sketch for a monument, or a tiny little drawing might be on the back of an envelope, but in your mind would be the equestrian statue that is over life-size. In the same way, these little plaster maquettes that I make, to me, are all big sculptures. Therefore, when I choose the one that I think has the best possibility and retains my interest, then it's only carrying out one's original idea in reality.

489, 490 Two Forms *1969 L 90.1 cm Carrara marble* City Art Gallery, Manchester

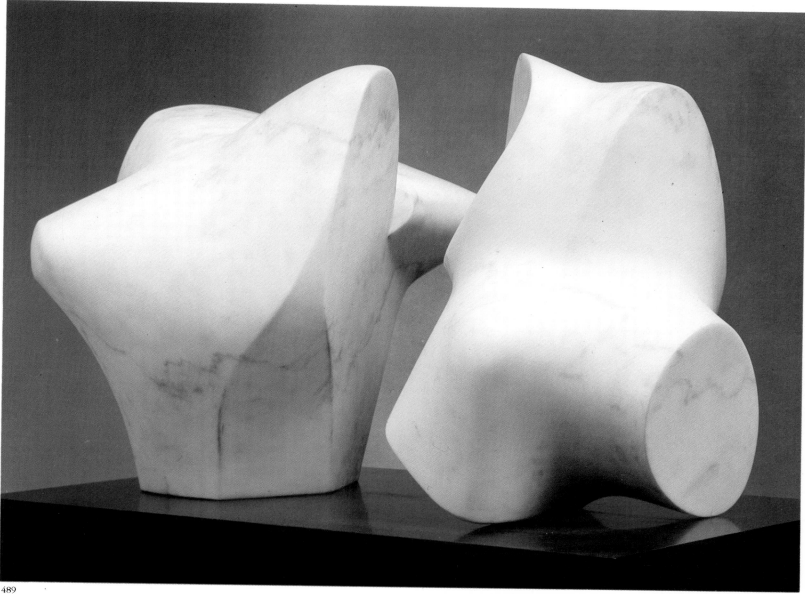

489

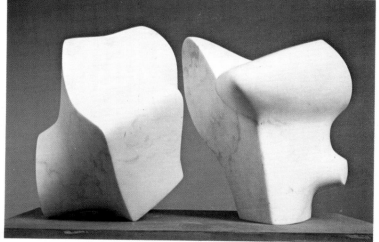

490

491 Working Model for Animal Form *1969–71 L 66 cm Bronze, edition of 9*

492 Animal Form *1969 L 1.22 m Travertine marble*
Private collection, Chicago

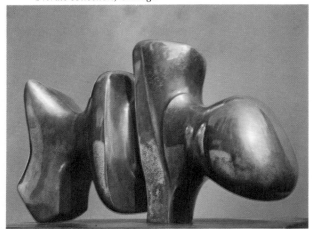

491

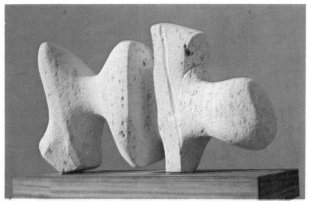

492

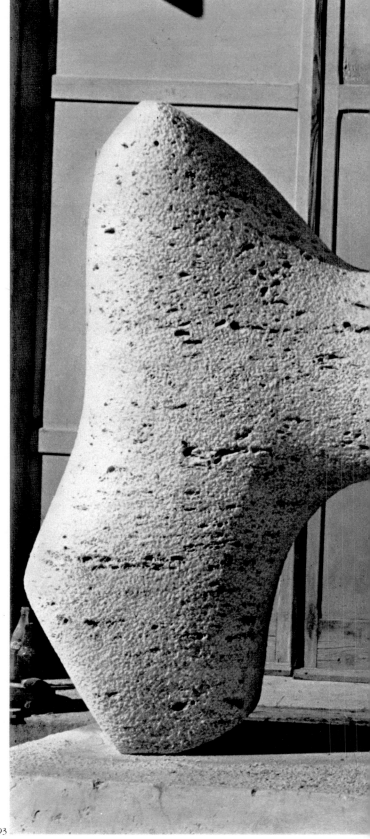

493

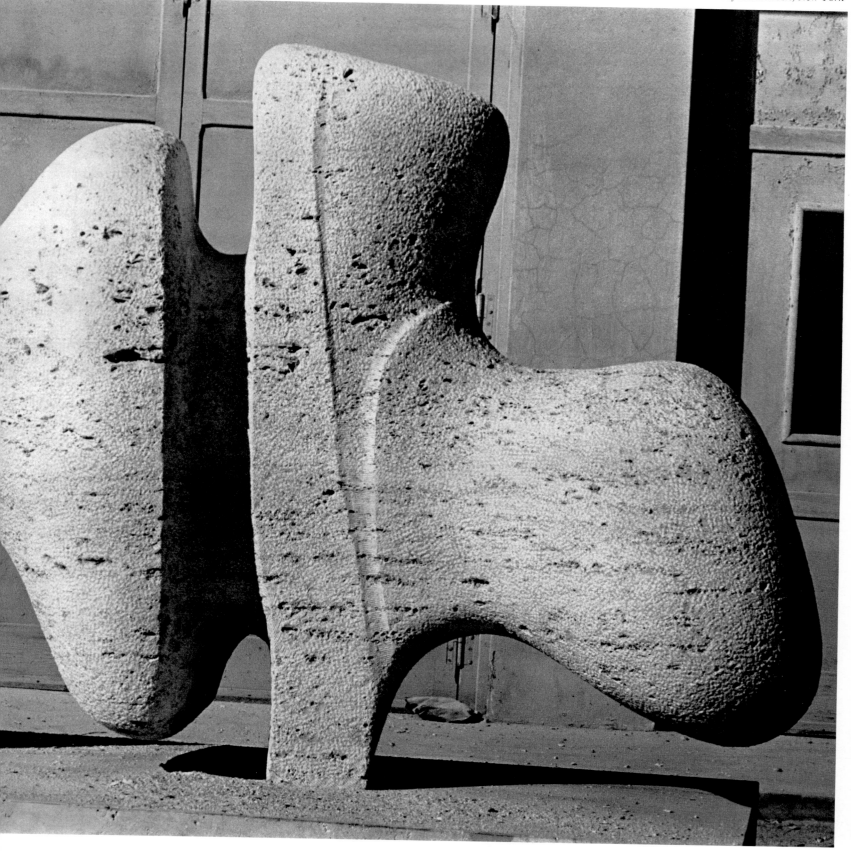

The idea of one form inside another form may owe some of its incipient beginnings to my interest at one stage when I discovered armour. I spent many hours in the Wallace Collection, in London, looking at armour.

Now armour is an outside shell like the shell of a snail which is there to protect the more vulnerable forms inside, as it is in human armour which is hard and put on to protect the soft body. This has led sometimes to the idea of the Mother and Child where the outer form, the mother, is protecting the inner form, the child, like a mother does protect her child.

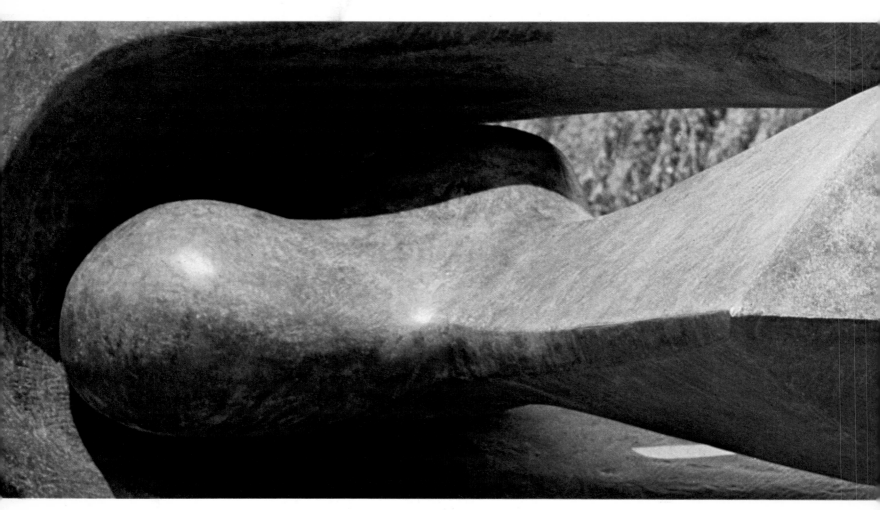

494-6 Reclining Connected Forms *1969 L 2.13 m Bronze, edition of 9*

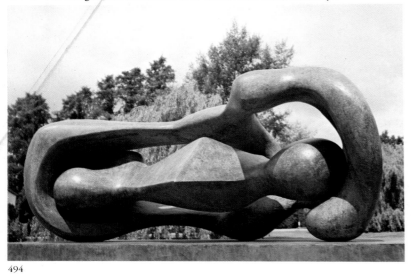

494

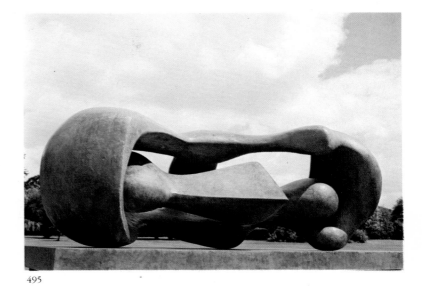

495

496

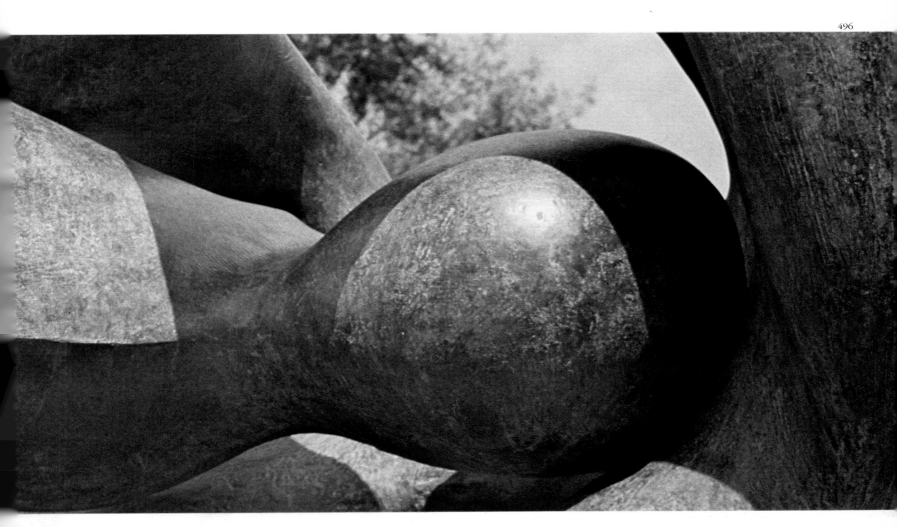

497–9 Reclining Figure *1969–70 L 3.43 m Bronze, edition of 6*

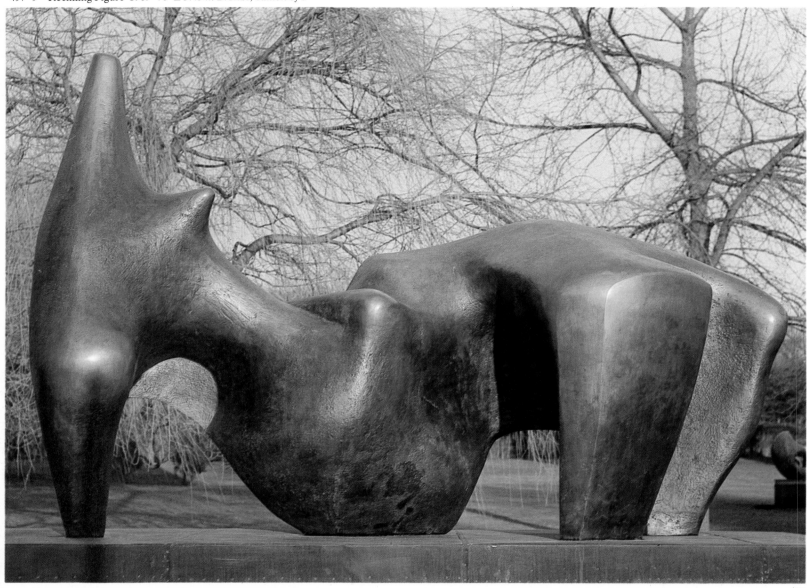

497

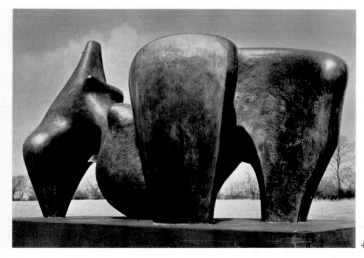

498

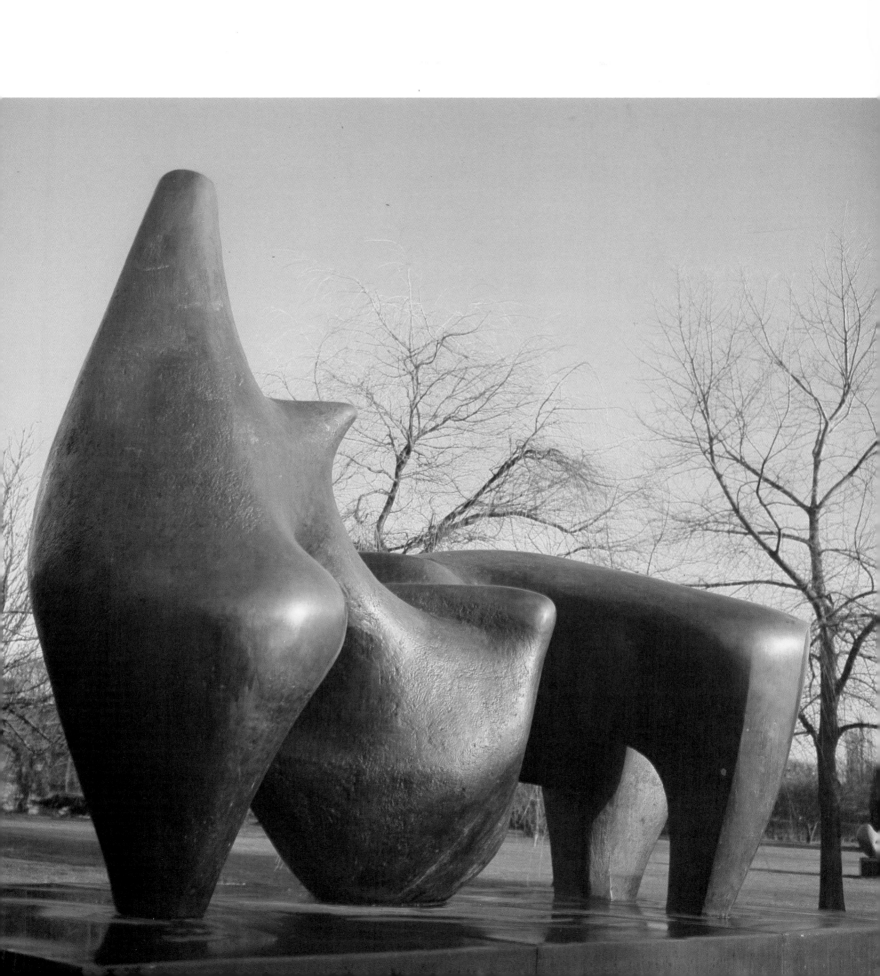

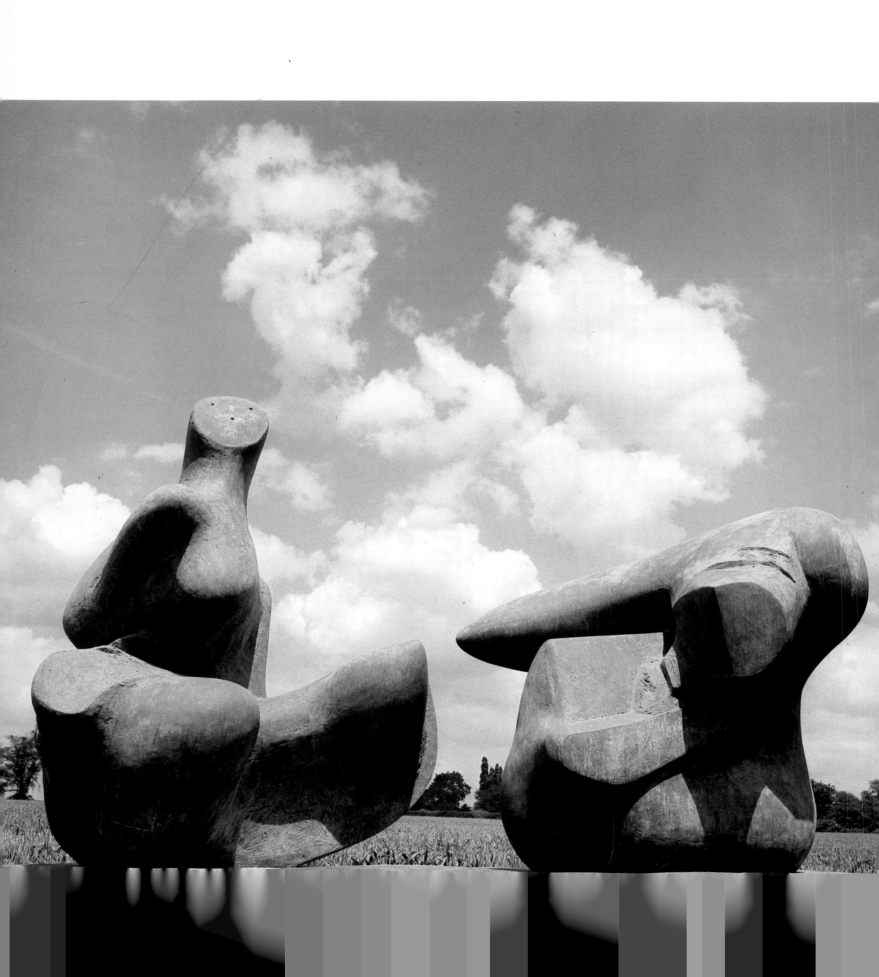

500, 501 Two Piece Reclining Figure: Points *1969–70 L 3.66 m approx. Bronze, edition of 7*

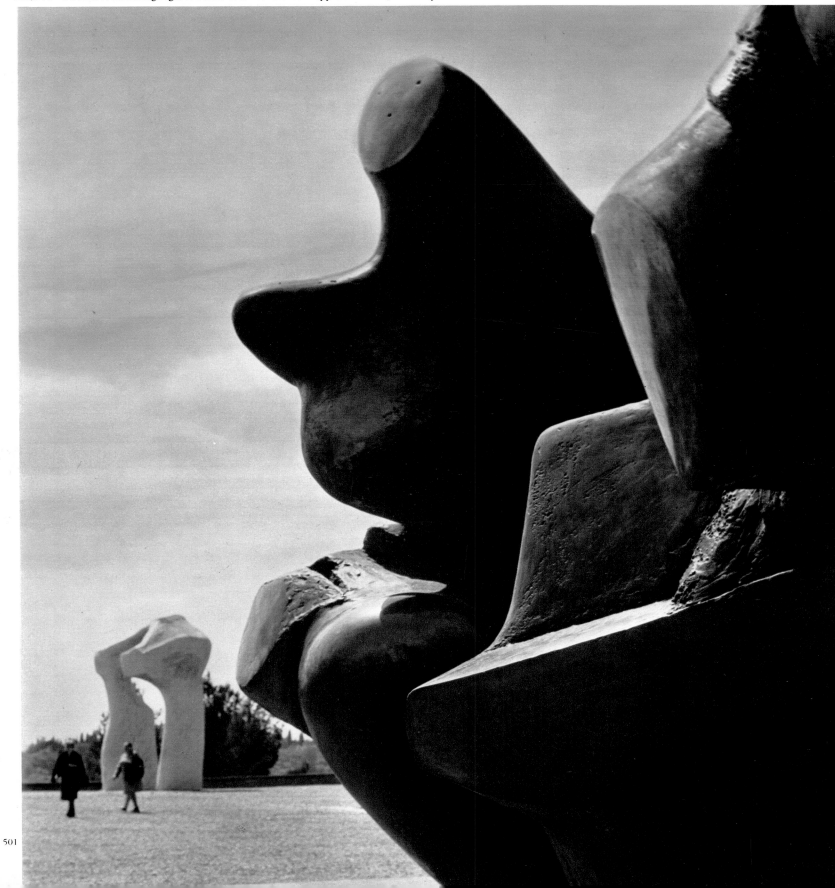

502, 504–8 Reclining Figure: Arch Leg *1969–70 L 4.42 m Bronze, edition of 6*
503 Bridge Form *1971 L 70.5 cm Black Abyssinian marble*

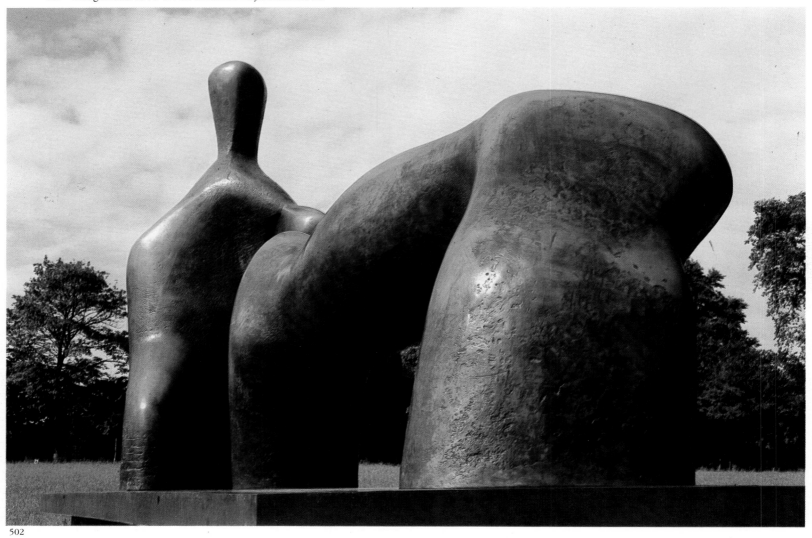

502

503

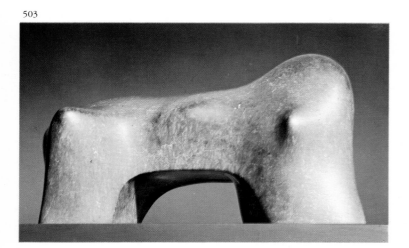

504

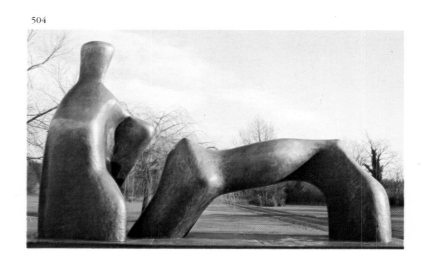

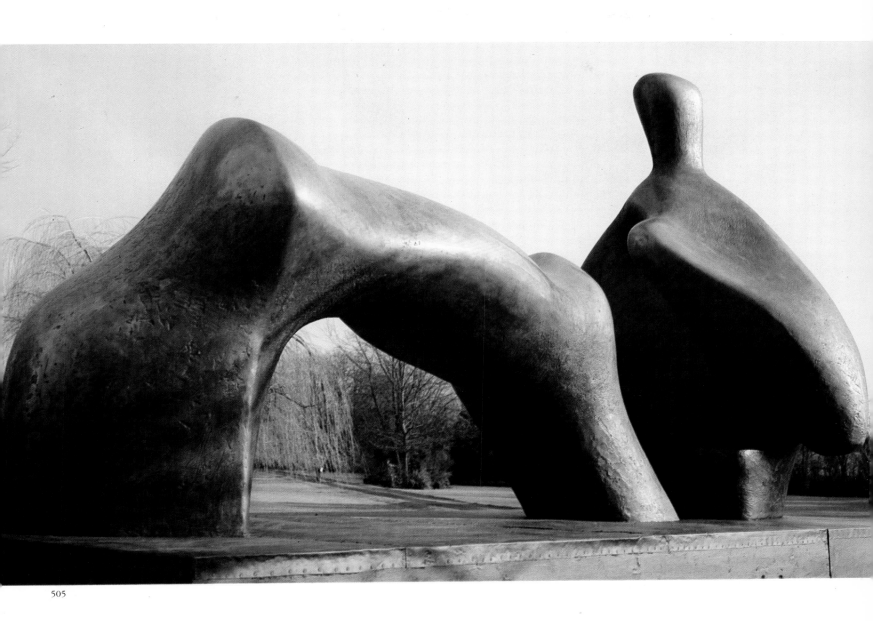

505

506

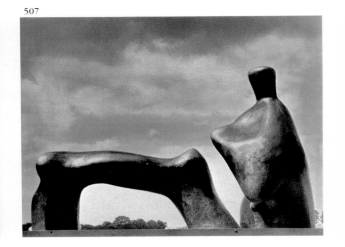

507

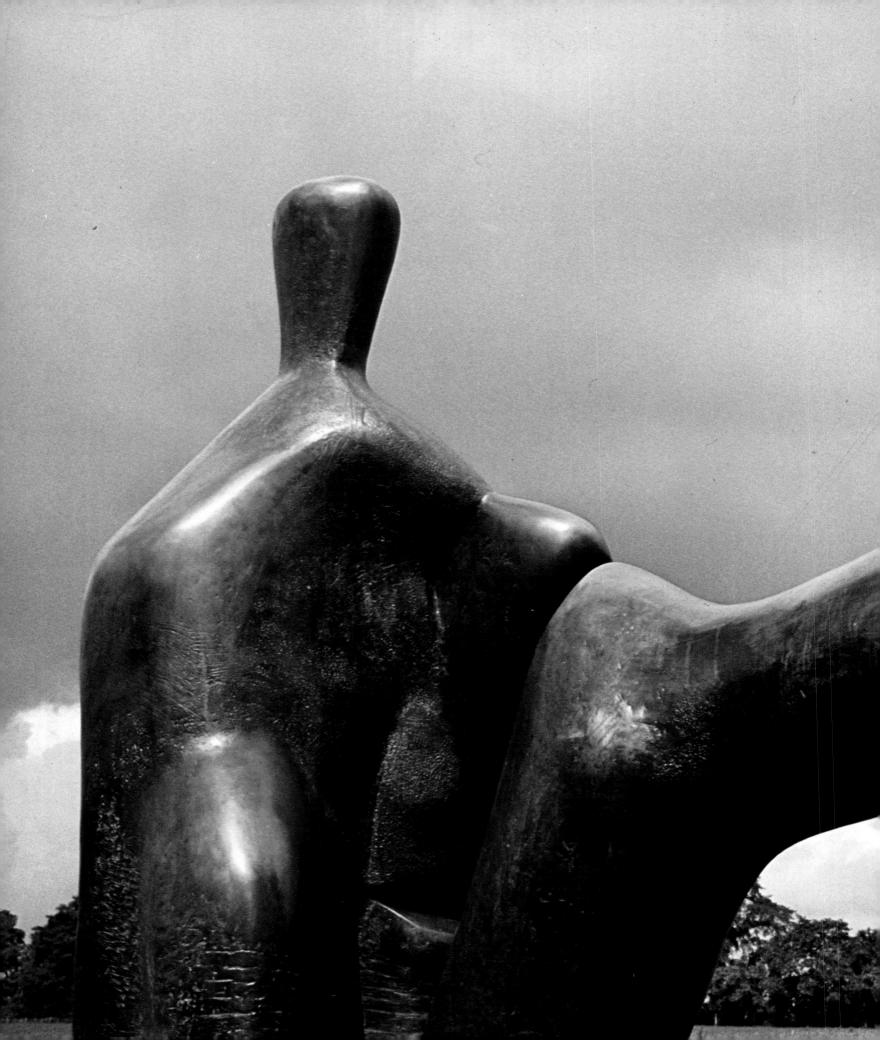

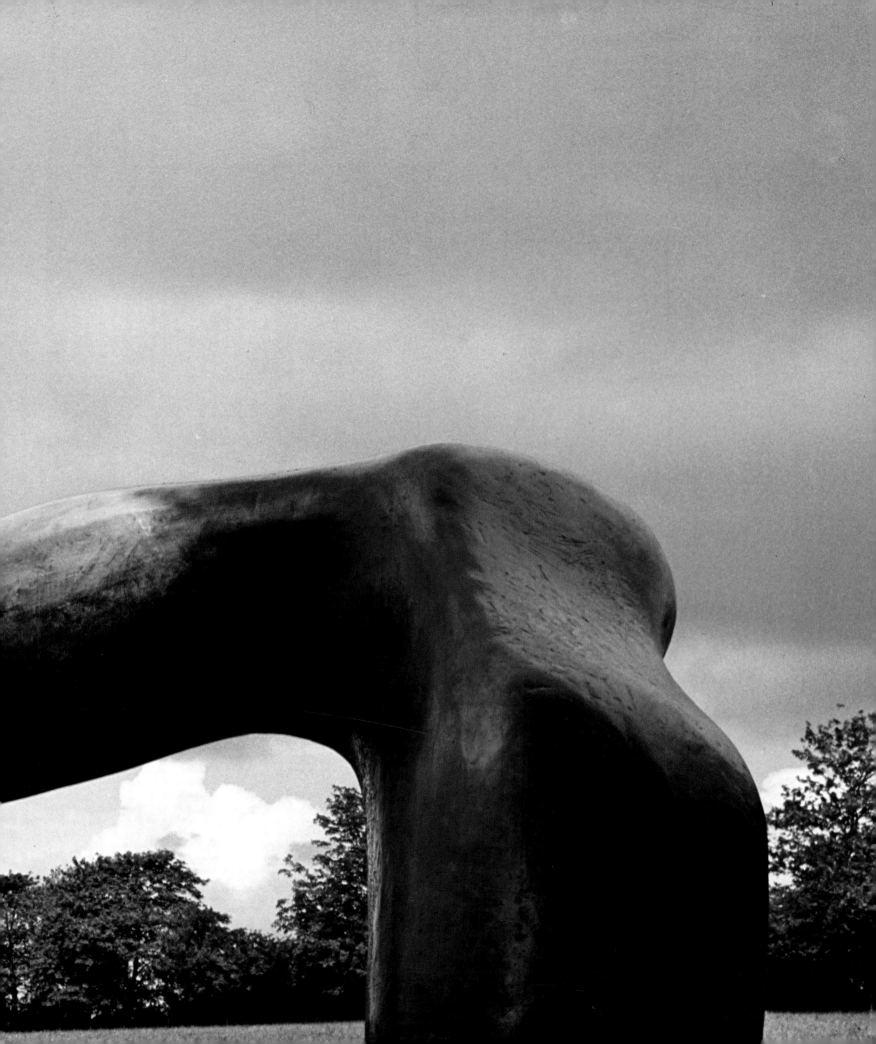

509, 510 Large Reclining Connected Forms *1969 and 1974 L 7.92 m approx. Roman travertine marble City of Baltimore*

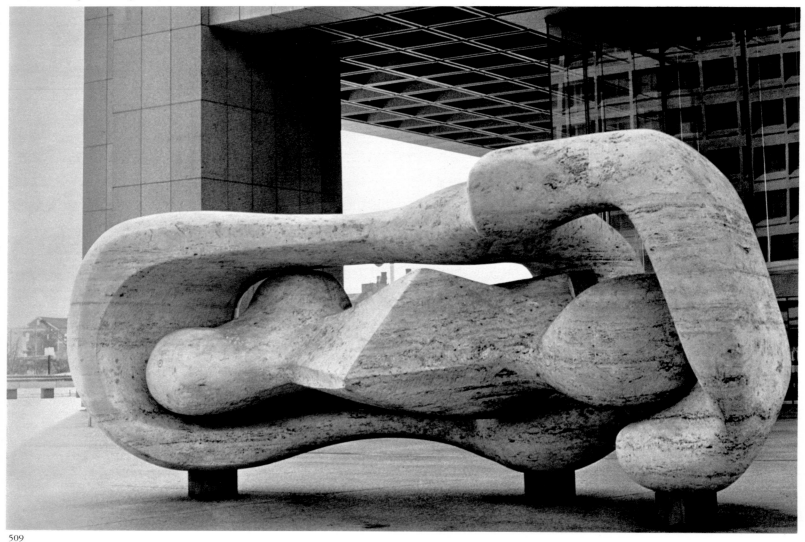

509

510

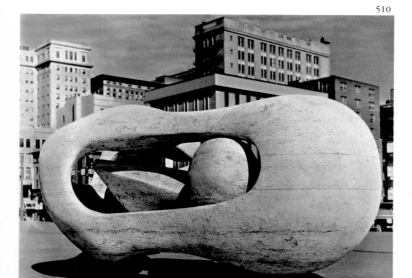

511 Oblong Composition *1970 L 1.22 m approx. Red travertine marble Kunsthalle, Karlsruhe*
512, 513 Arch Form *1970 L 2.13 m approx. Serpentine Private collection*

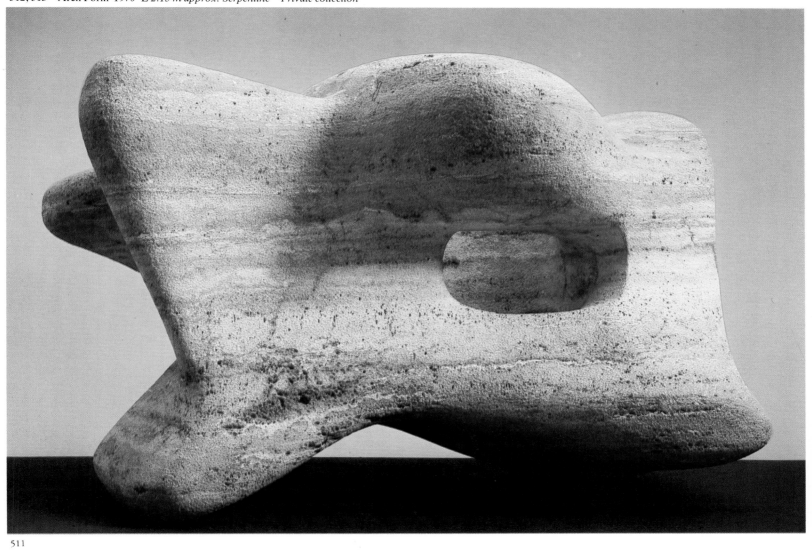

511

512

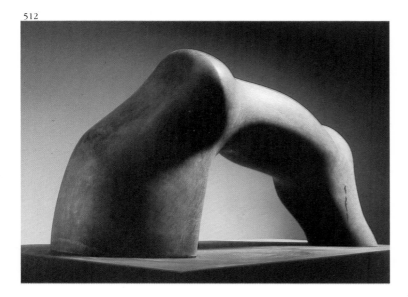

513

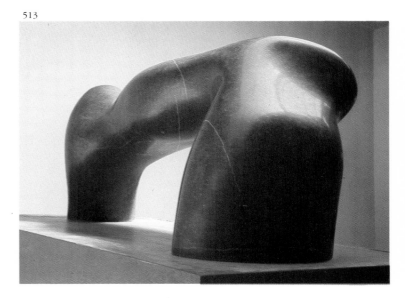

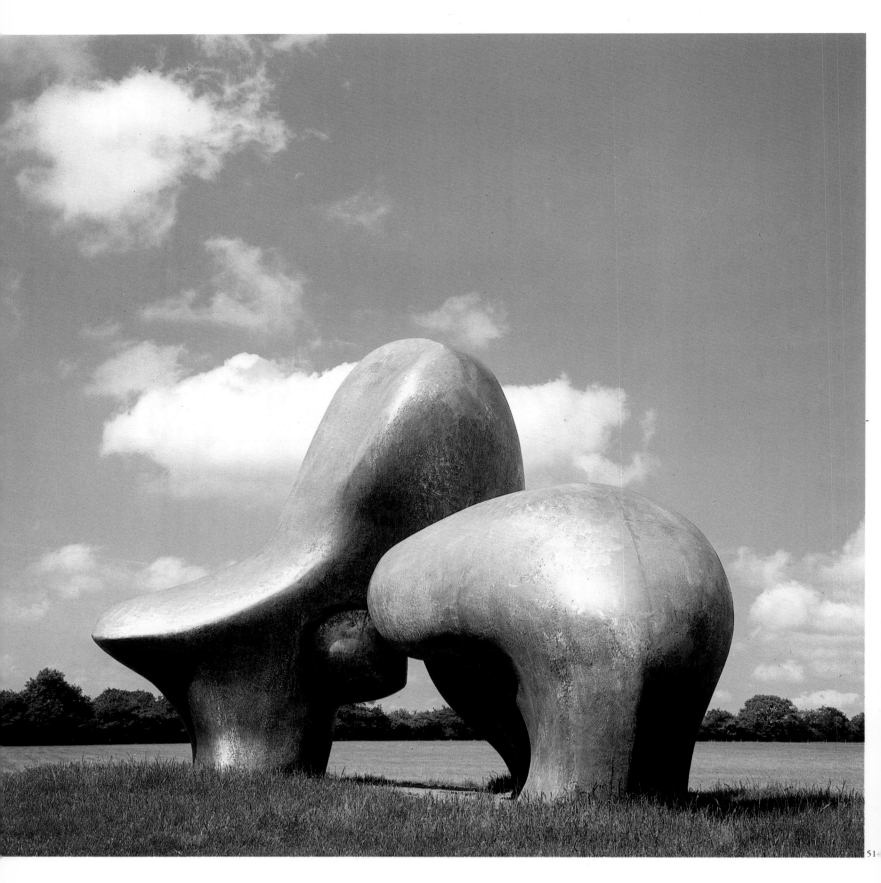

51

514–16 Sheep Piece *1971–2 L 5.79 m approx. Bronze, edition of 3*

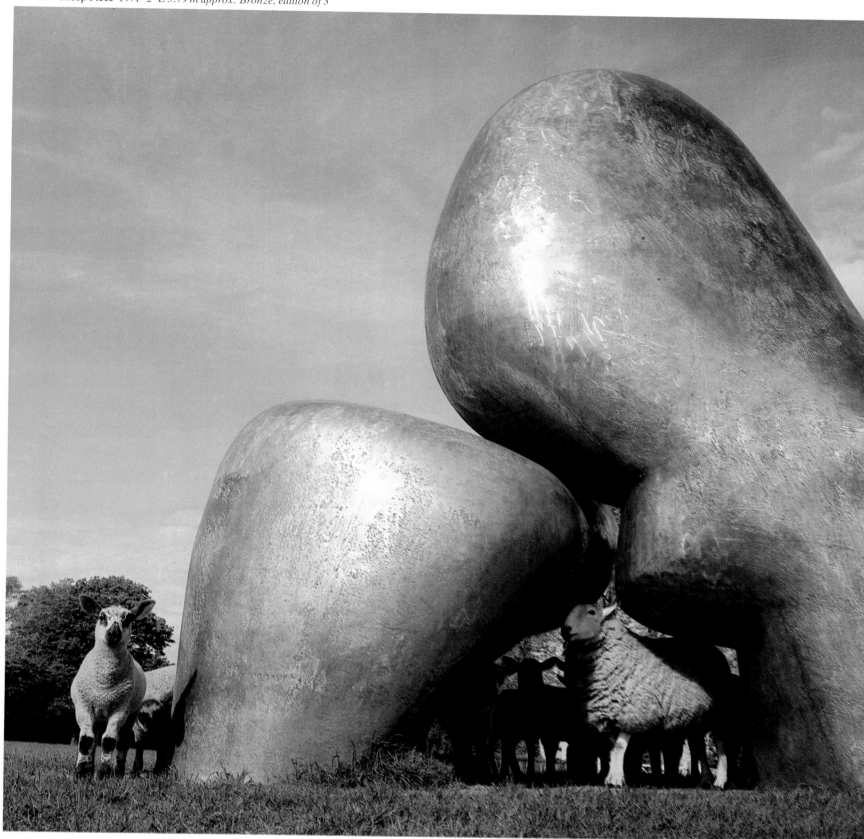

5

I have always liked sheep, and there is one big sculpture of mine that I call *Sheep Piece* because I placed it in a field and the sheep enjoyed it and the lambs played around it. Sheep are just the right size for the kind of landscape setting that I like for my sculptures: a horse or a cow would reduce the sense of monumentality. Perhaps the sheep belong also to the landscape of my boyhood in Yorkshire. If the farmer didn't keep his sheep here, I would own some myself, just for the pleasure they give me.

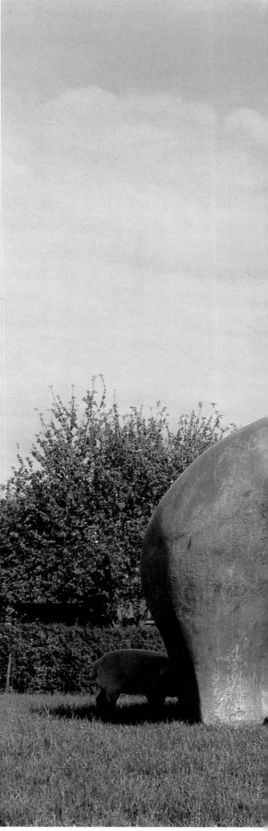

516

242

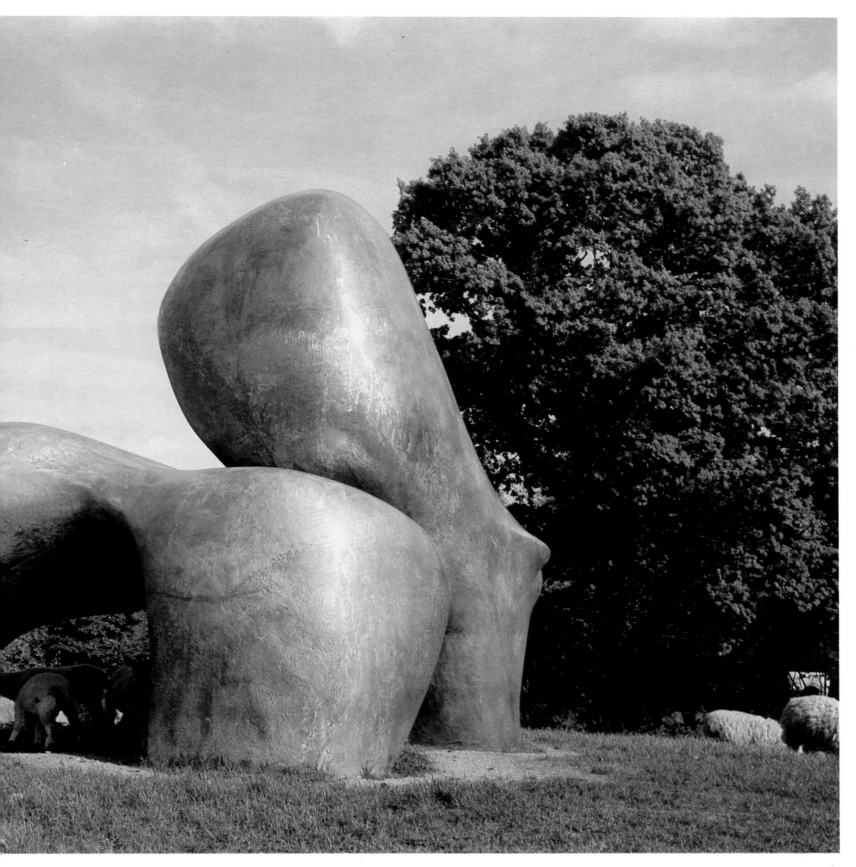

517 Double Tongue Form *1972 L 76.2 cm Carrara marble*
518 Three Way Piece Carving *1972 L 48.2 cm Carrara marble Private collection, Spain*
519 Head *1972 H 45.7 cm Travertine marble Bayerische Staatsgemäldesammlungen, Munich*
520 Column *1973 H 16.83 cm Bronze, edition of 6*

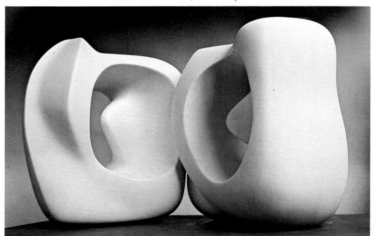

517

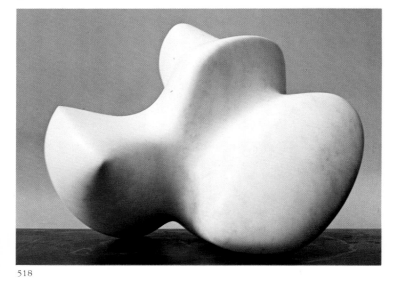

518

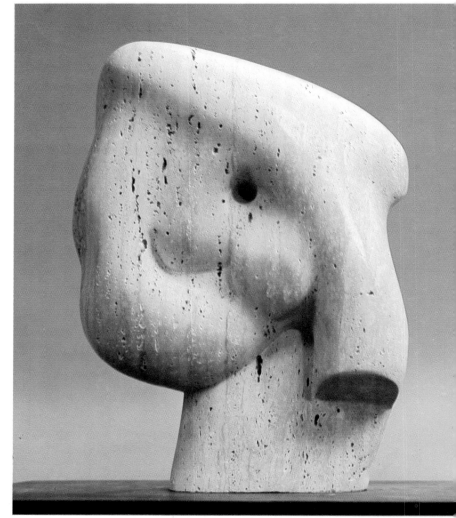

519

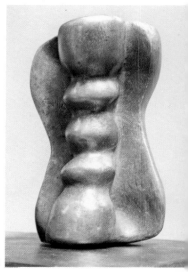

520

521 Bird Form I *1973 L 37 cm Black marble The Henry Moore Foundation*
522 Fledglings *1971 L 16 cm Bronze, edition of 12*
523 Reclining Figure: Bone *1974 L 27.3 cm Bronze, edition of 9*
524 Bird Form II *1973 L 40 cm Black marble The Henry Moore Foundation*
525 Serpent *1973 L 24 cm Bronze, edition of 9*

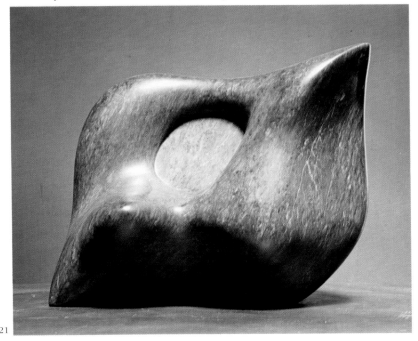

521

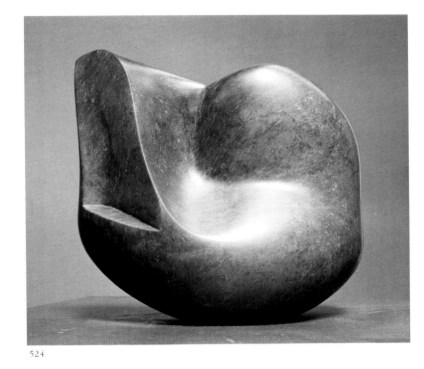

524

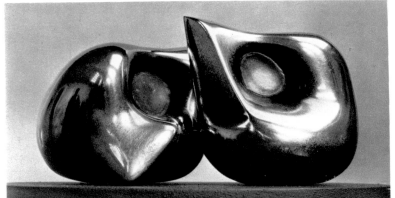

522

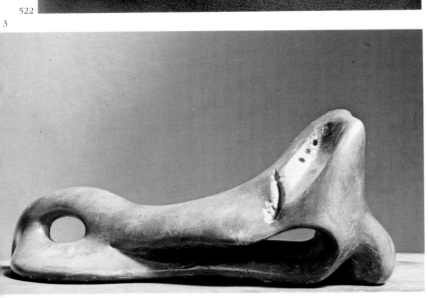

3

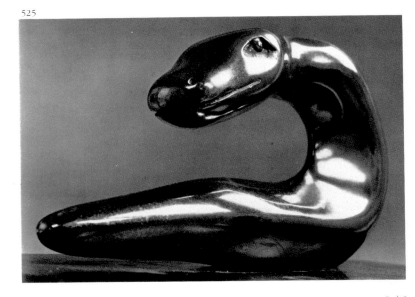

525

526, 527 Large Four Piece Reclining Figure *1972–3 L 4.02 m Bronze, edition of 7*

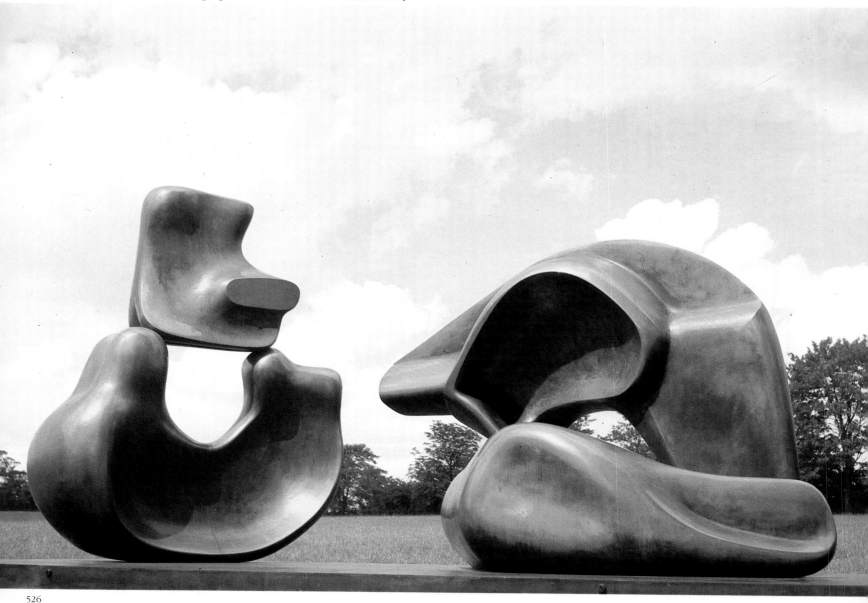

526

Landscape has been for me one of the sources of my energy. It is generally thought that no sculptor is much interested in landscape, but is only concerned with the solid, immediate form of the human figure or animals. For myself I have always been very interested in landscape. (I can never read on a train – I have to look out of the window in case I miss something.) As well as landscape views and cloud formations, I find that all natural forms are a source of unending interest – tree trunks, the growth of branches from the trunk each finding its individual air-space, the texture and variety of grasses, the shape of shells, of pebbles, etc. The whole of nature is an endless demonstration of shape and form, and it surprises me when artists try to escape from this.

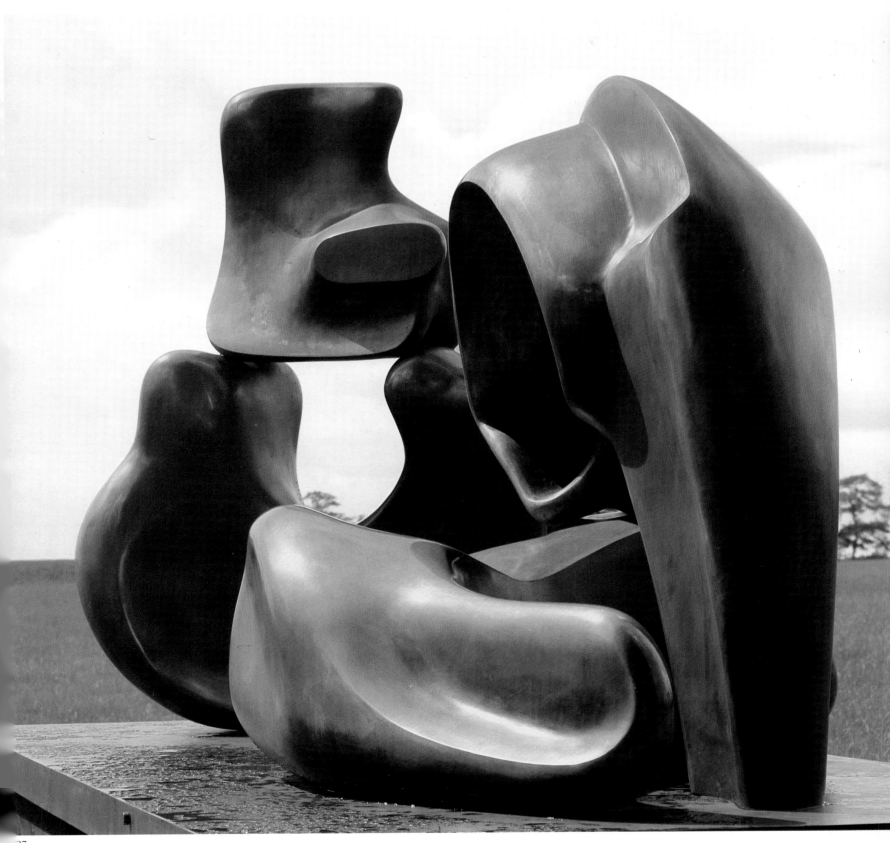

528–31 Hill Arches *1973 L 5.5 m approx. Bronze, edition of 3 Installation of Sculpture at Deere & Company Administrative Center, Moline, Illinois*
532 Working Model for Hill Arches *1972 L 1.09 m Bronze, edition of 9*

528

529

530

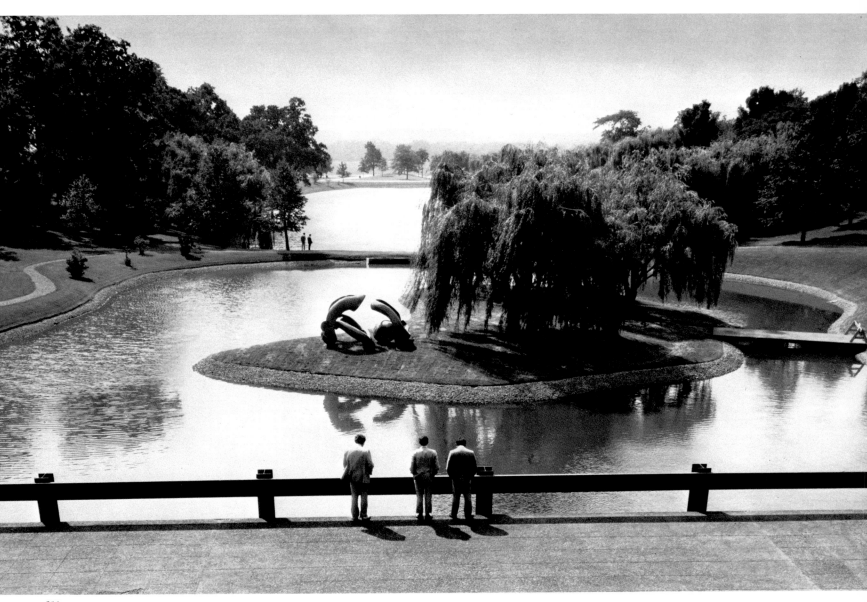

531

Some sculpture finds its best setting on a stretch of
lawn or beside a pool. Others might be more effective,
more poignant, set against the rhythm and raggedness
of trees. Some of these might look best against oaks and
others against elms. Yet others need the secret glade, a
patch of grass enclosed by high bushes to give a sense of
privacy. It is certain that one wouldn't want to see, say,
a realistic nude of an adolescent girl exposed on a bleak
hillside, and except in a warm sunny climate such a
figure would be best indoors.

But there are a great many places that no sculptor has
thought of – or has ever seen – that must be superb
settings for sculpture, and this is where collectors and
museum directors and parks committees and owners of
country estates can make discoveries of great
importance for the future of sculpture.

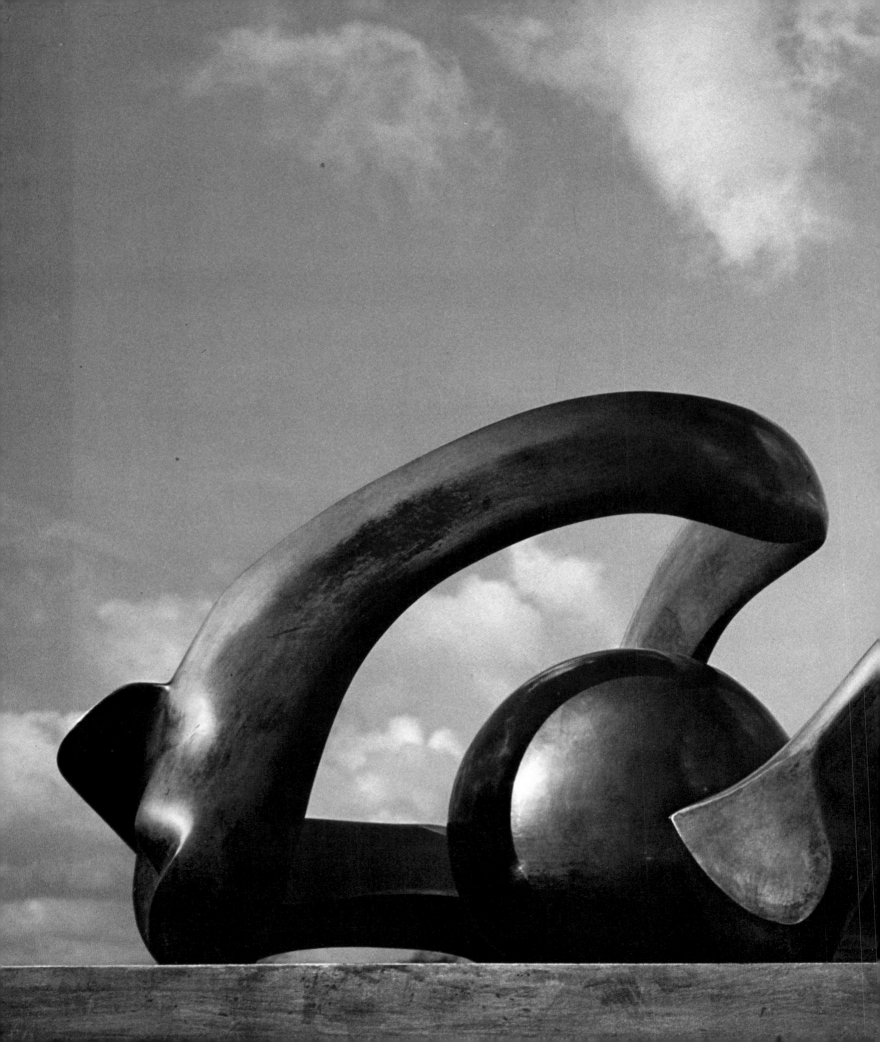

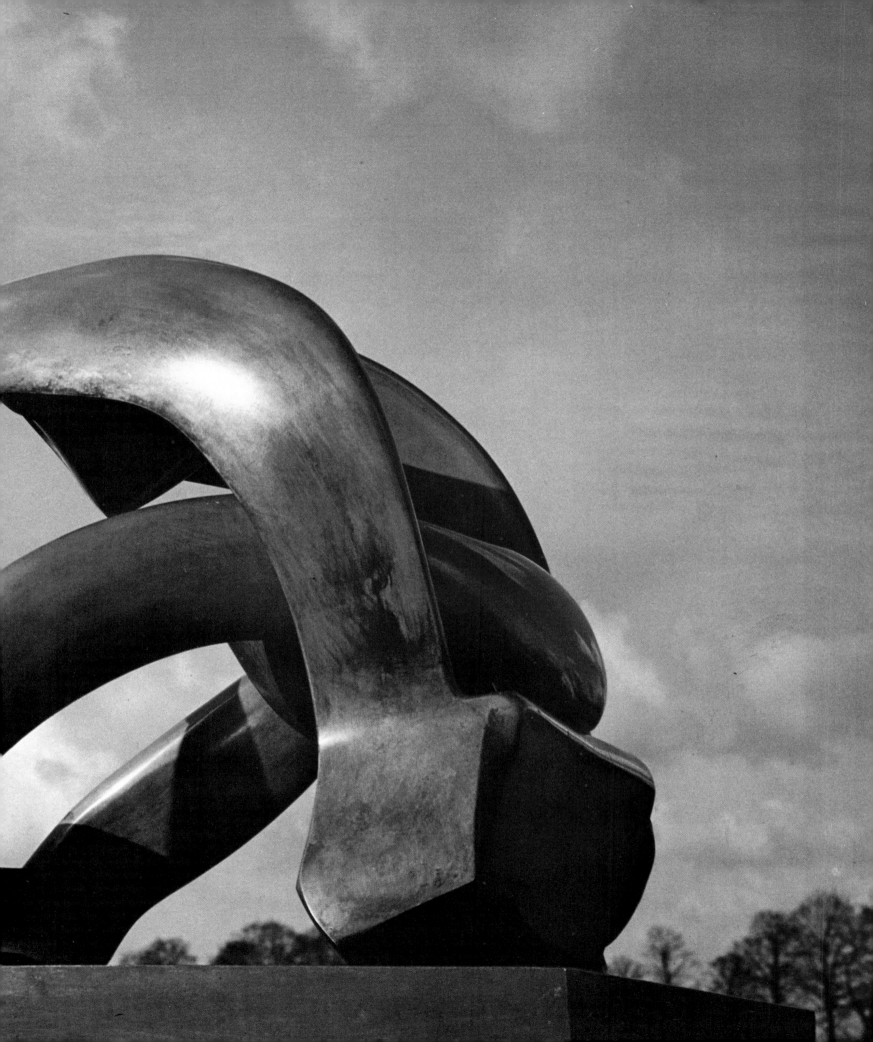

533–5 Goslar Warrior *1973–4 L 2.49 m Bronze, edition of 7*

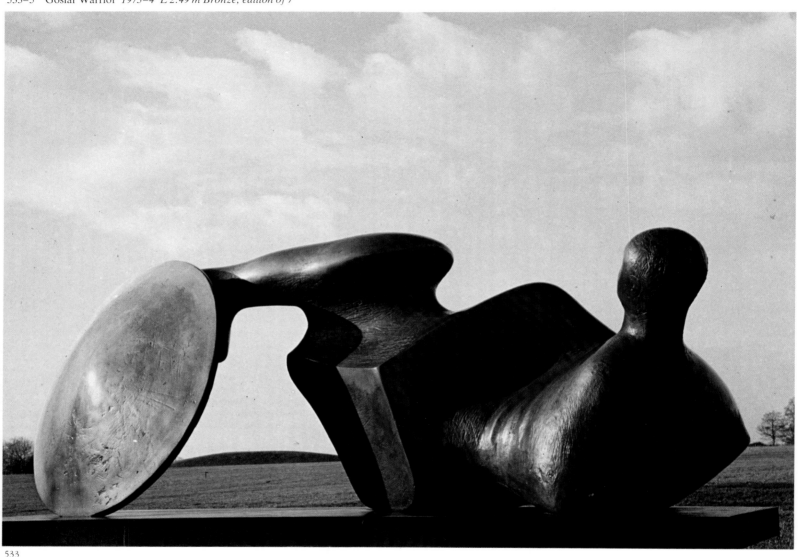

533

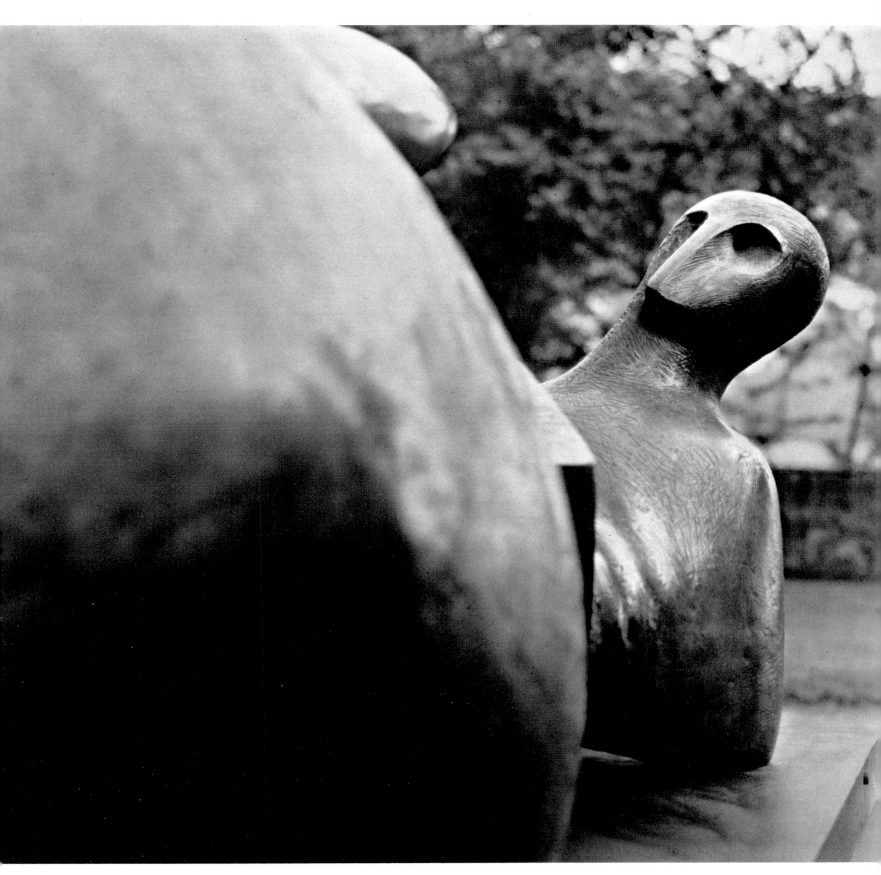

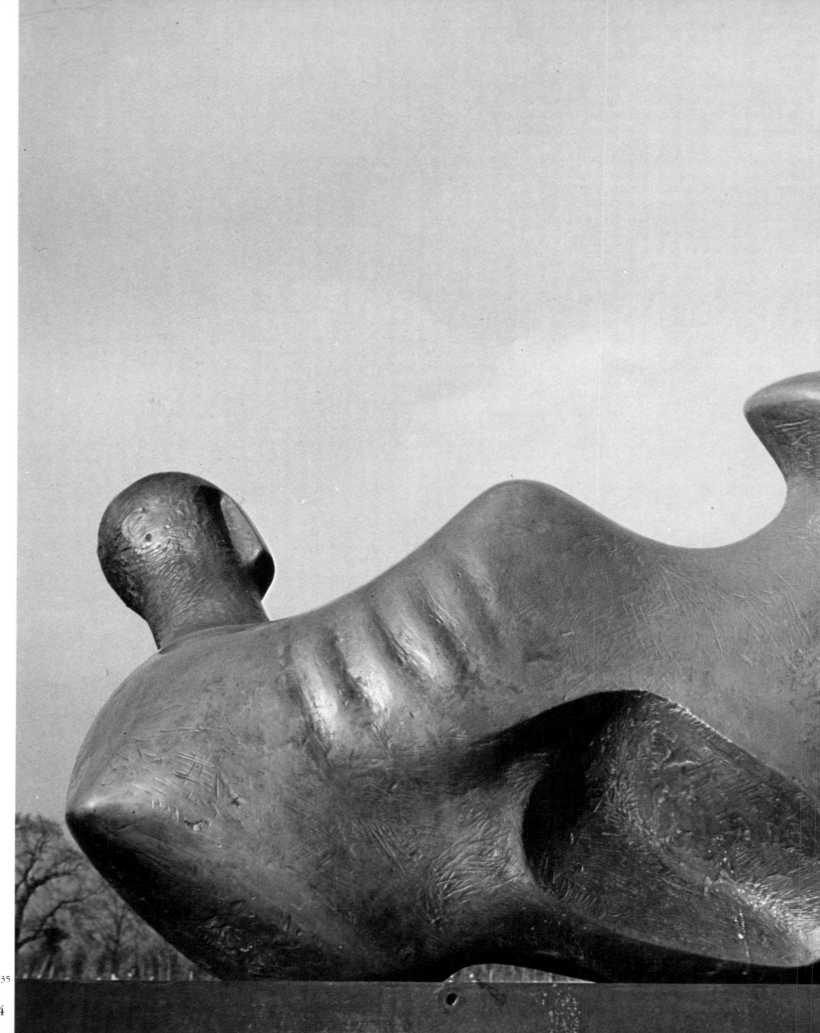

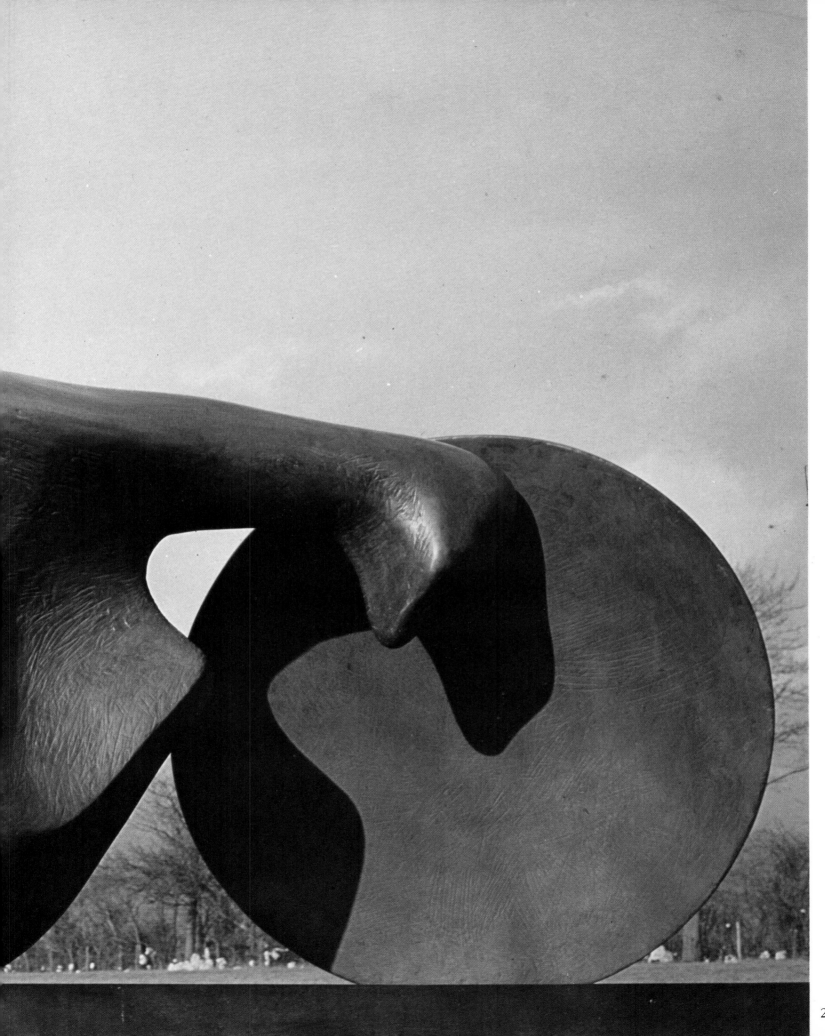

536, 537 Reclining Figure: Bone *1975 L 1.57 m Travertine marble The Henry Moore Foundation*

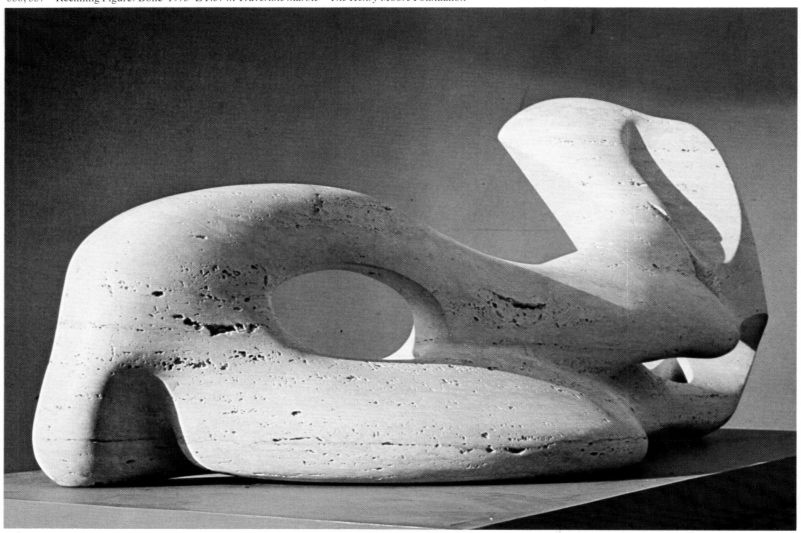

536

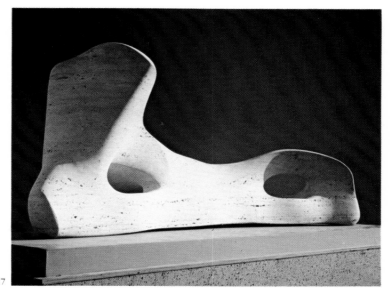

537

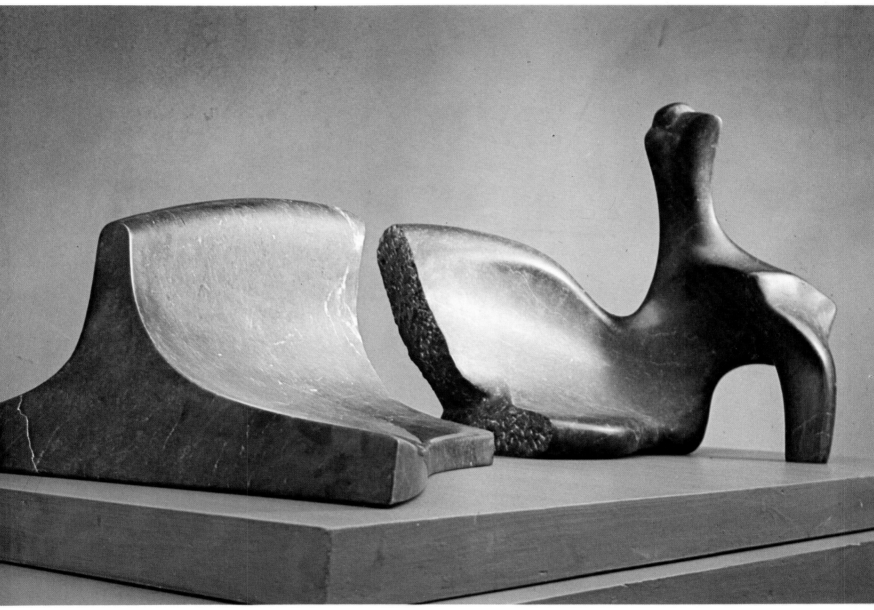

538

This idea is connected with my two-piece sculptures, but it came directly from a small plaster maquette which broke accidentally. While handling the two pieces I found that I actually preferred a longer figure and so I arranged them together, leaving a calculated gap between the two parts.

In making the larger version in black marble I repeated the gap, as a natural break.

539–42 Reclining Mother and Child *1975–6 L 2.13 m Bronze, edition of 7*

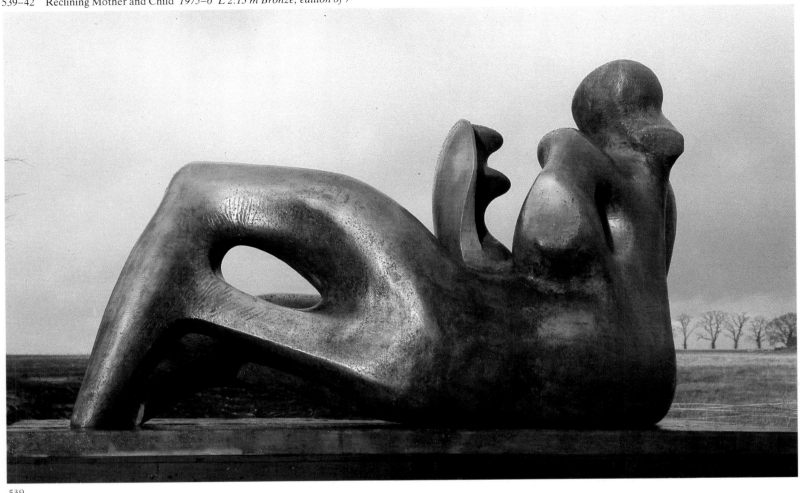

539

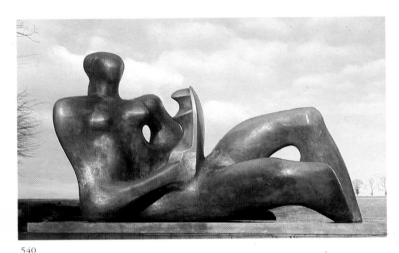

540

541

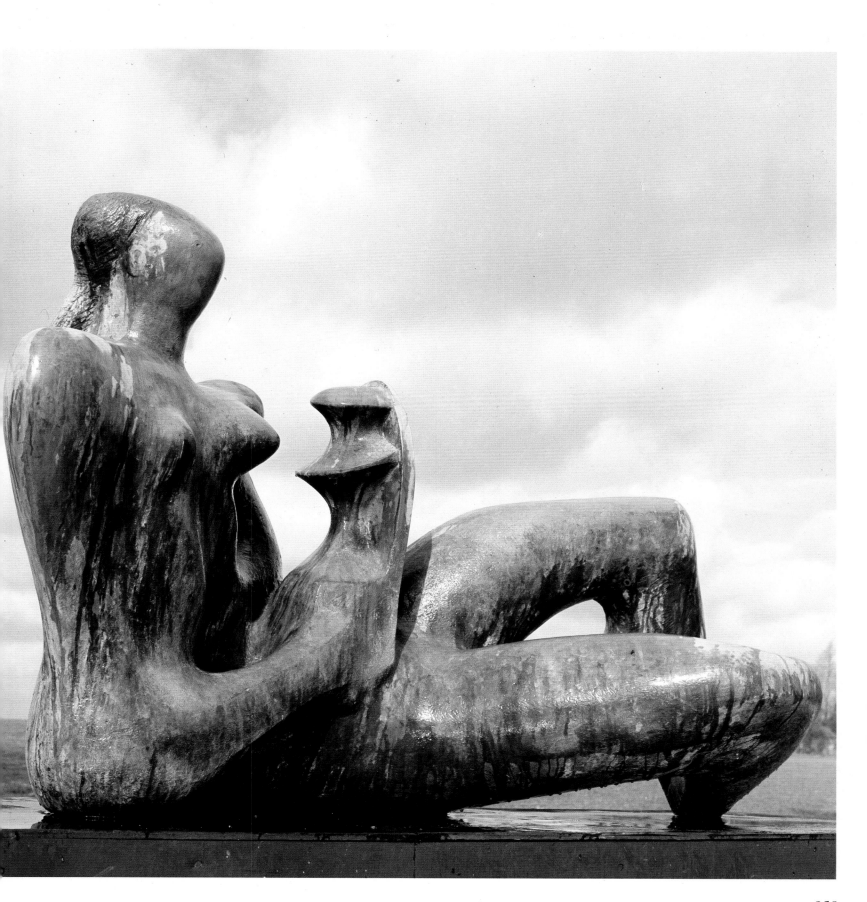

261

545–7 Reclining Figure: Holes *1975–8 L 2.22 m Elmwood* *The Henry Moore Foundation*

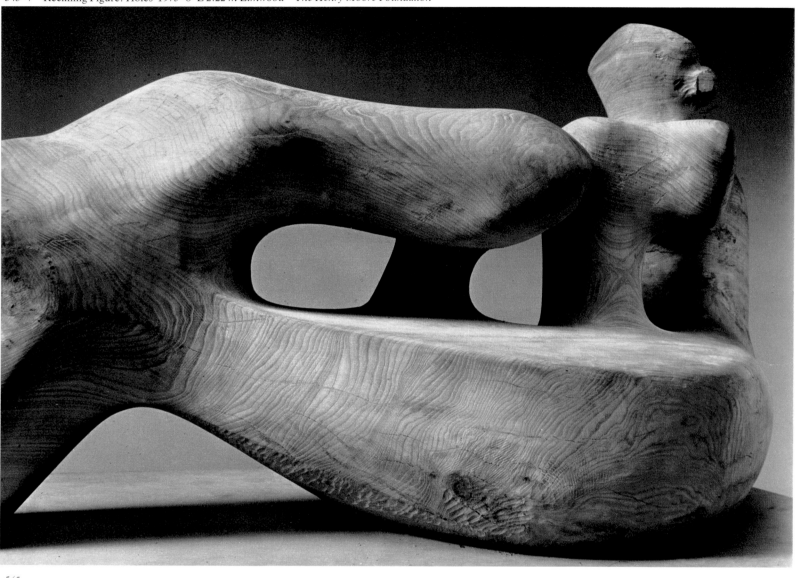

545

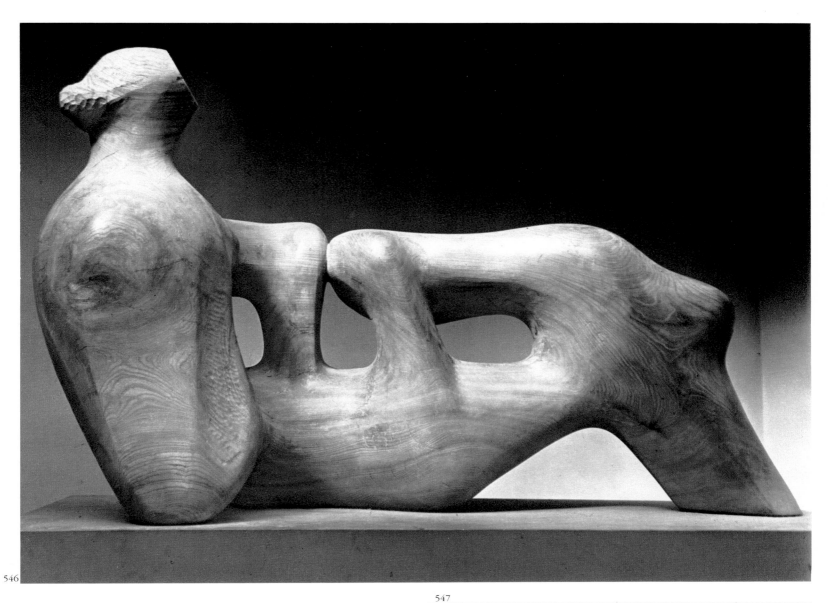

546

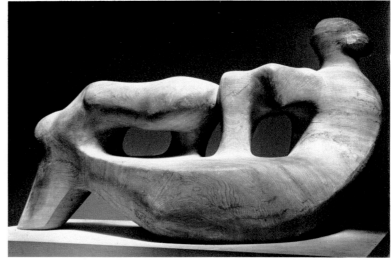

547

I enjoy woodcarving, particularly if I can get a large block of wood on which in the early stages I can freely use an axe. In England, until the arrival of elm disease, the wood most easily available in large pieces was elm. I have carved five or six large over life-size elmwood sculptures. Most of these sculptures (since I wanted to make full use of the bulk of the trunk), have a one-directional rhythm, either vertical or horizontal.

Elm trees are usually straight-growing, but this last large block of wood which I acquired had a slight curve in it and was big enough to allow for a bend in the sculpture's pose. This is something which in my other large elmwood carvings I wasn't able to do. For this reason I look upon this particular sculpture as having something special and different from the others.

548 Girl and Dwarf *1975 H 15.5 cm Bronze, edition of 7*
549 Reclining Mother and Child: Shell Skirt *1975 L 20.3 cm Bronze, edition of 9*

548

549

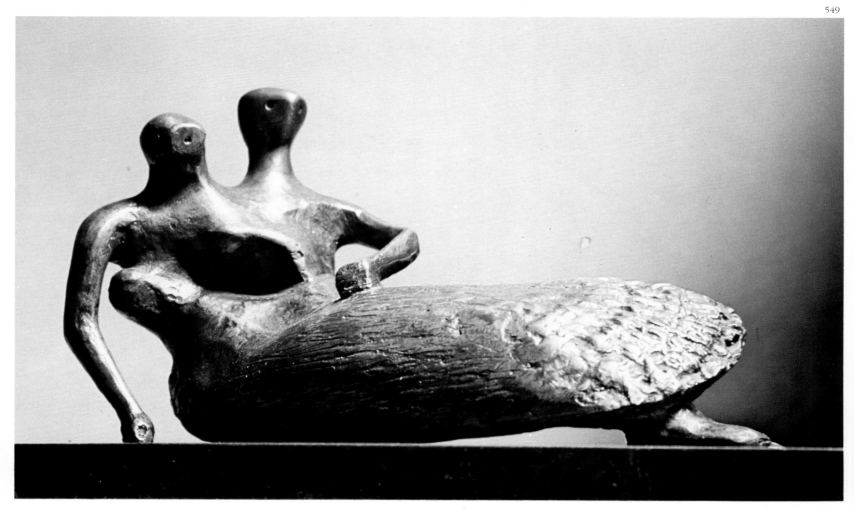

550 Mother and Child: Gothic *1975 H 19 cm Bronze, edition of 9*
551 Seated Mother and Child *1975 L 22.9 cm Bronze, edition of 9*
552 Mother and Child: Pisano *1976 H 14 cm Bronze, edition of 9*
553 Standing Mother and Child *1975 H 22.9 cm Bronze, edition of 9*

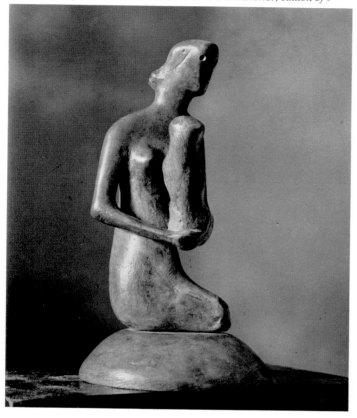

550

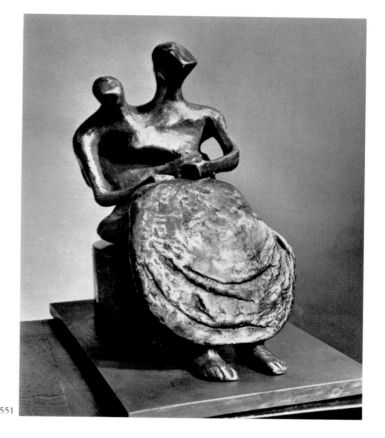

551

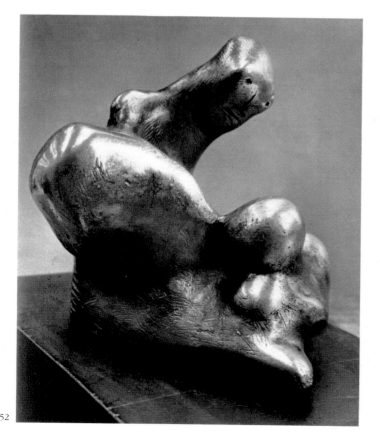

552

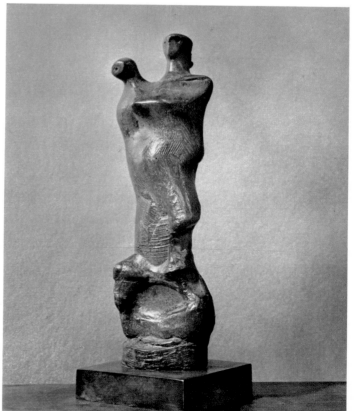

553

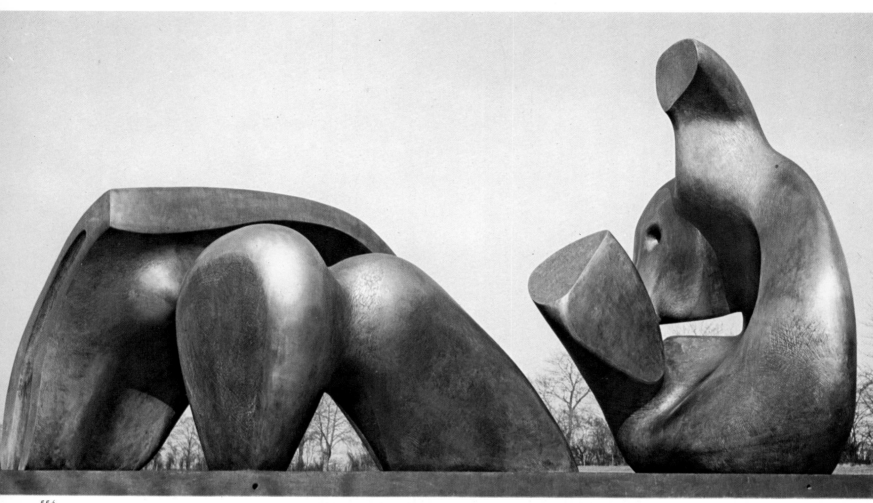

554

555

Sculpture that is made in several pieces which are arranged in relation to each other is something which I as a sculptor am particularly conscious of. The distances apart between the different pieces of a sculpture, if they were wrong, is what I would notice immediately. It is like when in a museum the art historians have found fragments of a Greek sculpture: they may have found a head, a bit of an arm, a knee and perhaps a foot, but they don't stick the foot on the knee and so on – they make a gap between them with a wire connecting each piece and this distance apart between each piece is what they must have right. My two-piece and three-piece sculptures have the space between each part which to me is the same as spacing the knee from the foot. This space between each piece is terribly important and is as much a form as the actual solid, and should be looked upon as a piece of form or a shape just as much as the actual material.

554–7 Three Piece Reclining Figure: Draped *1975 L 4.47 m Bronze, edition of 7*

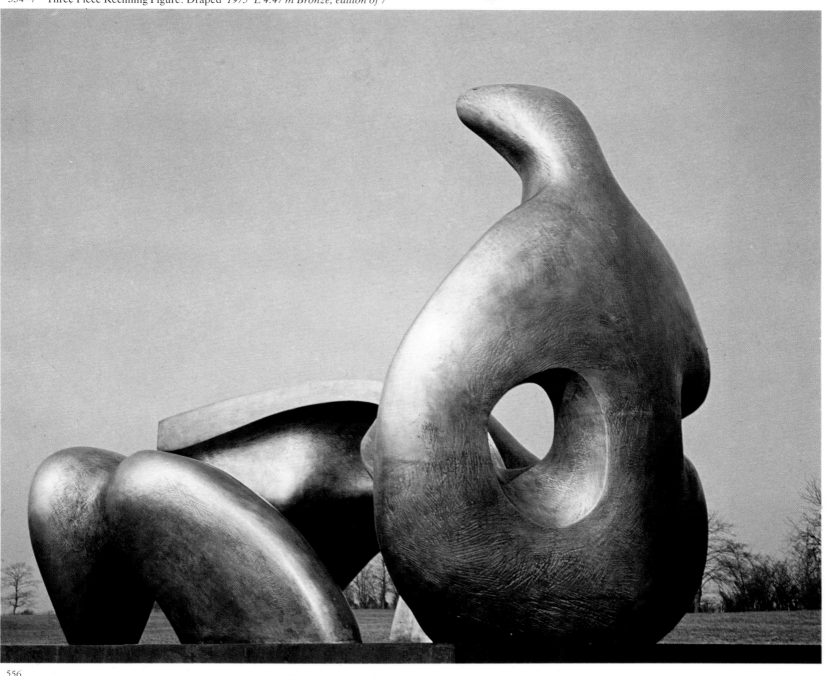

556

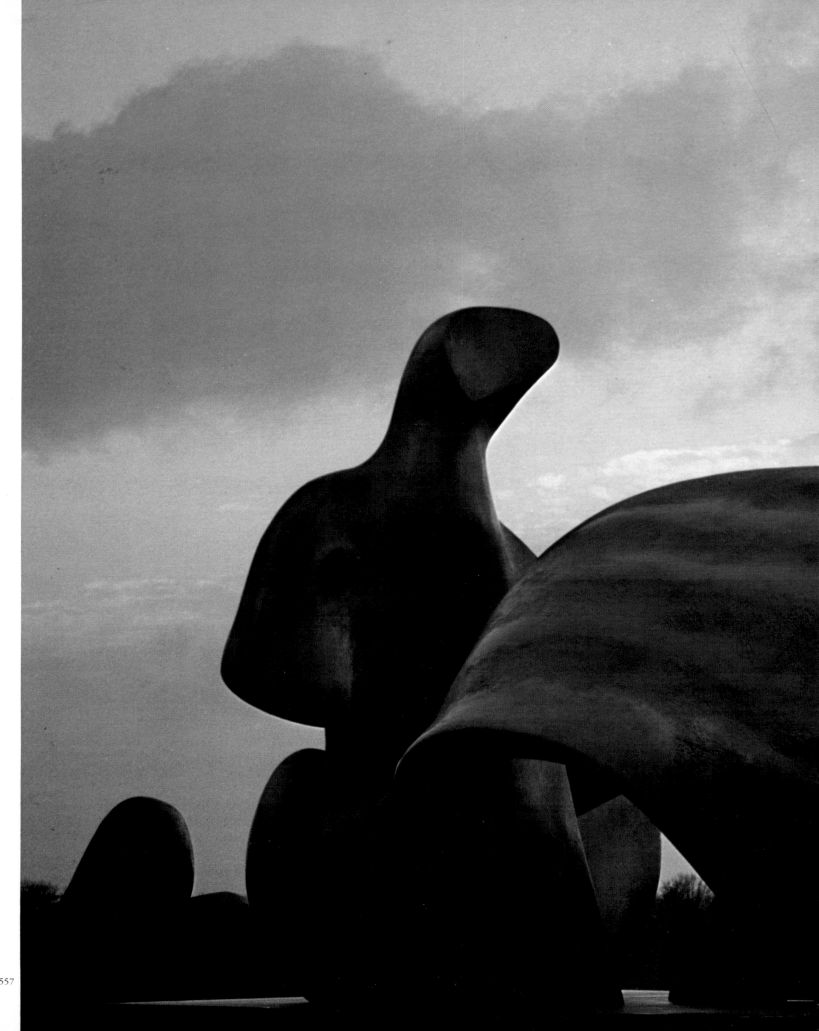

557

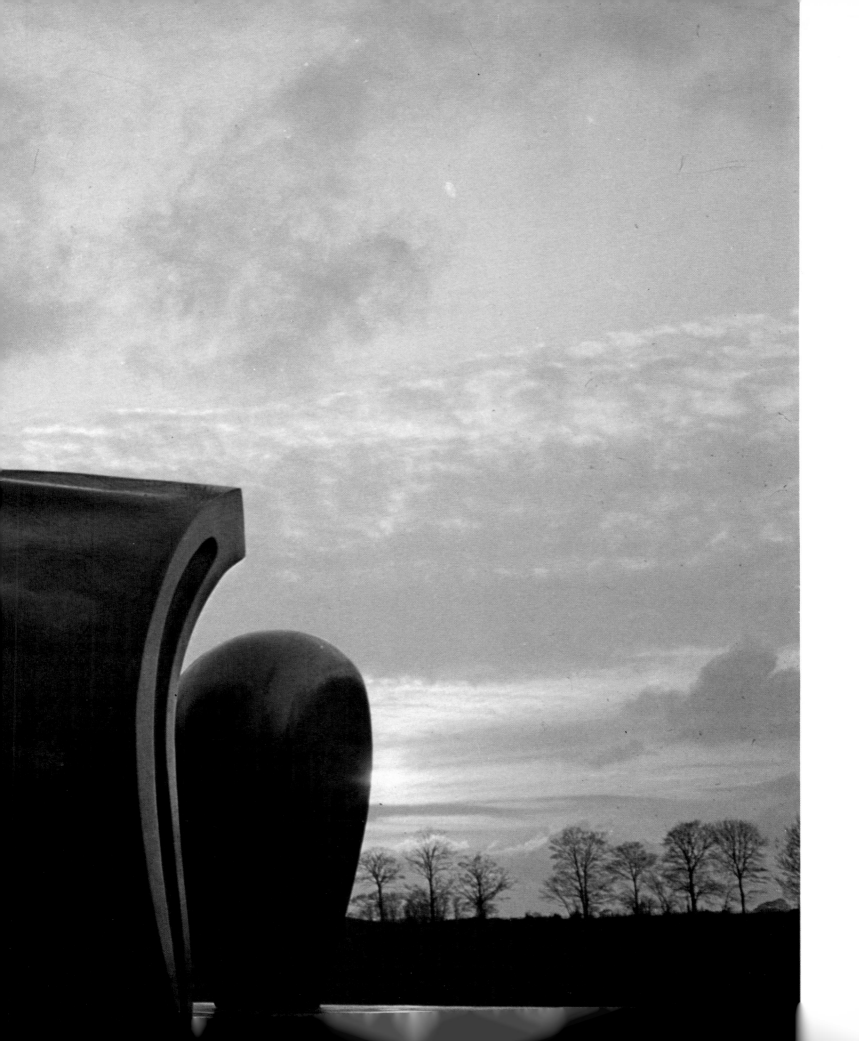

558 Two Piece Reclining Figure: Holes *1975 L 1.28 m White marble Private collection, Hong Kong*
559 Two Piece Reclining Figure: Bust *1975 L 1.08 m White marble Private collection, USA*

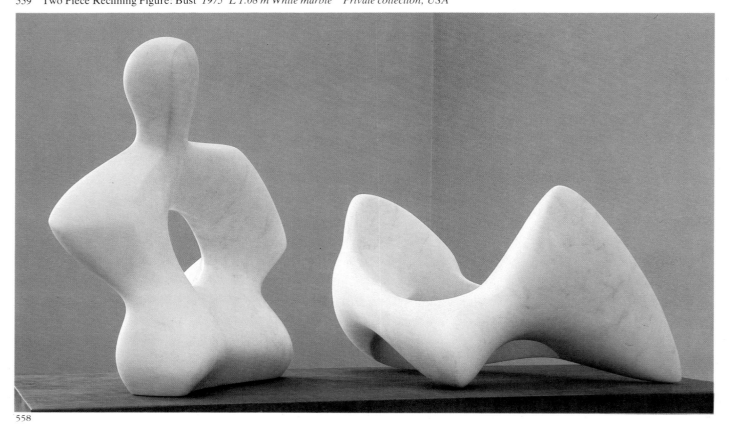

558

559

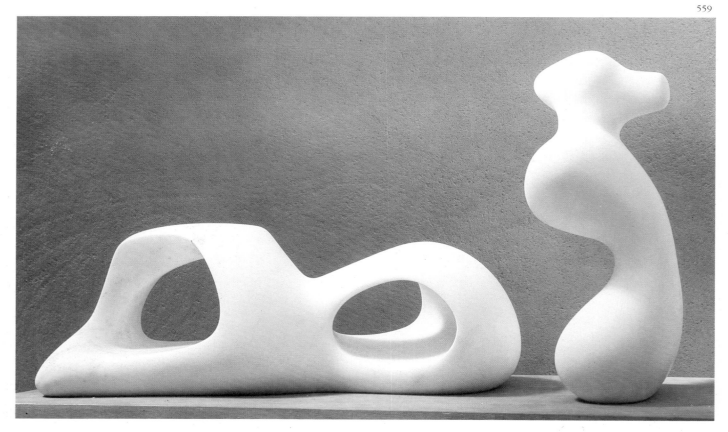

560 Two Forms *1975 L 87.6 cm Roman travertine marble Private collection*
561 Carving: Points *1974 L 86.4 cm Rosa Aurora marble Private collection*
562 Girl: Bust *1975 H 68.6 cm Roman travertine marble Private collection*

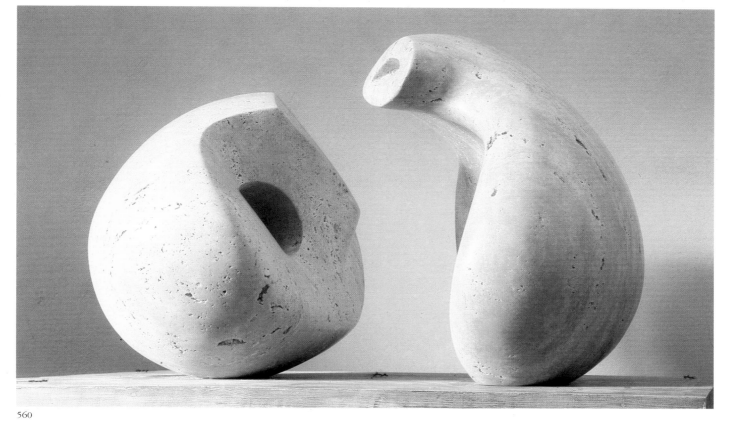

560

561

562

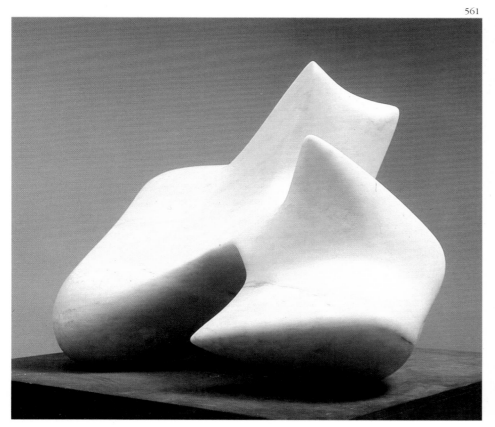

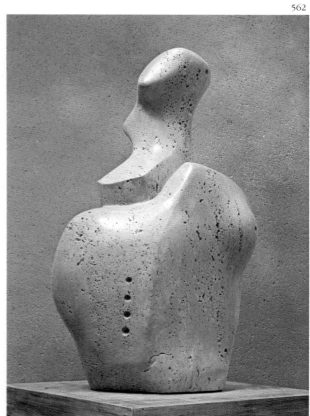

563, 564 Working Model for Reclining Figure: Angles *1975–7 L 91.4 cm Bronze, edition of 9*
565, 566 Reclining Figure: Angles *1979 L 2.18 m Bronze, edition of 9*

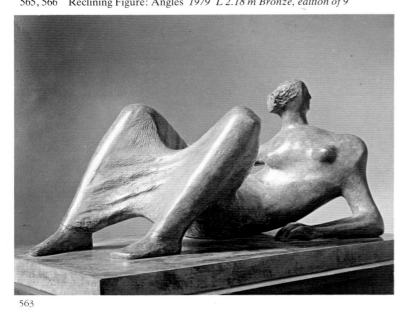

563

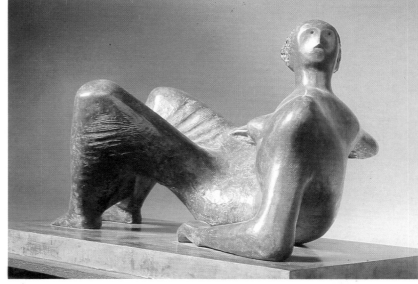

564

565

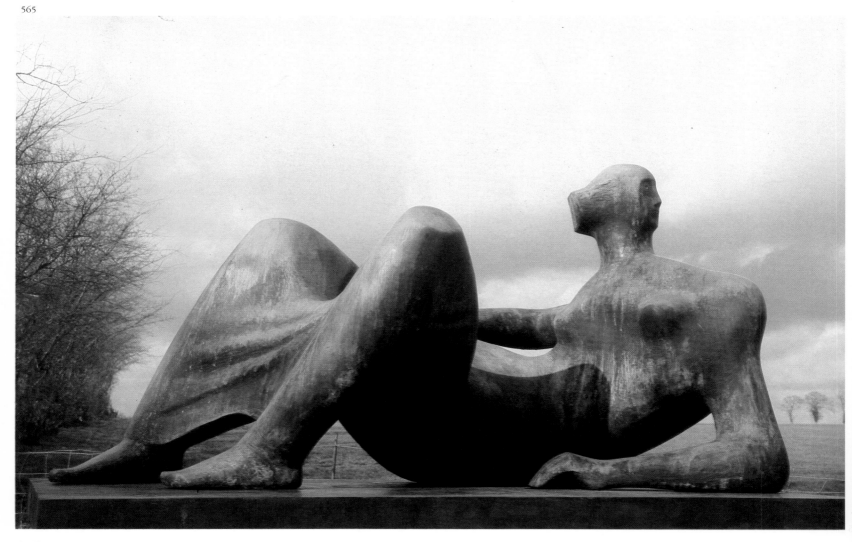

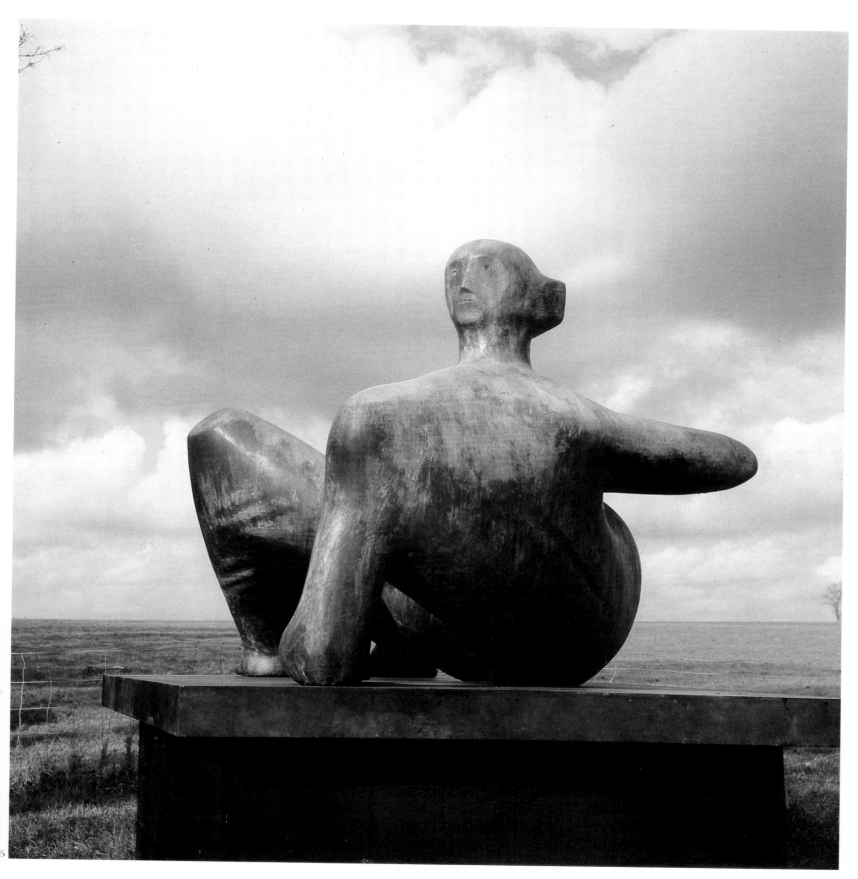

567 Reclining Figure: Thin *1976 L 26 cm Bronze, edition of 9*
568 Reclining Figure: Spider *1975 L 18.4 cm Bronze, edition of 9*
569 Reclining Figure: Crossed Legs *1976 L 20.3 cm Bronze, edition of 9*
570 Reclining Figure: Umbilicus *1976 L 16.8 cm Bronze, edition of 7*
571 Reclining Figure: Flint *1977 L 21 cm Bronze, edition of 9*

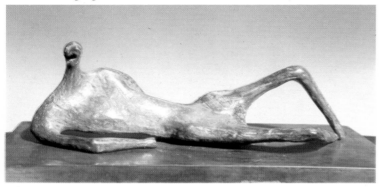

567

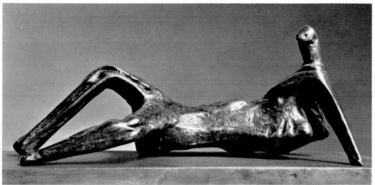

568

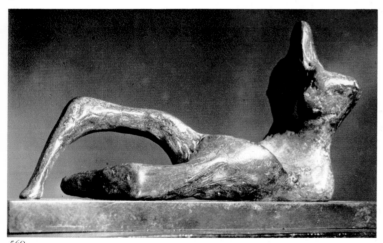

569

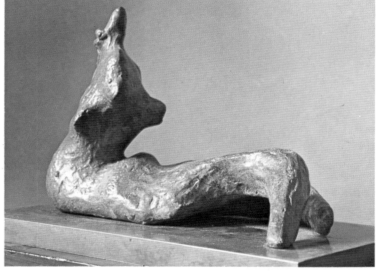

571

570

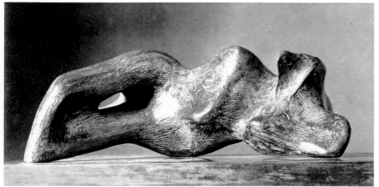

With the vast extension of means of communication, the growth of internationalism, the intense flare of publicity which falls on the artist once he has reached any degree of renown, he is in danger of losing a still more precious possession – his privacy. The creative process is in some sense a secret process. The conception and experimental elaboration of a work of art is a very personal activity, and to suppose that it can be organised and collectivised like any form of industrial or agricultural production, is to misunderstand the very nature of art.

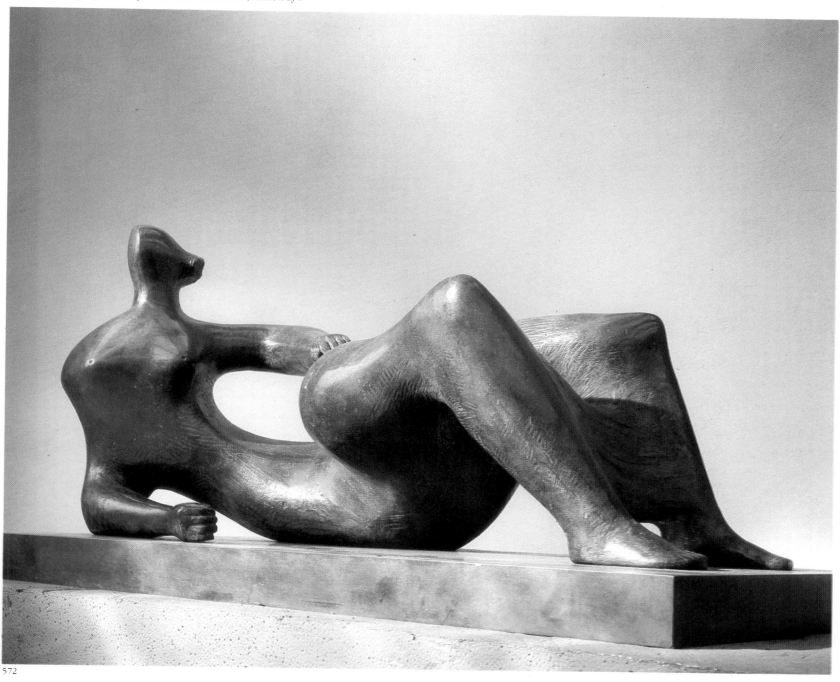

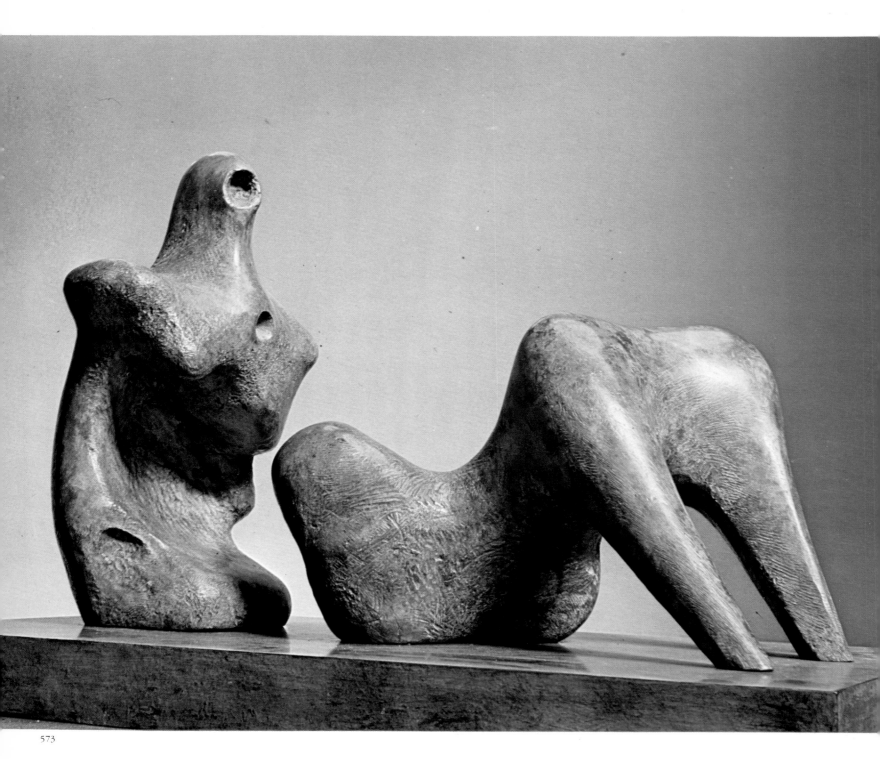

573

573　Working Model for Two Piece Reclining Figure: Armless *1975 L 61 cm Bronze, edition of 9*
574　Reclining Figure: Curved Smooth *1976 L 21 cm Bronze, edition of 9*
575, 576　Reclining Figure: Curved *1977 L 1.44 m Black marble Private collection, USA*

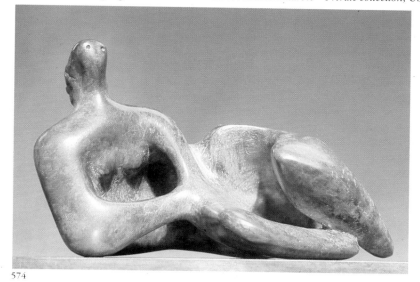

574

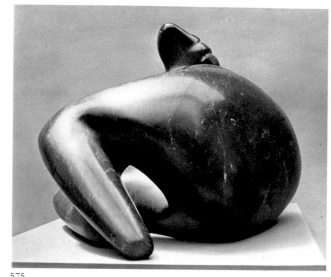

575

576

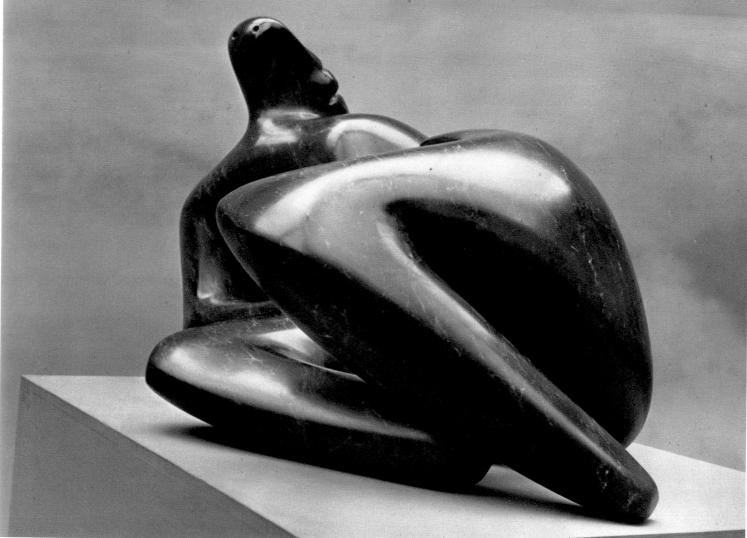

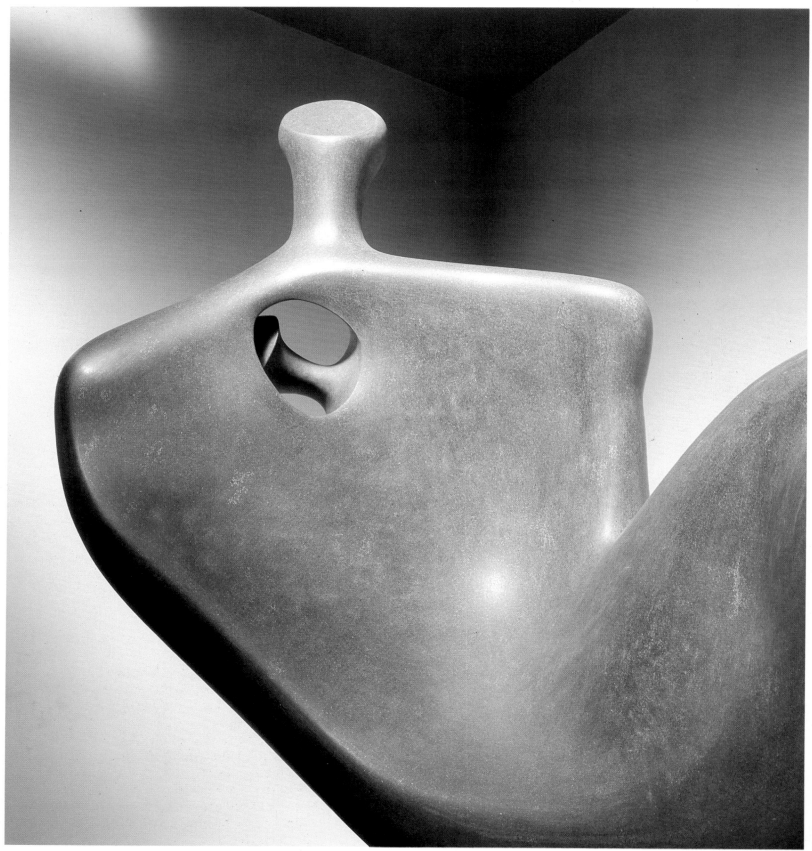

577

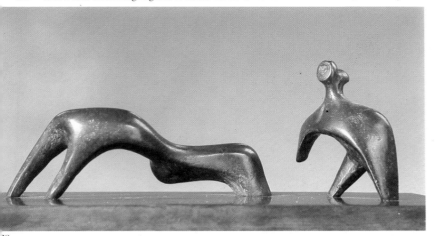

78

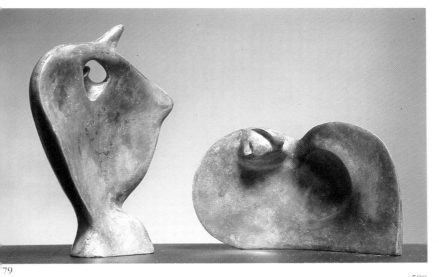

79
580

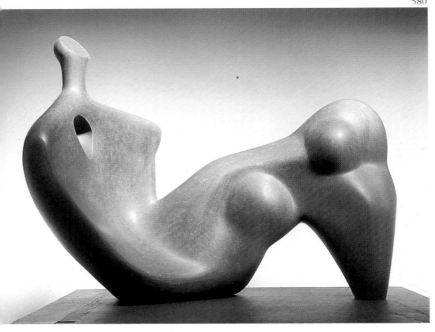

This figure (*figs 577, 580*) is in granite – a very hard but marvellously durable material.

The Egyptians used granite a lot even for colossal figures. No doubt an army of slaves was used especially in the finishing and polishing of a large work in granite.

I have used very hard materials similar to granite in small sculptures, but not until this figure in a large size.

No doubt there is something about the resistance of hard stone which gives a finality that a soft material tends not to have. Also the length of time needed to carve into such a hard material gives something, a kind of permanence perhaps, that a soft material, done quickly, does not have.

279

581, 584 Mother and Child: Arms *1976–9 L 79.7 cm Bronze, edition of 9*
582 Mother and Child: Hair *1977 H 17.5 cm Bronze, edition of 9*
583 Seated Mother and Baby *1978 H 20 cm Bronze, edition of 9*

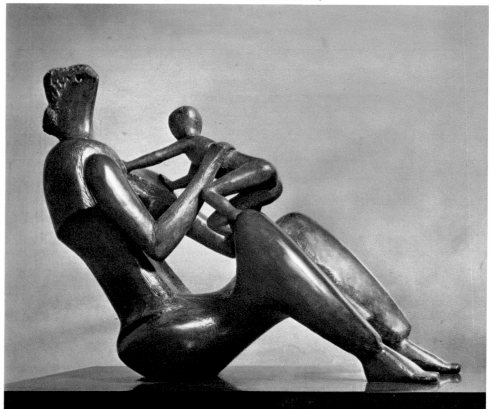

581

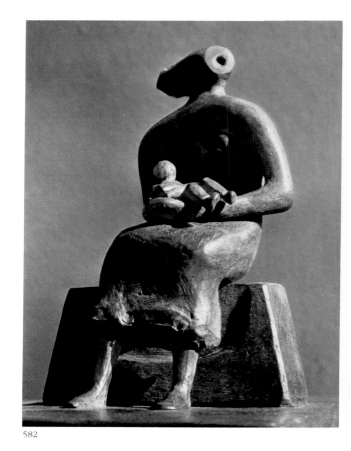

582

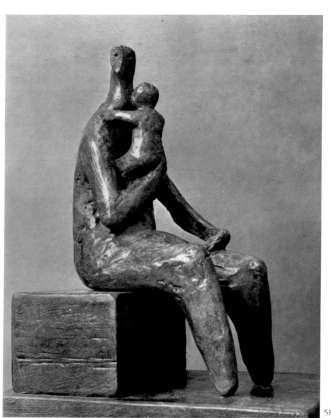

583

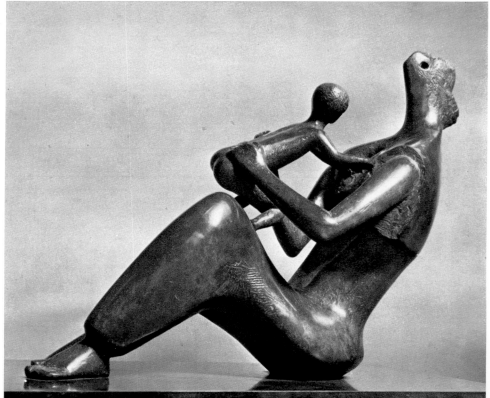

585 Mother and Child: Upright *1978 H 57.8 cm Bronze, edition of 9*

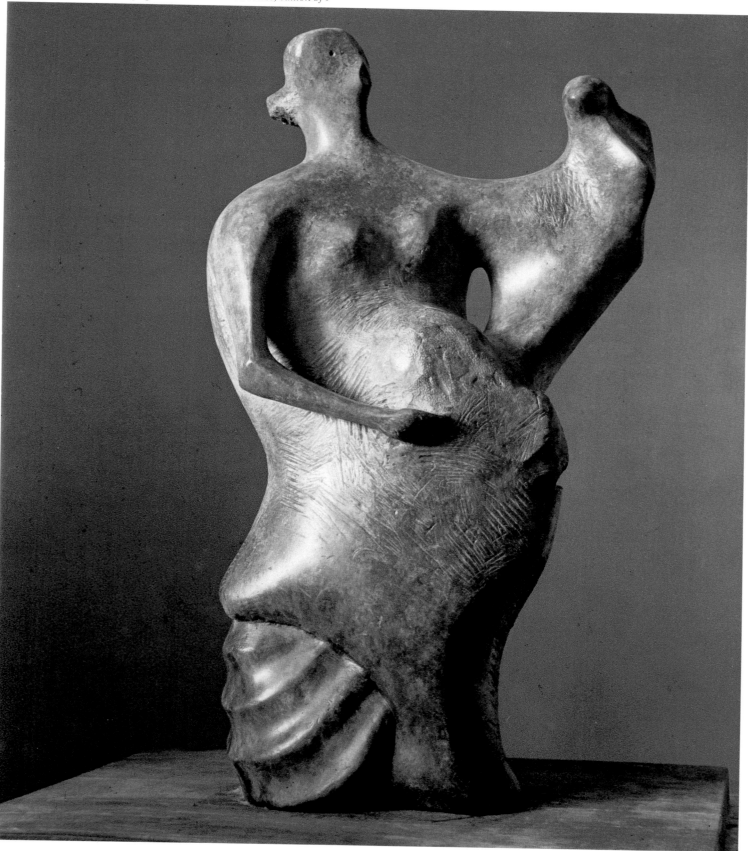

585

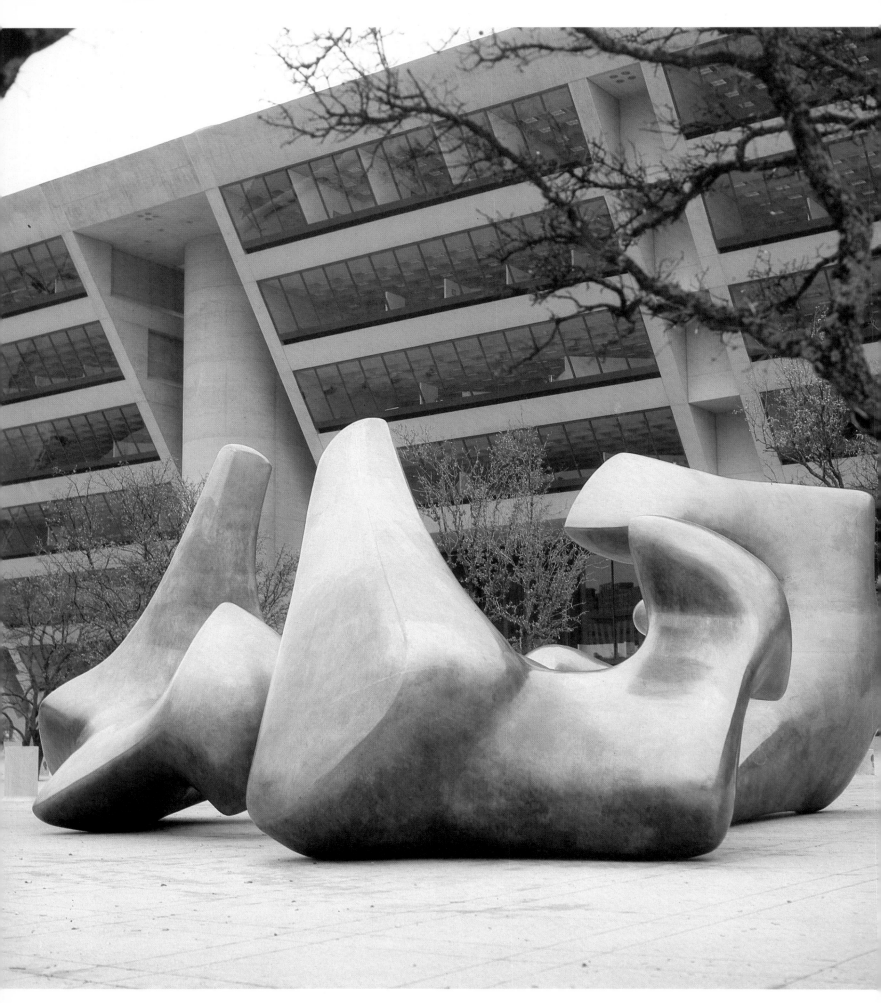

586, 589 Three Forms *1978–9 L 12.19 m approx. Bronze, unique cast City Center, Dallas*
587 *Henry Moore with the plaster working models for* Knife Edge Two Piece *and* Mirror Knife Edge, *Much Hadham 1976*
588 *Mirror Knife Edge 1977 L 7.62 m Bronze, unique cast National Gallery, Washington DC*

587

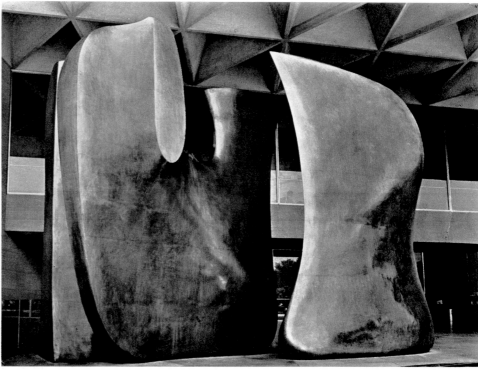

588

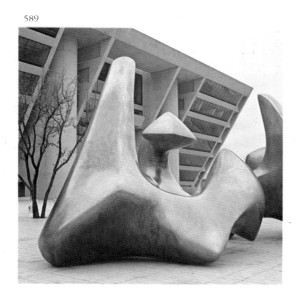

589

I never mind making a bigger variation of a sculpture I have already done because I enjoy seeing a small maquette made larger. I would never reduce something from what it is to fit another place. That, I would think, was a diminishing of life.

The architect I. M. Pei asked me to make a sculpture for his new extension to the National Gallery in Washington. When we had to decide, he came to my studio with photographs, plans and scale drawings of the building and suggestions of where he thought a sculpture could be placed. This was at the entrance to the new building. We both agreed that whatever sculpture it was, it would have to be on a very big scale, otherwise it would only look like somebody going in and out of the gallery. After some consideration we both thought that an existing sculpture, the *Knife Edge Two Piece* (figs 355–8), would be the right idea if made big enough, but we both agreed that if it were the other way round, that is, a mirror image of itself, it would suit better the entrance, because people could go through it into the gallery, whereas the other way they would be running into the wall. I thought it was a good experiment for me to have to do a sculpture as a mirror image. This was done and I think successfully.

590, 591　Working Model for Draped Reclining Figure　*1977–8　L 99 cm Bronze, edition of 9*
　592　Draped Reclining Figure　*1978　L 1.83 m Roman travertine marble　The Henry Moore Foundation*
　593　Reclining Figure: Bone Skirt　*1978　L 1.75 m Roman travertine marble*

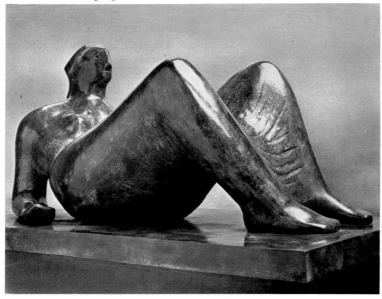

590

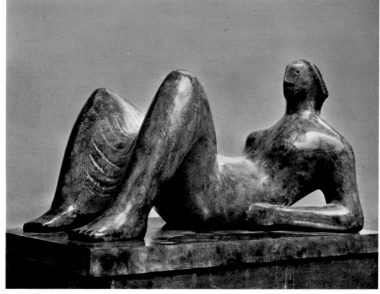

591

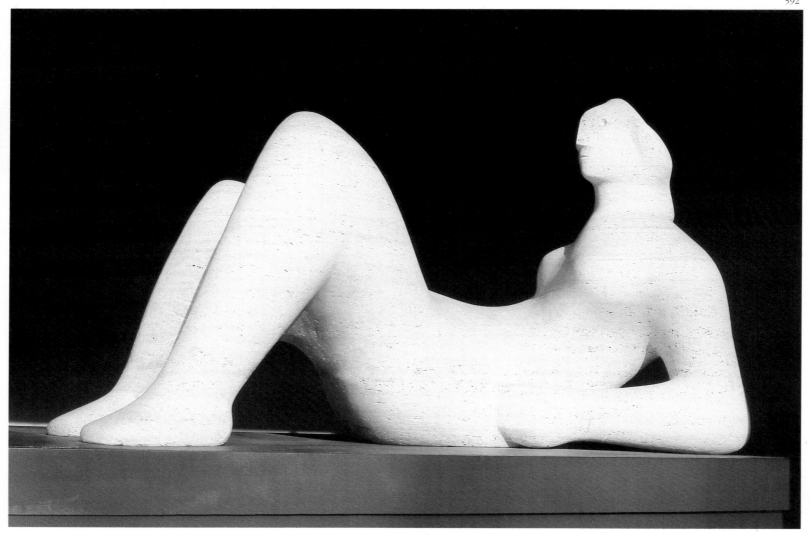

592

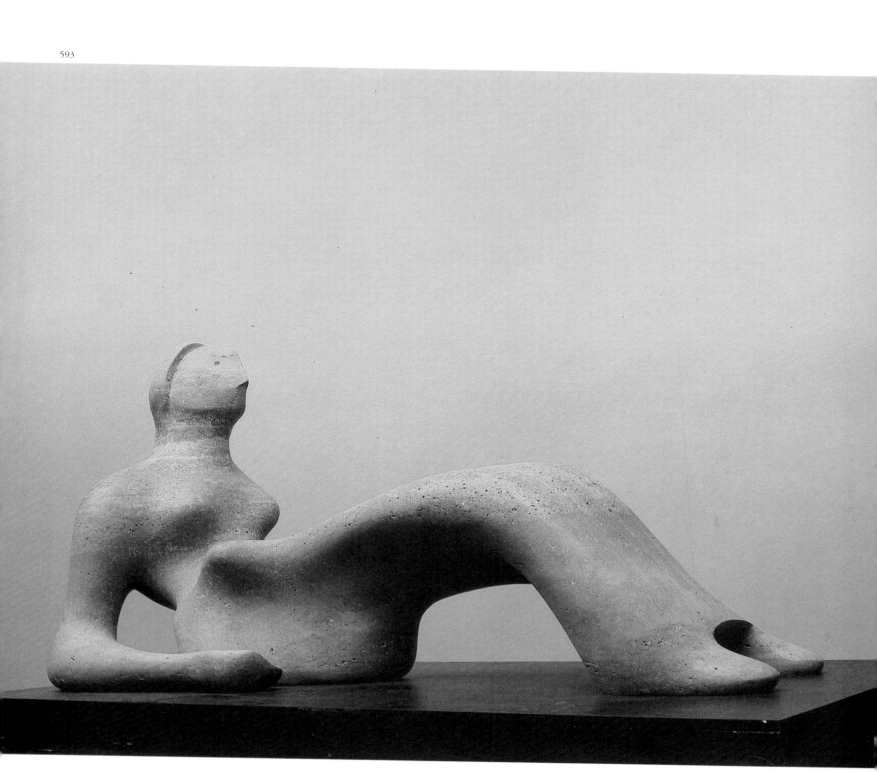

594, 595 Reclining Figure: Hand *1978–9 L 2.21 m Bronze, edition of 9*

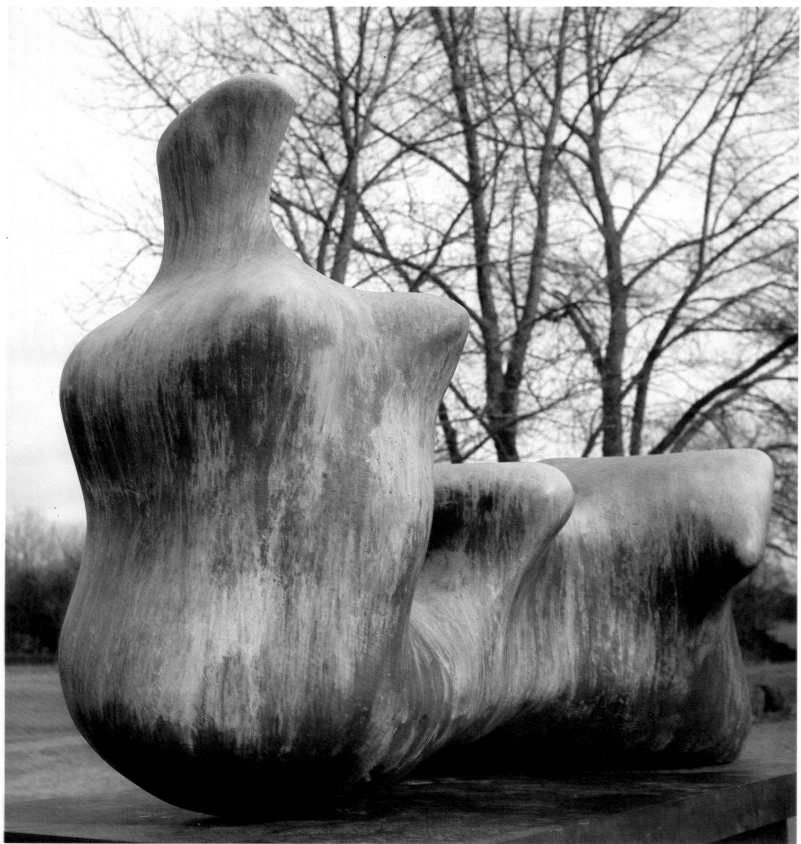

594

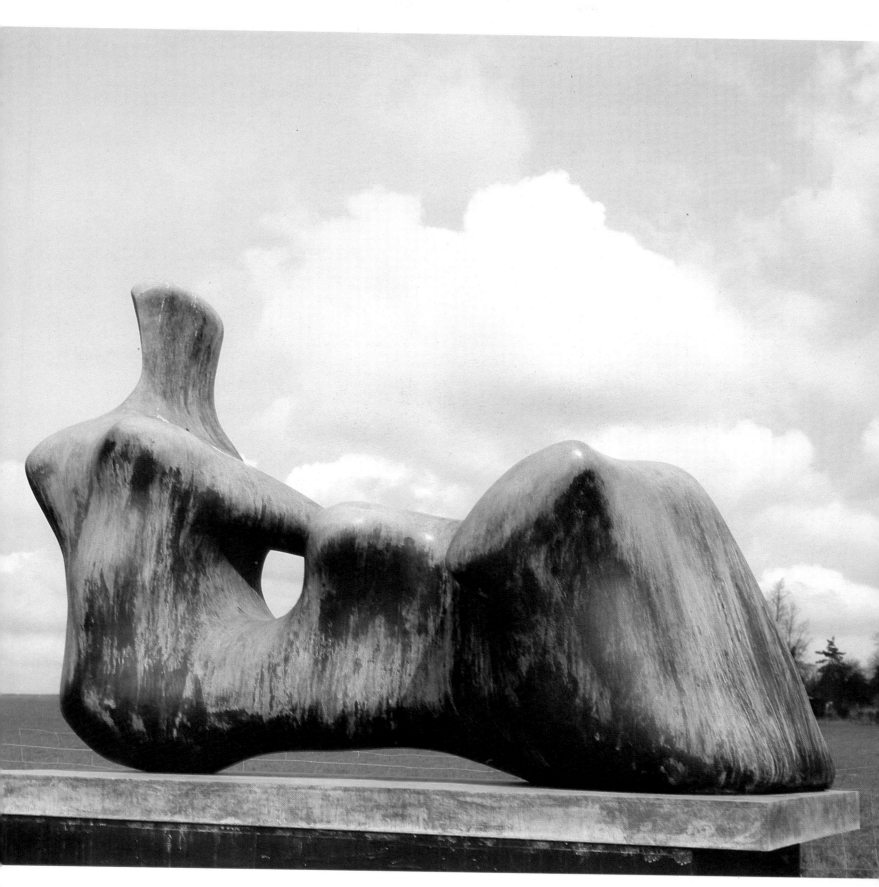

596 Mother and Child: Egg Form *1977 H 1.94 m White marble The Henry Moore Foundation*
597 Maquette for Mother and Child: Egg Form *1977 H 17.1 cm Bronze, edition of 9*
598 Maquette for Egg Form: Pebbles *1977 L 11.4 cm Bronze, edition 9*
599 Egg Form: Pebbles *1977 L 11.4 cm approx. White marble Private collection*

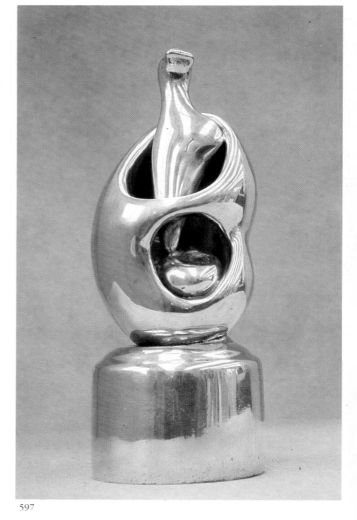

597

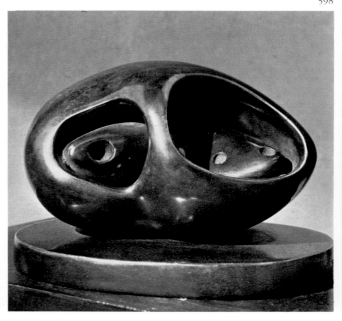

598

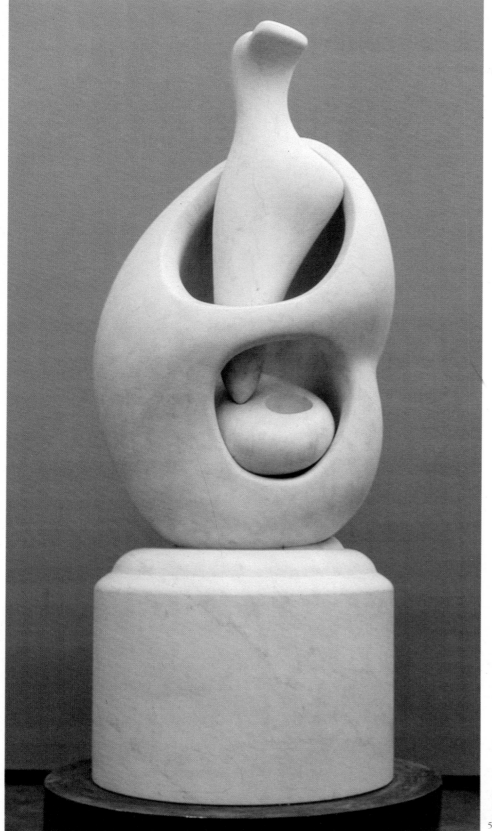

596

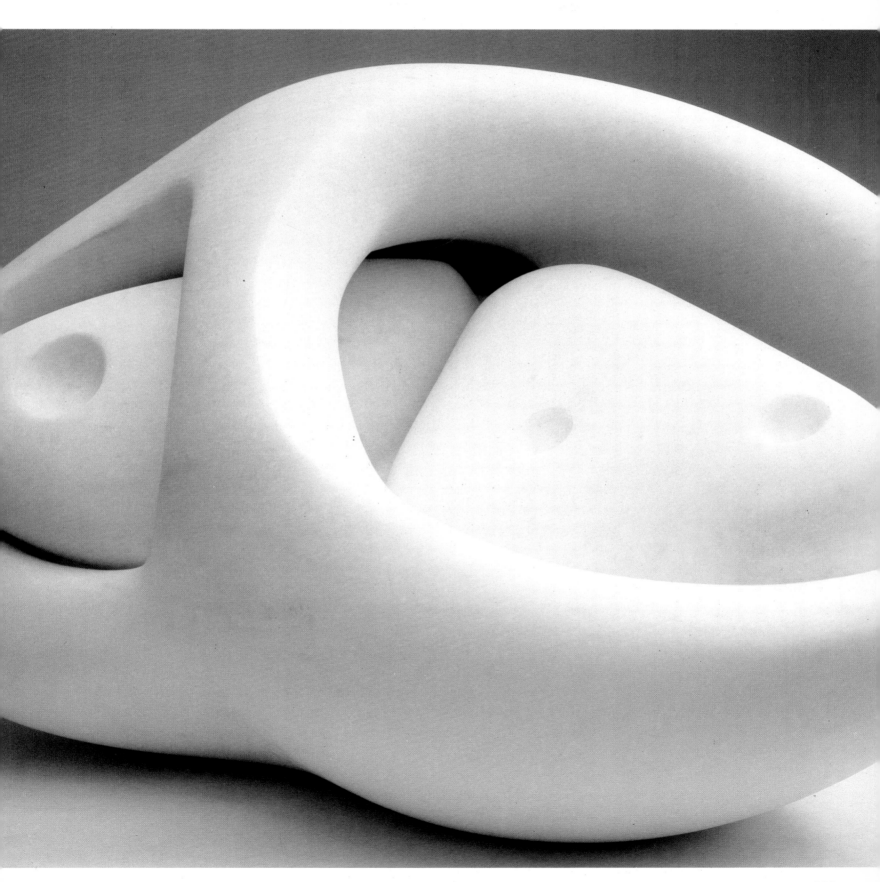

600 Trois Baigneuses *1873–7 by Paul Cézanne (1839–1906) H 30.5 × 33 cm Oil on canvas*

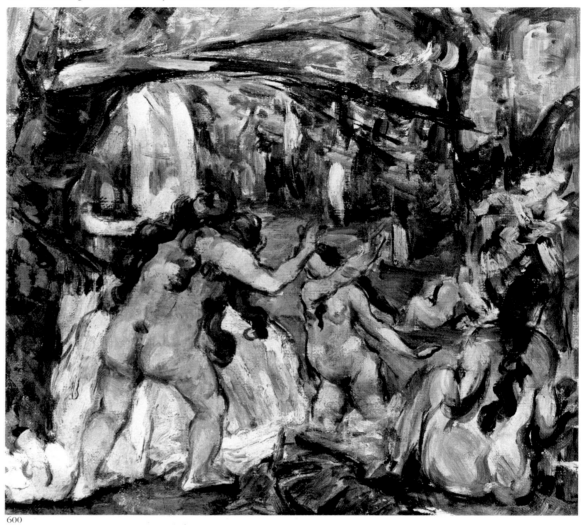

600

Perhaps the most prized possession in my home is a small oil painting by Cézanne, a sketch for one of his *Bathers* compositions. It hangs in my bedroom, and I have looked at it and studied it again and again.

Having looked so often at our little picture, I felt that I could turn the three bathers into sculpture, and decided one day to prove to myself that I could do so.

I spent about an hour, one morning, modelling each of the three figures in plasticine. Later, they were cast into plaster and I set them up on a base in the same spatial relationship as they have in the picture.

I am sure Cézanne's figures were so real to him that he could have drawn or painted them from other viewpoints. Having made my maquette, I drew the group from the back, from the sides, from the front, and from all round.

I enjoyed the whole of this experiment. I had thought I knew our *Bathers* picture completely, having lived with it for twenty years. But this exercise – modelling the figures and drawing them from different views – has taught me more than any amount of just looking at the picture. This example shows that working from the object – modelling or drawing it – makes you look much more intensely than ever you do if you just look at something for pleasure.

601–6 Three Bathers – after Cézanne *1978 L 30.5 cm Bronze, edition of 7*

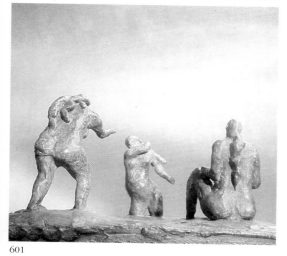

601

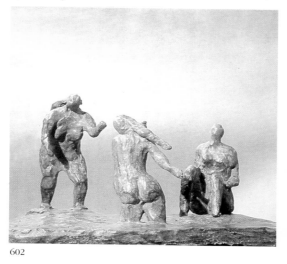

602

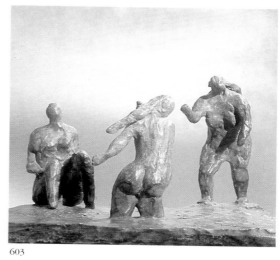

603

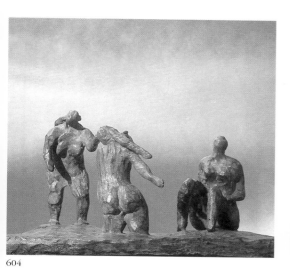

604

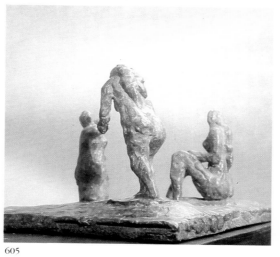

605

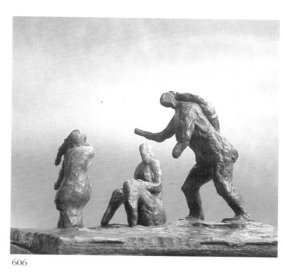

606

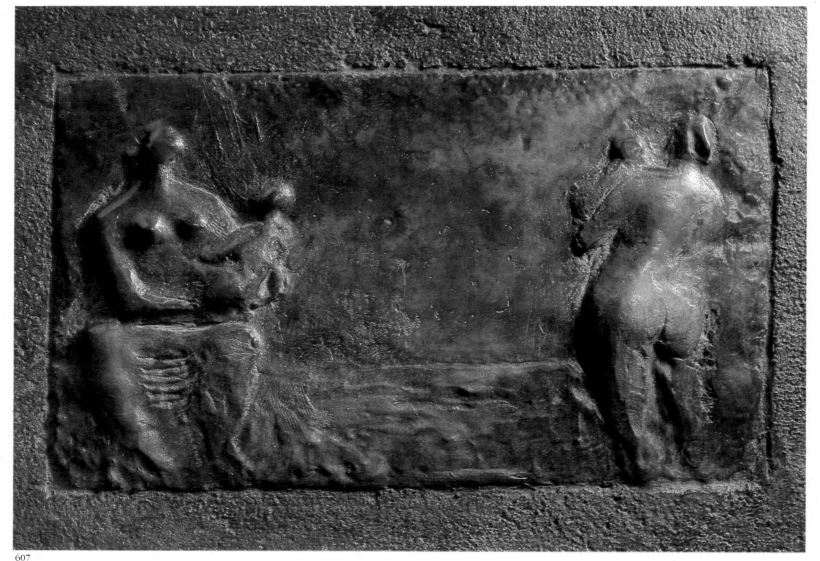

607

When I first went to art school, sculpture reliefs were the main production of sculptors for architecture. We were told that architecture was the 'mother of the arts' (implying that painters and sculptors must look to architects for employment). That of course was quite wrong, for religion is more the 'mother of the arts'. In Gothic and early Renaissance times a sculptor and an architect were often the same person.

As a young student I resented the supposed domination of architecture over sculpture and painting. Because of this general belief, of architecture being the dominant art, architects tended to find empty wall spaces on their buildings which they didn't know what to do with, and fill them with sculpture reliefs.

I believe that the great difference between painting and sculpture is the three-dimensionality of sculpture, which can have an endless number of different views from all round as reality has. You do not look at a painting from the back . . . you look from straight in front. I think that each art should exploit, and make the most of, its own particular possibilities. This belief meant that I developed a prejudice against reliefs.

However, I love drawing. A single drawing is done from one point of view, and in that sense reliefs are more akin to drawing and painting than to sculpture in the round, so occasionally I do make reliefs but think of them as more related to my drawings.

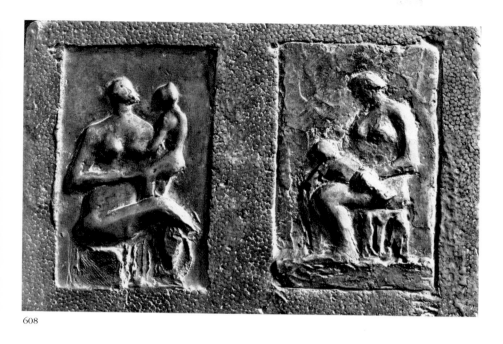

608

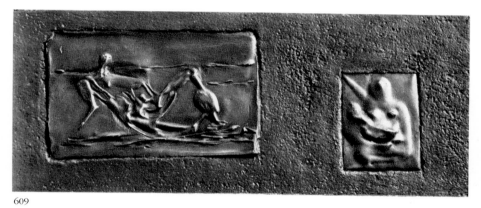

609

610

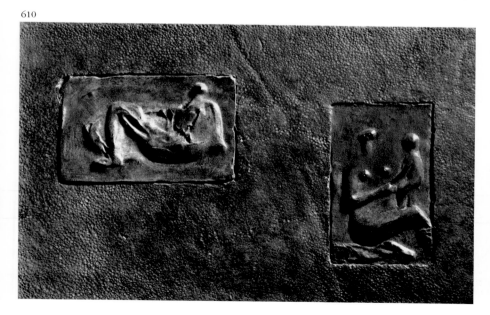

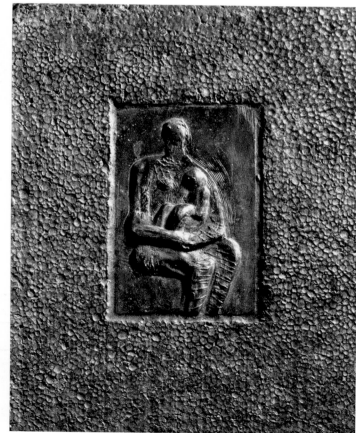

611

612 Head *1976 H 35.6 cm approx. Black marble Private collection*
613 Butterfly *1977 L 47 cm Marble Private collection, USA*
614 Twin Heads *1976 L 15.9 cm Bronze, edition of 9*
615 Torso *1977 H 67.6 cm Green marble Private collection*

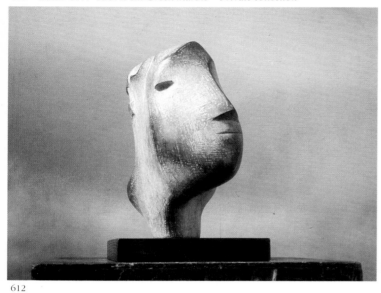

612

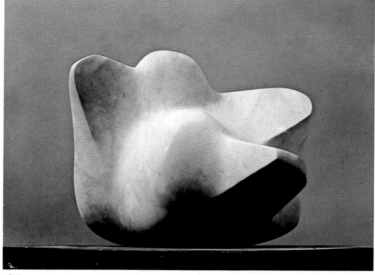

613

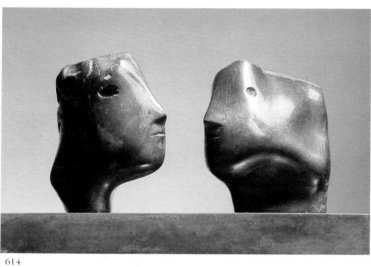

614

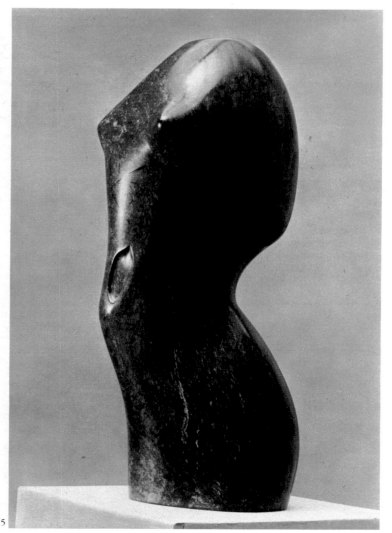

615

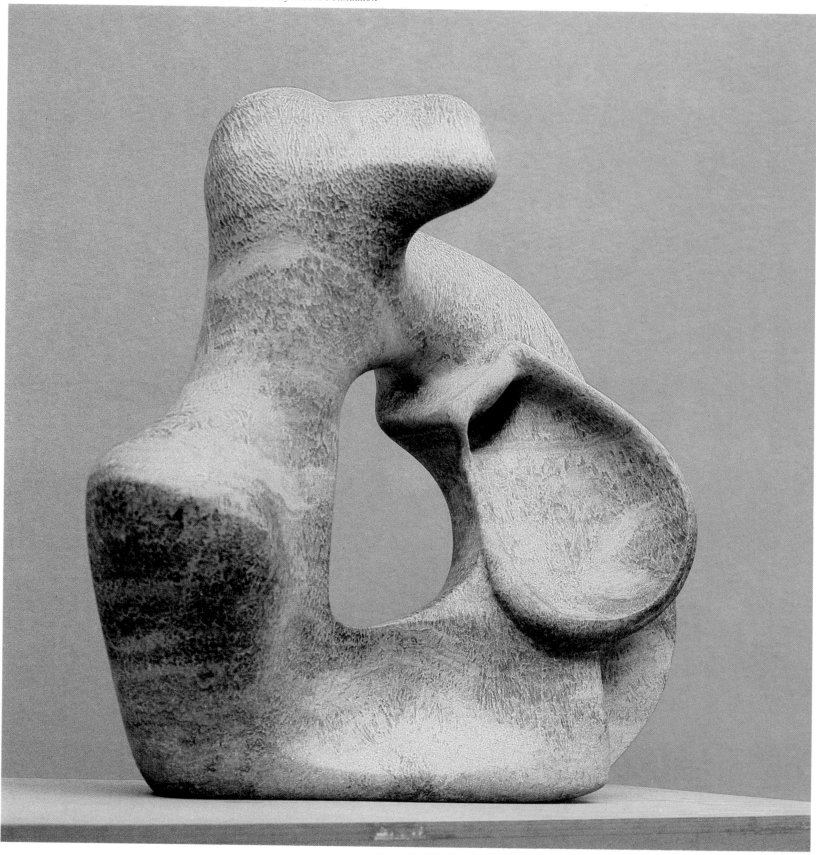

616

617 Architecture Prize *1979 L 33 cm Bronze, edition of 9*
618 Reclining Figure: Distorted *1978–80 L 91.4 cm Bronze, edition of 9*

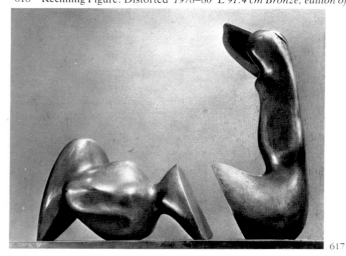

617

The whole of my development as a sculptor is an attempt to understand and realise more completely what form and shape are about, and to react to form in life, in the human figure, and in past sculpture. This is something that can't be learnt in a day, for sculpture is a never-ending discovery. I think about sculpture all the time. I have seen a great deal of the sculpture of the past. I work at it in my studio for ten to twelve hours a day. I even dream about it.

618

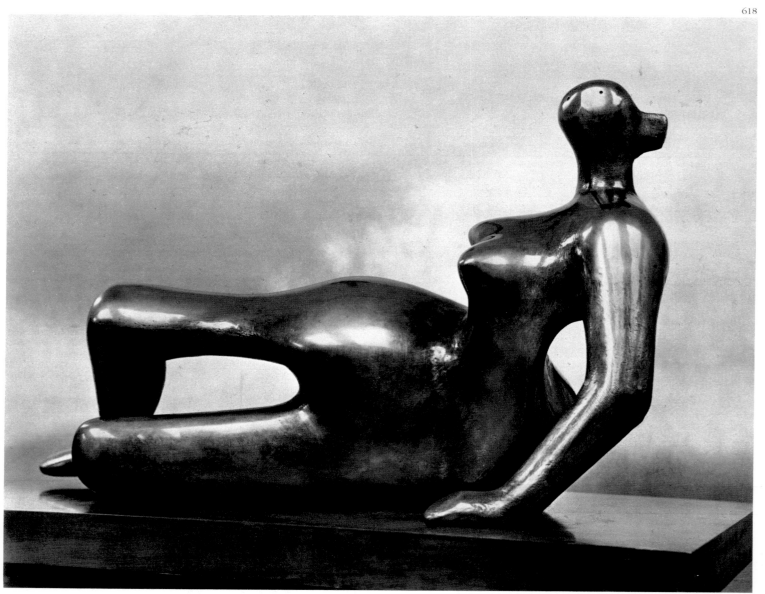

619, 621 Thin Reclining Figure *1978–80 L 1.93 m White marble The Henry Moore Foundation*
620 Thin Reclining Figure *1978 L 64.1 cm Bronze, edition of 9*

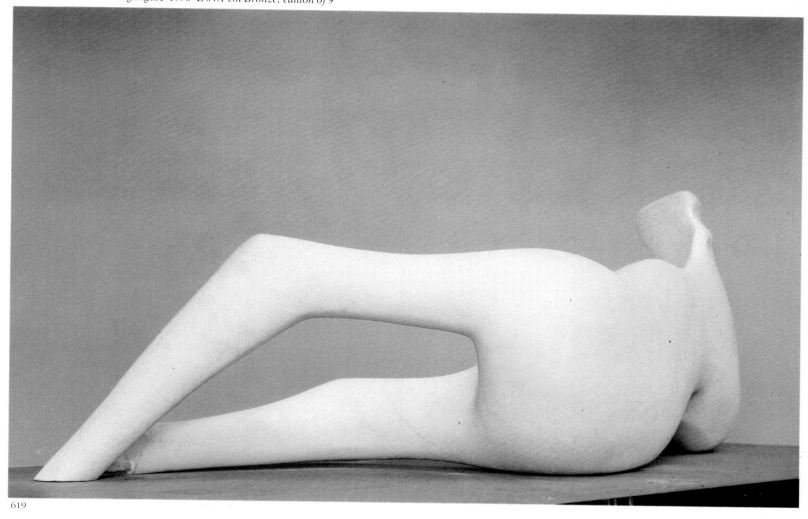

619

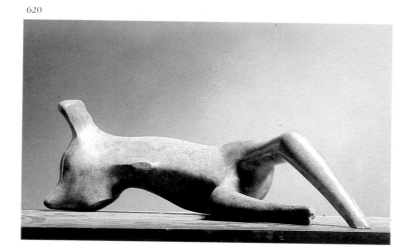

620

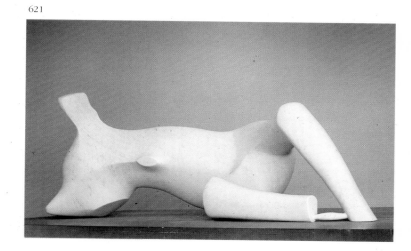

621

622 Reclining Mother and Child I *1979 L 20.3 cm Bronze, edition of 9*
623 Reclining Mother and Child II *1979 L 21.3 cm Bronze, edition of 9*
624 Reclining Mother and Child III *1979 L 23.5 cm Bronze, edition of 9*
625 Reclining Mother and Child IV *1979 L 20.3 cm Bronze, edition of 9*
626 Mother and Child: Towel *1979 H 27 cm Bronze, edition of 9*
627 Mother and Child: Rubenesque *1979 L 15.9 cm Bronze, edition of 9*

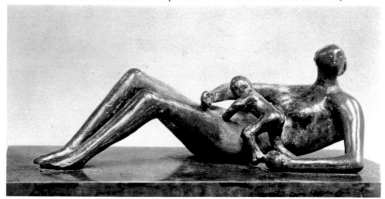

622

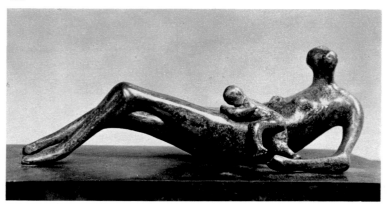

623

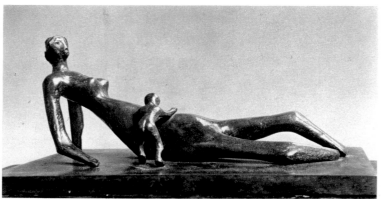

624

625

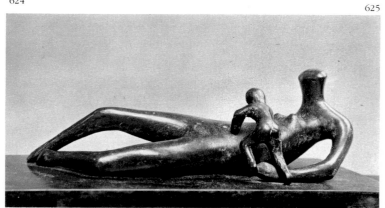

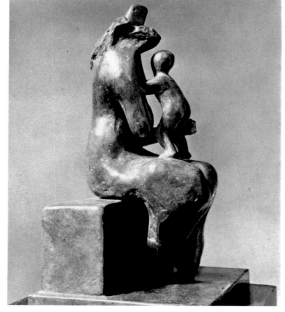

626

627

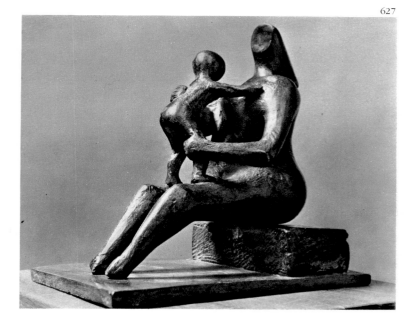

628, 629 Mother and Child: Hands *1980 H 19.7 cm Bronze, edition of 9*
 630 Draped Seated Mother and Child on Ground *1980 L 20.3 cm Bronze, edition of 9*
 631 Draped Mother and Child on Curved Bench *1980 H 19 cm Bronze, edition of 9*
 632 Thin Nude Mother and Child *1980 H 17 cm Bronze, edition of 9*

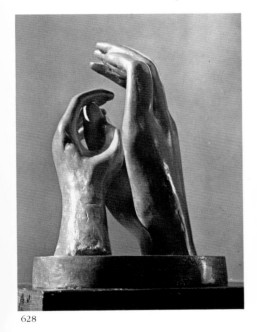

628

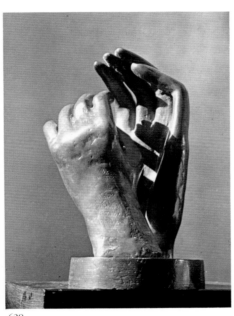

629

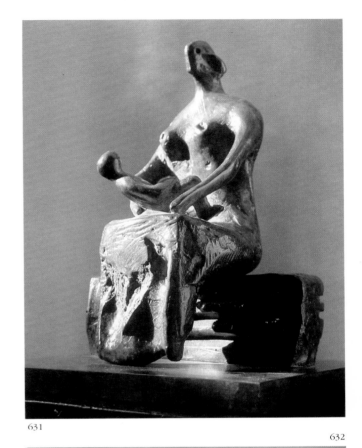

631

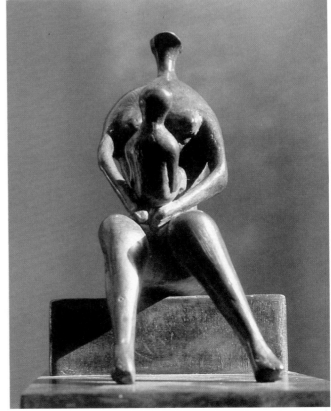

632

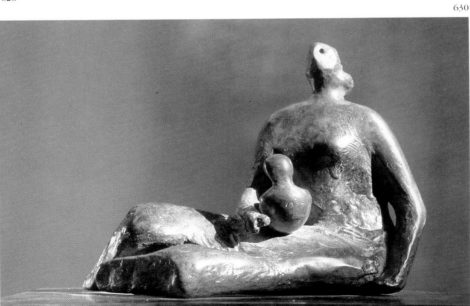

630

633 Upright Motive No. 9 *1979 H 3.46 m Bronze, edition of 6*
634 Three Quarter Figure: Lines *1980 H 83.8 cm Bronze, edition of 9*
635 Maquette for Three Upright Motives *1977 H 20.3 cm Bronze, edition of 9*

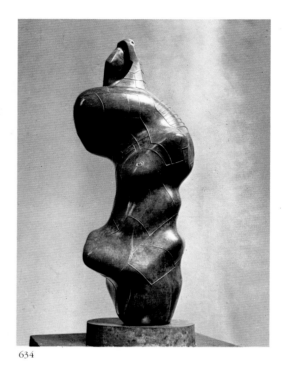

634

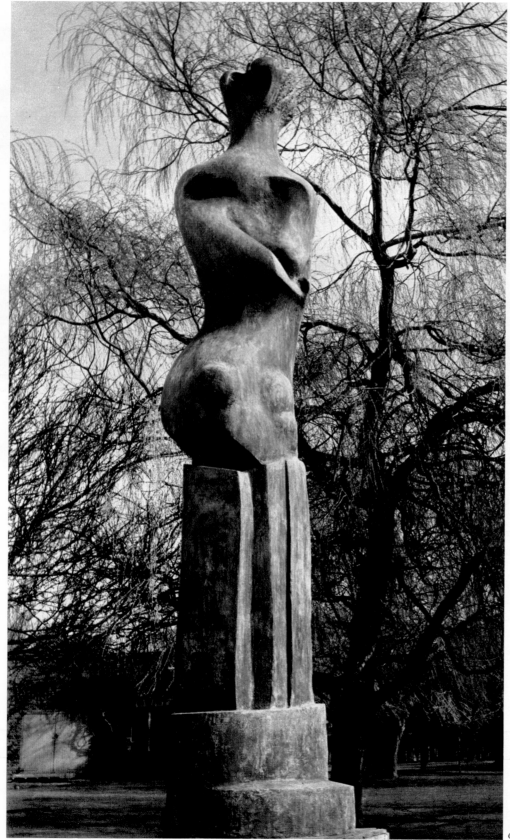

633

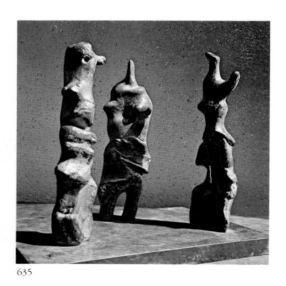

635

636　Three Upright Motives *1979–80　H 2.69 m Roman travertine marble*　*The Henry Moore Foundation*

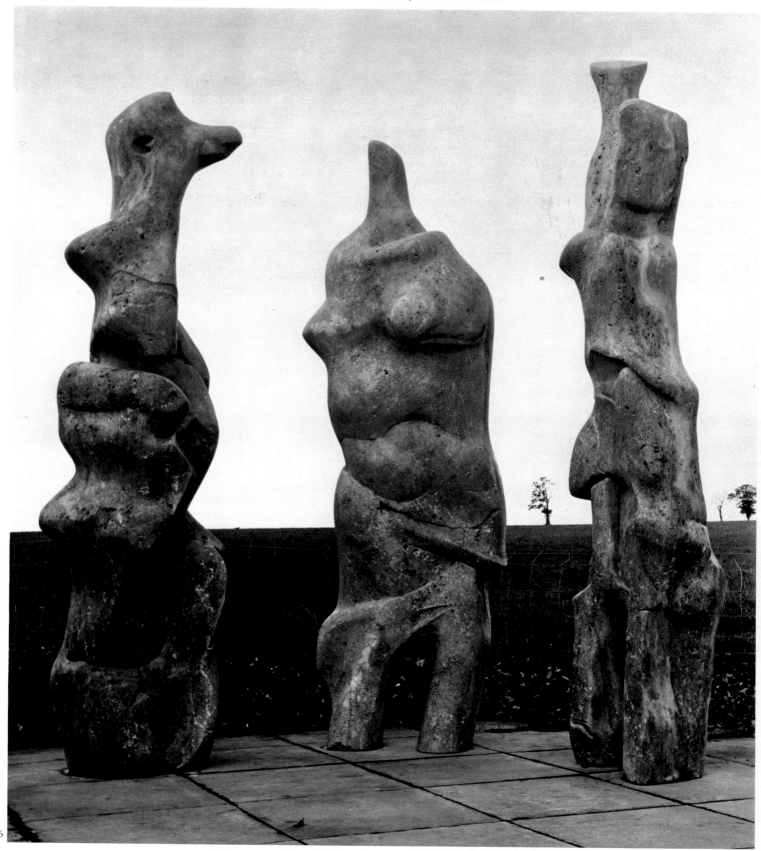

636

637–9 The Arch *Carved 1979–80 H 5.79 m Roman travertine marble* *The Department of the Environment, London (Kensington Gardens)*

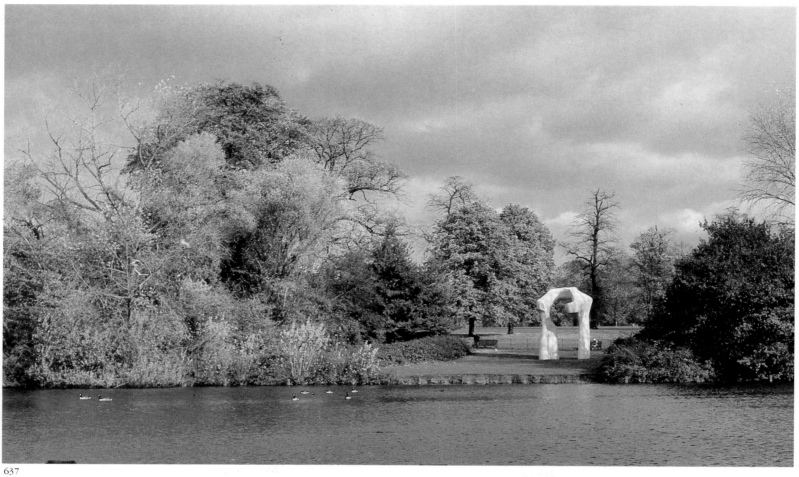

637

638

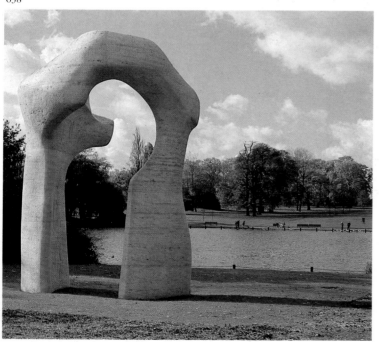

After the 1978 exhibition at the Serpentine Gallery in London, in which several large pieces were located in Kensington Gardens, there was a request for me to leave a sculpture there permanently, which I agreed to do.

I thought the *Large Arch* was very naturally sited, particularly as it could be seen reflected in the water from across the lake.

During the exhibition many people believed the sculpture to be made of marble, but in fact it was a fibreglass exhibition cast (*fig 369*) made originally for my exhibition at the Forte di Belvedere in Florence, because of the difficulty of getting a very heavy bronze or marble on to the site. Therefore, so that it could be left as a permanent sculpture in Kensington Gardens, I produced a version in travertine marble which is a very lasting material (the Coliseum and the Forum in Rome are in this stone).

The sculpture was unveiled on 1 October 1980.

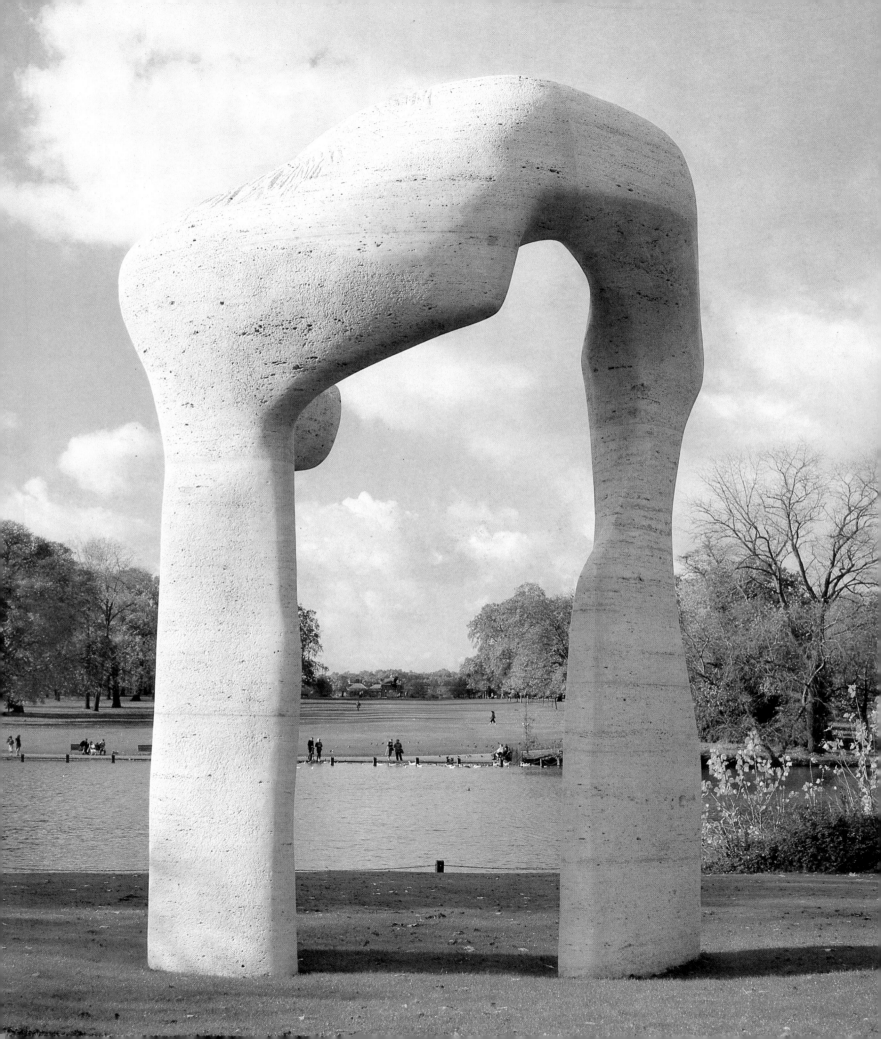

Chronology

Henry Moore's work as a sculptor, draughtsman, engraver and lithographer has been presented to the public in many museums and galleries throughout the world and may be seen in the national collections of many countries – Argentina, Australia, Austria, Belgium, Brazil, Canada, Chile, Czechoslovakia, Denmark, Egypt, France, Greece, Hong Kong, Iran, Ireland, Israel, Italy, Japan, Luxembourg, Mexico, The Netherlands, New Zealand, Norway, South Africa, Spain, Sweden, Switzerland, the United States, the United Kingdom, Venezuela and West Germany. In addition there have been well over a hundred retrospective exhibitions of the artist's work in cities all over the world. Where these are of special importance they have been mentioned in the chronology.

1898	Henry Moore born Castleford, Yorkshire, 30 July
1902–10	Attended Castleford Primary School; won scholarship to the local Grammar School
1915–16	Gained his Cambridge Senior Certificate and began studying to be a teacher Worked at his old school in Castleford
1917	Joined the Army (Civil Service Rifles, 15th London Regiment) and sent to the French front Gassed at the Battle of Cambrai; returned to England
1918	P.T. and Bayonet Instructor with the rank of Lance-Corporal Redrafted to France
1919	After demobilisation returned to teaching Enrolled at Leeds School of Art where he studied for two years
1921	Awarded scholarship to study sculpture at the Royal College of Art, London
1923	First of many trips to Paris, where he visited the Pellerin Collection
1924	Granted Royal College of Art Travelling Scholarship Appointed instructor in the Sculpture School for a term of seven years
1925	Travelled for six months in France and Italy
1926	Exhibited in a mixed show at the St George's Gallery, London
1928	First one-man exhibition at the Warren Gallery, London
1929	Married Irina Radetsky, a student in the School of Painting at the Royal College of Art
1930	Member of the Seven and Five Society
1931	One-man show at the Leicester Gallery, London First sale to the Continent, to the Museum für Kunst und Gewerbe, Hamburg Bought cottage at Barfreston, Kent, for use during college vacations

1932	Head of the new sculpture department at Chelsea School of Art
1933	Member of the avant-garde group 'Unit One'
1934	Left Barfreston for cottage with large garden at Kingston, near Canterbury, where he could work in the open air Publication of the first monograph on his work (by Herbert Read)
1936	Participated in the International Surrealist Exhibition at the New Burlington Galleries, London Signed manifesto against British policy of non-intervention in Spain Visited Altamira, Madrid, Toledo and Barcelona
1938	Participated in the Exhibition of Abstract Art at the Stedelijk Museum, Amsterdam
1939	Gave up teaching when Chelsea School of Art was evacuated
1940	Moved to Much Hadham, Hertfordshire, when London studio damaged by bombing Appointed official war artist (until 1942)
1941	Trustee of the Tate Gallery, London (1941–56) First retrospective exhibition at Temple Newsam House, Leeds
1943	First one-man exhibition outside England, at Buchholz Gallery, New York
1945	Honorary Doctor of Literature, University of Leeds
1946	Birth of his only child, Mary Visited New York on the occasion of his first major retrospective exhibition at the Museum of Modern Art
1948	Awarded International Prize for Sculpture at the XXIVth Biennale, Venice Member of Royal Fine Art Commission (1948–71) Foreign Corresponding Member of the Académie Royale Flamande des Sciences, Lettres et Beaux-Arts de Belgique
1950	Foreign Member of the Swedish Royal Academy of Fine Arts
1951	First retrospective exhibition in London, Tate Gallery
1953	Honorary Doctor of Literature, University of London Awarded International Prize for Sculpture at the 2nd Biennale, São Paulo; visited Brazil and Mexico
1955	Appointed to the order of the Companions of Honour Trustee of the National Gallery, London (1955–74) Foreign Honorary Member of the American Academy of Arts and Sciences
1957	Awarded prize at the Carnegie International, Pittsburg Awarded the Stefan Lochner Medal by the City of Cologne
1958	Chairman of the Auschwitz Memorial Committee Honorary Doctor of Arts, University of Harvard
1959	Honorary Doctor of Literature, University of Reading Honorary Doctor of Laws, University of Cambridge

Awarded Gold Medal by the Society of the Friends of Art, Krakow
Awarded Foreign Minister's prize, 5th Biennale, Tokyo
Nominated Corresponding Academician by the Academia Nacional de
Bellas Artes, Buenos Aires

1961 Honorary Doctor of Literature, University of Oxford
Member of the American Academy of Art and Letters
Member of the Akademie der Künste, West Berlin

1962 Honorary Fellow of Lincoln College, Oxford
Honorary Freeman of the Borough of Castleford
Honorary Doctor of Engineering, Technische Hochschule, West Berlin
Honorary Doctor of Letters, University of Hull

1963 Member of the Order of Merit
Awarded the Antonio Feltrinelli Prize for sculpture by the Accadèmia
Nazionale dei Lincei, Rome
Honorary Member of the Society of Finnish Artists

1964 Awarded Fine Arts Medal by the Institute of Architects, USA

1965 Bought house at Forte dei Marmi, near Carrara
Honorary Fellow of Churchill College, Cambridge
Honorary Doctor of Letters, University of Sussex

1966 Fellow of the British Academy
Honorary Doctor of Laws, University of Sheffield
Honorary Doctor of Literature, University of York
Honorary Doctor of Arts, Yale University

1967 Honorary Doctor of Laws, University of St Andrews
Honorary Doctor, Royal College of Art, London
Honorary Professor of Sculpture, Carrara Academy of Fine Art

1968 Retrospective exhibition at the Tate Gallery, London, on the occasion of
his seventieth birthday
Awarded the Erasmus Prize, The Netherlands
Awarded the Einstein Prize by Yeshiva University, New York
Awarded the Order of Merit by the Federal German Republic
Honorary Doctor of Laws, University of Toronto

1969 Honorary Doctor of Laws, University of Manchester
Honorary Doctor of Letters, University of Warwick
Honorary Member of the Weiner Sezession, Vienna

1970 Honorary Doctor of Literature, University of Durham

1971 Honorary Doctor of Letters, University of Leicester
Honorary Fellow of the RIBA

1972 Retrospective Exhibition at Forte di Belvedere, Florence
Honorary Doctor of Letters, York University, Toronto
Awarded Medal of the Royal Canadian Academy of Arts
Cavaliere di Gran Croce dell'Ordine al Merito della Repubblica Italiana
Awarded the Premio Ibico Reggino Arti Figurative per la Scultura,
Reggio Calabria
Foreign Member of the Orden pour le Mérite für Wissenschaften und
Künste, West Germany

1973 Awarded the Premio Umberto Biancamano, Milan
Commandeur de l'Ordre des Arts et des Lettres, Paris

1974 Opening of the Henry Moore Sculpture Centre at the Art Gallery of
Ontario, Toronto
Honorary Doctor of Humane Letters, Columbia University, New York
Honorary Member of the Royal Scottish Academy of Painting, Sculpture
and Architecture, Edinburgh

1975 Honorary Member of the Akademie der Künste, Vienna
Membre de l'Institut, Académie des Beaux Arts, Paris
Awarded the Kaiserring der Stadt Goslar, West Germany
Associate of the Académie Royale des Sciences, des Lettres et des
Beaux Arts de Belgique

1977 Formed the Henry Moore Foundation
Member of the Serbian Academy of Sciences and Arts

1978 Major donation of sculptures to the Tate Gallery, London
Eightieth birthday exhibitions at the Serpentine Gallery and in
Kensington Gardens, London, and the City Art Gallery, Bradford
Awarded the Grosse Goldene Ehrenzeichen by the City of Vienna
Awarded the Austrian Medal for Science and Art

1979 Honorary Doctor of Letters, University of Bradford

1980 Donation of *Large Arch* to the Department of the Environment for
permanent siting in Kensington Gardens
Presented by Chancellor Schmidt with Das Grosse Verdienstkreuz mit
Stern und Schulterband

1981 Major retrospective exhibition in and around Palacio Velázquez, Madrid

List of References

Principal Sources

Note: Titles of the principal sources given in full here are abbreviated in the list of references which follows.

Hedgecoe, J. *Henry Moore* Nelson, London 1968.
Henry Moore Drawings 1969–79 (Exhibition Catalogue, Wildenstein, New York) Raymond Spencer Co., Much Hadham 1979.
HM/DM recording, 1980. Extracts from conversations with the artist recorded by David Mitchinson, Much Hadham 1980.
Levine, Gemma *With Henry Moore: The Artist at Work* Sidgwick and Jackson, London 1978.
Sculpture in the Open Air edited by Robert Melville and recorded by The British Council, London 1954.
'The Sculptor Speaks', *The Listener* vol XVIII no 449, London 1937.

p 23 'The Sculptor Speaks', *Listener*, 1937.

p 25(i) *Unit 1: The Modern Movement in English Architecture, Painting and Sculpture* Cassell, London 1934.

p 25(ii) Hedgecoe, 1968, p 75.

p 26 Hedgecoe, 1968, p 131.

p 38 *Sculpture in the Open Air*, 1954.

p 39 Hedgecoe, 1968, p 56.

p 42 From an address given at an international conference of artists organised by UNESCO and held in Venice, 22–28 September 1952.

p 45 *Henry Moore Drawings 1969–79*.

p 46 'The Sculptor Speaks', *Listener*, 1937.

p 48 Levine, 1978, p 146.

p 50 *Henry Moore Drawings 1969–79*.

p 52 *Henry Moore Drawings 1969–79*.

p 59 Roditi, Edouard *Dialogues on Art* Secker and Warburg, London 1960.

p 65 Hedgecoe, 1968, p 67.

p 75 HM/DM recording, 1980.

p 81(i) Lake, Carlton 'Henry Moore's World', *Atlantic Monthly* vol 209 no 1, Boston 1962.

p 81(ii) Hedgecoe, 1968, p 105.

p 82 HM/DM recording, 1980.

p 86 Morse, J.D. 'Henry Moore Comes to America', *Magazine of Art* vol 40 no 3, Washington DC 1947.

p 88 Levine, 1978, p 29.

p 90 Compilation from three statements published in *Henry Moore on Sculpture* ed. Philip James, Macdonald, London 1966.

p 96 *Sculpture in the Open Air*, 1954.

p 98 HM/DM recording, 1980.

p 101 Hedgecoe, 1968, p 167.

p 102 Finn, David *Henry Moore: Sculpture and Environment* Thames and Hudson, London 1977, p 263.

p 105 Hedgecoe, 1968, p 178.

p 106 From a letter to the late H. Fischer, London (undated). HMF archives, Much Hadham.

p 110 Henry Moore *Sculptures in Landscape* Studio Vista, London 1978, Introduction.

p 112 Hedgecoe, 1968, p 118.

p 121 *Sculpture in the Open Air*, 1954.

p 123(i) Mundt, Ernest *King and Queen, Art and Artist* University of California Press, Berkeley and Los Angeles 1956.

p 123(ii) Hedgecoe, 1968, p 232.

p 124 *Sculpture in the Open Air*, 1954.

p 128 Finn, David *Henry Moore: Sculpture and Environment* Thames and Hudson, London 1977, p 254.

p 130 Forma, Warren *Five British Sculptors* Grossman, New York 1964.

p 132 Finn, David *Henry Moore: Sculpture and Environment* Thames and Hudson, London 1977, p 180.

p 134 HMF archives, Much Hadham.

p 136 HM/DM recording, 1980.

p 138 Hedgecoe, 1968, p 118.

p 142 Lake, Carlton 'Henry Moore's World', *Atlantic Monthly* vol 209 no 1, Boston 1962.

p 144 Hedgecoe, 1968, p 291.

p 147 Hedgecoe, 1968, p 326.

p 148 HM/DM recording, 1980.

p 151 Levine, 1978, p 37.

p 153 Hedgecoe, 1968, pp 337–8.

p 154 Hedgecoe, 1968, p 335.

p 157 Hedgecoe, 1968, p 266.

p 165 Hall, Donald *As the Eye Moves* Harry N. Abrams, New York (1968).

p 166(i) Levine, 1978, p 148.

p 166 (ii) Hall, Donald 'An Interview with Henry Moore', *Horizon* vol III no 2, New York 1960.

p 168 HMF archive, Much Hadham.

p 170 HMF archive, Much Hadham.

p 178 'Nuclear Energy', *Art Journal* spring 1973, p 286.

p 180 *Henry Moore Drawings 1969–79*.

p 181 *Unit 1: The Modern Movement in English Architecture, Painting and Sculpture* Cassell, London 1934.

p 184 Hedgecoe, 1968, p 85.

p 185 *Circle: International Survey of Constructive Art* ed. J.L. Martin *et al.*, Faber, London 1937.

p 186 HM/DM recording, 1980.

p 192 HM/DM recording, 1980.

p 196 Levine, 1978, p 131.

p 201 Hedgecoe, 1968, p 93.

p 204(i) Hedgecoe, 1968, p 83.

p 204(ii) HM/DM recording, 1980.

p 206(i) Levine, 1978, p 134.

p 206(ii) Hedgecoe, 1968, p 213.

p 214 HM/DM recording, 1980.

p 218 HM/DM recording, 1980.

p 224 Forma, Warren *Five British Sculptors* Grossman, New York 1964.

p 228 HM/DM recording, 1980.

p 242 Henry Moore *Sheep Sketchbook* Thames and Hudson, London 1980.

p 246 John Hedgecoe *Henry Moore: Energy in Space* Bruckmann, Munich 1973, p 19.

p 249 *Sculpture in the Open Air*, 1954.

p 257 HM/DM recording, 1980.

p 262 HM/DM recording, 1980.

p 266 HM/DM recording, 1980.

p 274 From an address given at an international conference of artists organised by UNESCO and held in Venice, 22–28 September 1952.

p 279 HM/DM recording, 1980.

p 283 HM/DM recording, 1980.

p 290 *Henry Moore Drawings 1969–79*.

p 292 HM/DM recording, 1980.

p 296 'The Sculptor Speaks', *Listener*, 1937.

p 302 HM/DM recording, 1980.

List of Works

316